Elements
of
Photo Reporting

Richard H. Logan III

AMPHOTO
American Photographic Book Publishing Co., Inc.
New York

Library of Congress Catalog Card No. 73-97877.

Manufactured in the United States of America.

ISBN 0-8174-0523-2

Acknowledgments

THE AUTHOR wishes to express appreciation for financial and spiritual encouragement in the preparation of this book to Dr. Charles P. Hogarth, president, Mississippi State College for Women; to Dr. Robert I. Gilbert, chairman of the college committee on research grants; to Ray A. Furr, late head of the Journalism Department; and to the Board of Trustees of State Institutions of Higher Learning in the State of Mississippi for subsidizing and encouraging such research work.

Sincere thanks are conveyed to photo editors and head photographers of the following publications for their valuable cooperation in outlining photo department operations and in describing current practices in press photography: The Biloxi-Gulfport *Daily Herald;* New Orleans *Times-Picayune, States Item,* and *Dixie Roto; The Kansas City Star-Times;* and *The Daily Oklahoman* (Oklahoma City).

Illustrations for this book have been selected by the editors from among more than 350 photos graciously contributed by many organizations and individuals, most of whom are listed in the photo credits. Special recognition is due Harvey Weber, photo director of *Newsday,* Garden City, N. Y., and his staff for the excellent group of news photos they sent the author; *The National Observer* for their photos by Dickey Chapelle; the *Telegraph-Herald,* Dubuque, Iowa, and Bob Coyle for his selection of the prize-winning photos.

Also, many thanks to Bill Lignante, ABC-TV, Hollywood, Calif., and John Chase, WDSU-TV, New Orleans, La., for their courtroom sketches; the *Memphis* (Tenn.) *Commercial Appeal* for both their technical advice and photos; Fred Ward, editor of the Jackson (Miss.) *Daily News;* the National Press Photographers Association for their help in obtaining the "Pictures of the Year"; and E. I. DuPont de Nemours & Co., Inc., Goodyear Tire & Rubber Co., and the Library of Congress for their invaluable cooperation.

The help of a number of fellow photographers and members of the Professional Photographers Association of America, Inc., in showing the author through their studios and describing some of their problems and the solutions they have worked out, is hereby acknowledged. Thanks are also expressed to such companies as Eastman Camera Company, Agfa-Gaevert, Ansco, DuPont, Bell and Howell, and to various camera shop owners and other persons in the field for supplying technical advice and for personal discussion of photographic problems.

Thanks also go to his wife for her help in compiling the material, editing, and typing the manuscript. Without her assistance it would never have been completed.

This book is lovingly dedicated to Mr. Ray A. Furr, who served as chairman of the Journalism Department at Mississippi State College for Women for ten years, until his untimely death in the fall of 1970. He will be long remembered for the invaluable contributions he made to journalism education. Much of the inspiration and encouragement for writing this book came from him.

Contents

Preface

THE PRIMARY purpose of this book is to provide a textbook for beginning press photographers in university level photography courses. The book is also intended as a reference work for people who are assigned photographic jobs, whether they are writers, public relations personnel, picture editors, or other members of a publications staff.

The text is prepared in an easy-to-read manner on a level above that of the simple photography books designed for amateurs but below that of the highly technical books published for skilled technicians.

Although an amateur could greatly increase his knowledge of professional photography by studying this book, it is not designed for the amateur hobbyist nor the snapshooter who occasionally takes a few pictures and delivers them to the corner drugstore for photofinishing in a large commercial processing plant. Nor is this book designed to be the only textbook one needs to become a full-time professional. Rather, the professional techniques and theory have been combined to give the starting press photographer a background that will enable him to make intelligent decisions as to how to handle a variety of photo assignments in the world of mass communications. Photo editors, editors, and other publications staff personnel who may not be photographers but need to know more about professional press photography will also be able to make more intelligent decisions when dealing with photographers and photo equipment, and when making assignments.

By studying this book and faithfully observing the principles it sets forth, a practicing photographer should be able to take high-quality photographs, properly exposed and in focus; to develop a negative in a professional manner; and from this negative to produce a print or enlargement suitable for publication, display, or similar uses. He should be able to photograph both single individuals and groups in poses that reflect interest in the caption or story, rather than producing trite "mug shots" or club officer groups staring blankly into the camera.

If he is or plans to be a photo editor, or is in some other position of selecting photographs, he should know the difference between a good photograph and a poor one; he should be able to direct his photographers in such a way that they will produce good-quality, well-posed, and storytelling photographs, eliminating the overworked subjects and poor-quality photographs that frequently appear in many publications. He will have a clearer idea of photographic layout and will be able to save his publication valuable space by proper cropping of pictures, retaining only those parts that give the greatest reader interest. He should also be able to write terse, eye-catching captions.

If he is in public relations work, using this book should give him an overall picture of the many facets of photography and reveal new uses to which it may be applied. It will enable him to buy or produce photographs and other material that will be more readily accepted for publication.

If he is a teacher or college professor, it will give him a good basic text combining theory with practical application, and yet allow him opportunity to augment the text with examples and illustrations from his own experience, research, and study.

For the small magazine or newspaper publisher, this book is intended as a handy reference for sending people with little professional experience out on specific types of photo assignments.

For the woman photographer, it should provide general information that enables her to become a better photographer and should help meet some of her special photographic needs. It can give her an edge in competing for good journalism positions.

For the advertising photographer working with a small agency or newspaper, it should equip him to produce photographs that not only satisfy his clients but also have greater selling power.

For the person who wishes to become a free-lance photographer, this book should help him shorten the time normally required for becoming a selling part- or full-time professional.

These are a few of the aims of this book. As with any such book, especially in the field of photography, it is impossible to include all phases or give sufficient information on particular phases for certain individuals. For this reason, a list of suggested photographic books for further reading has been supplied at the close.

Most of the material included in this book is used in good photographic practice. Some is used only in specialized application, and a few tips and discoveries are included that the author has developed or learned from experience in operating a professional photographic studio, both for himself and others, as a photographer and reporter for daily newspapers, as a publicity photographer for a large publishing company, and while operating his own advertising and industrial photography agency.

Some practices in various parts of the country may deviate somewhat from those recommended here. Each photographer, therefore, must test the various methods and discover which system works best for him.

CHAPTER 1

Introduction: The Role of the Photographer and the Problems He Faces

ONE DAY a customer walked into the photographic studio of a friend of mine and asked, "How much do you charge for portraits?"

"I charge $5, $10, and $15," my friend replied.

"Why the difference in price?" the customer wondered.

"It's $5 as you are, $10 as you think you are, and $15 as you'd like to be," my friend informed him.

Prices are higher today, and great improvements have been made in chemicals, films, and camera equipment; yet the basic problem that the press or any other professional photographer must continually face is still how to take the $15 picture.

The secret of making a good photograph is starting with a good negative. It is easier to make a perfect print from a good negative than from a poor one. And even the most skilled photographer finds it difficult to make a good print from a poor negative. The novice, however, can often make an excellent print from a perfectly exposed negative with very little practice.

Today's automated cameras have light meters built in that select the proper exposure setting. Some cameras even develop a print only a few seconds after the shutter clicks. Also, a wide variety of films, developers, and photographic papers are available for all types of prints and enlargements. With all this specialized equipment and material geared to meet almost any need or situation, why isn't it possible for anyone to get a perfect negative or to make a perfect print every time?

The answer is, in part, that making photographs is not a mechanical

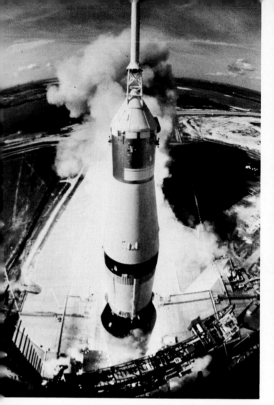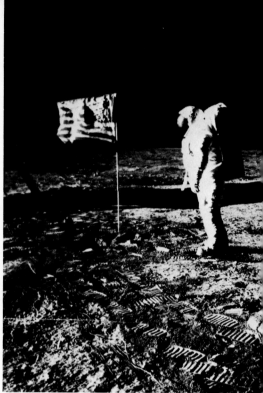

Figs. 1-1a and b. Man's first journey to the moon! (a) From the Kennedy Space Center in Florida, Apollo 11 clears the launching pad to begin its historic mission. (b) As astronaut Neil A. Armstrong mans the camera, Edwin E. Aldrin poses beside the implanted U.S. flag. His footprints are clearly visible in the foreground. Courtesy of NASA, Washington, D.C.

operation but a process of painting with light, much as an artist paints with oils or water colors.

Photography is a personal thing: a certain camera-film combination with the right techniques may prove highly successful for one photographer, but completely fail for another. Why is this true? It is the intangible quality, the abstract factor that makes the difference. The more one studies photographers and their individual techniques, the more apparent the importance of the personal element in photography becomes.

QUALIFICATIONS FOR SUCCESS

Being a good photographer may include having skill as an artist, scientist, psychologist, and inventor, in addition to possessing visual creativity. A good photographer needs a combination of many skills plus a breadth of knowledge in his own and other fields. No two photographers work in exactly the same way or have exactly the same backgrounds.

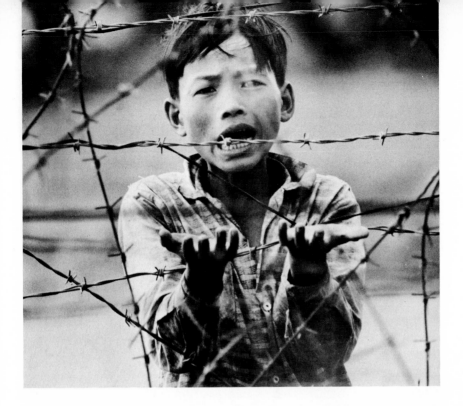

Fig. 1-2. This picture, entitled "Hunger—Vietnam," is from the second place portfolio of Bill Strode, photographer for the *Louisville* (Ky.) *Courier-Journal*. This was a winning photo in the 1967 Annual Pictures of the Year Competition, sponsored jointly by the National Press Photographers Association, the University of Missouri School of Journalism, and the World Book Encyclopedia Science Service, Inc.

Career counselors and guidance personnel have found, through testing, that some individuals show a greater capacity for learning in some areas than others. Capacity alone, however, is not a true indicator of potential success. Sheer drive, an environment conducive to learning, or the financial means to undertake a comprehensive course of study may outweigh the factor of capacity.

Because of the complexity of the discipline, success in photography cannot be accurately predicted, and the route to success can follow a variety of patterns. Many photographers have become artists, and many artists have become photographers. Yet being an artist is no guarantee that one will be a good photographer, and the "arty" side of photography is much overemphasized, for it is actually only a very small part of the total photographic process. Being a musician, physician, or newspaper reporter may give one a better background for becoming a good photographer.

In my college photography classes, artists do no better than any other group. Give me a student who is dedicated, possesses above average intelligence, can dig things up for himself, likes to work with his hands, gets

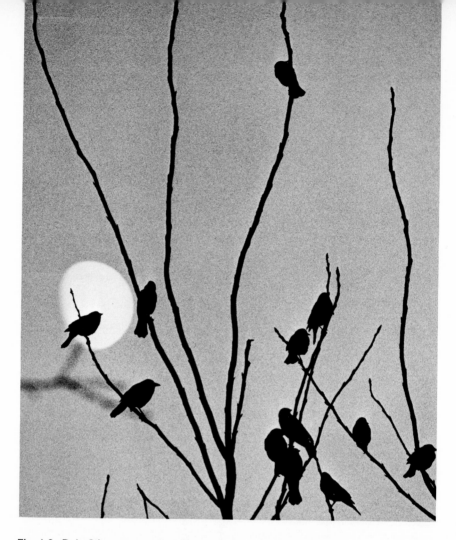

Fig. 1-3. Dale Stierman won first place in the National Press Photographers Association contest with this serene picture of birds silhouetted against a cloudless sky. Courtesy of the *Telegraph-Herald,* Dubuque, Iowa.

along well with people, and has good eyesight. This is the person I would expect to become an outstanding photographer—provided he is willing to work hard and long enough.

Photography is one of the most difficult of all disciplines to master. If one is to become an expert photographer, skill must be combined with long and intensive study. For this reason, the mastery of photography is more difficult than the mastery of a discipline that requires study and research alone, or of a craft that requires mainly experience and practice in handling the tools of the field. Mastery of photography involves both study and practice.

A VAST FIELD REQUIRING MANY SKILLS

Photography cuts across so many fields of knowledge that the term itself is a misnomer; it encompasses everything from radiology and metallurgy to the simple act of taking an ordinary snapshot.

Most professionals have mastered only a small segment of the photographic field. The majority still study, read, and attend photographic clinics in an effort to improve their skills. Yet, as a result of the rapid changes in cameras and the continual introduction of new techniques, it is almost impossible to keep abreast of all the new photographic developments. The challenge to the photographer is limitless.

The skills of most press photographers are confined to a few areas of the field—taking pictures of people in the news, taking storytelling feature photographs, taking photographs of sports events, and making copies of other photographs for reproduction.

Because of the present widespread use of color in newspapers and magazines, more and more press photographers are required to have skill and knowledge in color photography, and the time period between novice and professional grows longer as more techniques must be acquired.

Fig. 1-4. "Killer Tornado!" Perry Riddle, former staff photographer for the *Topeka* (Kan.) *Capitol-Journal,* snapped this sensational picture before dashing to safety. This won second place in the spot news category of the 1966 Annual Pictures of the Year Competition, sponsored jointly by the National Press Photographers Association, the University of Missouri School of Journalism, and the World Book Encyclopedia Service, Inc. Riddle now works for the *Chicago Daily News.*

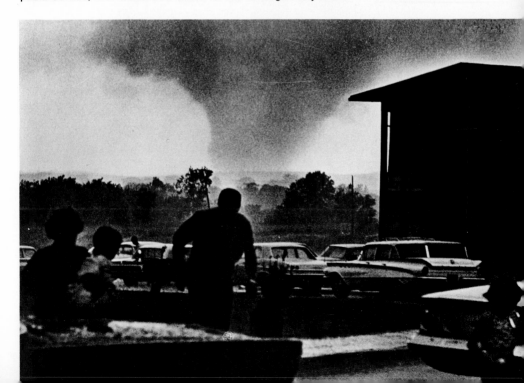

Although there are many excellent photographers working for newspapers, magazines, and press services, the average press photographer often lacks the knowledge or skill in the techniques that could improve the quality of his work. Most know very little about lighting or taking good portraits. Portrait photographers, on the other hand, usually cannot take good news pictures. Usually neither group knows how to take a good architectural photograph making the proper corrections for distortion, which is one of the greatest problems in this field.

Some press photographers specialize in sports photography and become experts in this area, yet they are often at a loss when called upon to take any other type of photograph. However, the most valuable and highest paid press photographers have a wide knowledge of photography gained through experience and intensive study. With this background and the technical ability to use the various types of photographic equipment, they are able to produce outstanding photographs for publication, even when working under the most difficult conditions on assignments requiring expertise in a number of different phases of photography.

Unfortunately, certain editors think that giving a writer or other staff member a camera will make him a photographer. Such a decision may be

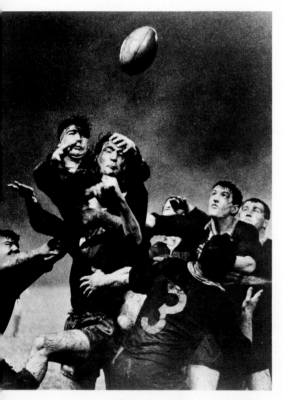

Fig. 1-5. Aussie Whiting of the Montreal (Quebec) *Gazette* won first place in the sports category of the 1968 Annual Pictures of the Year Competition, sponsored jointly by the National Press Photographers Association, the University of Missouri School of Journalism, and the World Book Encyclopedia Science Service, Inc., with this startling football picture entitled "Brute Force."

made because the publication cannot hire a full-time photographer or because no regular staff photographers are available to cover a story. In a way, the editor is right in thinking that any kind of photograph is better than none at all, and in an emergency, he usually has no other choice. Many excellent press photographers, indeed, began in just this way, but they did not acquire their skill when they were handed a camera. They achieved it by means of trial and error, by talking to other photographers, by reading about photography, and by practicing their photographic technique. They found, as many other persons have, that photography is so fascinating that once you are "hooked" on it, so to speak, you cannot abandon it. It possesses you, in fact, rather than your possessing it.

Because photographic ability is such an important asset on a newspaper, one of the first questions often asked of a new reporter or writer is whether he can take photographs. If he can both write and take photographs, he is a much more valuable employee and usually commands a higher salary than he would if he were only familiar with writing. This is

Figs. 1-6a and b. Two students were killed in May, 1970, by police gunfire during a night of student unrest at Jackson State College, Jackson, Miss. The aftermath is portrayed dramatically in these two photos of the bullet holes in the dormitory windows: (a) by Fred Blackwell, (b) by Jimmy Carmen. Courtesy of the Jackson (Miss.) *Daily News.*

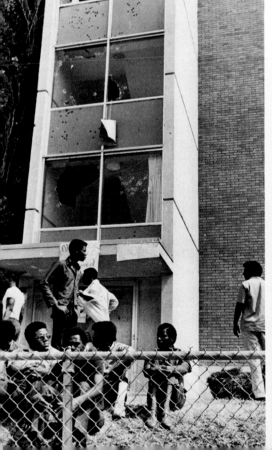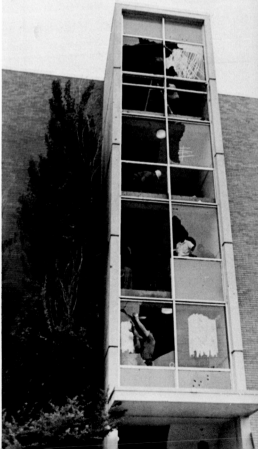

particularly true of small publications operating on limited budgets. Large organizations can usually pay top money for a top writer or photographer. Some will send both a writer and a photographer out on spot news assignments because one person often does not have time to do both jobs. These employees are selected on the basis of the work they have done for smaller publications and the reputations they have earned there.

Even the ability to write good cutlines or to do a simple news story enables a press photographer to get a better position than if he knows only photography. The demand for good press photographers in the past has always exceeded the supply, and from all indications this demand will become even greater in the future.

In order to enhance his chances of getting and holding top positions, a press photographer needs not only skill and experience in more than one phase of photography, but he must also continually study, experiment, and strive to keep up with new trends and to improve his professional skill. But doing all this need not be the chore it might seem. Anyone interested in photography talks over his problems with other photographers. Photographic associations hold clinics at their regular meetings and conventions. As in any profession, the photographer who gets ahead is so absorbed by his subject that he almost eats, sleeps, and breathes it as his vocation, avocation, and recreation.

THE IMPORTANCE OF A UNIVERSITY DEGREE

More editors are seeking university graduates, preferably with a journalism degree, to fill important positions on newspapers and other publications. One head newspaper photographer of a large daily told me that he tries to find university students who are willing to work summers and learn about the publications of the company. The person he chooses must have had some photographic experience, such as working on the yearbook or doing sports photography for his school before he can be accepted for summer work. Sometimes these students begin summer training while still in high school, and when they graduate from a university, they are hired on a permanent basis. Such a person coming to the newspaper has both an academic degree and practical experience, which make him much more valuable than if he had only one or the other.

Another large daily newspaper photo editor told me that he hires only journalism graduates if he can, and sometimes has difficulty finding well-qualified applicants for photographic positions.

The head of one of the finest college public relations departments in the South told me that he watches the work of press photographers in a number of large daily newspapers. When he has a position open for a staff photographer, he tries to hire a press photographer who has won some regional or national awards for his photographs. Of course, he also requires that the photographer have a university degree.

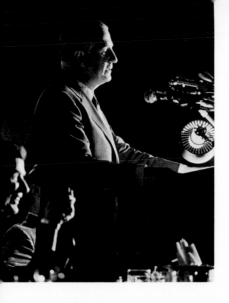

Fig. 1-7. This backlit shot of Vice President Spiro Agnew addressing a crowd of Republicans at a Suffolk County, Long Island, GOP fund-raising dinner in May, 1970, was taken by William Senft. Courtesy of *Newsday*, Garden City, New York.

One of the easier routes to success as a press photographer is to start on a small publication and then move up to larger publications as vacancies occur. Working part time or during summers helps to establish a work experience record while one is pursuing a university degree. With both a degree and experience, the graduating press photographer enhances his opportunity for obtaining one of the better jobs that are open.

SUMMARY

A good negative is the most important part of the photographic process. Becoming a good photographer requires the development of several skills in a coordinated manner. Success in photography is not easy to predict.

Press photographers are usually specialists in a limited area of photography. Combining press photography with writing skill often enhances the scope of the job and increases ease of employment.

More publications are seeking photographers who are university graduates, although it is still possible to enter the field without such advanced formal education.

QUESTIONS

1. Why may two photographers obtain different results when using the same film-chemical combinations under similar conditions?

2. What are some of the necessary factors to consider in becoming a successful photographer?

3. What are the most common types of pictures that news photographers take?

4. In what areas of photography are most press photographers weak?

5. How do qualifications for press photographers differ between large and small publications?

6. What type of experience should the beginning press photographer seek?

7. What are the advantages of starting on: (a) a small publication? (b) a large publication?

Cameras and Lenses

I ONCE SAW suspended from the neck of a press photographer from the *Miami Herald* three 35mm cameras, one with a normal lens, one with a wide-angle lens, and one with a telephoto lens. On other occasions I have seen press photographers carry four or five still cameras and perhaps a 16mm motion picture camera to obtain footage for a TV news program. Press photographers covering events in foreign countries usually carry an even greater number of cameras, lenses, and other equipment, the total load often weighing several hundred pounds.

Upon viewing such impressive outlays of equipment, one wonders: Is all this equipment necessary to become a press photographer? For the professional, the answer may be yes, because he is carrying extra equipment as a safeguard against breakdowns or lost equipment. Editors of magazines and press services want a variety of photographs, some close-ups, some long shots, and some normal shots. The editor may also want both black-and-white and color pictures. The professional cannot afford to miss, so he takes more than enough cameras, lenses, film, and so on to do the job assigned to him.

A BASIC APPROACH—SIMPLICITY

For the beginner all this equipment is not necessary, because he needs to stay with one camera, one lens, one shutter speed, one film, and one developer until he is able to produce photographs in a professional manner. This is one of the basic rules for becoming a good photographer,

Fig. 2-1. Carrying four cameras, this White House photographer is well equipped for any event. Beginning press photographers, however, should try to master one camera before buying another. Courtesy of *San Marcos* (Tex.) *Record.*

and for the novice to violate it will only add to his confusion and may hamper the learning process. The key to success in learning photography is simplicity—having as few variables as possible.

Exposure

By using only one shutter speed (preferably 1/100 sec. or 1/125 sec.) and one film-developer combination, the beginning press photographer has only two variables: the aperture (f/stop) and the focus. Anyone with good eyesight or wearing corrective lenses should be able to focus a camera easily, particularly one with a groundglass back.

The f/stop for bright sunlight under normal conditions should be memorized; adjustments for brilliant scenes, such as those at the seashore, or for darker than normal scenes, such as those taken on a dull, cloudy day, can then be computed in one's mind, using the normal f/stop for a bright, sunny day as the base. For ASA 125 film, the normal exposure is 1/125 sec. at f/16. For ASA 500 film, the normal exposure is 1/125 sec. at f/32, or 1/500 sec. at f/16, in case there is no f/32 on your camera lens. Theoretically, the two exposures let in equally as much light on the film. As is explained in Chapter 5 on exposure, 1/100 sec. or 1/125 sec. is an ideal shutter speed for taking most photographs, because it overcomes camera shake and stops most normal subject movement.

After a photographer learns the basic exposures, he need only remember to cock the shutter and focus the camera in order to take good negatives. I have had students using this method turn out better photographs within a few weeks than photographers who had had several years' experience. Again I emphasize that the secret of photography is simplicity, eliminating variables, and using a scientific approach to the technical phase of photography.

CAMERAS FOR THE BEGINNER

The best camera for a beginning photographer is one that has a fairly fast lens, $f/4.5$ or faster, with distinct markings for each f/stop. The camera should have several shutter speeds and adjustable focus. The shutter speeds should run from "time" and "bulb" to at least 1/200 sec. or 1/250 sec.

A camera using sheet film is handier than one employing roll film. (Some cameras, such as press cameras and certain makes of twin-lens reflexes, provide for using both roll and cut film.) With a camera that uses sheet film, one or two exposures can be made and developed immediately to check the results, with no waiting for suitable subjects to photograph in order to finish the roll. This facilitates testing, also. It is possible to shoot part of a roll and remove that portion from the camera in the darkroom, but this is better done by the experienced photographer and will only complicate the learning process for the beginner.

Even though the trend in press photography is toward cameras using the smaller film sizes, many professionals use the old workhorse of the press photographer, the $4'' \times 5''$ Speed Graphic or a $4'' \times 5''$ Linhof for certain types of photography, particularly groups or scenics for cover pages. Photographers in portraiture, advertising, and magazine photography may use not only a $4'' \times 5''$ but also a $5'' \times 7''$ or $8'' \times 10''$ view camera for much of their work. They use these large-format cameras because the larger the negative (or transparency, in color photography), the easier it is to make a good enlargement. There is no comparison between a color page reproduction made from an $8'' \times 10''$ transparency and one made with a 35mm camera as to the quality of reproduction, all other things being equal.

For ordinary newspaper reproduction with coarse-line engravings, a 35mm negative taken by a good press photographer will make a good print for reproduction, but it takes a highly skilled photographer to make good negatives consistently, using small-format cameras. A camera using 120 roll film, such as a twin-lens Rolleiflex, Yashica, or Minolta Autocord, is the smallest a beginner should use.

Press and View Cameras

I prefer that my students start with a $4'' \times 5''$ press or view camera, and I usually have several available for class use. This is because of the large negative size, the groundglass back for focusing, and the front movements, which are so useful for correcting perspective when photographing tall structures. Except for the 35mm focal length $f/2.8$ Nikkor Perspective Control lens for the Nikon F, cameras other than view and press cameras do not provide for correcting converging perspective lines.

The sheet film used in press and view cameras comes in a wide variety of emulsions, and all allow considerably more retouching on the nega-

tive than does roll film. There are two films, however, that have more "tooth" for the retouching pencil than other roll films—Kodak Tri-X Professional and a film manufactured by Ilford of England. Most portrait photographers prefer to retouch on medium or large negatives.

The view camera is the most versatile of all cameras, because it not only takes sheet film but also has suitable adapters for using roll film, film packs, and special magazines holding several sheets of cut film. Each of these adapters can be inserted or removed from the camera at will, without unnecessarily exposing the film to light. This is all accomplished through the use of a dark slide, which prevents fogging or exposing the film when the adapter is off the camera.

Cut film must be loaded in holders in the darkroom or in a changing bag. Film packs can be loaded from the package into an adapter in daylight and unloaded in daylight after the last of the film is exposed. It is also possible to change from color film to black-and-white, or from a slow-speed to a high-speed film for each individual photograph. Lenses are easily interchanged.

On press cameras, a modified form of the view camera, there may also be two additional viewfinders besides the groundglass back. Some makes have rangefinders that couple to several different lenses. All of these features offer advantages for professional use.

The press camera can be hand-held, as well as set on a tripod. View cameras must be used on tripods. Press cameras have fewer movements than do view cameras, usually having only front movements. Some press cameras have a tilting back and no front movements. Certain models of the Linhof cameras have both front and back movements. Press cameras usually come in 4″ × 5″ and 2¼″ × 3¼″ sizes, although 5″ × 7″,

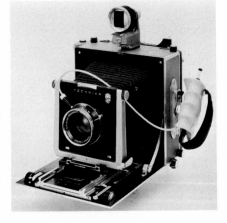

Fig. 2-2. This 4″ × 5″ Linhof Technika, one of the most versatile of all hand-held cameras, has a triple extension bellows, a rising and sliding front, and a movable back. A multiple-focus rangefinder is adjusted for individual lenses by replacing a cam for each lens. A multiple-focus optical viewfinder, shown on top of the camera, can be adjusted for a wide variety of lenses. Courtesy of Berkey Marketing Co., Inc.

3¼″ × 4¼″, 9 × 12cm, and 6 × 9cm models have been manufactured at one time or another. View cameras range from 2¼″ × 3¼″ to 11″ × 14″ in size.

On press cameras there may also be two additional viewfinders besides the groundglass back. Some models of press cameras combine the rangefinder with a viewfinder to enable the photographer to focus his camera and see exactly what he is taking at the same time. The rangefinders are usually of the superimposed image type, with the photographer seeing two images when the camera is out of focus and only one when it is in focus.

Rangefinders, like other mechanical devices, are subject to failures of adjustment. For this reason, I always have my students focus on the groundglass when time permits, because it is impossible to get the camera out of focus if the groundglass is used properly. Getting the picture in perfect focus is just as important as getting a good negative, and if a student has trouble focusing on the groundglass, I usually find that there is something wrong with his eyesight. For such cases I suggest an eye check-up with an ophthalmologist.

For those who wear glasses, it is possible to have prescription lenses put in many viewfinders, especially those for 35mm cameras. Check to see if your camera store offers this service.

Many beginning photographers do not have the use of a press camera. I do not advocate buying one unless the price is very low and then only for special uses, such as photographing large buildings, groups, and so forth. However, many newspapers have sold either all or most of their press cameras, and it is often possible to find a used one for under $100. I know of one instance in which a photographer friend of mine bought one for $25.

Twin-Lens Reflex

Even though the press camera has certain learning advantages for the beginning press photographer, I suggest that purchasing a new twin-lens reflex is more practical, as this type of camera is widely used by press photographers throughout the country. Some newspapers buy only twin-lens reflexes for their entire photographic staff.

Although most professional magazine and news photographers prefer a Rolleiflex or Mamiyaflex when using this type of camera, I recommend the Yashica D or the Yashica-Mat because of the small amount of money involved ($70 to $100 as against $200 to $450 for the other two makes). It is possible to buy a new Yashica twin-lens for the cost of repairing a Rolleiflex. Camera repairs are highly priced because of the shortage of trained personnel in camera repairing. At two universities and two colleges where I have taught journalism, the Yashica cameras withstood the hard wear that students give to cameras.

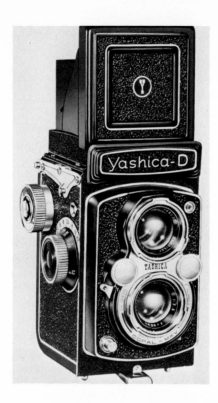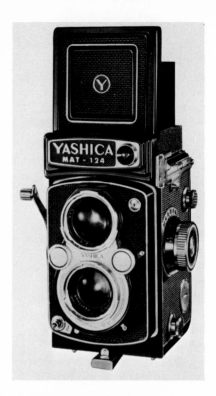

Figs. 2-3a and b. The Yashica-D and Yashica Mat-124 are both excellent twin-lens reflex cameras. (a) The Yashica-D is probably used by more press photography students than any other camera because of its durability, handling ease, and modest cost. It takes 120 film, has sharp lenses suited to professional photography, and has 1 to 1/500 sec. shutter speeds and two f/3.5 80mm lenses. (b) The Mat-124 will take 220 roll film as well and has a built-in light meter. A reliable single-stroke, crank-action film transport and an automatic exposure counter are extra features most professional photographers desire. It has an 80mm f/3.5 four-element taking lens and an f/2.8 viewing lens. The Copal-SV shutter has speeds from 1 to 1/500 sec. Courtesy of Yashica, Inc., Woodside, N.Y.

Many daily newspapers, such as the New Orleans *Times-Picayune* and *States Item,* do the greater part of their press photography work with the Mamiyaflex, because this is one of two twin-lens reflex cameras currently made that uses interchangeable lenses and offers a choice of wide-angle, telephoto, and normal lenses. These make the camera suitable for many picture-taking situations. This camera also has a number of other features not found on other twin-lens reflex cameras.

Most twin-lens reflexes use 120 roll film, which is available almost anywhere in the world and gives twelve 2¼" × 2¼" negatives per roll. Some twin-lens reflexes take 16 exposures on a 120 roll, and those using 220 roll film size make twenty-four 2¼" × 2¼" exposures per roll of film.

THE FIRST CAMERA

The first camera, the *camera obscura* (Latin for dark room), was just that—a room with a hole in one wall through which the image outside was projected upside down on the opposite wall. The image formed was neither brilliant nor sharp, and as the hole was enlarged, brightness increased, but definition became worse. Although not actually the discoverer, Leonardo da Vinci described the process in his private notes. Publication did not come, however, until 1558 with the book *Magiae naturalis* (*Natural Magic*) by Giovanni Battista della Porta.

It then remained to introduce a lens, to gather and concentrate the light rays (Girolamo Cardano, 1550). In 1725 Johann Heinrich Schulze observed the darkening of salts of silver when they were exposed to light. Thus, all the ingredients of the modern camera were available to science by 1725. Although a number of scientists worked on the problem during the latter half of the eighteenth century and the first quarter of the nineteenth, it was not until 1826 that Nicéphore Niépce first succeeded in producing a fixed image by truly photographic means.

Fig. 2-4. This huge *camera obscura* was constructed in 1646 by Kirschner in Rome. As a portable room, it was easily carried to the desired location. An artist entered it through a trap door in order to trace the image cast through the hole onto transparent paper. Courtesy of the George Eastman House Collection.

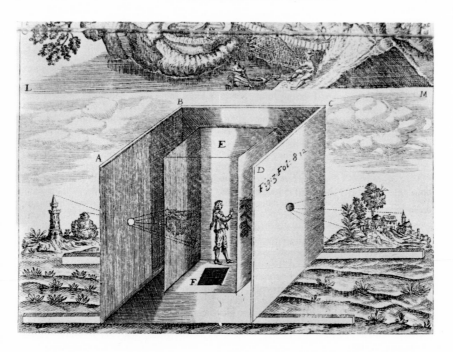

THE PINHOLE CAMERA

The modern camera thus uses a lens, has a shutter, and holds sensitized material (film). You can actually make a camera by taking a box, such as a wooden cigar box, and making a hole about ¼₄ inch in diameter in the lid or through a piece of metal that has been inserted in the lid. Load the film in a dark room by taping it to the inside bottom of the box and sealing the box with a suitable tape that will make it light-proof. Then take the box, being careful to keep the pinhole covered, into the bright sunlight, rest it on some stationary object, and make an exposure. The exposure time must be long because of the small diameter of the hole. Tests may be made to determine the best exposure, but an average exposure in bright sunlight should be approximately one minute.

For best results, the hole should be sharp and clean with no burrs. A sewing needle of suitable diameter and a piece of brass will perhaps be easiest to work with. The metal should be blackened to prevent any flare. By altering the position of the hole in the box, you can correct for distortion, such as must be dealt with when photographing a high building. In this case, the pinhole would be placed near the top of the lid and would be farthest from the ground when the pinhole camera was in taking position. Because of the small aperture, everything will be in focus, but the definition will not be as sharp as can be obtained with cameras using lenses.

THE LENS

The introduction of a lens in 1550 made the image of the *camera obscura* more brilliant. As time passed, improvements in lens design and the addition of shutters to control the light came about. The *camera obscura* was used by many different kinds of persons, including fortune-tellers and magicians, who used the device to mystify their customers. It was also used by amateur artists, who traced the images projected and made drawings or paintings from the tracings.

The Meniscus Lens

In 1806 an English physican, William Hyde Wollaston, basing his work on optical studies of the previous two centuries, designed a simple lens that was corrected for certain aberrations but was not color-corrected. It had a fairly good definition at $f/16$, and was known as a *meniscus lens*. From the simple lenses of that day have come the fast modern lenses, some of which have many *elements*. (An element is actually a lens, one section of the multiple-element lenses.)

The meniscus lens was the foundation for the modern camera lens system. Others following Wollaston learned how to correct for color, adding more elements to make the lenses faster, using coating to reduce

internal reflection, and developing lenses with continuous variable focal lengths (within certain limits).

Lens Design

The main purpose of the lens is to control the light waves, bringing them together in such a manner that the light from the subject being photographed converges at one plane on the groundglass or film and is in sharp focus. The compound lenses in today's cameras use both concave and convex surfaces. The shape of the surfaces is arrived at by complex mathematical formulas and by the use of electronic computers. Lenses are usually made of optical glass, but experiments have been conducted with plastics and other materials. Some of the inexpensive cameras use plastic lenses.

Two great problems of lens design involve the correction of aberrations, particularly for the three primary colors, and internal reflections, or *flare*. Flare becomes more noticeable as the number of elements in the lens increases. It is necessary to coat such lenses with a thin layer of metallic fluoride, even though some or all of the elements are corrected for certain aberrations. This extremely thin coating sets up a form of light interference, counterbalancing the stray reflected light in such a way that it transmits almost all of the incident light.

Uncoated wide-angle lenses are particularly susceptible to lens flare. Thus, lens coating not only cuts down the unwanted reflection but transmits more light through the lens, enabling the photographer to take sharper pictures and get more of the light through his lens.

Selecting a Lens

Depending upon individual taste, the minimum equipment that a press photographer should consider is at least three lenses—a normal, wide-angle, and telephoto, plus a camera body that will accept interchangeable lenses. A second body will, of course, allow the use of two different kinds of film or the use of two different lenses at the same time.

No one lens is best for all types of press photography, but a normal or semi-wide-angle lens will be most useful. Normal lenses for 4″ × 5″, 2¼″ × 2¼″, and 35mm cameras are six inches, three inches, and two inches in length, respectively. For general shooting with a 4″ × 5″ press camera, I prefer a 127mm Ektar or some other good semi-wide-angle lens. The normal wide-angle lens for this camera is 90mm; extreme wide-angle lenses will be of shorter focal length. Some 2¼″ × 3¼″ press cameras have a 90mm normal lens, but most use a 100mm–105mm normal lens. Wide-angle lenses run from 65mm to the extreme wide-angle 47mm Schneider Super Angulon. This is a wonderful lens for special wide-angle effects.

I also prefer a 65mm wide-angle lens for my Mamiyaflex C-33. The normal lens for this camera is 80mm, with some photographers using the 105mm lens instead of the 80mm.

The normal lens for a 35mm camera is 50mm, but many photographers prefer wide-angle lenses for most of their shooting, usually a 35mm or 28mm focal length. Some wide-angles for 35mm cameras come in 19mm and 8mm focal lengths.

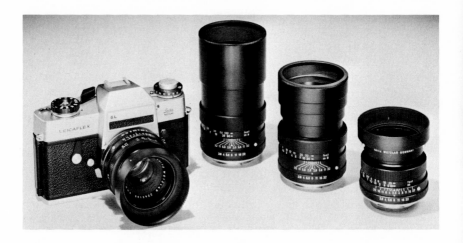

Fig. 2-5. The Leicaflex SL was one of the last of the single-lens reflex cameras to reach the market, because of the many years of popularity of the Leica, the original 35mm camera. Shown are the 50mm f/2 lens (on the camera), the 35mm f/2.8, the 90mm f/2.8, and the 135mm f/2.8 lens. Courtesy of E. Leitz, Inc., New York.

DEPTH OF FIELD AND HYPERFOCAL DISTANCE

The zone of sharpness extends in front and in back of any point upon which the camera is focused. This sharpness gradually declines and finally reaches a point where it becomes a blur. In small prints, this blur may not be noticeable, but if an enlargement of any size is made, the blur will become apparent.

The zone in which the blur is not apparent is called the *depth of field* of the lens. The depth of field is also controlled by the aperture, the focal length of the lens, and the distance of the subject from the lens. The depth of field is greater when the focal length of the lens is shorter. It is also greater when the subject is farther away. The more the lens is stopped down, the greater the depth of field. In the case of the pinhole camera, the depth of field is virtually unlimited, because of the very small opening.

The preference for the wide-angle lens is due to the great depth of field it allows, as compared with normal lenses. To facilitate shooting, most press photographers do not take time to refocus for each picture. For instance, with a camera using an 80mm lens, such as a twin-lens

Fig. 2-6. Taken by Anthony C. Reed, this photo of Joe H. Engle, an X-15 pilot, illustrates the concept of depth of field. Using a Nikon F with a 50mm lens, Reed exposed Tri-X film at $f/2.8$ for 1/1000 sec. in the shade. By using this rapid shutter speed, he was able to open his lens to a point where the background was out of focus but the pilot appeared clear and sharp. Courtesy of the *Wichita* (Kan.) *Eagle & Beacon.*

reflex, if the focusing scale is set at 15 feet, everything from about 8½ feet to 76 feet will be in focus when the camera is set on $f/16$. At $f/11$ everything from 10 feet to 33 feet will be in focus. At $f/8$ everything from 11 feet to 24 feet will be in focus.

For a camera using a 65mm lens focused at 15 feet and set at $f/16$, everything from 6½ feet to ∞ (infinity) is in focus. At $f/11$ everything from 8 feet to 75 feet will be in focus. At $f/8$, everything from 9 feet to 44 feet will be in focus. Other lenses follow a similar pattern; check the instruction booklet that comes with your camera for the depth-of-field scales for your particular lens. The library may also have a book that gives this information.

Of course, some photographers will point out that the image size is smaller on a wide-angle lens and the photographer must move closer, thus limiting his depth of field. In theory this is true, but in practice it is not. There is a depth-of-field advantage with a wide or semi-wide-angle lens in press photography.

The *hyperfocal distance* is the nearest point that is in focus when the lens is set at infinity, and it is also the nearest point at any $f/$stop or focusing distance behind the subject where the depth of field is infinite.

Formulas for working out the depth of field and the hyperfocal distances of lenses can be found in books on lenses. These figures are sometimes marked on the lenses themselves. As a rule of thumb, the depth of field will normally extend one-third in front of and two-thirds behind any given point on the focusing scale. Professional photographers use this knowledge in what is known as *zone focusing*. They will set their camera at 30 feet for far subjects, 12 feet to 15 feet for nearer subjects, and 8 feet to 10 feet for close subjects.

Obviously, at very close distances of 10 feet or less, even the most experienced photographer will probably try to focus his camera exactly rather than use the zone focus, because the depth of field is narrow at very close distances.

WIDE-ANGLE LENSES VS. TELEPHOTO LENSES

Wide-angle lenses are generally more valuable to the press photographer than telephoto lenses. A wide-angle lens enables the photographer to take pictures of buildings or in rooms where the working distance is too close for a normal lens. One problem with wide-angle lenses, however, is the distortion, as will be discussed in Chapter 9 on portraiture. Often the foreshortening of an arm, nose, foot, or the lopsided faces at the edge of a large crowd photograph taken with a wide-angle lens are distracting and displeasing.

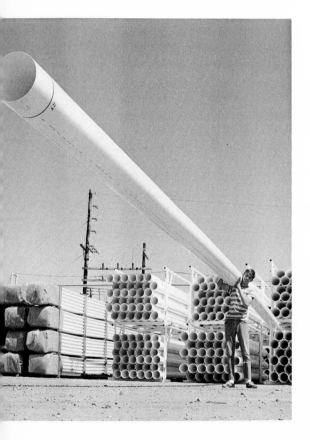

Fig. 2-7. This 40-foot length of 12-inch irrigation pipe weighs only 80 pounds, one-seventh the weight of cast iron pipe the same size and length. Shot with a wide-angle lens, which tends to distort subjects, this photo takes on added impact. Courtesy of Goodyear Tire & Rubber Co., Inc., Akron, Ohio.

Fig. 2-8. Taken from the roof of a press box in a college football stadium, this is an excellent example of the use of a 400mm telephoto lens on a 35mm camera. Even though the subjects were on the playing field far below, the printing on the award can be read in an 8″ × 10″ enlargement. Photo by author.

Telephoto lenses are used for portraits, sports, wildlife, and scenic photography—under conditions in which the photographer cannot get close enough to use a normal lens. Telephoto lenses come in various focal lengths, with the widest selection for 35mm cameras. Telephoto lenses are used quite frequently in sports photography, particularly for football and baseball games where the distances are great and the photographer is unable to be in the middle of the playing field but must shoot from the sidelines or the press box. A 10- or 15-inch telephoto lens is most commonly used with 4″ × 5″ press cameras.

Bellows extensions prohibit the use of longer telephoto lenses without special adaptations. Regular view cameras normally have a longer bellows extension and can accommodate longer focal length lenses. Some view cameras make provision for adding extra bellows and can take extremely long focal length lenses.

For 2¼″ x 2¼″ single-lens reflexes, there is a wide choice of lenses, varying from 105mm to 500mm. The longest focal length for a twin-lens reflex, the Mamiya C series, is 250mm. Lenses up to 2,000mm can be purchased for 35mm cameras. However, most 35mm photographers usually carry either a 135mm, 200mm, or 400mm telephoto lens as part of their regular equipment, the latter two being used frequently in sports and wildlife photography.

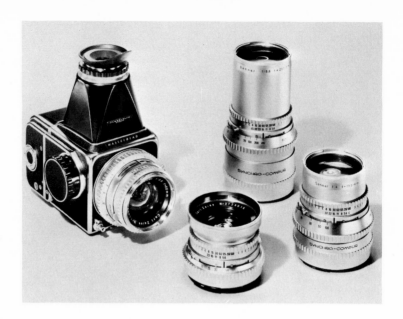

Fig. 2-9. The 500-C Hasselblad is a 2¼" × 2¼" single-lens reflex camera with interchangeable magazines and Carl Zeiss lenses, each with a 1 to 1/500 sec. synchronized shutter. Shown are the 80mm standard lens (on the camera), the 40mm wide-angle lens, and two telephoto lenses—150mm and 250mm. Also shown is a magnifying hood over the viewfinder for precision focusing. This model is widely used by magazine, industrial, and other professional photographers. Courtesy of Paillard, Inc.

Fig. 2-10. This is a new model 80mm to 240mm Tele-Variogon f/4 Schneider Zoom Lens (for 35mm SLR cameras) with an automatic diaphragm, which operates through a special pistol grip attachment. This lens zooms rapidly from one focal length to another without refocusing and can be adapted to almost any 35mm SLR by the use of interchangeable adapters. Courtesy of Burleigh Brooks, Inc.

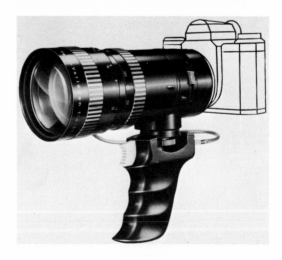

Usually, the longer the focal length, the more expensive the lens, although there are some excellent inexpensive telephoto lenses that do a fairly good job. It is more important to buy a top-quality wide-angle lens than a telephoto lens, if such a choice must be made.

As a rule, the longer the telephoto or the wider the wide-angle lens, the slower the lens is. Long focal length lenses need to be steadied by placing the camera on a tripod or other stationary base.

ZOOM LENSES AND CONVERTERS

There are also variable focal length lenses known as *zoom lenses,* which are available for both 35mm and 2¼″ × 2¼″ single-lens reflexes. These lenses are usually not as sharp as single focal length lenses.

Various other attachments are available which will convert a normal lens into a longer focal length or shorter focal length, depending upon the lens attachment. These are fairly inexpensive, but they often impair the quality of the negative image. Some of the better grades, however, will hardly be noticeable at normal enlargement. Included in this group are the monoculars, which will even convert the normal lenses of twin-lens reflex and other cameras into telephotos at low cost.

35MM CAMERAS

Many students ask me, "What is the best type of 35mm camera for press photography?"

There is no one best type of 35mm camera, or even brand of camera, for press photography. At one time, before the advent of the single-lens reflex with a prism viewfinder, the rangefinder cameras such as the Leica, Contax, Nikon, and Canon were widely used by press photographers. These cameras have many accessories and a wide choice of interchangeable lenses to fit them. The rangefinder cameras were restricted to focal lengths of 200mm or less, unless a special reflex viewing attachment was placed on the camera for use with longer focal length lenses, which would not work with the coupled rangefinder of the camera. Many press photographers still use rangefinder cameras, and some also carry one of the single-lens reflex models that have become so popular.

The single-lens reflex will work especially well with long focal length lenses, whereas the rangefinder model works better with the wide-angle lenses. Some models, such as the Alpa 7 and 8, have both a viewfinder–rangefinder window and a single-lens prism reflex finder. The Alpa camera is noted for its fine workmanship and critical sharp lenses.

The most popular single-lens reflexes for press photography are the Nikon F and the Pentax. Both of these cameras have many accessories and a wide selection of interchangeable lenses. Other popular makes are Canon, Miranda, Beseler Topcon, Minolta, Kodak Retina Reflex, and

Fig. 2-11. The Honeywell Pentax Spotmatic, with attached motorized drive allowing rapid-sequence photography, is very useful for sports photography and is one of the more popular 35mm SLR cameras in this country. It has a through-the-lens CdS meter, shutter speeds to 1/1000 sec., and F-X synchronization. Many lenses are available. Courtesy of Honeywell, Inc.

Fig. 2-12. The Nikkormat is a widely used single-lens reflex 35mm camera with through-the-lens metering. It takes the same interchangeable lenses as the more expensive Nikon F series. Shutter speeds range from 1 to 1/1000 sec. Courtesy of Ehrenreich Photo-Industries, Inc.

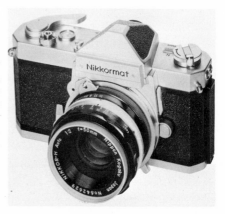

Yashica. The Miranda is noted for having an exceptionally quiet shutter.

Because behind-the-lens meters offer certain advantages over other types of light meters, cameras so equipped have gained great popularity with all photographers.

CAMERA OPERATION AND PROTECTION

If possible, all cameras should be placed on a tripod and the shutter released with a cable release. This assures a steady camera and prevents camera movement. Any type of shutter release should be squeezed in much the same way as a rifleman fires his gun. If the camera is hand-held,

34

the photographer should hold his breath at the very instant the shutter is released. Bracing the camera against a building or against oneself will also help to prevent camera movement.

Some shutters on cameras are harmed if moved from one shutter speed to another when cocked. Always move the shutter speed indicator before cocking any camera shutter. Never leave the shutter cocked when storing the camera, as this may put extra wear on the shutter parts.

Protect all lenses with lens caps and clean lenses with a lens brush or lens tissue—never anything else—in order to prevent scratches on the lens.

SPECIAL EQUIPMENT

No matter what type of equipment a photographer has, he will always find that he needs some special equipment for doing certain photographic jobs. Many times he will have to improvise, using such expedients as double-sided tape (the kind printers use for sticking engravings to the backing) for holding down 16″ × 20″ paper to the baseboard of the enlarger or to a sheet of masonite while making an enlargement. Sometimes he needs a special gadget that must be made or bought, such as a step-up or step-down ring, which allows filters of one series to be used with a filter holder of another series. Such equipment will save many dollars by allowing the photographer to avoid the purchase of more than one set of filters.

One favorite lens attachment of many amateur photographers and no few professionals is the close-up lens, which allows a camera lens to focus closer than it normally would. These lenses, which slip or screw on like a filter and come in filter sizes, are useful for making copies of documents and photographing coins or other small objects close enough to fill up most of the camera negative. With a rangefinder camera, a tape measure and a wire framing device projecting in front of the camera are necessary. With a single-lens reflex, the viewfinder tells when the subject is in focus and properly framed. Unless a pair of matched close-up lenses like Rolleinar I, II, and III lenses are used, twin-lens reflex cameras will need some sort of device to shift the taking lens into the position of the viewing lens after the latter is focused with a single close-up lens, in order to correct for the parallax. The Paramender attachment, which raises and lowers the Mamiya C cameras, is made especially for this purpose.

Close-up lenses come in several strengths, +1 to +10, and a special variable-strength model, the Proxivar lens, which takes the place of eight different close-up lenses.

Closely allied to close-up lenses are bellows extensions and extension tubes, which permit the use of lenses from other cameras, close-ups with camera lenses without any other attachment, and macro work. A reverse adapter will allow the use of some regular camera lenses in a reversed

position for close-up work and give a very sharp image. Many photographers have found the tiny Tensor lights useful with tabletop and close-up photography.

Besides regular and heavy-duty tripods, there are many special models. Some are made in the form of a chain that is held taut by the photographer's foot; another is a unipod, having only one leg; a third is a belt tripod, a small tripod fastened to a man's belt; a fourth is shaped like a gunstock, being especially useful for long telephoto lenses. Some miniature tripods are so compact that they will fit into a man's coat pocket; others have all sorts of clamps that can be fastened almost anywhere, even on an automobile window; still another small tripod comes in the form of a pistol grip, often having a built-in cable release.

For those using a microscope, there are a number of adapters made to use with various cameras and to fit various makes of microscope.

Long cable releases enable the photographer to stand some distance from his camera and are especially useful in child portraiture and bird photography. The longest releases, usually air driven, are 30 feet or longer.

A dry-mounting press for mounting photographs neatly and permanently is a valuable piece of equipment that every serious photographer should own. The best make is the Seal press, and I have found their dry-mounting and laminating tissues better than any other brand.

For the photographer with some artistic talent, an airbrush will soon pay for itself in professionally retouched photographs. Other retouching tools include dyes for color and black-and-white prints and negatives, etching knives, artists' stumps, pencils, and so on. Two good books on retouching are *Retouching* by O. R. Croy and *Negative and Print Retouching* by Anne J. Anthony. The former is more comprehensive, including a section on airbrushing, while the latter is easier for a beginner to understand. (Retouching is a separate photographic art in itself, and many people who are not photographers learn to retouch.)

By buying 35mm film in bulk and reloading one's film cartridges, a substantial saving of money can be made. A daylight bulk film loader and film tongue cutter are useful tools in reloading film.

For the more experienced photographer, an enlarging meter will speed up the darkroom processing.

Telephoto lens extenders are relatively inexpensive and will double or triple the focal length of a 35mm camera lens. These extenders, however, do not give as sharp an image as a lens of the same focal length of the extender and the telephoto lens combined.

In an emergency, film can be dried with an electric hair dryer.

One accessory that a number of professional photographers find valuable is a Polaroid film holder for 4″ × 5″ press and view cameras, using one of the professional-quality emulsions manufactured by the firm. Shots taken with these film holders are useful for getting an immediate picture

in order to check exposure and lighting or for making a proof photograph in the case of a portrait. Many photographers use them first before shooting expensive color film. Type 55P/N emulsion gives both a negative and a finished print. The former can be used for making enlargements. In order to make any such print or negative permanent, it should be hypoed and washed just as a regular negative or print.

There is also a 4″ × 5″ back, which will fit 4″ × 5″ cameras with Graflok backs, but I prefer the holder, because it is much easier to use and is lighter in weight.

SUMMARY

Professional press photographers may own a variety of photographic equipment in order to cover many types of assignment. The beginner, however, should use only one camera until he masters it. The key to success in photography is simplicity and the elimination of variables. This includes using one camera, one film–developer combination, and one shutter speed for normal photographic situations.

The press photographer should have little need for a light meter if he memorizes his standard exposure and makes adjustments for prevailing conditions.

The ideal camera for a beginning press photographer is a twin-lens reflex with an $f/4.5$ or faster lens and shutter speeds to 1/250 sec.

The smaller the camera negative size, the more skill is required of a photographer.

Press and view cameras are more versatile than other types of camera.

The types of camera used in press photography vary with the publication. The first camera was the *camera obscura,* a hole in the wall of a dark room.

The introduction of the camera lens made the image of the *camera obscura* more brilliant.

Modern camera lenses evolved from simple lenses such as the meniscus lens, developed in 1806. Lenses control the light waves and are usually made of optical glass but may be of plastic or other materials. Most modern-day lenses are developed through the use of the computer and are coated to cut down reflections.

No one lens is best for all types of press photography. It is usually preferable to have at least three lenses: a normal, a wide-angle, and a telephoto lens.

Press photographers often take advantage of the depth of field of a lens rather than focus for each individual picture.

The smaller the negative size, the wider the choice of lenses (usually), with the 35mm size having the widest selection.

The single-lens reflex has become the most popular 35mm camera for press photography.

No matter what type of equipment the photographer has, he will always find that he needs some other special equipment for doing certain photographic jobs. Such equipment includes close-up lenses, tape measures, parallax correctors, bellows or extension tubes, unipods, devices to adapt the camera to a microscope, long cable releases, and even an airbrush.

QUESTIONS

1. Why is it important for the beginning press photographer to start with only one camera?

2. What is the easiest way to simplify the exposure variables when taking pictures under normal daylight conditions?

3. If the normal exposure on a bright sunny day is 1/125 sec. at $f/16$ for an ASA 125 film, what would the exposure be for an ASA 500 film under similar conditions?

4. Why is 1/100 sec. or 1/125 sec. an ideal shutter speed for taking most photographs?

5. What are some of the advantages of a twin-lens reflex camera? a 4″ × 5″ press-type camera?

6. When should the press photographer use a 35mm camera?

7. Which camera is the most versatile of all cameras, and why?

8. Why is it preferable to use the groundglass in focusing rather than the rangefinder when using the press camera?

9. Name the three types of lens that are desirable for every press photographer to have.

10. What is a pinhole camera?

11. What is a *camera obscura*?

12. What are two great problems of lens design?

13. What does coating the lens do?

14. How do press photographers take advantage of the depth of field of a lens?

15. What is the hyperfocal distance?

16. What type of subject are the following used for: (a) the wide-angle lens? (b) the telephoto lens?

17. What precautions must be taken in using an extremely long telephoto lens?

18. How should the shutter be released?

19. What is the best type of 35mm camera for press photography?

20. Name some types of special equipment that might be useful for a photographer under special conditions.

CHAPTER 3

Developers, Films, and Testing

Most BEGINNING photographers and many professionals are always looking for the one magical "soup" (developer) that will easily solve all the problems of exposure and development. One way to find this ideal developer is to ask successful photographers what film and developer they use. Doing so may only add to your confusion, however, because there seem to be almost as many kinds of black-and-white film as photographers using them, and an even greater number of film developers. What works for one photographer may not do at all for another. This is hard for a beginner to understand; the final result in the photographic process depends upon a number of steps, each involving a minimum of two or three choices and often many more.

With all factors multiplied together, the number of combinations of film and developer appears to approach infinity. Simply stated, this means that there is no one film–developer combination that is perfect for every photographer and every photographic situation. Each photographer must test scientifically to find the one film and one film developer best suited for most of his shooting. The beginner should start with film and developing chemicals that are fairly common and easy to purchase in his area.

The secret of getting a good negative is to use only one film and one developer until the process is mastered, always employing fresh developer at a pre-determined temperature, such as 68° F., and keeping a record of each exposure made. Only by using a scientific approach can a photographer determine why he got a poor negative or a good one. Haphazard methods have no place in professional photography.

EARLY DEVELOPING AND FILM

Joseph-Nicéphore Niépce and Louis Jacque Mandé Daguerre are generally credited with the invention of photography. Niépce used a camera with a lens as early as 1816 and it is believed his first permanent camera image was taken in 1826. The process eventually developed by Niépce and Daguerre produced a single image known as the Daguerreotype. The negative-positive system used in photography today most closely resembles the Calotype process patented by William Henry Fox Talbot in 1841.

Niépce first used silver plates in 1829, and in that year he became a partner of Daguerre, who discovered the light sensitivity of iodized silver plates in 1831. The Daguerreotype process was introduced to the world through a payment to Daguerre by the French government in 1839. Brought to the United States, the process became widely used throughout the country.

Fig. 3-1. Mathew Brady in 1850 from a lithograph by François D'Avignon, reproduced from an original Daguerreotype made in 1846. Brady, one of America's best-known photographers, is famous for his thousands of pictures of the Civil War. Courtesy of the George Eastman House Collection.

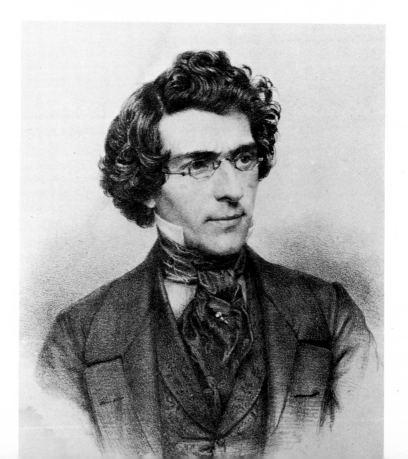

Mathew Brady began using the Daguerreotype process in 1844 and became a nationally known portrait photographer. However it is as organizer of the photodocumentation of the Civil War that Brady is best remembered today. The wet plate process he used for this work required bulky equipment, long exposures and was carried out under adverse conditions. Even so, the war photographs taken by Brady and his staff match and sometimes surpass war photographs taken by the best photojournalists today.

In the 1880's, a large number of hand cameras suddenly appeared on the market. These cameras were known as *detective cameras* because they looked like books, watches, luggage—anything but cameras. The most famous of these cameras was the Kodak, manufactured by George

Fig. 3-2. Roger Fenton, called the first combat photographer, took this photograph of the Genoese fort at the entrance to Balaklava Harbor during the Crimean War in 1855. Like Brady, he used the short-lived collodion glass plates and a big camera to encompass vast vistas, because he could not get the close-ups and instantaneous action possible with today's fast film and small cameras. Courtesy of the George Eastman House Collection.

Eastman in 1888. It was not the camera that was so important but the fact that it took 100 exposures per roll. This was the first use of roll film, the first rolls being actually a paper emulsion, which was replaced by celluloid film in 1889. From this point, amateur photography grew until it became one of the most popular hobbies in the nation.

In the meantime, the professionals used glass plates for photography until the 1920's, when emulsions on film became more popular. Very few glass plates are used today, although they are still available in several different emulsions.

FILM

Graininess

Basically, there are three types of black-and-white film: slow-speed, medium-speed, and high-speed. Film derives its sensitivity to light from minute silver halide particles suspended in a binding agent, usually gelatin. When exposed to light, the silver particles form what photographers call the *grains*. These grains are apparent when film is placed under a microscope or when a negative is enlarged several times. Fast films, those with a high ASA rating, are more grainy than those with a lower ASA rating. The finest grained films are normally those with the lowest ASA light sensitivity rating.[1]

Grainy enlargements are common when a combination of high-speed film and miniature (35mm) cameras is used. Sometimes photographs are made grainy for artistic effects in advertising; sometimes graininess cannot be avoided because lighting conditions are so adverse that a high-speed film–fast lens combination, usually only available with 35mm cameras, is needed.

Photographs published in newspapers will not show the grain as much as those used in publications that use finer engraving screens and better quality paper. Many newspaper pictures, also, if not enlarged too many diameters will show little if any grain.

Film for the Beginner

Which is the best film for a beginning press photographer? The quality of amateur films is surprisingly good. For all-around picture shooting, a medium-speed, medium-grain film is most suitable. Any good ASA 125–200 speed film that is sold by camera stores, drugstores, and mail order houses will serve this purpose. Films that fall into this category are Ansco's[2] All-Weather Pan, Versapan, and Hypan; Kodak's Verichrome Pan and Plus-X; and films by a number of foreign manufacturers including Agfa, Fuji, and Ilford.

[1] There are exceptions to this rule. Some high-speed films have an exceptionally fine grain.
[2] Ansco is now known as GAF, which stands for General Aniline and Film Corp.

Film sensitivity and characteristics are changed frequently by manufacturers. For this reason, I hesitate to recommend any one film. However, I frequently use two amateur roll films, Ansco's All-Weather Pan and Kodak's Verichrome Pan, because they can be purchased at most places where camera supplies are sold. I have attained good results with private label films sold by chain drugstores and mail order houses. Using my 127-size Rolleiflex, I have made good 8" × 10" and 11" × 14" enlargements from private label films.

Ansco's Versapan and Kodak's Plus-X Pan are two medium-speed films with extremely fine-grained emulsions. These films also come in sheet film sizes and can be developed with a wide range of developers. Versapan has an extremely long tonal range.

High-speed films are normally used for sports or action pictures, or low light-level conditions. A film of exceptionally high speed is Agfapan 1000, which comes in roll and sheet film sizes. Two other high-speed films are Ansco's Super Hypan and Kodak's Tri-X, both available in roll and sheet film sizes.

Ultra-fine grain, slow-speed films are normally used when photographers wish to make a large photograph from a small negative, or even a wall-size mural from a 4" × 5" or 8" × 10" negative. Films available in this category include Agfa Isopan-FF, Ansco's Finopan Gafstar, Adox KB14, and Kodak Panatomic-X.

Fig. 3-3. "Alone in a Crowd" was made on Adox 14, ASA 20 film, in a dimly lit auditorium, using a 100mm f/3.5 lens on a Canon FT. I experimented with an exposure of 1/4 sec. Less than one-half the negative area is shown here. Since this film is very fine grain, it is suitable for use when extreme enlargements are desired. Photo by author.

Sometimes, even though the emulsions carry the same name in 35mm film, 120 roll film, and cut film sizes, they may not have identical characteristics. It is very important that the photographer study the information sheet accompanying his film, in order to determine the characteristics of the specific film being used.

Some years ago, one of the large manufacturers put out an amateur film that was of excellent quality. According to the instruction sheet, the film was rated at ASA 80. After making my own test, I learned that the true speed of the film was ASA 160. Later, after having used the film for some time, I developed my negatives one day and found them underexposed. Immediately I started checking my camera, my light meter, and other equipment to discover what had happened. After testing another roll of this particular film, I found that the speed of the film was not the same as it had been. The underexposure had not been my fault; the manufacturer had changed the speed of the film without indicating a new speed. My findings were later substantiated when I read an article in one of the photography magazines stating that the manufacturer had lowered the speed of the film.

For the beginner, however, this is not likely to be such an important factor, because today's black-and-white films have wide exposure latitudes.

Cut Film

Emulsions for cut film are thicker than those for roll film, and there is a greater variety of emulsions in cut film. One great advantage of cut film is that it can be retouched with a lead from a pencil or a dye, using artists' watercolor brushes. Cut film is stiffer than roll film, making it easier to keep in a flat plane under the enlarger. Cut film usually comes in boxes of 25 or 100 sheets.

Another advantage of cut film is that it allows the photographer to shoot two or three negatives without having to expose a whole roll of film. He can also use one emulsion for one picture and a different type, such as one for color film, for the second picture.

Cut film is packed in holders that may be inserted or taken from the camera at any time through the use of a dark slide, which covers the film when it is out of the camera. Some roll film cameras, usually 2¼″ × 2¼″ reflexes, have cut film attachments that enable the photographer to use some of the emulsions available in cut film that are not available in roll film. These attachments are also handy when a photographer wishes to make one or two exposures and develop them immediately.

All but a few emulsions are *panchromatic* (sensitive to all colors). Photographers taking portraits of men often prefer an *orthochromatic* emulsion (sensitive to all rays of the visible spectrum except those that are deep orange or red), because this gives a more pleasing appearance to masculine flesh tones.

Fig. 3-4. Resembling an artist's pen-and-ink drawing, this photo by Richard Ingalls was copied on lithographic film to eliminate the middle tones. Courtesy of Raven Industries, Inc., Sioux Falls, S. Dak.

Lithographic and Copying Film

Although not normally used by press photographers, lithographic films, the kinds used for making line engravings, are sometimes helpful in creating unusual pictures for advertising and special effects. These films are of the high-contrast type, tending to eliminate middle tones.

Special slow-speed films for making copies of artwork and photographs are made by several manufacturers. These special copy films tend to increase contrast and eliminate the graying effect present when copying is done by general purpose panchromatic film. There are also orthochromatic copy films used for copying colored line originals. For more information on copying, see Chapter 15.

DEVELOPERS

When a piece of film is exposed to light, a latent image is formed by the silver particles suspended in the emulsion. As the light reflected from an object goes through the camera lens, it causes the silver to change chemically. The more brilliant the light, the greater is the change that takes place. To the camera, any scene, whether a landscape, a portrait, or the reflection of moonlight on water, is simply a matter of areas that vary in brightness.

As soon as the film is put into the developer, those areas receiving any amount of light start to turn black. An extremely bright object will appear black and so opaque by the end of the development time that it is almost impossible to see through that portion of the film, no matter how bright the viewing light is.[3] Areas not affected by exposure to light will be clear and transparent at the end of the developing process.

Developers can be classified in several ways, one of which is by their working characteristics. Some are called high-contrast developers, and others are called low-contrast, or soft-working, developers. Into the latter group would fall portrait developers and many fine-grain developers.

Some developers work very fast, having development times as short as a minute or two, and are known as high-speed developers. These developers are important for rushing spot news photographs into print quickly.

The Contents of a Developer

A film developer usually has the following four main agents: (1) a single or compound developing agent, which converts the sensitized silver of the negative into a black image of various densities corresponding to the amount of light the negative has received; (2) a chemical to preserve the developer and to prevent it from deteriorating too rapidly; (3) an alkali, since most developing agents will work only in an alkaline solution; and (4) a restrainer, which helps to reduce fog during development.

Some fine-grain developers have an additional ingredient that acts as a solvent on the silver salt. Depending upon the brand, some developers also include a hard-water conditioner, and others may include a wetting agent to break down molecular attraction and thus reduce the risk of *air bells*, or tiny bubbles, on the negative. Air bells cause undeveloped areas, which result in black spots on the photographic print made from the negative.

Certain developers have a tanning agent that tans the emulsion and

[3]Panchromatic film that is being developed must remain in total darkness until it is fixed sufficiently so that light will not fog it unless it has been chemically desensitized for viewing by the reflected light of a very dim green safelight. Orthochromatic films may be developed and viewed under a weak red safelight (see the section on developing by inspection in this chapter).

Fig. 3-5. "Moonlighting" by Ricardo Ferro received honorable mention as a pictorial in a Florida newsphoto contest. The high contrast and lack of intermediate tone is usually achieved by taking a high-contrast subject and recopying it on lithographic film. Courtesy of the *St. Petersburg* (Fla.) *Times*.

are used in special applications of color photography, such as dye transfer matrices and photolithography.

Some developers contain a dye, but I avoid this type for a very good reason: I normally have my hands in the developer tray during a good part of the developing time when developing sheet film and when a film tank is not available for roll film. After trying out a new film developer some time ago, I discovered that it contained a dye that turned my hands brown. Neither soap and water nor diluted acetic acid would remove the dye from my hands, and it took several weeks for the brown color to wear off.

Mixing a Developer

Many photographers make up their own developers according to formulas. Most, however, buy the chemicals ready mixed in one can and mix the contents with water. Some developers come in a concentrated liquid form and are ready to use when diluted with water. For small quantities, it is usually cheaper to buy ready-mixed chemicals.

In mixing a developer, you should use the purest water obtainable.

If the tap water contains iron or other chemicals, unusual development problems may arise. It is best to use distilled water when tap water is questionable.

Impurities will not usually cause the problems in black-and-white developers that they do in color developers. One well-known color photographer in Memphis, Tenn., suddenly found unusual stains on his color prints. After trying many remedies, such as mixing fresh developers, cleaning his developing tank thoroughly, and even ordering a fresh stock of chemicals and papers, he discovered that his problem resulted from standard plumbing practices. A plumber had installed a new laboratory for him some time previously, using copper tubing on all water supply lines. Each time the plumber had sweated (soldered) a water connection, he had left shavings or other copper particles from the pipe he had cut in the water supply line. These particles had finally worked themselves through the tap and into the developing solution, where they made copper stains on some of the color prints being processed. Most color laboratories install filters to catch any such foreign matter in their water lines, and many newspapers have followed this practice in their darkrooms.

Choosing a Developer

In choosing a film developer, you should settle on one standard type and remain with it until you have mastered it. Jumping from one developer to another or from one film to another will only add to the confusion of the beginning photographer.

Although there are many good film developers on the market, three standard brands that I prefer are GAF Hyfinol, Edwal FG 7, and Kodak D-76. I also like GAF Isodol with GAF films.

Hyfinol has the ability to process many rolls of film and keep the developing time constant without being replenished. Since it also has a long shelf life, it may be stored for long periods of time. Although a replenisher will lengthen the life and usefulness of a developer, I seldom use one, as I prefer to use fresh developer each time.

I dilute Hyfinol one part stock developing solution (mixed according to the manufacturer's instructions) with one part water and add one minute to the development time. I keep all developing solutions at 68° F., either by using ice, warm water solutions, or temperature-controlled sinks. A GAF representative disapproved of my one-to-one dilution, but I find that it works best for me, as it seems to cut down the contrast of my negatives and gives more detail in the shadow areas.

Edwal FG 7 is a highly versatile liquid concentrate that can be diluted in various ways to produce tailor-made results. I normally use a 1 part stock solution to 15 parts water, using the developer only once. Edwal FG 7 can also be used for two-bath film processing. Two-developer processing gives a great variety of control. Edwal FG 7 also has a long shelf life.

Kodak D-76 is a developer that has a long shelf life, can be replenished, and has been on the market for many years. When using D-76, I also add about one minute to the manufacturer's recommended developing time and dilute the solution one part stock to one part water, to cut down the contrast of my film. Many press photographers prefer D-76 to any other black-and-white developer.

Developers for Professionals

Most newspaper laboratories keep one developer solution for developing negatives in a hurry. One popular solution that will develop film in one and one-half minutes is Ethol 90. The photographer must remember that short developing times must be measured very carefully. A slight error in either time or temperature will have disastrous results. For this reason, I do not recommend fast developers for the beginning photographer.

Three other special purpose developers widely used by professionals but not recommended for the beginning press photographer are Acufine, Kodak Microdol-X, and Agfa Rodinal. Acufine is comparatively expensive but enables the photographer to expose his film at a much higher ASA number than the manufacturer recommends, without producing graininess or sacrificing high acutance. It can also be somewhat tricky to use if the photographer has not had a good background in developing.

Microdol-X is a fine-grain formula that gives good sharpness and is reasonably priced. Rodinal, although expensive, lasts a long time because it can be diluted anywhere from 1:50 to 1:100 for one-time use. Offering a wide variety of control, it is recommended only for experienced photographers. It is known for its high acutance.

DEVELOPING THE NEGATIVE

After one has exposed his film properly, the next most important step is to develop it so that the negative is neither too thin nor too thick (dense). In thin negatives, if there is little shadow detail and only the highlights are recorded, *underexposure* is the problem. If the highlights lack sufficient density but there is some shadow detail, the problem is *underdevelopment*. When negatives are dense but lack contrast, the fault is *overexposure*. A dense negative that shows much greater than normal contrast is *overdeveloped*.

In order to get a good negative, which should print on a No. 2 or 3 grade enlarging paper, a photographer must be systematic and work out a certain method of doing things, whether he is exposing the film, developing the negative, or taking a reading with his light meter. The real secret of mastering photography is to eliminate as many variables as possible and to make the laws of probability work for you. I recommend that a beginning photographer start with one film and one film developer and

Fig. 3-6. To silhouette these men sweeping debris into a stream, John F. Quarrick shot against the light on a somewhat hazy but sunny day. The effect the photographer is striving for largely governs his exposure and development. Overexposure and underdevelopment tend to flatten photographs, whereas underexposure and over-development make them more contrasty. Hasselblad 500-C, *f*/16, 1/125 sec., Tri-X film. Courtesy of the *Brownsville* (Pa.) *Telegraph.*

that he work with these two in combination until he can get a high-quality printable negative almost every time he makes an exposure and develops the film.

Equipment

Any size sheet or roll film can be developed in a tray made of glass, hard rubber, plastic, or fiberglass. There are also special tanks for roll film and cut film, some of which need only to be loaded in the dark, and the other operations can be carried on in the light.

For roll film, I recommend stainless steel tanks and reels because they will last a lifetime if washed immediately after each use and given reasonable care. The smallest tank a photographer should buy is one that

holds two 120-size reels or three 35mm-size reels. Kodak makes an inexpensive black plastic tank that will hold one roll of 120 film and is suitable for the person who does not want to buy the more expensive stainless steel tank. This is the easiest of all tanks to load, because the film is merely rolled (in the dark) in a loose roll of clear plastic that has a crimped edge. This tank will also handle 127 and 35mm films with the purchase of additional plastic inserts.

GAF has a black plastic tank that is fairly easy to load and is the only other black plastic tank that I recommend for darkroom use. The film is inserted into the reel at the outer edge. When the reel is rotated back and forth, the film automatically feeds itself toward the center of the reel. Being adjustable, the reel will accept several sizes of film, the widest being the 120 size.

All tanks require some practice in loading. It is best to practice with an old roll of film before actually using any tank to develop good film.

Some sheet film tanks use metal hangers to hold the cut films, enabling the photographer to develop a number of sheets of film at one time. Care must be exercised with cut film hangers, because it is easy to scratch the emulsion with the corners of the hangers. Solutions in sheet film tanks can be kept fresh longer by using covers that float on top of the liquid.

For film developing, a photographer should have some kind of timer, a good photothermometer, an accurate graduate to measure chemicals, and so on. Do not use thermometers made for other purposes, as they may not be accurate enough for photography. One should also be cautious about using manufactured measuring cups (intended for home use), as they are usually printed by a silk screen process and are not accurate.

Photochemicals

All photochemicals should be handled in stainless steel, glass, hard rubber, fiberglass, or some similar container. Strong solutions of acid should be kept only in glass containers.

If one is developing sheet film in a tray, ample solution should be placed therein, with a minimum of 8 ounces for one sheet of 4″ × 5″ film, or 16 ounces for a dozen 4″ × 5″ sheets. The developer should be cooled to 68° F. or 70° F. (70° F. in the case of FG 7). Some photography teachers recommend developing film at whatever temperature the developer happens to be, then changing the development time to compensate for the temperature. This is an unsatisfactory method, however, because changing the developing time also changes the tonal scale of the film. Even though a film developed at 68° F. and another developed at 80° F. have the same density, the tonal range of the two films will be quite different. For this reason, it is important that one temperature be maintained every time film is developed.

Developer that is too warm can be cooled by placing it in stainless steel containers or bottles and setting them in water cooled with ice. Do

Fig. 3-7. Winning first place in the sports category of the 1966 Inland Photo Contest, "Come'n Down Hard" is a fine example of rodeo photography, with a full range of tonal values. James Johnson purposely overexposed his film and then underdeveloped it in order to use a larger aperture. thus cutting down the depth of field and making the background unsharp. Nikon F, 180mm lens, $f/5.6$, 1/1000 sec., Tri-X film. Courtesy of the *Wichita* (Kan.) *Eagle & Beacon.*

not put ice directly into the developer, however, as this will dilute the solution. It is also possible to put ice in airtight, watertight plastic bags and suspend them in the solution to lower the temperature.

It is desirable to have all the chemicals and the wash water as nearly as possible at one standard temperature. Only the developer, however, is critical. A one-degree difference in temperature of the developer can make a considerable change in the density of a film negative.

The second solution, following the developer, in the developing process is the *short stop*, sometimes called the *stop bath*. It is made by mixing one part 28% acetic acid with 32 parts water, always pouring the acid into the water, as this is the correct way to handle all acids. For one roll of film or a few sheets of cut film, ½ ounce of acid and 16 ounces of water will be ample. Some photographers use plain water rather than the short stop solution; I prefer an acid stop bath.

The stop bath merely slows the development process and removes the developing solution clinging to the surface of the film. The developer

actually in the swollen emulsion layer will not be stopped until it reaches the *hypo,* the third solution.[4] The most common chemical used for hypo is sodium thiosulfate. To save time, I use rapid hypo rather than regular. A negative will be fixed in about 3 minutes in the former but may take 10 to 15 minutes in the latter.

I use three different brands of hypo, manufactured by GAF, Edwal, and Hunt, depending upon which is available. The Hunt brand is made for lithographers and has a longer life than the other two kinds.

The fourth solution in film processing is *hypo neutralizer.* Although I use both Edwal's and Kodak's hypo neutralizer, I have no preference in brands. The hypo neutralizer counteracts the hypo and shortens the washing time.

Washing is the fifth step in negative development, and after the negatives are washed thoroughly, they are put into a solution containing a wetting agent. For this, I use Kodak Photoflo, mixed according to the manufacturer's specifications.

After removing the film from the wetting agent bath, I wipe all excess water from it with photo sponges. One should not use sponges purchased at the grocery store for this purpose, as they may scratch the film.

HOW TO DEVELOP FILM

In Trays

In a room that can be made absolutely dark, prepare your chemicals for the developing process.[5] With an accurate thermometer, check the temperature of the developer to be sure that it is 68° F. (or 70° F. for FG 7). Arrange the trays in chronological order as they will be used (see Chapter 4). Trays of 5″ × 7″ are usually large enough to develop several sheets of 4″ × 5″ film.

Turn off the light, unload the film from the holders, set the timer, and place the sheets of film in the developer one by one. As each sheet is inserted, be certain that it is thoroughly covered with developer. Negatives must be handled carefully so that they will not be scratched by fingernails or the edges of other negatives. (It is possible to develop 18 or 20 negatives in an 8″ × 10″ tray with ample solution without ever scratching one.)

[4]There may be some confusion in terms, as hypo is also called *fix,* or *fixer,* by some photographers and manufacturers.

[5]To test the darkness of a room, remain in it for 15 minutes until your eyes have adjusted to the darkness. Then, if you see light, tape the holes and put a rug against the door or a blanket at the window to keep out all light. Some rooms may be unsafe for developing in the daytime, as it takes very little light to fog film.

Film should be agitated by gently lifting alternate ends of the tray from 15 to 30 seconds when it first reaches the developer, and subsequent agitation must be systematic. If agitated continuously, the film will build up contrast and density faster than if developed by intermittent agitation. The photographer should agitate for exactly the same amount of time each time he develops. I usually agitate for the first 20 seconds with roll film and then again, for 15 seconds at one-minute intervals. With sheet film, I vary my method, depending upon the amount of film being developed. If I have a number of sheets of film, I agitate almost constantly and shuffle them, picking up each sheet from underneath and placing it on top of the others. I know, from experience, just how much to agitate, but this can only be learned by practice. The rule is to do the same thing in the same way every time; then, when something is wrong, the photographer knows it must be old chemicals, bad film, or some other such condition rather than the developing method. Uniformity in processing is an important habit to form and one of the secrets of success in becoming a professional photographer.

As soon as the bell rings on the timer, put the film immediately into the short stop and agitate continuously for about 30 seconds. Pick up the film, allow all the solution to drip back into the short stop tray, and place the film in the hypo. Agitate the film in that solution for 30 seconds, and for 10 seconds each minute afterward until three minutes have passed.

The room light may now be turned on. If the hypo is fresh and it is one of the rapid fixing solutions, the film has been in the hypo long enough. If the film looks cloudy or milky, this is a sign that the anti-halation backing has not cleared in the hypo. When this happens, keep the film in the hypo for twice the time it takes to clear, agitating it properly.

Follow this rule: Fix all film for at least twice the time it takes to clear.

Caution should be taken not to over-fix any film or photographic paper, because this will bleach the emulsion. Regular hypo will require from 10 to 15 minutes to fix film.

After the film has been in the hypo the correct length of time, pick it up, allow the excess solution to drip back into the tray, and place it in the hypo-neutralizing solution for two minutes. Agitate the film several times during this period, then pick up the film, let it drain, and place it in a pan of running water for five minutes. Because hypo is heavier than water, it tends to settle on the bottom of the tray; all the water in an ordinary pan should be changed several times while the negatives are washing. If hypo-neutralizer is not used, the negatives should be washed in running water for 30 minutes. A regular negative washer or an attachment for siphon washers made for washing prints or negatives in pans will dispose of the water in the bottom of the washing pan first.

After the negatives have washed for 5 (or 30) minutes, they should

be placed in a wetting agent solution for 90 seconds, wiped with a sponge to catch excess water, and hung in a dust-free atmosphere to dry. The wetting agent helps eliminate water spots on negatives.

Negatives should dry in from two to five hours, depending upon the temperature and humidity in the atmosphere. Rapid drying by heat, alcohol, electric fan, or heat lamp in special heated cabinets is often used by press photographers who are in a hurry for their negatives. If a drying cabinet is used, it should be filtered to be sure the air is clean. The other methods are not recommended for the novice, as they require experience.

All negatives dried by any rapid method should be fixed in a hypo that has a hardener. This toughens the emulsion and makes it less susceptible to scratches and other abrasions. Some photographers may differ with me on this point.

In Tanks

Roll film developing follows the same procedure outlined for tray developing, except that the room lights may be turned on once the tank is loaded and the lid placed on it. The solutions are poured in and out of the tank, instead of having each in a separate tray. Film may also be washed on the reel in the tank. A daylight tank may be loaded by the use of a changing bag, a zippered cloth bag with two light-tight sleeves that enable the photographer to load and unload film in ordinary light.

Roll film may also be developed in trays, and some professional photographers are proficient at developing more than one roll in a tray at one time. I prefer to develop roll film in a tank, if one is available.

In developing cut film on hangers, follow the steps outlined for developing in trays with the following exception: When the film on the hangers is agitated, it is brought up, tilted to one side to permit the solution to run that way, returned to the solution, lifted up, and tilted to the other side, allowing the solution to fall back into the tank. This prevents streaks or uneven development when using film hangers. Film may also be washed and dried on the film hangers, although I prefer to use clothespins on a line or special film clips for drying.

THE NINE-RING-AROUND TEST FOR THE PERFECT NEGATIVE

There is a simple way to get a perfect negative, if a photographer uses the same film and develops it in the same developer at the same temperature each time. As simple as this may sound, many photographers shoot film haphazardly and buy all types of developers in search of the one secret way, or a new, exotic way to produce good negatives. As hard as they may try, however, they are often unable to get a good, printable negative.

Because developing and exposing film are interrelated, the nine-ring-around test should be conducted on an average day with normal

bright sunlight, no clouds, or at least none that will shade the subject, for the complete test. It is best to make the test during hours when there is ample sunlight—10 A.M. to 2 P.M. in winter; 9 A.M. to 3 P.M. in summer.

Use a film such as an ASA 125 film and set the shutter speed at 1/125 sec. (the same test should be conducted at 1/500 sec. for an ASA 500 film, such as GAF Super Hypan). With cut film, make three exposures at $f/16$, which is normal, three exposures at $f/8$ (two stops overexposed), and three exposures at $f/32$ (two stops underexposed). (If you do not have $f/32$ on your camera, use $f/22$ and change the shutter speed to 1/250 sec., the exposure equivalent to $f/32$ at 1/125 sec.) Mark each holder so that you can tell which were exposed at which f/stop.

Separate these films in the darkroom so that there are three packs of three films each, each pack containing one sheet of film exposed at $f/32$, one exposed at $f/16$, and one exposed at $f/8$. These exposed films can be stored in old film boxes or in some other light-tight containers. As a precautionary measure, it is advisable to mark with a pencil, clip the corners, or in some other way specify each group of films so that each is clearly identifiable after they are developed, in case they should become mixed together.

Develop each of these three-film units in fresh developer at the same temperature but for a different length of time, which will approximate the equivalent of the two stops difference in exposure, over and under.

Using Ansco Versapan (ASA 125), for example, develop one set in Hyfinol (1:1 dilution) for six minutes at 68° F. Develop the second set of three films at 10 minutes and the third set at 4½ minutes. After all these negatives have dried, choose the one that will print on a standard No. 2 enlarging paper. All future exposure and developing times are based on the results obtained with the standard (No. 2) negative. If your subject was a normal one, lighted under average conditions, it should be possible from now on to get a near-perfect negative every time you expose film under similar conditions.

Knowing what the exposure is for average lighting conditions, you should be able to make an adjustment in your f/stop for brightly lit beach scenes, subjects in the shade, or cloudy days. All this can be done without the aid of a light meter and through bracketing, as mentioned in Chapter 5 on exposure.

CUSTOM LABORATORIES

Students sometimes ask me where to send their films for developing and enlarging because they do not have darkroom facilities. In the case of black-and-white film, top-quality developing and printing can only be obtained through the services of a custom laboratory. These laboratories are usually located in the larger cities, and their names and locations can

be found by asking professional photographers and camera stores catering to professionals and by reading advertisements in photography magazines.

Custom laboratories charge a little more for their services than do the corner drugstore and other photofinishers catering to the amateur snapshot photographer. There is little need, however, to buy a good camera and film unless the photographer plans to do his own work or to hire the services of someone who does, because the quality of most black-and-white photofinishing done in this country is poor. Expect scratches, fingerprints, or even a neat row of holes in your negatives caused by a misplaced film clip when you patronize the snapshot photofinisher.

Some of the photofinishers doing amateur color developing and printing do a fairly good job; others are, like their black-and-white counterparts, poor. It may take some shopping to find good color work. I dislike taking chances and usually bring or mail my color film to someone who does custom color work.

Some processing firms do work only for professional photographers, and the names of such organizations can be found in photography magazines read by professional photographers, such as *The Professional Photographer.*

DEVELOPING BY INSPECTION

At one university where I taught photography, I had a student in the Air Force who invited me to see the photo laboratories on his base. Several darkrooms were located on the base, and I learned to my surprise that much of the black-and-white film there was developed by inspection, a method not used today as much as it once was.

The steps in the developing process are the same for this method, except that the photographer usually uses a de-sensitizer, and he turns on a dim light, usually green, from time to time to look at the film and see how it is progressing. Being able to look at the film while it is being developed might seem to be an ideal arrangement; the drawback is that one must train himself to know what to look for under the dim light, and this training includes almost daily practice over an extended period.

The photographer in the base photo laboratory did not use de-sensitizer and developed the film for three-fourths normal time before looking at it, because the closer the film is to full development, the less chance there is of fogging it. Other photographers may keep the light on during the entire developing time with certain kinds of cut film or for a few seconds at a time with miniature film. However, the light cannot be kept on long during the development without using de-sensitizer.

The most commonly used de-sensitizers are pinakryptol green, pinakryptol yellow, and pinakryptol white. The first two are used in a two-minute forebath and the last one, in the developer. Instructions for the

use of these chemicals can be obtained when they are bought at a camera store.

Some developers, such as those containing hydroquinone, do not work well with de-sensitization agents. Film that has been de-sensitized may require up to 50 per cent longer developing time. Here again, what appears to be an easy method is tricky and is suitable only for the professional who has had considerable experience.

SUMMARY

No one developer or one film is suitable for all photographs. The beginning photographer should use one film, preferably of medium speed and relatively fine grain, in combination with one film developer, until he is able to get a perfect negative nearly every time. He should follow the scientific approach, make exact measurements, and use exact temperature control in an orderly darkroom. Haphazard methods are not suitable for professional photography.

Niépce and Daguerre are called the fathers of the photographic process. Brady, following their methods, became America's leading portrait photographer. Eastman, with the development of the snapshot camera in 1888, invented the first roll film photographic process.

Film derives its light-sensitivity from silver halide particles suspended in the gelatin base. There are three types of black-and-white film: slow, medium, and high-speed. Generally, the faster the film, the grainier the emulsion. Fine-grain, slow-speed films are normally used for making great enlargements; fast, grainy films are used to stop action in sports photography or under adverse lighting conditions. A medium-speed film is generally best for most photographic situations.

Cut film is often used by portrait and commercial photographers because it is easily retouched and comes in larger sizes and a wide variety of emulsions.

Most films are panchromatic, or sensitive to all colors, rather than orthochromatic, which is color-blind to red.

When film is placed in the developer, the areas that have been sensitized to light begin to turn black. The film developer is usually composed of four main agents, each with a specific purpose. Developers range from high- to low-contrast, depending upon the result the photographer desires.

Increasing either development time or temperature from the norm will increase the contrast of a negative, but not in constant ratio to each other.

Negatives for press photography should be developed so that they will print on No. 2 or No. 3 grade enlarging paper.

Roll film is usually developed on a reel in a cylindrical tank, but it can be developed in a tray. Cut film is usually best developed on hangers in a tank or in a tray.

In developing, film normally goes through the following steps: (1) developer; (2) short stop; (3) hypo; (4) hypo-neutralizer; (5) wash; (6) wetting agent; (7) dry.

The best way to find a perfect negative is to use the nine-ring-around test, which provides for making three different exposures and using three different developing times.

Developing by inspection requires great skill; it is done under a dim green light, usually with a de-sensitizer.

QUESTIONS

1. Why will one film developer not solve all problems of exposure?

2. Why should the beginning press photographer master one film and developer before using another?

3. Name: (a) two early French pioneer photographers; (b) an American Civil War pioneer photographer.

4. Who is famous for developing the roll film camera?

5. What are some of the characteristics of slow-, medium-, and high-speed films?

6. Name the two main manufacturers of roll film in the United States.

7. How does cut film differ from roll film, and what are some of its applications?

8. How does panchromatic film differ from orthochromatic?

9. What takes place when a piece of film is exposed to light?

10. What happens when it is placed in the developer?

11. Explain the complete cycle of the film developing process.

12. How do film developers differ in their characteristics, and which type should the beginning press photographer choose?

13. What type of tank is preferable for roll film?

14. How is cut film best developed?

15. What is a wetting agent, and what does it do?

16. How do you make a nine-ring-around test with an ASA 125 film?

17. What advantage is there in sending your film to a custom laboratory for developing rather than to the local drugstore?

18. What is meant by "developing by inspection"?

CHAPTER 4

Enlarging and Printing

A GOOD ENLARGER can often cost more than a good camera and may, in some ways, be the most important piece of photographic equipment a photographer owns. Enlargers, like cameras, require a number of extra accessories to make them more versatile and to enable the photographer to handle a variety of darkroom work, often saving precious time. Much of the professional photographer's money is made in the darkroom, and any time saved in doing darkroom work often means more income, especially if he freelances.

CHOOSING AN ENLARGER

How much should a good enlarger cost? A good-quality enlarger with a good enlarging lens for 4″ × 5″ film will cost from $350 upward. Special models with built-in color filtration cost several hundred dollars more. An 8″ × 10″ enlarger can cost as much as $3,000 to $4,000. A high-quality enlarger with a lens for 2¼″ × 2¼″ and smaller negatives costs from $125 upward.

If you are beginning to worry about enlarger costs, however, remember that a good enlarger will last for years with a nominal amount of maintenance. It is almost impossible to wear one out, unless it has been used in a production laboratory. Even then, after a few years a few new parts may make the instrument work almost like new.

I have bought both new and used enlargers, and for the money, a used enlarger is often a better buy. Check the camera stores and the

classified advertisements in a large city newspaper. If you are not in a hurry, you can usually find just what you want for sale. It is preferable to buy a good-quality used enlarger than to spend the same money on a cheaper-grade new one. Any enlarger, of course, is better than none, and I have seen some very good photographs made with inexpensive or homemade enlargers. In most cases, however, the photographer could have produced a better photograph more easily and more quickly with a good lens and a sturdy, well-made enlarger.

Most newspapers use 4″ × 5″ Beseler and Omega enlargers, the latter being more popular. Third in popularity is the Durst enlarger, which comes in several models for different size negatives, as do the Beseler and the Omega. Portrait photographers tend to buy 5″ × 7″ enlargers, since many portrait cameras use 5″ × 7″ cut film. Only advertising, commercial, and industrial photographers ordinarily buy 8″ × 10″ enlargers.

There are a number of other makes of good enlargers, including models made by Agfa, Leitz, and Primos. Most of these enlargers are made for medium- and small-format negatives. Some photographers who shoot only 35mm negatives buy a top-quality machine designed for that special size alone, in order to turn out top-quality work.

In buying an enlarger, the photographer's first consideration is what size to buy. The rule is to buy an enlarger that will handle the largest negative size that the photographer expects to shoot. In other words, if the photographer uses both a 2¼″ × 3¼″ press camera and a 35mm

Fig. 4-1. This professional 4″ × 5″ Beseler CB-7 condenser enlarger has a built-in electric timer and a motor to shift the enlarger up and down as well as sideways. A variety of enlarging lenses and negative carriers are available so that any film size from single-frame 35mm to 4″ × 5″ sheet film can be enlarged with ease. The Beseler is one of the two most popular enlargers used in press photography darkrooms in the United States. Courtesy of Charles Beseler Co., East Orange, N.J.

single-lens reflex, the practical solution is to buy a 2¼″ × 3¼″ enlarger and two lenses, a 50mm lens for 35mm negatives and a 105mm lens for 2¼″ × 3¼″ negatives. If the photographer plans to use a 4″ × 5″ press camera, then a 4″ × 5″ enlarger is the smallest size to buy, plus enlarging lenses to match each different size negative and a set of condensers to match the focal length of each enlarging lens, if the enlarger is a condenser enlarger.

THREE BASIC ENLARGERS

There are three basic types of enlarger, with some variations, in use today—the *diffusion,* the *cold light,* and the *condenser* enlarger. The least expensive is the diffusion type, as it is cheaper to make, using only a piece of frosted glass instead of the more expensive condensers. The cold light enlarger is really a diffusion enlarger also, except that the tungsten light source is replaced by a circular fluorescent tube similar to those used in ceiling light kitchen fixtures or mercury vapor tubes.

The lamp in the cold light head of my Omega enlarger burnt out one day, right in the middle of an important darkroom printing session. I removed the head from the enlarger and took it apart to see what size of fluorescent tube it used. To my dismay, it required a tube of a standard size, but the burnt-out lamp had a special socket fitting, different from those of standard tubes.

Since there was no professional camera store in the area, I called an electrician friend of mine, and we promptly adapted the cold light head to take standard circular fluorescent lamps. This gave me an added advantage, in that now I can not only buy a circular lamp anywhere, but I also have a choice of lamp colors, which is important because variable-contrast enlarging paper does not work well with the light emitted from the cold blue lamps.

The advantages of diffusion and cold light enlargers are that they do not heat up the negatives and that they tend to subdue blemishes, dust particles, scratches, and negative grain. Diffusion and cold light enlargers are also more suitable for use with portrait and other warm-tone printing papers. This is why photographs of a good portrait photographer look the way they do, with open shadows, long tonal gradation, and warm or slightly warm tones. Such work is not possible with a condenser enlarger and cold-tone paper. I use either a condenser head or a cold light head on my enlarger, depending upon what type of photograph I am trying to make. One type of enlarger is not suitable for all photographic jobs.

Press photographers almost always use the condenser enlarger, because it makes more contrasty prints than either of the others. In fact, a negative that will print on No. 2 paper under a condenser enlarger will require No. 3 paper under the other two.

Fig. 4-2. The Omega A3 for 35mm and 126 negatives is a very compact condenser enlarger selling for under $100 with a lens. It is ideal for the part-time photographer who does not have much space, since it can be quickly disassembled and stored in a drawer or on a shelf. It will make up to 11″ × 14″ prints or even larger if projected on the floor instead of the baseboard. Courtesy of Berkey Marketing Companies, Inc.

Condenser enlargers come equipped with one, two, or three condensers—those with one condenser being more inexpensive, those with two being the most common, and those with three being of the variable-condenser type, which changes the focus of the rays of the lamp by placing the third condenser on different levels in the lamp housing. This is done in order to match the focal lengths of different enlarging lenses. Without this third condenser, it is necessary to buy matched pairs of condensers for enlarging lenses of different focal lengths. In some cases, a slight change in focal length of the enlarging lens, however, will not require a different set of condensing lenses.

FOCUSING THE ENLARGER

Another aid is a focusing device for the enlarger. Such devices cost very little, yet help to get negatives in focus.

In using the enlarger, the lens should be opened up to its fullest aperture during focusing and then stopped down to the recommended $f/8$ for the test strip.

Enlargers vary in design, but most have a fine-focusing knob used to bring the negative into focus once the enlarger head is moved up and down until the point is found that gives the size wanted on the easel. It is important to focus accurately, and some photographers, when using a double-weight paper, actually use a sheet of discarded double-weight

63

paper in the easel in order to get exact focus. If the negative is too dense to focus, a sharp, easily focused negative or one of the special negatives that can be purchased with focusing grids on them can be used instead.

Some enlargers have devices for keeping them in constant focus. These are called *autofocusing enlargers,* and no matter whether the enlarger is up or down, it remains in focus, because a cam compensates for the difference in focus at various heights. It is necessary to have a different cam for each lens used on these enlargers.

Other focusing aids include special devices that magnify the image, and some enlargers even have a rangefinder that lights up and projects two images on the easel when the enlarger is out of focus and only one image when it is in focus.

Some photographers calibrate their enlargers so that they can tell the difference in exposure time between a 5″ × 7″ and an 8″ × 10″ of the same print by setting the enlarger on the calibrations they have made.

NEGATIVE CARRIERS

All enlargers have some type of negative carrier. Some have what are called *rapid carriers,* which enable the photographer to move a roll or section of film through the enlarger without taking the negative carrier out of the enlarger. There are two main types of negative carriers. One uses a glass to keep the negative flat and is known as a *glass negative carrier.* The problem with this type of carrier is that any scratches on the glass show on the enlargement, as will dust. The glass type of carrier is

Fig. 4-3. Taking negatives up to 2¼″ × 2¼″, the B-22 XL (left), for making large blowups, and the B-22 Omega enlargers can be purchased with an extra condenser and carrier for using both 35mm and 2¼″ × 2¼″ film. Although suitable for the advanced amateur or the occasional professional, the full-time professional would probably want heavier duty equipment. Courtesy of Berkey Marketing Companies, Inc.

generally used with larger negatives to keep them perfectly flat. The other type, the *glassless carrier,* is used by most photographers because it eliminates the problem of introducing another potential imperfection between the negative and the paper.

LETTERPRESS AND OFFSET

Newspapers use coarse engraving screens, a series of tiny dots or lines, to get good reproduction on rough newsprint. Only contrasty photographs work well with 60-, 65-, or 75-line (coarse) engraving screens. This is one reason why almost all newspapers and magazines use condenser enlargers in their darkrooms. In the Sunday magazine section of the newspaper, the printing method may not be letterpress but rotogravure. Because of the difference in paper and the finer screen that is used, such magazines use photographs with longer tonal gradation, more detail in the shadows, and less contrast.

Large metropolitan daily newspapers use the *letterpress* method of printing, but on small daily and weekly newspapers the trend has been to *offset* printing. The quality of a good offset halftone is much better than one printed by the letterpress method, partly because offset newsprint is usually of better quality and engraving screens used for offset photographs are finer. A third factor is that the original offset halftone engravings are used on the offset press. On the web-fed press of the large dailies, the original halftone engravings are matted or pressed against a paper compound the size of a newspaper page. This mat is then *stereotyped*—put in a machine where hot metal is cast against it. The result is a metal cylinder printing plate capable of printing newspapers at from 60,000 ot 80,000 pages an hour or even more under certain conditions. Some of the quality of the original halftone is lost in this stereotype process.

With the trend toward offset printing among the smaller publications, it is not unusual to find a press photographer who is also a platemaker part of the time. Even some dailies, such as the Biloxi-Gulfport (Mississippi) *Daily Herald,* employ their head photographer as a part-time engraver, making the zinc or magnesium halftone plates for the letterpress printing plant. Photoengraving and press photography are closely related to one another. The more the press photographer knows about engraving, the better his pictures are likely to be. With the color revolution in newspapers, this knowledge becomes even more important, because of the complexity of both color photography and the making of color printing plates.

THE ENLARGING LENS

One of the most important features of an enlarger, apart from its sturdiness, is the lens. It makes no sense to take pictures with a top-quality

camera lens and then use a poor- or medium-grade enlarging lens. Only a critically sharp and color-corrected enlarging lens will turn out professional looking work. A photographer should expect to pay more than twice the price of a medium-grade enlarging lens for one that is critically sharp. Such a lens for 35mm negatives will run from $60 to $100. One for 2¼″ × 2¼″ will cost from $75 to $120, and one for 4″ × 5″, $100 and upward.

For the beginning press photographer with a limited budget, a medium-grade enlarging lens is a better buy than a cheap one. After he becomes a proficient and more affluent professional, he can trade his medium-grade lens in for a top-quality one. Camera lenses should be used for enlarging only as a temporary measure. Enlarging lenses are specially made for working at close range and have a flat field, whereas camera lenses are designed for use with distant objects.

Top-quality lenses are made by a number of manufacturers. It is best to consult someone at a camera store catering to professionals for information on the prices and differences in lenses. Among the many manufacturers making top-quality enlarging lenses are Kodak, Rodenstock, Schneider, and Wollensak.

SETTING UP A DARKROOM

If a beginning press photographer does not have access to a darkroom and is trying either to freelance or improve his darkroom techniques, he soon finds himself looking for suitable space for a darkroom.

Fig. 4-4. A sturdy 2¼″ × 3¼″ enlarger ideal for anyone owning both 35mm and 120 roll film cameras, this Beseler 23 C-11 condenser enlarger takes various lenses to fit the different film sizes. Courtesy of Charles Beseler Co., East Orange, N. J.

Most first darkrooms are built in space not normally valuable for anything but storage, such as a closet in an apartment or a basement in a residence.

Improvised Darkrooms

The bathroom often serves as a part-time darkroom in an apartment, mobile home, or motel room. If there is only one bathroom and several people using it, this can create a problem. I rented a basement apartment in an old miner's mansion in the capitol hill district of Denver once, just because I had the use of three built-in laundry tubs on an abandoned stairway. I built a darkroom on the narrow stairway and turned out as many as 1,000 enlargements in a day from this darkroom and the three laundry tubs just outside the door.

Although it is desirable to have running water and electricity in a darkroom, I have worked in darkrooms with no running water and with the electricity brought in through a long extension cord. Even a photographer who is travelling can carry his darkroom with him in the car or plane if he brings a changing bag, which will allow him to load film in film tanks, unjam a camera, or load cut film holders while sitting in his seat in broad daylight.

Making a room light-tight can be a problem in hotel closets or bathrooms. One way of doing this is to pin a blanket on the outside of the door at the top, so that it covers the cracks around the door. The crack at the bottom can be stuffed with paper, or a rug can be placed against it. Today's high-speed films fog very easily in the dimmest light.

Fig. 4-5. Darkrooms should be light and pleasant places to work. Here a group of industrial arts' students are being shown how to operate a 4″ × 5″ Beseler enlarger. Photo by author.

Darkroom Equipment

It is much easier to time enlargements with an automatic timer that is calibrated in seconds, rather than turning the enlarger on and off manually. It is only necessary to set such a timer for the number of seconds desired and push the button or set the lever, and the machine will automatically turn on the enlarger for the desired time. At the end of the period, it will not only shut off but reset itself for the next enlargement. There are several makes of these timing devices, two of the most popular being Time-O-Lite and Gra-Lab timers.

If one does not have a timer, one can turn on the enlarger and start counting, "One thousand one, one thousand two, one thousand three . . . ," letting each number represent one second of time, and at the end of the desired interval, turn off the switch.

A handy device to use with timers is a foot switch, which leaves both hands free to dodge the print during the time the enlarger is on, as the timer can be turned on by foot.

Print tongs for handling photographic prints in the chemical solutions are a must, because it is so easy to contaminate photographic prints by using only the fingers. Certain chemicals, particularly the hypo, are hard to remove from the hands and will carry over to a dry print, leaving a fingerprint or other stain on the print. Only a thorough washing of hands with soap and water will remove the hypo.

The best type of print tongs is made of stainless steel; these usually come in sets of two, one being used for the developer and the other for the hypo and short stop, both acid solutions. Some photographers disagree on the use of print tongs, but I find that the beginning photographer, particularly, will proceed much faster with the tongs than without them. It takes only a little practice to learn to use them, and the effort is well worthwhile.

Ample shelves for storing paper, chemicals, and other equipment should be provided in the darkroom. Because of the wide variety of available spaces and sizes, it is advisable to get a special book on building a darkroom, such as the one put out by Eastman Kodak, or to study photographic books that contain darkroom plans. As a rule, these books are good only as guides, however, because usually no two darkrooms are the same size or contain exactly the same equipment.

Darkrooms in basements are often damp and, therefore, unsuitable for paper and chemical storage without the aid of a dehumidifier to remove the excess moisture. It is possible to use silica gel, a dessicant, for this purpose. After some use, this chemical must be dried out by baking in an oven. Silica gel is often found in small packages inside shipments of cameras and other equipment from overseas.

All darkrooms need at least three trays, whose size depends upon the size of the prints to be made. I recommend, as a minimum, 11″ × 14″ or 16″ × 20″ trays, if the photographer plans to make large blowups.

Usually, 8″ × 10″ and 5″ × 7″ trays are suitable for making smaller enlargements or developing sheet film in a tray.

Some sort of film timer, besides the one used with the enlarger, is needed to time film development, and one or two safelights are also necessary. I always use a safelight that is suitable for variable-contrast paper. The old red safelight has very little application in the modern press photographer's darkroom, because today's films are sensitive to red, except for orthochromatic sheet films.

A good paper knife is also important for cutting test strips and large paper into smaller sizes. It is best to get as large a paper knife as possible, even one that will cut 16″ × 20″ paper, if the photographer is planning later to make enlargements that size.

Although a contact printer is handy for making contact prints or viewing negatives on the groundglass and even for doing a small amount of retouching on the negatives, it is advisable to put more money into an enlarger and do without the contact printer than to buy both, because contacts can be made with a sheet of clear glass to hold the negatives in contact with the enlarging paper while the enlarger is turned on.

Perhaps one of the most important steps is to arrange the darkroom in such a way that there is a continuous flow from one pan to another after the print leaves the enlarger and is finally placed in the wash.

Because of the rapidity with which news breaks, particularly spot news, deadlines, and the rush to get pages on the press in order to get the paper out on time, all newspaper photographers must resort to short-cut methods either regularly or part of the time. When the 4″ × 5″ press camera was commonly used, photographers often made prints from either the wet negative or a wet glass plate directly out of the hypo. This requires careful cleaning of the enlarger and lens after each printing session, of course, in order not to corrode the metal in the enlarger and to keep the lens free from chemicals. At one time, when I was doing a volume of prints, I found it better to leave the hypo on the film than to even attempt to wash the negatives slightly, because the hypo had less tendency to form drops on the wet negatives. This type of printing had one advantage in that it reduced the grain and kept slight scratches on the negative from printing on the enlargement. It requires considerable experience to use wet negatives, however, and the practice is not rcommended for the novice photographer.

To speed processing, some photographers dry films with lamps or alcohol. Perhaps the most commonly used quick-drying method today is a special photo-drying solution manufactured by Yankee. With this solution and a mechanical film dryer, it is possible to dry negatives in a very short time. The longer the drying solution is used, however, the longer it takes to dry the film, and the solution finally reaches the point where it must be replaced. It does have a long shelf life, though, and can be used over a long period of time.

Fig. 4-6. This contact proof sheet of 34 candid photos was taken in a college class-room in less than 30 minutes. Making proof sheets of all negatives is a good way to select and edit photographs. Canon FT, 85mm *f*/1.9 lens, 1/125 sec., GAF Super Hypan film. Photo by author.

For the press photographer not in a great hurry, a film dryer either constructed of plywood and using infrared lamps and a blower or one that has been purchased from a manufacturer will dry most film in 10 to 15 minutes. Color film, however, requires special handling and should be dried only under conditions satisfactory for the particular color film that the photographer is using. Check with the manufacturer or a camera store that caters to professionals for information on drying color film.

A print washer is almost a necessity for anyone doing a great number of prints. Devices can be purchased that will siphon the water out of the tray or will convert an ordinary kitchen sink into a print washer, but these are satisfactory only when the photographer is making a few prints. Washers may be trays, or drum-shaped or circular pans.

The important thing in washing is to be sure that the hypo, which is heavier than water, is drained off from the bottom. All print washers or print washing devices make provision for this factor. The prints should be under constant motion while washing, so that the chemical is drawn off from them. Having too many prints in the washer at one time will prevent the water from covering all sides of each print.

In the darkroom, there is also a need for a ferrotype tin. Although somewhat more expensive, the chrome brass ferrotype plates are best because they will not rust as the chrome steel or black enamel plates do. Ferrotype plates should be handled with care, washed after use, dried with a clean towel, and frequently waxed to give best results. The best ferrotype prints are made by using glossy paper on ferrotype plates and running them through a photo wringer, which resembles the old-fashioned washing machine wringer, thus squeezing them together in perfect contact.

A squeegee is necessary for ferrotyping glossy paper face down on ferrotype tins in order to get a good gloss on prints. These come shaped like rollers or flat with a handle for pushing the squeegee over the back of the print.

There are various kinds of photo dryers, some with blotters and some with ferrotype tins. Some are flat or slightly curved; others are drum-shaped. The latter tend to stretch the prints out of shape, and for that reason, I recommend the flat or slightly curved dryer.

The ferrotype surface on these dryers is not usually as good in quality as the top-quality ferrotype plate. Dryers, however, enable the photographer to get rush work out in a hurry and are used on most newspapers. More and more, however, newspapers are installing new rapid automatic print processors, commonly known as *stabilization processors*. For these, the paper used has the developer in the emulsion, and only a very short time, two or three minutes, is required from the time the exposure is made on photographic paper until the print is developed and ready for reproduction.

The stabilization processor also has some disadvantages, however. One chief photographer on a large daily newspaper told me that they

71

were not using the process because the prints turned out were damp, and they were set up for dry prints. What he meant was that prints come off the automatic developing machine feeling somewhat sticky, rather like a limp handshake, and the newspaper's art department found these prints hard to retouch, preferring those made on regular photographic paper by conventional processing.

Another complaint made by several photo editors and photographers was that the prints faded after about three or four months and had to be put into a hypo bath and washed like regular prints in order to be made permanent. This is a vital factor, because newspapers keep prints that are used each day on file in the library for use in the future. A print that is not permanent is of little value to the library of the newspaper.

A third factor even more detrimental is that prints made by the stabilization process, which had not been fixed in regular hypo and then washed to eliminate the hypo, contaminated other photographs with which they came into contact. As with any new development, there always seem to be new problems to replace the old ones already eliminated. In the end, to make prints permanent, the stabilization process takes as long as, if not longer than, conventional processing methods. (These automatic processors come in different sizes and require no water or plumbing, but merely pouring in the chemicals and hooking up to the electricity. The actual processing of a print takes from 10 to 20 seconds after the exposed paper enters the processor.)

For the photographer who plans to mount his pictures for display, a dry-mounting press with a tacking iron to tack the dry-mounting tissue to the back of the print is a useful aid. The Seal Company makes several different sizes of dry-mounting presses, up to a professional size that will take very large sections of a photomural. It is also possible to mount prints with an electric iron, but those mounted on a dry-mounting press usually stick better. There are two types of dry-mounting tissue, one that is permanent and one that can be removed again.

All darkrooms should be ventilated in some manner, because of fumes from the chemicals and the fact that it is unhealthful to work in an atmosphere of stale air. A fan of the small squirrel cage variety, with an outside vent and a light trap, is the best type for moving a great deal of air. Most photographers who use this system usually put a light trap on the bottom of the darkroom door, including in the construction of the vent a removable filter of the type used on air conditioners. This helps to keep dust out of the darkroom (a problem in most cases). Color photographers often mix their chemicals in another room, to avoid getting chemical dust in the darkroom.

One of the best darkroom accessories to eliminate dust from negatives is a static brush, which will remove dust from the negatives with ease. Available also is a camel's-hair brush with a rubber squeeze-bulb that will blow dust from negatives. In order to combat dust, many photog-

raphers also ground their enlargers to a water pipe or some other type of ground to eliminate static electricity, which makes dust stick to negatives.

It is highly important to work with as much care as possible in a darkroom. Avoid spilling chemicals on the floor and occasionally go through the darkroom with a vacuum cleaner to remove all dust and accumulated dirt. This also helps to prevent dust spots on negatives and prints.

One way to keep contamination to a minimum in the darkroom is to have a wet area and a dry area, the wet area being the sink, which can be of several varieties, including fiberglass, stainless steel, or even an ordinary kitchen sink. All mixing, washing, and any other processes in the wet stage will be carried on in this area. All film, paper, and enlarging or printing operations remain in the dry area, which will be some kind of bench with perhaps a light-tight drawer for storing paper or a cabinet above for keeping various lenses and accessories. If the room is narrow, one area can be on one side and one on the other. In some cases, the wet area will be in the center of the room, with all washing and developing taking place there, and the enlarger or enlarging area will be around the outside. This island arrangement is common in darkrooms where several persons are printing at the same time.

Many photographers build their own sinks, and one portrait photographer friend of mine made a sink from exterior plywood. It was about 8 feet long, 8 inches high, and 26 inches wide. He covered the sink with fiberglass and resin of the type used for fiberglassing boats. His is a busy studio with five full-time employees, and a large volume of work goes through this sink in a year's time. After two years' use, he told me that this sink held up quite well and needed only to be touched up about once a year.

For those who can afford it, a temperature-controlled darkroom sink is ideal. These sinks may also have refrigerators for storing bottles of chemicals. The most important feature is that the sink can be set for a certain temperature, such as 68° F. or 70° F., and through a refrigerator or heating unit, the sink will remain within one degree of the set temperature at all times. Temperature-controlled sinks and temperature-controlled mixing faucets are widely used by color laboratories, because temperatures are so critical in color work. Many black-and-white photographers use them also, since such a sink makes processing easier and quicker.

Although it is commonly thought that a darkroom should be painted black, almost any color, especially a pleasing pastel, will work quite well in the darkroom. From a psychological standpoint, the right pastel color will make the darkroom a much more pleasant area in which to work.

Safelights may be of several types, including ceiling, wall, and inverted models. The photographer can test his safelights by leaving a piece of photographic enlarging paper half covered and out in the open for

about five minutes with the safelights on in the darkroom. If a line shows on the paper after development, this indicates that the safelights are too bright and should be made dimmer. A bright darkroom is much easier to work in than one that is dim, and I try to keep mine well lighted with several safelights.

Certain papers, such as those used in color printing, will require dimmer safelights of a special kind. Check the instructions on the kind of color processing you are doing to determine the kind of safelight to use.

It is also important to protect one's clothes in the darkroom by wearing a darkroom apron or smock. The best rule is to wear only old clothes in the darkroom, and then if developer is splashed on them, there is no loss.

Enlarging paper can be held down by glass or thumbtacks, the latter method often being used for making large murals. The best way to hold paper down, however, is with an enlarging easel, which can be bought for less than $10 or more than $100, depending upon the size and the sturdiness a photographer needs. For general use, an easel that will take up to 11″ × 14″ paper is recommended. An adjustable easel that will make different size borders and will handle any size rectangular paper up to 11″ × 14″ is the most valuable and can be purchased for less than $20.

Some photographers use the Speed Easel, which comes in standard paper sizes and is nominal in cost. Another popular easel is the Airquipt 4-way easel, which handles standard paper sizes up to 8″ × 10″. Neither of these easels is adjustable.

All sorts of items can be bought for the darkroom, such as spot meters for reading film densities under the enlarger and densitometers for computing densities in color work. Even an old beverage cooler or a refrigerator is useful for cooling chemical solutions.

A telephone extension in the darkroom for the photographer always on call may bring him an important assignment. An intercom will enable him to answer the front door or talk to his wife upstairs while processing film. A radio is useful for keeping up with the news, and its music will soothe his nerves during a dull processing session. The list of darkroom accessories is endless.

PRINTING THE PICTURE

The Test Strip

The shortest distance in time from the negative to a good photograph is by way of a test strip. The test strip zeroes in the correct exposure under the enlarger in a way similar to an artillery gunner's practice of first getting one shot over and one shot under before all guns of the battery open up on the target.

The test strip is such a simple thing that photographers often disregard its use, thinking they can outguess the laws of probability. The properly exposed test strip is the secret to getting professional-looking

photographs every time from a printable negative. This point has been brought home to me many times upon seeing some of my students, after only four or five weeks' instruction in photography, make better prints than some press photographers who have worked two or three years on a newspaper.

To get a test strip, it is only necessary to cut four or five equal sections from an 8″ × 10″ sheet of enlarging paper (with only the safelights turned on, of course) and then return them all to the paper box or package. After focusing the negative on the easel set for an 8″ × 10″ photograph, stop the enlarging lens down to $f/8$.[1] Most enlarging lenses are as sharp, if not sharper, at this stop as at any other.

With the enlarger light off, place one of your test strips across an important part of the image projected on the easel. Cover all but one-fourth of the strip and expose that part for 4 seconds; expose another fourth for 8 seconds, a third for 12 seconds, and the last for 16 seconds. The easiest way to do this is to hold a piece of cardboard or some other opaque object under the enlarger and set the time for 4 seconds, uncovering one-fourth of the paper each time you make a 4-second exposure.

After making the test strip in this way, put it in the paper developer (the first tray) and develop it for exactly 1½ minutes for glossy or regular photographic paper or for 2 minutes for portrait paper, which also requires a portrait paper developer for best results. (Instructions for mixing paper developer appear on the back of all containers of paper developer. Follow these instructions when mixing.)

After the test strip has been developing for exactly 75 seconds, pick it up with tongs and let the developer drip back into the tray for 15 seconds. Then place the test strip in the short stop (the second tray), made by combining 1 ounce of 28% acetic acid and 32 ounces of water. The tray should be agitated during the entire process.

After the test strip has been in the short stop for 30 seconds, pick it up with another set of print tongs, let it drip for 15 seconds, and then place it in the hypo. Agitate the test strip in the hypo for 30 seconds continuously and then wait two minutes before turning on the white light to see what it looks like.

Before turning on the white light, always make it a habit to check that all paper is tightly covered; otherwise, you will end up with several dollars' worth of ruined enlarging paper.

From the four different exposures on the test strip, it should be possible to determine the most likely one. If the right exposure appears to be between 8 and 12 seconds, try 10 seconds. A certain amount of interpolation must be done throughout any photographic process.

[1] Slower or faster papers may require that the enlarging lens be stopped down or opened up.

Fig. 4-7. Contact proof sheets of negatives can be made on regular 8″ × 10″ enlarging paper by placing the negatives shiny side up on top of the paper, with a sheet of window glass to hold the negatives flat. If the enlarger is raised to the position that would normally make an 8″ × 10″ enlargement from a single negative of the size being proofed, the exposures of all negatives can be determined from the proof sheet by the test-strip method. Shown here is a proof sheet of four 4″ × 5″ negatives. Photo by author.

If the 4-second exposure is too dark, the lens should be stopped down to f/16 and the process repeated, exposing one-fourth of the paper for 4 seconds, one-fourth for 8 seconds, one-fourth for 12 seconds, and the last fourth for 16 seconds. If the 4-second exposure on the second test strip is still too dark at f/16, in all probability the negative is too thin, and the best solution is to throw it into the wastebasket.

If the 16-second exposure on the original test strip is too light, this means that either the negative is dense or your paper is a slow-speed variety that will require a much longer exposure. Take another test strip and expose one-fourth for 30 seconds, another fourth for 36 seconds, another for 42 seconds, and the last for 48 seconds. If the paper is still too light, this means that the negative is probably too dense to make a good print and should also be discarded.

These instructions are given primarily for the beginner who wants to become a good photographer. The professional may be able to save some of these problem negatives through using variable-contrast paper, reduction, or intensification of negatives.

An intensifier builds up the red coating on the film and will make a thin or underdeveloped negative print more nearly like a normal one. The process requires some experience and judgment and is not recommended for the beginning photographer, but one who has had some experience in enlarging, developing, and printing.

Instructions for use of the intensifier come with the dry powdered chemical. The photographer should always use rubber gloves with either intensifier or reducer, since these chemicals are poisonous and the gloves prevent absorption through the skin.

If a negative is over-intensified, this can be corrected by placing it in the hypo and removing the chemical from it. Negatives that have been intensified should be thoroughly washed and placed in the wetting solution just before being hung to dry.

There are several intensifiers, some including a bleaching and redeveloping process, but the Victor brand is far superior to any other and will give much better results. There are also several types of reducers on the market, the most commonly known being Farmer's Reducer, which is a mixture of potassium ferricyanide and hypo. The two solutions should not be mixed until immediately before the negative is placed in them, since once they are mixed they will oxidize within 15 minutes.

Farmer's Reducer will reduce some of the silver in dense negatives and make them easier to print. It will not reduce the contrast, however, and as with most remedies for improperly exposed or developed negatives, will not make a bad negative good but may help the photographer get a better print from what would otherwise have been an unprintable or very poor negative. Farmer's Reducer is sold in all camera stores. (Do not try to use reducer until you have had enough photographic experience to make good negatives and are able to tell a good negative from a poor one.)

Three good paper developers are GAF's Vividol, Edwal's Platinum, and Kodak's Dektol. Because any good paper developer will work with another brand of paper, it is not necessary to use developer and paper of the same brand. One brand of paper developed in a different make of paper developer will, however, result in a difference in the contrast of the paper. A No. 2 paper, for instance, developed in the same maker's paper developer will be a No. 2, whereas developed in another paper developer, it may be a No. 2½ or No. 1½ grade. Some photographers, particularly before the advent of variable-contrast paper, used this method to get in-between grades of paper.

Enlarging papers come in grades numbered from one through four and with some exceptions, five or six. The beginner should stay with a

No. 2 or No. 3 grade paper; otherwise, he may become confused with so many grades and the varying results obtained.

The difference in paper grades relates to the gray scale, with No. 1 paper having the longest gradation on the scale and No. 4 paper at the other end having a much shorter gradation on the gray scale. Contrasty negatives are printed on No. 1 paper, and thin negatives, or those that lack contrast, are printed on No. 4 paper.

If the beginner will shoot his negatives so that they will print on either No. 2 or No. 3 paper, he will advance more rapidly and will find, after a period of time, that he will be able to salvage some of his improperly exposed or improperly developed negatives by varying his techniques.

Experience and judgment are required to determine whether a print will look better on a No. 2 or No. 3 paper. For the beginner, it is best to make one print on No. 2 paper and one on No. 3 paper and compare the two to see which is better. This will require making test strips for each grade of paper, because there is a difference in the exposure time for the various grades of paper. The No. 3 paper will have to be exposed longer than the No. 2 paper, in most cases.

Some photographers prefer to use a multiple-contrast paper, such as GAF VeeCee, because there is also a factor of being able to develop it for only 75 seconds, rather than for the normal 90 seconds or for 2 full minutes instead of the 1½ minutes called for by the paper developer instructions. Some photographers try to hurry their work by omitting the test strips and judging exposure by eye, stopping the lens down to what appears to be the proper opening and pulling the print out of the developer when they think it has been developed enough, even if it has only been in the developer for 60 seconds. This is a very haphazard approach to photography and can only result in wasted paper and time and at best, the production of mediocre prints.

Some photographers are able to make good prints without test strips because they shoot so many rolls or sheets of film every day that their negatives are more or less consistent, and they can tell from their negatives just about the proper exposure time. Yet even this photographer will waste much time and paper trying to make a few prints when he has a bad day.

Certain types of meters and other devices calculate the exposure. These are particularly valuable to the professional doing a considerable amount of work, since taking a reading on the negative and having the machine compute the exact time eliminates having to make the time-consuming test strips.

Many photographers use variable-contrast projection paper, since it is possible to get a number of grades, from one to four, in one box of paper. There are four main brands used in the United States—GAF Vee-Cee, DuPont Varigam, Ilford Multigrade, and Kodak Polycontrast. Ilford filters and papers are tailored for one another and work in a slightly dif-

ferent manner from other variable-contrast papers. DuPont and Kodak filters will work with DuPont, Kodak, or GAF paper.

DuPont's Varigam was the original multiple-contrast paper and at first used a set of ten filters, the yellow filters giving a soft contrast and the blue and magenta filters giving a hard contrast. A new set of five Varigam filters has been rated superior to any other, because the set offers a greater contrast range, for the first time making a true No. 4 print from variable-contrast paper. Heretofore, the hardest contrast, although called a No. 4 paper, was more nearly a No. 3½.

One of the best combinations is DuPont filters with GAF VeeCee paper, because this gives perhaps greater print control than any other filter-paper combination. VeeCee has the quality of being able to vary the grade by the development as well as by the use of the filter. This, of course, requires considerable skill and experience and will probably only confuse the novice if he depends upon this procedure for most of his printing.

Ilford makes sets of filters for both the condenser and cold light enlargers, and it is possible to get greater contrast with Ilford filters than with any other brand, by using both sets of filters in a condenser enlarger. Ilford papers can also be manipulated for more control by increasing or decreasing the standard 90-second developing time. Varigam and Polycontrast papers tend to resist such maneuvers and should be developed for exactly 90 seconds.

It is possible to use almost all variable-contrast papers except Ilford without a filter and get about a No. 2 grade. Ilford requires a filter to get a No. 2 grade, because the soft contrast is obtained without a filter. There are seven filters in Kodak's set, and Ilford has two sets of five filters each, one for cold light enlargers and one for condenser enlargers.

The use of variable-contrast paper will enable the photographer to make better prints than he could in any other way. For example, in a negative taken in both shade and bright sunlight, it would be possible to print the contrasty part taken in bright sunlight with a No. 1 filter, and that taken in shadow with a No. 4 filter, balancing the two extreme contrasts more easily than could be accomplished by any other photographic process.

Any standard paper developer will work with variable-contrast paper, such as GAF's Vividol, Edwal's Platinum, and Kodak's Dektol, which are good cold-tone paper developers. These firms also make warm-tone paper developers for portrait papers.

So many variables may affect making a good print in the darkroom that it is almost impossible to mention them all. Wires, bottles, or other such objects sometimes reflect stray light into the enlarging area; the enlarger itself may leak light and fog the paper or be otherwise distracting. One of the problems I have found in working with students is that they have a tendency to bump against the enlarger or the bench upon which it

rests, thus setting up a vibration, which may give what appears to be a slight fuzziness to the print. For this reason, it is of the utmost importance to have, if possible, a bench that is fastened securely to the wall and an enlarger and darkroom floor that do not vibrate easily. Otherwise, it is quite possible to have problems getting good, sharp prints.

DEVELOPING THE PRINT

There are several steps in developing a print. These follow almost the same sequence as those for developing film, except that the time is different and the temperature of the paper developer is not so critical. Ideally, the paper developer should be maintained at 68° F. for best results, but temperatures higher or lower than this will work almost as well.

The first solution is a paper developer, the second is a short stop, and the third is the hypo, commonly called the fixing solution. Most cold-tone paper developers that are made from a stock solution, such as Vividol or Dektol, are diluted with two parts water to make the developing solution. In an 8" × 10" tray, a 32-ounce solution should be sufficient for several prints. Platinum is poured from the manufacturer's bottle and is more highly concentrated, requiring a higher dilution. Read the manufacturer's instructions on how to dilute.

The short stop is mixed one ounce of 28% acetic acid to 32 ounces of water. In mixing acid with water, it is always best to pour the acid into the water. With some acids, if the water is poured into the acid an explosion, or at least a violent reaction, can occur and injure the person mixing the solution. Weak acetic acid is of the vinegar family, however, and requires only a common amount of precaution. Full-strength acetic acid needs more care in handling, however.

Hypos are sold both in powdered form in a can and in a liquid stock solution. Most press photographers use a rapid fix, a hypo that will fix both film and paper in three to four minutes. Regular hypo may take 10 to 15 minutes to fix both, depending upon whether single- or double-weight paper is used.

Some photographers, in order to be sure their hypo is still good, buy a hypo check solution, which tests the hypo for exhaustion. Two brands are Braun Labs' Wash Test and Edwal's Hypo-Chek.

If a print or negative is left in fresh hypo too long, a bleaching action will occur, so it is advisable to fix no more than three minutes in fresh hypo, with a certain amount of agitation during the fixing time.

After the print has been in the hypo a sufficient amount of time to fix it thoroughly, it should then be washed either for 30 minutes if it is a single-weight print, or for one hour if double-weight. Instead of washing for this length of time, a hypo-neutralizing agent, which may be purchased under a number of brand names including GAF, Edwal, and

Kodak, may be used. The neutralizing agent should be mixed according to directions on the package or bottle. It will usually cut the washing time of a print to about one-third.

After the print has been thoroughly washed, it is dried face down either on the ferrotype tin or the ferrotype tin of a dryer, after having been soaked for 90 seconds in a wetting agent solution (one of the best-known brands is Kodak's Photoflo). As much water as possible should be squeezed out by rolling or squeegeeing on the back of the print. When the print finally dries, it will pop off the tin. Do not try to pull the print off before that time, since this may cause it to tear, crack, or acquire spots or some other distracting marks on the glossy surface.

With a dryer, a print on the ferrotype tin will usually dry in about 15 or 20 minutes. Without a dryer, it may take several hours for the print to pop off, depending upon the humidity and temperature of the room.

Matte-surface prints are never put face down on the ferrotype tins but are placed either in blotter rolls after all the water has been wiped off or on a dryer face up. If the matte paper print is put face down on a ferrotype tin, it will become shiny in some places and matte finished in others and will not look right.

Most hypos either have a hardener mixed in or one that can be added. Where the climate is warm, using a hardener is particularly advisable. If prints are to be toned, however, no hardener is normally added. The hardener protects the gelatin surface from scratches and other such blemishes.

Toning

There are a number of toners, such as sepia, blue, gold, and so forth. Some work in the regular paper developing agent, or the print can be brought right out of a hypo bath and put in a hypo toner. One of the most popular toners is the selenium toner, which is used on portrait paper to give a warm brown tone. To obtain this tone, it is necessary to use a portrait paper and a portrait developer, such as GAF's Ardol or Kodak's Selectol.

Prints to be toned should have all hypo removed from them. Most photographers wash prints an extra time to be sure no hypo is left in them. One reason that portrait photographers do a considerable amount of brown-toning is that brown-tone photographs are best for the hand-coloring artist to color with oil. The brown tone, in combination with the flesh oil colors, produces a picture difficult to distinguish from one made on color paper unless it is examined closely.

Most toning is accomplished by putting a finished, thoroughly washed black-and-white print in the toner and agitating until the desired tone is reached. This may take 5 to 15 minutes, after which the print is washed for about the same length of time required to wash a print taken from the hypo.

Fig. 4-8. "An Amish Coyote Hunt, Well, Almost" by James Johnson won first place in the portrait/personality class, 1967 Pictures of the Year, National Press Photographers Association competition. The picture was dodged under the enlarger to bring out the hunter's facial features and the folds in his jacket. Courtesy of the *Wichita* (Kan.) *Eagle & Beacon.*

Many effects can be achieved with toning. A blue-toned picture has a moonlight effect; with skill and the use of an artist's frisket, different parts of the photograph can be toned different colors.

Press photographers will probably do very little toning, except for display pictures or to obtain some unusual effect, such as in a mural, in a photograph not to be reproduced in the paper.

Cold-tone papers, such as those used for press photography, developed in regular cold-tone developers, will not tone as easily as do portrait papers developed in a portrait developer.

IMPROVING PRINTS

Small scratches on film can sometimes be eliminated by smearing the negative with a small amount of vaseline. Even using a wet negative tends to eliminate scratches. Some wet negative carriers sandwich the negative between two pieces of glass. There are also commercial dust and scratch removers, which provide a coating that goes on the film. All oil or vaseline coatings should be wiped off with a cotton swab before the negative is returned to the file.

There are a number of ways in which prints can be improved by dodging, or holding back. Devices for this purpose can be purchased, but most photographers usually make their own from a piece of coathanger wire and variously shaped pieces of cardboard to hold back heads or other important parts of the picture. Holes of various shapes can be cut

Fig. 4-9. Making an excellent agricultural shot requires proper lighting, a good angle, and some manipulation in the darkroom. In this photo, the sky was burnt in (given added exposure) to add tonal value, and the light on the subject's face was dodged (held back) to make it appear lighter than normal in a deep shadow. Courtesy of Campbell Soup Co., Camden, N.J.

in a large piece of cardboard, and places that have received too much light in comparison with the rest of the picture can be given two or three times additional exposure under the enlarger while the rest of the print is held back.

Using these devices takes skill, of course, and only through experimentation and watching other photographers work can one really learn to do a good job of dodging or burning in an area. Some photographers like to use the vignetter, which can be made by cutting out a saw-toothed oval in a large piece of cardboard and exposing the negative through this oval while moving the latter up and down rapidly so that the edges are feathered.

Another device is an oval on a piece of wire to hold back the center of the picture while burning in all the corners to darken them or unwanted areas. Because of all the different controls and manipulations that are possible, it is important that the press photographer have as much experience in darkroom work as he can in order to become a better photographer.

KEEPING SOLUTIONS FRESH

A help to the beginner is Edwal's Signal Short Stop, which turns purple when the solution is exhausted. Short stop and paper developer should be mixed fresh each time the photographer starts to work and also when running through a large number of prints, no matter how much or how little time has passed. These solutions are easily contaminated, and developer in an open tray should be mixed fresh if it has been sitting for more than four or five hours.

Hypo can be used until it takes too long to fix prints or clear the milky backing from negatives. There are on the market a number of hypo checks, or solutions that tell whether a hypo is exhausted. It is better to have fresh chemicals and to know that the solutions are fresh than to take a chance on those that are old or may be contaminated. This is particularly important when there are several people working in a darkroom.

SUMMARY

Precision enlargers enable the photographer to do a variety of work, and often save time in the darkroom. It is better to buy a good-quality enlarger than a cheap one, and it is best to buy an enlarger that handles the largest negative size the photographer shoots.

Most press photographers use the condenser enlarger, although there are two other types—the diffusion enlarger and the cold light enlarger. The latter two are more suitable for use in portraiture.

Most newspapers use coarse engraving screens, but magazines use finer engraving screens. The coarser the engraving screen, the more contrast is required in the print to get acceptable reproduction.

The trend in newspapers is toward offset printing, which normally gives better halftone reproduction than the letterpress method. The latter is used most frequently by large metropolitan dailies.

The press photographer should buy the best-quality color-corrected enlarging lens that he can. Camera lenses are not usually satisfactory for enlarging lenses, because they are designed for a different purpose.

Darkrooms can be built almost anywhere—in a closet, in a bathroom, or even in a trailer. It is desirable to have running water and electricity in the darkroom. Some of the tools and devices necessary for efficient darkroom work are a timer, safelight, easel, print tongs, and developing trays. A set of filters is required when the photographer uses variable-contrast developing paper. Paper cutters and print dryers are also handy.

The stabilization process is fast, but it also has certain disadvantages.

Printing from wet negatives, employing fast film developers, and fast drying are methods often used by the press photographer to rush pictures of late-breaking news into the newspaper.

Darkrooms should be ventilated so as to provide a continuous flow of fresh air. Separate areas for wet and dry stages are desirable.

Sophisticated darkrooms often provide temperature-controlled sinks, especially for color processing. The list of darkroom accessories is almost endless.

The test strip is the simplest and best way of getting a perfect print from any negative. It should be developed for 90 seconds, with the exception that portrait paper is developed for two minutes.

An intensifier will often make an underdeveloped negative more printable. At the opposite end is a reducer, which reduces a thick negative and makes it easier to print.

Photographic paper does not necessarily have to be developed in the same brand of developing chemical, but the contrast of the paper may vary when different makes of developer are used.

Photographic paper comes in six grades, with No. 2 and No. 3 grade papers being most common and most satisfactory for the beginning press photographer.

Variable-contrast paper changes its contrast under the enlarger through the use of filters. Some variable-contrast papers can be varied by lengthening or shortening the standard 90-second developing time; others cannot.

The sequence for developing a print follows somewhat that of developing film—developer, short stop, hypo, hypo-eliminator, washing, drying. For glossy prints, a special bath at the end of the process may be used to give a higher gloss.

Toning is a process that changes the color of the black-and-white print. It is not normally used in the press photography process.

Negative carriers come in various sizes and may be either of two types—glass or glassless.

Some enlargers are called *autofocus*, because they have a cam that keeps the enlarger in constant focus.

QUESTIONS

1. Why is a good enlarger a prime consideration?
2. What should a quality 2¼″ × 2¼″ enlarger cost? a 4″ × 5″?
3. What size of enlarger should a beginning press photographer buy?
4. What are the three basic types of enlarger? How do they differ in use?
5. What type of engraving screen is used by newspapers? by magazines or Sunday supplements?
6. Why should a photographer buy a critical enlarging lens?
7. Where can a darkroom be constructed?
8. Name some of the accessories needed to equip a darkroom for developing and printing.
9. Describe how you would develop a print using the test strip method; give the complete development cycle from exposing the paper under the enlarger to producing the finished dry photograph.
10. What is a stabilization processer? State some of its advantages and disadvantages.
11. What is: (a) a dry-mounting press? (b) a static brush?
12. What color should a darkroom be painted?
13. How can you test a safelight?
14. What is an easel?
15. What is the difference between an intensifier and a reducer?
16. Explain the difference between multiple-contrast paper and regular enlarging paper.
17. Why should the enlarger be fastened down securely?
18. What is meant by toning?
19. What is the purpose of the negative carrier?
20. What is dodging?

Exposure, Light Meters, and Filters

ONE SUMMER AFTERNOON two young ladies were talking about going swimming in the Gulf of Mexico. One who had just arrived from an inland city asked the other, "What type of suit is best for salt water? I brought a one-piece and a two-piece suit."

Smiling, her friend replied, "It really doesn't make any difference; whichever one is more comfortable and will allow you the greatest freedom of movement while swimming is best."

EXPOSURE

Getting the right exposure is a similar problem. The right exposure is the one that allows the photographer to make a good print with the greatest ease. In black-and-white photography, this may vary greatly with the photographer, because no two in a group may be striving for the same effect, even though all might be using exactly the same film and developer. Part of this difference is due to the individual techniques of the photographer and part, to the difference in cameras and the wide latitude of black-and-white materials. This variance is often smaller in color photography because color materials do not have such a wide latitude and cannot be manipulated as easily.

How, then, can the beginning press photographer get a good negative every time he is sent out on an assignment? First, he tests until he gets a perfect negative that will print on No. 2 enlarging paper (see nine-ring-around test, Chapter 3). Once this negative is obtained, all exposures, developing times, and other calculations are based on using one

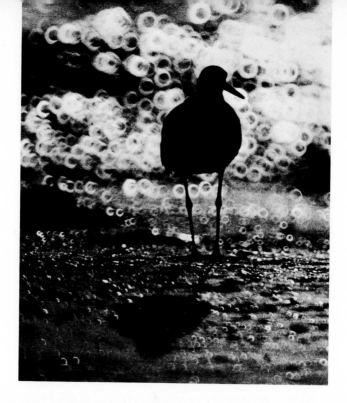

Fig. 5-1. "Ring-A-Ding" by Ricardo Ferro won a second place pictorial award in a Florida newsphoto contest. The donut effect was caused by a 500mm mirror lens on a Nikon F. Just the right placement of the gull was required for the backlighting to give the silhouette effect. Courtesy of the *St. Petersburg* (Fla.) *Times.*

film, one film developer, one developing temperature, and, if possible, one camera set on the same shutter speed, 1/100 sec. or 1/125 sec.

With these factors constant, there are only two variables, as previously mentioned—the correct aperture for the amount of light falling on the subject and the correct focus. With the camera focused, either by using the groundglass on a press camera or looking through a rangefinder when there is no time to use the former method, the photographer has only to make three exposures to be sure of getting a perfect black-and-white negative—one at the normal exposure, one two stops under, and one two stops over. All calculations are based on an average subject taken in normal sunlight, on which the nine-ring-around negative test was made. Positive color films allow only half-stop bracketing each way, but negative color films allow up to one stop each way and in some cases more.

Once the correct exposure is known for an average subject in bright sunlight, other exposures can be computed with ease. If the subject is sidelit, open up one stop for the normal exposure; if backlit, open up two stops. If the subject is near the water on a bright sandy beach, close down one stop for the normal exposure. If the subject is close to the camera, open up one stop. If the day is cloudy-bright with no shadows, open up

two stops; for heavy overcast, open up three stops. On a normal bright or hazy day, open up 3½ stops for normal exposure when the subject is in open shade.

Subjects that are bright, such as a bride in her wedding gown, or subjects that are dark, such as a ruddy-complexioned person dressed in dark clothes, will require different exposures even though all other factors, such as lighting, film, and so forth, are the same. The sooner a beginning photographer learns to take these factors into consideration, the sooner he will become a professional photographer.

Most press photographers learn through experience how to expose a film under a variety of common lighting situations, even in dimly lit interiors. This is a desirable accomplishment, one that the photographer should acquire as soon as possible through testing and experimentation.

Another secret of mastering the technique of getting a perfect negative every time is to record each exposure as it is made, telling what the subject was, the lighting used, and any other important factors. A small notebook that will fit into a shirt pocket, purse, or camera bag will provide means for recording this important information. Many times I have

Fig. 5-2. Taken in the soft light of a cloudy day, this shot of a small boy in a pile of corn illustrates how what otherwise might be a disturbing background can emphasize the subject by making him the center of interest. Courtesy of the *Daily Star*, Hammond, La.

Fig. 5-3. Photographed by Dave Swan to illustrate the end of a long dry spell, this is an excellent example of having just the right exposure for shooting through raindrops falling on a windowpane. Courtesy of the Bend (Ore.) *Bulletin*.

asked a student what his exposure was and received the same answer, "I don't remember, but I think it was" There is only one way to be sure and that is to be methodical, recording every exposure. By keeping an accurate record of each exposure, the photographer can soon tell why one of his pictures did not come out or why his negative was too dense.

The effective approach to making good photographs is not with a haphazard manner but by the scientific method. The beginning press photographer who does not keep a record of his exposures only handicaps himself. After he becomes an experienced professional, he may dispense with the chore if he wishes, but the photographer who keeps accurate records of each exposure is the one who can determine his mistakes and correct them more readily.

One factor the photographer may be unable to predict is the idiosyncrasies of the actual equipment being used. Even though the shutter speed may be marked 1/125 sec., there are differences in the shutters used on various makes of cameras and within the same make. One camera

marked 1/125 sec. may be exposing film at 1/100 sec. or 1/135 sec. instead of the indicated time. Shutter speeds on the better-grade cameras will not usually vary as much as on the inexpensive ones; part of the price one pays for the more expensive cameras is the cost of testing the lens, shutter, and general mechanism by the manufacturer's quality-control experts.

The focal lengths of lenses may also vary. It is quite possible to buy a lens marked 50mm and learn later that it is really 52mm, but usually this makes no difference. And even a new camera may have something wrong with it; the shutter may have become rusty, the lens may be covered with dust or mildew from dampness, or the camera may be internally damaged in shipment. All new and used equipment should be examined thoroughly and adequate tests made before it is used on a critical job.

Cameras, films, papers, and chemicals all need to be tested if they have not been used recently or if they are new to the photographer. Hot or cold weather can make a great difference in results. If a shutter is worn or dirty, it may become sluggish in cold weather. Professional photographers normally use more than one camera when photographing subjects in extremely cold weather, always keeping one camera warm with body heat or some other means and changing cameras frequently so that one camera does not get too cold and become inoperative.

STORAGE

Because color film and paper are more subject to temperature changes, unused and unopened color materials are usually stored in the frozen food compartment of a refrigerator until ready to be opened and used by the photographer.[1] Color materials that are to be used within a week or two may be stored in the regular part of the refrigerator instead of the freezer. All film stored in the freezer should be transferred to the outer compartment for at least a day before being used and then removed from the refrigerator, still sealed, three to four hours preceding use, to prevent condensation on the film or paper. Unsealed packages should not be stored in the freezing compartment but in the regular compartment.

Color film is stored in this manner because the colors are subject to shift when stored at warmer temperatures. The colder and drier color materials are kept, the less chance there is for the colors to shift.

Black-and-white film that will not be used for two or three months should also be stored in the freezer compartment; otherwise, storage in the regular compartment is sufficient.

[1]Professional photographers usually buy color film and paper in quantity so as to have them all of the same batch number. Different batches will usually have slightly different characteristics, and professionals test each batch before use to determine those characteristics.

It is important that cameras and film not be stored in the glove compartment or trunk of a car where they will be subject to heat. Most film comes with a sealed wrapper, commonly called *tropical pack,* to prevent mildew and high humidity from deteriorating the unexposed film in the tropics. Some photographers keep their film in a small cooler or other insulated unit while travelling during hot weather. Some of these units run by electricity and others are cooled by ice, as one would refrigerate food.

EXPOSURE METERS

Many photographers start with the use of an exposure meter, which is a device for measuring either incident or reflected light.[2] The incident light meter is not used nearly as much as the reflected light meter, because most correct exposures are determined by the amount of light being reflected off the subject or scene being photographed. The incident light meter measures the amount of light falling on the subject. Portrait photographers sometimes use incident light meters in balancing the amount of light falling upon the subject in the studio.

The reflected type of light meter contains a photoelectric cell. When struck by light, this cell releases an electrical current that moves the meter indicator up on a calibrated scale. The stronger the light reflected, the more current is sent through the wire to the meter and the higher the

Fig. 5-4. The Gossen Luna-Pro is a very sensitive light meter with CdS batteries and with attachments that can convert it to a variable-angle spot meter, an enlarging meter, or a photomicrography meter. Courtesy of Berkey Marketing Companies, Inc.

[2]There are a number of printed exposure guides and photo computers as well. The pocket-size *Kodak Masterguide* is an especially good buy, but none of these will replace a good light meter.

indicator goes. By reading this scale for a specific ASA film speed, the photographer is able to select a number of shutter speed–aperture combinations that will supposedly give the right exposure for the light being reflected from the subject.

Some meters are activated merely by the light falling on the photoelectric cell. Those measuring very low levels of light take the light falling on the cell and use a current from a small dry cell battery to run the meter. These are commonly called *CdS (cadmium sulfide cell) meters*. By the use of a battery, it is possible to make light readings in very dim light. Some of the more sensitive meters almost seem to be able to make a reading in the dark.

CdS meters are very popular now as built-in features of 35mm cameras and are used with other sizes as well, in some cases. Some of these meters are merely built-in light meters such as you would hold in your hand. Some are cross-coupled to the shutter speed or aperture or both, yet take their readings outside the lens area. The recent trend in cameras with built-in light meters, particularly in the 35mm single-lens reflex group, is a meter that will read through the lens, enabling the photographer to use any number of interchangeable lenses and still take the reading through the lens.[3]

Some of these meters are also called *spot meters,* in that they read only a very small portion of the area being photographed. Spot meters are particularly valuable in shooting scenes with a long telephoto lens, when the photographer cannot easily walk up to the subject and take a direct reading off the subject.

One problem with the battery-operated meter is that it needs a replacement battery about once a year. There is usually a button on the meter for testing the battery. I ran into another problem with these meters when one electronics firm sold me a replacement battery that appeared to be a duplicate of the original battery but was not and caused the light meter to read inaccurately.

For most purposes, a good non-battery-operated reflected light meter will serve the needs of the beginning press photographer. Some of these meters have a booster cell, a device for reading in low light; they can handle about 99 per cent of the jobs the press photographer is assigned.

One important factor to consider in purchasing or using a light meter that either attaches to or is built into a camera is the angle of view. The more critical (and more expensive) meters usually have a narrow angle of view. These are the spot meters mentioned above, so called because they make it possible for the photographer to stand some distance away

[3]One interesting 35mm single-lens reflex camera with a built-in meter is the Canon Pellix model, which has a non-moving pellicle mirror instead of a quick return mirror such as most other single-lens reflexes have.

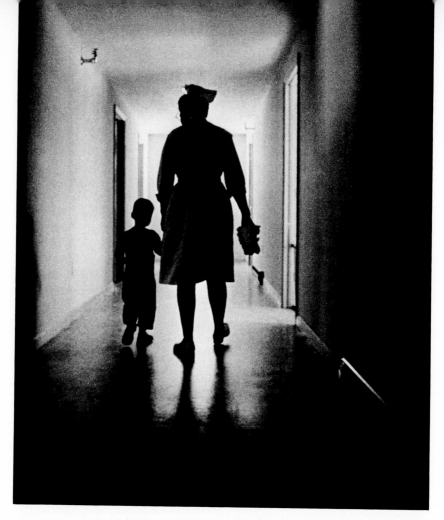

Fig. 5-5. Eugene D. Trudeau won honorable mention in the 1969 New England Press Association contest with this backlit, available light photo used to illustrate a story on a nursery for retarded children. He uses a Honeywell spot meter with a Gossen pilot meter as a back-up when he measures his exposure. Courtesy of the *Lakeville* (Conn.) *Journal.*

from his subject and take a reading of either the side of the face in the shadow or the highlight in the sun. For the experienced photographer, these meters can be valuable tools. For the novice, it is a waste of money to use one until he is ready for it, because if such a meter is not properly used, it may cause the exposure to be off several f/stops.

The general meter, such as the non-battery-operated type or the CdS model, which reads the overall scene, will be sufficient for the beginning press photographer, because he needs only to walk up closer to his subject to get a reading similar to one he would get with a $50 or $100 spot meter.

The most important thing to remember is that the light meter gives only an average reading. If held toward the sky, it may read light that will cause the meter to read too high. For this reason, readings taken outdoors are generally made with the meter tilted slightly downward in order to exclude the light of the sky.

Most photographers take a reading of the highest highlight on the subject and then the lowest shadow area that they wish to expose and shoot their exposure somewhere between these points. In the case of a distant subject, a meter reading may be taken of an object close at hand. Where the model is across a moat, for instance, or inaccessible for a close-up reading for some other reason, the reading may be made off the back of the photographer's hand. This is particularly important for making the right exposure for skin tones on color film.

As the beginning photographer becomes more experienced, he will find that the D log E (or H & D) curve[4] for a particular film will enable him to calculate his exposures for critical subjects with more accuracy when using a light meter. The curve is greatly affected by differences in developing times. A knowledge of how the curve works for a particular film will allow the photographer to lengthen or shorten developing times in order to make perfect color separation negatives or to increase or decrease contrasts of flat or harshly lit scenes. The Photo Lab Index will give these curve charts, or the information can be obtained from the film manufacturer.

FILTERS

Because white light includes all the colors of refracted light coming from Isaac Newton's prism, the sensitivity of any film can be altered by placing a dyed glass or gelatin filter in front of the camera lens. View and press cameras that have interchangeable lens boards will also accept filters behind the lens. Professionals prefer this placement, if possible, because there is less chance for distortion of the image by the filter and it is easier to keep the filter clean when it is behind the lens. Some cameras, such as the subminiature Minox, have built-in filters that can be moved into place merely by tripping a lever.

Filters come in the form of inexpensive gelatin sheets, glass-mounted gelatin, and dyed optical glass. An optical glass filter will stand more abuse than a plain gelatin filter and is not subject to separating, as sometimes happens with filters cemented between two pieces of glass. The best glass or glass-mounted filters are also coated. Filters are made in two shapes—round and square.

[4]Named H & D for Ferdinand Hurter, a Swiss chemist, and Vero Charles Driffield, an English chemist, who developed a system for measuring the characteristics of photographic emulsions.

There are three basic ways of mounting a filter to a lens: (1) a screw mount, which is used on most 35mm cameras; (2) a bayonet mount, used on single- and twin-lens 120-film size reflexes; and (3) a filter holder, which may have either a screw mount or a bayonet mount or may simply slip over the lens. Filter holders give more versatility to filters, in that more than one filter can be attached at one time, and filters of different sizes may be used on the same camera. This cuts down the cost of buying custom filters for each different camera.

There are even filters for enlargers, usually of the gelatin sheet type, because of the expense involved in buying large-size glass filters. Here again, the filter may be placed in front of the lens or somewhere behind it, such as in a special filter holder drawer found on more expensive enlargers. Professional photographers prefer to use filters behind the lens, if possible, because there is less chance for dirt or distortion in picture-taking when the filters are used in this way.

With one or two exceptions, filters for black-and-white photography are of a different type from those used in color work. Those used for black-and-white photography are used most often to make clouds appear whiter than they are or to give unusual artistic effects, such as making a daylight scene appear to have been taken in moonlight. This technique is

Fig. 5-6. A view of Ethiopia and Somali taken from the Gemini II spacecraft. Most aerial photos require some type of filter. If the photo is in color, a filter is used to color correct, cut haze, and in some cases, reduce reflections. If the photo is black and white, a filter is needed to cut the haze. Courtesy of NASA, Houston, Tex.

quite common in western movies, and a person accustomed to viewing such films can readily pick out the pseudo-moonlight scenes that were made in daytime.

Photographers use filters for a wide number of purposes. One, mentioned above, is to exaggerate contrasts. Other uses include: correcting the color sensitivity of the film to make the scene appear more nearly normal, as the eye sees it; changing the color temperature of color film (these are the CC, or color-compensating, filters); cutting down reflections of the sky or other objects with a polarizing filter; photographing under invisible light with infrared materials; and penetrating haze in both black-and-white and color photography.

Filter Factor

Almost all filters have what is called a *filter factor*, which varies with the type of film being used. The filter factor increases the exposure time anywhere from a half stop to six or seven stops, depending upon the density of the filter and the color sensitivity of the film. It is important, therefore, that the photographer make his own tests and read the information about filters furnished with each type of film. It would be impossible to give all the filter factors for the various films here. Films change from time to time, of course, and the information on filter factors should be current.

Which Filter to Use

A filter lets in light of its own color and tends to hold back the light of its complementary color or colors. In other words, a red filter, which is used to darken the sky in black-and-white film, would make a blue sky appear black on the finished print. Anything red, such as a red rose, would appear lighter.

If one keeps this fact in mind, it is easy to determine the effect of any color filter without too much confusion. A light yellow filter, known as K1 or K2, also tends to darken the sky in black-and-white film and is one of the most commonly used filters. Although not easy to find, there are some filters graded from yellow at the top to clear at the bottom. These filters improve the appearance of the sky, increase the contrast between sky and clouds, and equalize exposure between the sky and the balance of the scene. These filters require no correction in *f*/stop.

Closely related to the K-type yellow filter is the orange-yellow filter of the G series, which will give an over-correction of the sky in most outdoor scenes. I prefer this filter to the yellow filter when using black-and-white film.

A green filter is used for making foliage lighter and prevents the washed-out flesh tones associated with flash photography. This filter is of the X series.

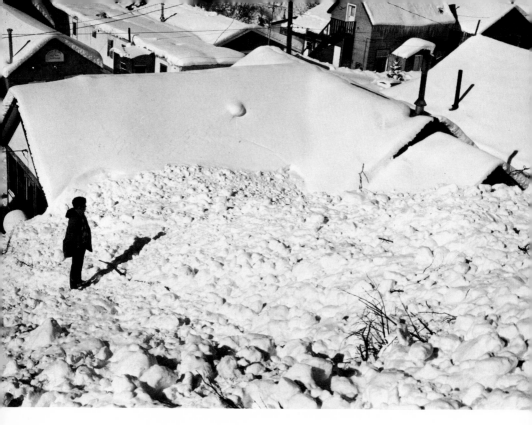

Fig. 5-7. This January, 1969, snowslide piled as much as ten feet of snow on houses in Red Cliff, Colo., and received national exposure. Photographer F. R. Bochatey used a Mamiya 23 press camera with a normal lens, Plus-X film, and a K2 filter to give contrast and tonal value to the snow. Courtesy of *The Herald Democrat*, Leadville, Colo.

A red filter, such as the A25 or the F29, is used to give the moonlight effects referred to above with infrared film. This filter with the infrared film will make the foliage on trees appear very light and will darken the blue sky. Green leaves of plants reproduce almost white in infrared photographs, because the chlorophyll in their leaves reflects the infrared light very strongly. (For other infrared effects, see Chapter 7 on night photography.)

These are the main filters used with black-and-white film. It is also possible to get a blue filter to make things that are blue appear lighter. This is particularly useful when trying to copy a photograph or other material on which there is a blue ink stain. (See Chapter 15 on copying photographs.)

Infrared film with an infrared filter will penetrate haze better than any other type of film-filter combination. Some haze penetration can be attained by using ordinary film with either a red or yellow filter, however. A polarizing filter will also penetrate haze slightly, but this filter is used

Fig. 5-8. This unusual shot framing a plane in the propellor blades as a mechanic works on the engine won Fred Comegys first place in the black-and-white category of the Army National Guard's nationwide contest in 1968. Taken with a 35mm camera, a 28mm lens, and a red filter. Courtesy of the *Wilmington* (Del.) *News-Journal.*

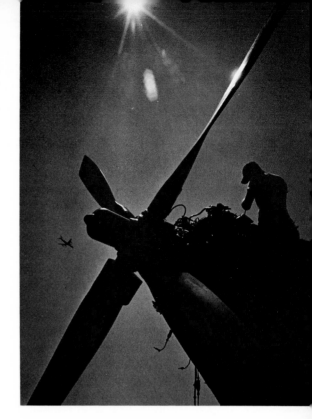

Fig. 5-9. This greenhouse was photographed on a day when there was ample light coming in through the windows, but on dark days artificial illumination may be required to get this exposure. A green filter will lighten dark green plant foliage. Courtesy of Campbell Soup Co., Camden, N.J.

to darken the sky and to cut out unwanted reflections, such as those on shop windows and other shiny surfaces. One reason the polarizing filter is so valuable in color photography is that it is colorless and does not change the color of light; this factor is not as important in black-and-white photography. (See Chapter 7 on night photography for other uses of this filter.)

In color photography, the ultraviolet rays from the sky tend to make some kinds of reversal color film bluer than it should be. Two different kinds of filters are used to correct this factor, which grows more pronounced the higher the elevation becomes. Above a 5,000-foot altitude, a UV16 or UV17 filter should be used with any positive color film. I have also found the general use of a UV filter at any altitude desirable in many photographic situations. On heavily overcast days, a UV17 filter will correct most color film to make the transparency appear as if it were taken on a sunny but shadowless day. A second blue-correcting filter is the skylight filter, which has a slight pinkish cast rather than the yellow cast of the UV filters. For this reason, I prefer the UV filter, but with some Kodak films the skylight filter will correct the ultraviolet light satisfactorily.

Professional photographers will argue pro and con on this point, but one must remember that manufacturers change their color films from time to time, and what is applicable in one instance may not apply in another. This all leads to a great amount of confusion about when to use a filter and when not to. Personally, in most cases I like the little extra warming effect I get from using a UV16 or UV17 GAF filter.

Light-balancing filters for color films are calibrated so as to convert one type of light to another. For instance, a person may have a light that is too blue, such as that from daylight in the open shade. One of the filters in the 82 series would be used to correct this blue light. If the light were too yellow, one of the filters in the 81 series would make the correction. Light-balancing filters are arranged so that an 81 filter gives a small amount of correction, and an 81D provides much greater correction. The further down the alphabet the letter is, the greater the color-correction will be.

One problem the photographer may have is trying to determine whether to use daylight film or tungsten film when making exposures under fluorescent light. This is a difficult problem, because most fluorescent lights have a color temperature somewhere between that of tungsten film and that of daylight color film. The daylight fluorescents, however, are nearer to daylight than are other fluorescent colors. One should make his own tests with the 81 series if he is using daylight film and the 82 series if using tungsten film. For more difficult lighting, CC filters may have to be used.

In some cases, there may be both daylight-type and white or warm bulbs all in the same room. This makes it extremely difficult to arrive at

any true color balance, as is also true when trying to mix tungsten light with daylight for color film.

Another set of filters called the *decamired* usually has eight in the group. With the combination of one or more filters, any color-correction can be made, as with the CC filters, whose use is explained below. The decamired filters are based on mired (abbreviation for microreciprocal degrees) values, with 5,000° K. (Kelvin) corresponding to 200 mireds, and 3,200° K., to about 313 mireds. In some ways, the decamired filters are easier to use than CC filters. Based on the mired system, the degree to which the filter raises or lowers a certain color temperature will depend upon two factors—the initial color temperature of the source and the depth of the filter. Filters that would lower the color temperature actually raise the mired value. There are special color meters that are calibrated to use the mired system. One advantage of this system is that it requires fewer filters than those used in the 81 and 82 series.

Color-compensating filters are used to change the color balance of transparencies and color negatives when used in an enlarger. These filters come in six different varieties: yellow, which absorbs blue; magenta, which absorbs green; cyan, which absorbs red; red, which absorbs blue and green; green, which absorbs blue and red; and blue, which absorbs red and green. The standard densities of the filters run from 5/1000 to 50/1000. These filters are used in a number of ways in various kinds of color printing and can be keyed to various types of color meters used in the darkroom. Also available are enlarger color heads, which have built-in lights with controls to change the color of the light to numerous CC filter combinations. Color-compensating filters can also be used over the camera lens for various color corrections, but their most common use is in the darkroom.

There are also filters for using tungsten film outdoors and for using daylight film indoors. Some photographers have much greater success at doing this than others. It is advisable, however, to use a film that is nearer the type of light that is on the scene.

Even though photographers claim that there is no need for filter correction when shooting color negative films under various lighting conditions, many photographers use a daylight conversion filter when shooting Kodacolor and Ektacolor outside. Usually an 85 filter is used over scenes shot outdoors under daylight conditions. The reason for using this filter, which will require an adjustment in the ASA rating, or a filter factor (read the instruction sheet for this) is that prints are thus easier to make in the darkroom.

Processors who process film for professional photographers sometimes become irritated when a professional photographer shoots a roll of color negative film under all sorts of lighting conditions, because it requires considerable skill and filtering to turn out normal prints. The reason most photographers do not try to correct color negative film is that they cannot

be bothered with filter corrections and they try to compensate in the darkroom or let the photo laboratory worry about that part of the operation.

Another type of filter used with both black-and-white and color film is the neutral-density filter, which reduces the effective intensity of light under bright lighting conditions, avoiding overexposure. However, this filter is seldom used with color film, since this film is not usually of the high-speed variety, and neutral-density filters may change the color balance of any color film slightly.

SUMMARY

Exposure

The right exposure is the one that allows the photographer to make a good print with the greatest ease. There is less latitude with color films than with black-and-white.

Bracketing exposures is the only sure way to get perfect negatives or transparencies.

When conditions deviate from normal, compensating adjustments in the aperture must be made.

A record of each exposure and its lighting conditions should be kept, in order that the photographer may determine any errors in either after the film is developed.

All new cameras, films, or processes should be adequately tested before being used on a critical assignment. The difference in cameras or lenses of identical type and make can produce varied results, because of the range of the manufacturer's tolerances or the condition of the equipment.

Both black-and-white and color film should be protected from heat and humidity, preferably stored under refrigeration if not used soon after purchase.

Light Meters

An exposure or light meter is a device for measuring light. When properly used, such a meter will enable the photographer to get the correct exposure under any type of condition.

Some cameras have exposure meters built-in, but most professionals prefer to use one or more separate exposure meters because of their greater light range and other advantages. Usually, the more critical in measurement and angle of view the exposure meter is, the more expensive the mechanism is.

Filters

The sensitivity of any film can be altered by placing a dyed glass or gelatin filter in front of the camera lens (or sometimes inside the camera, between the lens and the film).

Filters come in various sizes and in two shapes—round or square. They are mounted to cameras with several different types of mount. Filters used for black-and-white photography are not normally used for color photography. Black-and-white filters are used for a wide number of purposes, usually to exaggerate normal contrast, such as making the sky dark, lightening green foliage, or even photographing by invisible (infrared) light. Most black-and-white filters have a filter factor, which means that the exposure must be increased to compensate for the use of the filter.

The filter lets light of its own color pass through and tends to hold back the light of its complementary color.

In color photography, the main problem is color-correction, or changing the color of the light falling on an existing subject so that it balances with the color temperature (degrees Kelvin) of the film being used. One type of color filter, called a color-compensating filter, is used to correct the color balance of transparencies and color negatives when used under an enlarger.

Polarizing filters are special types of filters used to eliminate unwanted reflections and to penetrate haze. They are used in both black-and-white and color photography.

A second type of filter used with both black-and-white and color film is the neutral-density filter. Its main purpose is to cut the ASA exposure index of a fast film in order that it may be used under bright lighting conditions.

QUESTIONS

1. What is the right exposure?
2. Why may it vary from one photographer to another?
3. Is this variance the same in color photography? Explain.
4. Explain what is meant by bracketing.
5. Compare bracketing in black-and-white film with that in color.
6. Your subject is on a sandy ocean beach on a bright sunny day. What compensation would you make in your aperture over your normal bright sunny day exposure?
7. Why must a record be kept of each exposure?
8. Explain why two pieces of photographic equipment of the same make and model may not give identical results.
9. Explain the value of refrigerating film.
10. Explain the difference between an incident light meter and a reflected light meter.
11. What is meant by a spot meter?
12. How does a light meter work?
13. What is a CdS meter?
14. What are some of the advantages of the CdS meter?
15. Name some of the uses of filters with black-and-white films, color films, and enlargers.

16. What is meant by *filter factor?*

17. In color photography, how would you correct for a heavy concentration of ultraviolet light?

18. What is the purpose of: (a) a neutral-density filter? (b) a polarizing filter?

Flash Photography

WHEN I FIRST MOVED to Las Vegas, Nevada, I was asked by a local photographer to help an Associated Press photographer take pictures of the explosion of an atomic bomb, one morning just before daybreak.

I had never witnessed such an explosion before but had seen the light in the sky during some previous tests conducted at Frenchman's Flats. I had heard all kinds of stories about how eerie the light from the bomb was, and I was ready to expect anything. High up on a mountain top, I was waiting for the explosion with my camera mounted on a tripod

Fig. 6-1. "Baker Day at Bikini," July 25, 1946, depicts the first underwater explosion of the atomic bomb, photographed from special facilities on the ground at a nearby island. Courtesy of the U.S. Atomic Energy Commission.

and was, of course, very tense. Much to my surprise, when the explosion took place, instead of being eerie and mysterious, it looked to me like a huge photoflash bulb going off.

The light at the beginning of the explosion was very weak, building up rapidly to a brilliant sun that lit up everything and then receding just as rapidly from its brilliant peak. That was some flashbulb!

The firing of a common flashbulb, also, results in a controlled explosion. Starting with a surge of electric current, a tiny wire filament heats until it is white hot and then burns out. As this happens, it ignites the primer, a paste or a powder that burns very rapidly, at the rate of approximately 1/1000 sec. (scientifically known as a millisecond). As the primer burns, it starts the aluminum or zirconium wire or foil burning at a controlled rate. The intensity of the light increases to a brilliant peak and recedes very rapidly, the whole process taking about 30 milliseconds in most cases. All the flash-producing elements are sealed in an atmosphere of oxygen at a reduced pressure. Designs of different types of bulb vary, with some of the smaller ones using only an extra amount of paste for the light.

FLASH POWDER

Just as many press photographers today shoot photographs under the existing light, the original press photographers used whatever light was available, even when exposures were counted in minutes and all cameras had to be set on a tripod or other stationary object. That is, they did until flash powder was invented by Adolf Miethe and Johannes Gaedicke in Germany in 1887.

Before the two Germans' invention, a well-known Civil War photographer, Timothy H. O'Sullivan, had used magnesium flares, which burned for several seconds, while making some remarkable pictures several hundred feet underground in the Comstock Lode mines, Nevada City, Nevada, in 1867. However, the new German flash powder, a highly explosive mixture of powdered magnesium, potassium chlorate, and antimony sulfide, burned instantaneously.

Old-time press photographers talk about the sometimes comical but often serious accidents that occurred while using flash powder. It was highly explosive and difficult to control, and many photographers had their eyebrows singed or their hair burned when the powder went off unexpectedly. The explosion of the powder also produced a certain amount of smoke and was a fire hazard. After flash powder came into general use, it was banned in many public buildings.

In order to be transported safely, flash powder must be carried in two separate containers, one for the magnesium powder and another for the primer. The two powders are mixed by the photographer just before use and put into a small, oblong tray or trough having a handle by which

Fig. 6-2. This self portrait of Timothy O'Sullivan, 1840–1882, was taken from a stereograph made in 1870 in Panama on an expedition to survey and map the possibility of a ship canal across the Isthmus of Darien. O'Sullivan was the first photographer to use magnesium flares to take pictures inside mines hundreds of feet underground. Courtesy of the George Eastman House Collection.

the photographer holds it high above his head. Originally, the powder was fired by lighting a fuse paper with an open flame or spark; later a cap fired by a mechanism was used. Present-day flash powder units are fired by dry-cell batteries, which set off the magnesium.

Flash powder is seldom used by photographers in the United States, but it does have two advantages over other flash equipment: it can produce a large quantity of light, and it is less expensive than large flashbulbs. Although synchronization is possible, it is difficult, and exposures made with flash powder are usually time exposures. Besides the safety hazards, flash powder is not as reliable as flashbulbs. Photographers have turned to other sources of light for making photographs.

FLASHBULBS

In 1929, a new type of photoflash light was patented in Germany by Johannes Ostermeier. This new flashbulb, resembling a light bulb filled

with aluminum foil, was adopted quickly by press photographers everywhere, and particularly in the United States. Here was a noiseless, smokeless light-producer that could be carried anywhere. Fitted with a screw base, it could be fired with an ordinary flashlight using dry-cell batteries.

At first, the new bulbs had a certain number of misfires and sometimes exploded, throwing glass into the air. It was found that a lacquer coating similar to that used on flashbulbs today prevented the glass from shattering.[1] When colored blue, the lacquer also serves to give off light very nearly the color temperature of the sun in the middle of the day. Blue-colored bulbs are used most frequently with daylight, or outdoor, color films. Blue bulbs can also be used with black-and-white films, but the blue coating, although giving a whiter light than the clear bulbs, also cuts the intensity of the bulb to about one-half that of a clear bulb the same size in most cases. Clear bulbs, therefore, are generally used for black-and-white films and indoor, or tungsten, color films.

Flashbulbs come in various sizes, the larger bulbs being the same size as 15 (No. 11) to 150 watt (No. 50) household bulbs and the smallest, about as large as the first joint of the little finger. Almost 100 of the latter (AG-1) will fit into an empty cigarette package. Generally speaking, the larger the flashbulb, the greater the light output. Some miniature flashbulbs, however, produce nearly as much light as some medium-size bulbs. Much also depends upon the efficiency of the reflector.

A bright flash reflector will transmit almost twice as much light as a matte-finished reflector. The shape of the reflector is also more important than its size. I took a lot of ribbing just after World War II when I had a flashgun designed that held four D-size photoflash batteries, rather than the three-battery size that was so common then. On top of this overlong flashgun was a four-inch diameter, semi-flat, polished reflector, which was puny-looking compared with the six- and seven-inch reflectors most press photographers used at that time. However, when some of the photographers saw how evenly lit my flash photographs were, they began asking where such reflectors could be bought. My small reflector carried as much light as did their big ones and created no "hot spots" in the center of the negatives as did most reflectors.

The four-cell gun, of course, was used to fire two flashbulbs, one near the camera and the other on an extension flash unit as much as 30 feet away.

ELECTRONIC FLASH

A third type of flash unit, the electronic flash, was first used in photography by William Henry Fox-Talbot, a pioneer British photographer

[1]Even today's flashbulbs will explode under certain conditions. Once I had 10 bulbs out of a case of 100 explode, but fortunately the glass did not hit anyone. As a safety precaution, a plastic shield should be used to prevent injuries from exploding flashbulbs.

Fig. 6-3. Although light from the electric welding torch is so bright that the welder must wear a dark-glass mask, this picture has been greatly improved by the use of a single flashbulb. If the flash had not been used, the pipe would have photographed black, and there would have been little definition between it and the dark background. **Courtesy of Hobart Brothers Co., Troy, Ohio.**

and the inventor of the negative-positive process so widely used in photography today. In 1851, he obtained a patent for a high-speed electrical spark used as a photographic light source. To demonstrate his new electronic flash, Talbot made a photograph of a whirling newspaper page. The light stopped the action, and the finished photograph showed the printing unblurred.[2]

At this time, photographic exposures were long, because the sensitivity of photographic plates was slow. The common method then was to uncap the lens, count or otherwise time the exposure, and then recap the lens. There were no shutters or a need for them. The discovery of electronic flash at this time was accorded little importance. As with many inventions, Talbot was ahead of his time and reaped no material benefits from his electronic flash.

Not until 1931 did the public and the photographers become interested in electronic flash. Dr. Harold E. Edgerton and his associates at the

[2]Talbot also invented the photoglyphic engraving process using metal plates and resembling photogravure, invented by Carl Klic in 1895. The photoglyphic process was not well received by printers, because the engraving plates were not as high as the type and had to be printed separately from material set in type. Talbot also contributed another important photographic invention, that of photography on paper. But at the time of his inventions, photographers were more interested in Daguerreotypes because the Daguerreotype process produced much sharper pictures.

Massachusetts Institute of Technology designed a repeating electronic flash of extreme intensity and short duration. Edgerton's flash unit was a sealed tube covering a large area; Talbot's was an open spark covering a very small area. Edgerton's light was so fast (1/10,000 sec.) that hummingbirds' wings or a bullet could be stopped in flight.

The first units of the Edgerton design were bulky, heavy, and relatively expensive. Even the first portable battery-operated units sold to photographers weighed 16 pounds, as compared with some of today's compact electronic flash units, which weigh only a few ounces and may be as small as a pack of cigarettes.

THE BEST TYPE OF FLASH

There are advantages and disadvantages to both flashbulbs and electronic flash units. Most press photographers use electronic flash units because the cost per exposure is less than for flashbulbs, when one is taking several photographs daily. An electronic flash unit is good for thousands of flashes, needing only replacement of the dry-cell batteries occasionally or recharging the unit overnight, for those that have rechargeable wet or dry batteries.

Some electronic flash units work on either 110-volt alternating current (AC) or batteries. Others work only on one or the other. The large light output units used by professional photographers in studios operate on AC only. The press photographer normally employs either a unit powered by batteries only or a combination unit using both battery and AC. Electronic flash units suitable for press work may cost as little as $25 or as much as several hundred dollars. The more expensive the unit, generally speaking, the greater the light output and, of course, the heavier the

Fig. 6-4. An electronic flash fill cuts the normal shadows of bright sunlight in this photo of a ground-breaking ceremony, taken by Mel Kenyon. Twin-lens reflex Rolleiflex, f/16, 1/250 sec., Tri-X film. Courtesy of the Ft. Lauderdale (Fla.) *News*.

unit. A heavy-duty unit suitable for most press photography work costs from $100 to $300.

Most of today's electronic flashtubes have a light duration from 1/500 to 1/2000 sec. Such speeds stop most moving objects and provide sharp pictures.

Why doesn't everyone use electronic flash? For one reason, electronic flash units have a way of working improperly at the most crucial picture-taking times. Small units are inexpensive, but they do not put out much light compared with a flashbulb. Large units are fairly expensive and tiresome to carry; whereas a small folding fan flash can be carried in a woman's small purse or a man's shirt pocket with little trouble. Some electronic flash units can give a photographer a bad shock, particularly when wet.

The electronic flash unit consists of a power supply that feeds one or more electrical condensers, known as *capacitors*. The capacitors store up electricity until it is discharged between the two electrodes in the flashtube. With most AC-powered units, the time between flashes may be from 2 to 5 seconds; with battery-powered units, the time is much greater and may be as long as 15 or 20 seconds. Waiting for the capacitors to build up to full strength (indicated on most units by a red neon ready light) can make the photographer miss pictures if the action is fast. If the photographer fires his electronic flash unit before it is ready, his pictures will be underexposed, often resulting in negatives so thin that they are not printable.[3]

As wonderful as strobes are, many professional photographers carry a spare flash unit in case the main electronic unit breaks down.[4] When

Fig. 6-5. The Honeywell Strobonar Model 65-D electronic flash unit, mounted on a Pentax camera, uses a 510-volt battery. Fairly light weight, it has almost instant recovery because of the dry battery. This feature is very important since a photographer can lose a picture by having to wait too long for his flash unit to build up enough energy to fire again. Courtesy of Honeywell, Inc.

[3]"Thin" means lacking in density, whereas "thick" means having too great a density. Thin negatives are caused by underexposure, underdevelopment, or both. Thick negatives are caused by overexposure, overdevelopment, or both.
[4]Edgerton's electronic flash unit was called Stroboflash and was used to take multiple exposures on the same film negative. The name has been shortened to strobe and applies to any electronic flash unit in common usage today.

using electronic flash, I always carry a small flash unit and a supply of flashbulbs in case my electronic unit breaks down or the batteries run out of power. Carrying an extra set of fully charged batteries with each flash unit and testing batteries and flash equipment daily before use are extra safeguards that help prevent a photographer from missing pictures.

WHEN TO USE FLASHBULBS

When should a press photographer use flashbulbs? To begin with, small flash units for bulbs cost very little, from $4 to $12. Some of the better units take three different base sizes of bulbs—the large bayonet base (General Electric's No. 5 or Sylvania's No. 25 bulbs), the small bayonet base (the "M" series bulbs), and small glass bulbs that have only a flattened glass base with four bare wires extending from it (the AG-1 series). The better units usually provide for one or more of the following: (a) bounce flash; (b) plugging in extension flash units; (c) a flashbulb tester; (d) open flash; (e) guide number scales; and (f) a folding fan-type reflector, with adjustments for narrowing or spreading the angle of the light coming from the reflector.

For the person who takes flash pictures only occasionally, a flash unit using bulbs may be far cheaper than owning and maintaining an electronic flash unit. Most electronic units must be used fairly often in order to keep them functioning properly. The condenser of the unit needs to be charged and discharged occasionally, and those using wet-cell batteries require periodic attention in order to keep the batteries in condition. Replacing wet-cell batteries can cost from $15 to $20 or more.

Figs. 6-6a, b, and c. When shooting indoor sports, photographer John G. Kenney prefers to use a bare bulb because it does not burn up subjects when shooting in close. He holds the bare bulb flash just behind his head and slightly to one side to give the best artistic lighting. (a) Kenney's bare bulb flash gun is shown here attached to a 2¼″ × 2¼″ Rolleiflex with interchangeable reflector head.

(b and c) These basketball shots are examples of his bare bulb flash system. Both were taken at f/5.6, 1/250 sec., Tri-X film, with (b) at 10 feet and (c) at 15 feet from the subject. Courtesy of the *Chronicle-Telegram,* Elyria, Ohio.

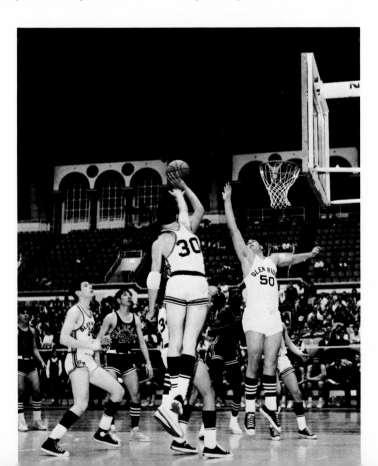

Most flashguns are light and can be carried with little effort; the large professional portable electronic units, however, are heavy and can be tiresome to carry over a period of time.

Flashbulbs put out a much greater quantity of light than do most electronic flash units. Placing the camera on a tripod and using open flash will allow a No. 5 bulb to cover a room 200 feet or 300 feet long. I have photographed 400 people sitting at banquet tables with two No. 5 bulbs in ordinary reflectors, with one of the flash units 30 feet from the other. This technique is also quite suitable for photographing large rooms in buildings.

The proper way to take such a large group as 400 people is to place the camera high (on a tripod), well above the subjects, using a wide-angle lens. With a No. 5 bulb, I usually set my f/stop at f/16 or f/22 for ASA 100 to 200 films and set the shutter on "Time." I stand as high as I can and get someone else, normally the tallest person I can find, to hold the extension gun. (Most people, even the president of a large corporation, will hold the flashgun if you ask them to in the right way. I have found very few who would refuse this request.)

With the cable release attached, in order not to jar the camera, I open the shutter, fire the flash on open flash, and then trip the shutter again to close it. If the camera does not have a "Time" but a "Bulb" setting, I keep the shutter open by pressing down on the release button, fire the flashbulb, and then release the shutter so that it closes. Altogether, this should not take more than three or four seconds with practice.

Getting a group to work with the photographer is easy; I just explain to everybody that I need their attention for a moment and ask them to stop. When I can see the subjects in the right position, I take the picture. In order to be sure of getting a negative free of movement, I take six exposures. Movement in the background will not detract from the picture, but too much movement in the foreground will ruin it, because of the large-size figures close to the camera.

One of the most important things a photographer can do to get better than average negatives with either a flashbulb unit or electronic flash is to use more than one flash unit for all pictures. I have heard photographers say this is not possible, because they do not have room or the equipment is too bulky. Usually, what they really mean is, "I don't want to bother with an extension unit."

Two units, one on the camera and one to the side and some distance from the camera, preferably higher than the main camera unit, will give a three-dimensional effect to flash pictures. Depending upon the distance of the units from the subject and the difference in intensity between them, one unit will be the main source of light and the other will act as a fill light, filling in the dark shadows that are so common in one-light pictures taken by press photographers who lack training in professional tech-

niques. Even the camera light will give more pleasing photographs if removed and held high and to the side opposite the extension flash.

EXTENSION FLASH

A number of units, both electronic flash and flashbulbs, can be operated by a photoelectric cell. With these it is possible to have a number of auxiliary flash units fired at approximately the same time as the main flash unit. The photoelectric cell perceives the flash of the main unit and triggers the slave. The advantage of using this type of unit is that there is no need for an electric cord between the lights, giving much greater freedom of movement. The disadvantage of these photoelectric eye triggers is that other people using flash units may fire your auxiliary flash unit before you are ready for it to be fired or in the case of electronic flash, before the unit has had ample time to build up again to full intensity.

Because of the difference between the times an electronic flash and a flashbulb take to reach their peaks, an auxiliary electronic flash unit fired by a photoelectric cell can be used satisfactorily with either a flashbulb or electronic flash synchronized to the camera. However, a shutter synchronized to an electronic flash unit on the camera will close too soon for an auxiliary unit with a flashbulb to reach its peak.

Synchronization

Cameras synchronized for a No. 5 bulb, which has a 20-millisecond peak, will work best with flashbulb remote units when the camera shutter speed is 1/30 sec. or slower. This is a great disadvantage for any pictures where there is action or movement.

Electronic flash units on the camera will trip another electronic flash unit instantaneously. The closer the photoelectric cell is to the light of the main flash, the more quickly the cell will be triggered by the light. Good synchronization can sometimes be attained with shutter speeds as short as 1/125 sec.

A camera shutter set for flashbulb synchronization can sometimes effectively use an electronic flash as a triggering device for the auxiliary flashbulb, if the light of the electronic flash is not wanted in the picture. In such cases, it is necessary to set the shutter synchronization on "M" and not "X," the correct setting for electronic flash units.

There are several classes of flashbulbs, and it is important to understand that some shutters have settings for different types of bulb. Most synchronized shutters have at least two settings, "X" and "M." The "X" setting is for zero-millisecond delay and is used with all electronic flash units. The "M" setting is used with medium flashbulbs having a peak delay from 18 to 22 milliseconds. If the camera is set on "X" and a flashbulb is fired, the shutter will close before the bulb gives forth much light. If the shutter is set on "M" and an electronic flash unit is fired, the shutter

will open too late to get the light of the bulb. It is important, therefore, that the photographer check his synchronization setting on the shutter each time when using any type of flash equipment.

Some shutters have a setting for Class F bulbs, which have a peak delay of from seven to nine milliseconds. When there is no such setting on a camera shutter, many photographers use the "X" setting for shutter speeds up to 1/50 sec. for Class F bulbs. Focal-plane shutters are synchronized for special focal-plane bulbs, which have no sharp peak but a long and fairly flat plateau. Most focal-plane shutters using focal-plane-type bulbs will synchronize at all shutter speeds, from 1/60 to 1/1000 sec., or shorter times, and will synchronize with electronic flash units at 1/30 sec. Copal shutters will synchronize at 1/125 sec.

Special Uses

An extension flash can be used to simulate fire in a fireplace for Christmas pictures or the candle in a jack-o'-lantern at Hallowe'en or sunlight coming in the window. I have also used an extension flash to take pictures of newborn babies in a hospital nursery, where I was not allowed in but was able to shoot the room through the glass. For this type of picture, flashbulbs should not be used unless the light is bounced off the ceiling. Young babies' eyes are extremely sensitive to light, and even though the duration of electronic flash is short, I recommend bounce flash for this type of picture. An extension cord can also be used sometimes for placing a flash inside a car or store window or other similar applications The extension flash is perhaps the most valuable piece of equipment a photographer carries when he needs to make a good flash picture, yet few press photographers carry this equipment.

Exposure for Flash

In determining the exposure for flash photographs with two units, the flash nearest the subject is the one that determines the f/stop. If both units are equidistant from the subject, compute the exposure as you would for a single unit. For three bulbs equidistant, decrease the exposure one f/stop; for four bulbs, decrease two f/stops from that used for one flash unit.

BOUNCE FLASH

When I was attending the University of Denver during the 1940's, I had the opportunity to talk with a famous magazine photographer. Bounce flash was becoming popular about this time, and as with other photographic fads and innovations, it was something new that would solve all the photographer's problems.

Bounce flash is obtained by bouncing the light off a wall, a ceiling, or in some cases, a white umbrella. This tends to give a somewhat shad-

Fig. 6-7. When flash is bounced from the ceiling or wall, better gradation of tonal values and a softer, more natural picture result. Courtesy of A. T. & T. Photo Service.

owless light and, of course, eliminates the horrible black shadows found in many newspaper photos. In many ways, bounce flash closely resembles available light photography, but it is trickier to work with than it might at first appear. If all ceilings were the same shade or the same distance from the floor or if there were always light-colored walls to bounce the light from, computing the f/stop of the flash exposure would be simple. Unfortunately, there are so many variations in color, texture, height, and so on that in some ways, making successful bounce flash pictures requires more experience than making straight flash shots.

As a rule of thumb, most bounce flash exposures require two to three stops more exposure than direct flash for the same distance. In computing the distance, remember that the light goes first to the ceiling, floor, or wall and then bounces toward the subject. This is a greater distance than if it were going from the flash to the subject in a straight line.

In color photography, bounce flash may reflect the wrong color from the surface transmitting the reflected light. For this reason, only neutral surfaces such as white or gray should be used with color film unless a special color effect is desired.

SYNCHRO-SUNLIGHT PHOTOS

Perhaps one of the most useful advantages that flash synchronization affords is making synchro-sunlight photographs. The flash is not used as a main light in such pictures but as a fill light. Since it is being used as a fill, with the sunlight as the main light, one flash unit is all that is needed for most such photographs unless the subject is a large group.

It is important to remember that since the flash is a fill light, the exposure is determined by the existing sunlight, and the flash unit is then moved to the distance from the subject that will give about the same average exposure as if the flashbulb were being used as the main light. For example: ASA 125 film, computed sunlight exposure $f/16$, 1/125 sec.; guide number for General Electric No. 5 or Sylvania Press 25 bulb, 220. Divide 220 by 16, which gives the approximate distance the flash fill should be from the subject; in this example, 12½ feet. In other words, the secret of flash fill is to divide the guide number by the f/stop of the computed sunlight exposure,

$$\frac{G}{F} = D.$$

Because there are so many guide numbers and so many different lamps and because bulb ratings change from time to time, the photographer should check the information given on the flashbulb carton or in the instruction book that comes with the electronic flash. Some electronic flashes have guide number scales on the back of the unit.

Synchro-sunlight pictures work well with backlighting, filling in shadows caused by headgear, or the normal shadows caused by direct sunlight. Interesting pictures can also be made by taking photographs indoors that show the outdoors as well. The synchro-sunlight technique is used in computing such exposures.

If the flashgun or electronic flash unit is held too close to the subject, the background will appear dark and the synchro-sunlight effect will be lost. People with light clothing, such as a wedding dress, or who are normally light-complexioned, may require less light fill that those who wear dark clothing or are ruddy-complexioned. In the case of the seashore, snow, white-colored gravel, or white building walls, which reflect considerable light, very little if any flash fill may be needed in direct sunlight photographs. Some photographers use aluminum reflectors or even a sheet of newspaper to bounce light into the subject's face. This type of shooting, however, requires judgment gained from experience and from experimentation.

In synchro-sunlight pictures, the flash unit must sometimes be held too close to the subject, giving too much light. There are several ways to correct this condition. Some photographers use a white handkerchief, placing one thickness over the unit to decrease the amount of light coming from the flash by one f/stop and two thicknesses for two f/stops. The

handkerchief trick will work the same with electronic flash, and because there is no danger of burning their fingers, some photographers extend one, two, or three fingers from the top down over the flash unit toward the center, which decreases the light in varying amounts. It is also possible to use a translucent piece of plastic over either a flashbulb or an electronic flash. These come in blue (for using tungsten bulbs with outdoor color film) or a neutral-density (gray or diffused), which cut down the light to some extent and are available in camera stores.

Any of these remedies will require some testing by the photographer to determine the exact result he wishes to achieve.

When using electronic flash for synchro-sunlight photographs, you may have to change the shutter speed of the camera in order to match the correct aperture for the sunlight exposure with the aperture required for the flash fill effect.

With flashbulbs, this process becomes somewhat more complicated and requires studying a guide number chart thoroughly, for as the shutter speed is changed, the guide number of flashbulbs also changes.

Fig. 6-8. This photo by Fred J. Griffith of a murdered bus driver in Memphis was lit by one light from a flash gun. The glare was almost unavoidable because of the many reflective glass windows in the bus. Courtesy of the *Memphis* (Tenn.) *Commercial Appeal.*

HIGHLY POLISHED SURFACES

If a photographer is attempting to photograph silverware or other highly polished metallic surfaces such as gold, brass, or stainless steel, he may find it difficult to get a good photograph under ordinary conditions. Usually such objects are taken from the window and photographed in what is called a *tent*, a device widely used by commercial photographers. This is a box-like frame of wood or metal, surrounded on all sides by a translucent material of either cloth or plastic, preferably white. Objects to be photographed are placed in the tent, with the lighting, either floods or flash, coming in from one or more sides and the object resting on a sheet of glass near the middle of the box. The box is covered on all sides but one, and the camera takes the picture through this one open side. Using such a tent effectively eliminates unwanted reflection when photographing highly polished metallic surfaces.

Where reflection and glare spots are still too strong, even with the use of a tent, highlights may be toned down with putty or spray from a can of special plastic material that subdues them. The latter is frequently used in television and movie making. Very small objects, such as coins, tie tacks, machined parts, and so on, are sometimes photographed with an electronic ring flash, which gives shadowless lighting.

GUIDE NUMBERS

One of the most important factors in determining the proper exposure for flash photographs is the guide number. Although the guide number seems to baffle many persons, it is relatively simple and merely requires knowing the ASA speed of the film, the shutter speed, and the distance the flash unit is from the subject. General Electric Company's Photo Lamp Department (Nela Park, Cleveland, Ohio) puts out a small booklet on using flashbulbs and a number of charts for determining the guide number in specific situations. The guide number is also given on the back of flashbulb packages and in instruction sheets that come with certain types of film.

Film speeds are normally given in vertical columns and shutter speeds are read horizontally. Matching the shutter speed with the film speed will give the correct guide number. In the case of a General Electric No. 5 or a Sylvania Press 25 bulb, the guide number is 220 for ASA 125 film at 1/125 sec. If the subject is ten feet away from the flash unit, divide the guide number by ten to find the f/stop, in this case f/22. If the subject were 22 feet away, the f/stop would be approximately f/10. Guide number over distance equals aperture, or f/stop:

$$\frac{G}{D} = A.$$

Most guide numbers are based on the use of a polished reflector.

Satin-finish reflectors may require one-half to one f/stop more exposure. The angle of the reflector also makes some difference in determining exposure. It is almost impossible to determine an exact exposure from any one flash unit–film combination without making some tests. In order to be sure of getting at least one correct exposure with black-and-white film, shoot one exposure at the normal f/stop, a second two stops higher, and a third two stops lower (this is called *bracketing*).

The guide number for an ASA 125 film, using an AG-1 bulb in a polished reflector is 110. If the subject were ten feet away, the normal aperture would be f/11. In bracketing the exposures for the ASA 125 film, shoot at f/11, f/22, and f/5.6, all at 1/125 sec.

It is also useful to remember that once you learn a guide number for a particular bulb and film, the guide number doubles when you quadruple your film speed. In other words, in the last example, the guide number of 110 will become 220 when the film speed is changed from ASA 125 to ASA 500. This also holds more or less true in other flash units.

Since light falls off the square of the distance, a flash unit moved twice the original distance will require four times the exposure. For example, using a guide number of 110 at ten feet requires the aperture f/11 at 1/125 sec. When the flash unit is moved to 20 feet from the subject, the aperture becomes *not* f/8 (twice as much light on the film) but f/5.6, the equivalent of letting in four times as much light on the film.

With flashbulbs, the guide number changes as the shutter speed is changed. This is not true with electronic flash. Electronic flash guide numbers remain the same regardless of the shutter speed. For this reason, it is easier to compute the placement of electronic flash units in synchro-sunlight photographs.

FLASHCUBE

For sequence firing of flashbulbs, the flashcube has had great popularity, particularly with amateur photographers. It was originally made for special cameras, but later attachments were made that would adapt the flashcube to almost any camera. More expensive than four AG-1 or AG-3B flashbulbs, the flashcube is a four-sided cube having a built-in reflector for each permanently mounted flashbulb. As one side is fired, it immediately spins one-quarter turn so that another is ready to fire. Thus, a photographer can take four flash exposures as quickly as he can transport his film and cock his shutter.

THE QUINT

Professionals prefer the Quint, which fires five flashbulbs, one at a time in rapid sequence, and can be reloaded rapidly. The Quint is more

versatile and more economical because it takes either the AG-1 or AG-3 series bulbs, available at most stores selling photographic film. Another advantage is that the Quint will fit any camera that has an accessory shoe, or it can be hand-held if the camera has no such shoe. The cube works only with special cameras or with flashcube adapters, most of which require that the photographer rotate the cube manually. The cube has an odd 13-millisecond peak, giving two-thirds as much light as an AG-1 when synchronized for a shutter speed of 1/25 sec. At 1/125 sec., it gives only half as much light as the AG-1.

POLICING UP

"What do you do with used flashbulbs?" someone asked me one day.

"You'd be surprised how handy they are," I laughed, citing the following example: I was once assigned to photograph a group of women golfers on Ladies' Hobo Day at a prominent country club. I arrived at the scheduled time and found the group enjoying the alcoholic beverages of the popular nineteenth hole bar. After introducing myself and chatting a minute, I got them all outside and posed in a semicircle, each with a golf club pointing toward the center. But when I asked for a golf ball, no one had one, and I had to substitute a used flashbulb. In the finished picture, it looked very much like a real golf ball, and no one could tell the difference who did not already know.

One artist friend of mine makes Christmas tree ornaments from used blue flashbulbs by painting decorations on them with white paint. However, the best thing to do with used bulbs is to be sure they are put in the wastebasket and not left littering the floor or ground where you have been working. Picking up one's clutter is the mark of an experienced professional photographer.

SUMMARY

The firing of a photoflash bulb is a controlled explosion ignited by a primer. The first flash powder was invented by Miethe and Gaedicke in Germany in 1887.

The first magnesium flares were used by O'Sullivan in 1867 in a mine in Nevada. Although flash powder was used extensively in the United States at one time, it has been replaced by flashbulbs and electronic flash units.

The first modern photoflash lamp was patented in Germany in 1929 by Ostermeier. These lamps were quickly adopted by press photographers everywhere.

Normally, clear bulbs are used with black-and-white film, and blue-

coated bulbs are used with color film. Flashbulbs come in several sizes, the smallest (AG-1) being a little larger than a peanut. Usually, the larger the size of a flashbulb, the greater the light output.

Size, shape, and finish of the reflector are contributing factors to total light direction and output.

The first electronic flash was used by Fox-Talbot, a British photographer, and was patented in 1851. The modern-day electronic flash was developed in 1931 by Edgerton. This unit was very heavy and bulky, as compared with many of today's compact units.

Electronic flash units cost less per exposure than flashbulbs but usually put out less light and are subject to operational failures at times. Electronic flash units usually have a light duration of 1/500 to 1/2000 sec., but special models may have much shorter flash times.

Small flash units using bulbs are economical and are useful either as a spare or for the photographer who takes pictures only occasionally.

Most electronic units require a certain amount of attention and use over a period of time and cost several times the price of a flash unit using a bulb.

It is preferable to use two flash units for most pictures, in order to give a three-dimensional effect to the finished picture. One unit is used as the main light, and the other is used as the fill light. A photoelectric cell that will trip an auxiliary flash is often used instead of the direct extension cord in situations where an extension cord cannot be used easily.

Most shutters have an "M" and an "X" synchronization. The former is for Class F flashbulbs, and the latter is for electronic flash units and certain other classes of flashbulbs.

Most focal-plane shutters can be synchronized best with a focal-plane-type flashbulb, although many modern focal-plane shutters will synchronize with electronic flash and certain other flashbulbs at slow shutter speeds.

Bounce flash is a method of bouncing light off a wall or ceiling and not directly on the subject. Normally, a bounce flash exposure will require the camera to be opened up two additional f/stops over direct flash.

Flash is extremely useful as a fill light outdoors, with the sun used as the main light. In such cases, the sunlight determines the exposure, with the flash unit being manipulated so as to give only enough light to fill in the shadows.

One of the most important factors in determining exposure for flash photographs is the guide number. Once the guide number is known, the distance of the flash from the subject determines the f/stop used. The guide number doubles when the film speed is quadrupled.

A flash unit moved twice as far from the original distance will require four times the exposure, because light falls off the square of the distance.

Two special types of multiple flashbulb units are those holding the flashcube and one that fires five bulbs in rapid sequence.

QUESTIONS

1. How does a photoflash bulb work?

2. Name two photographers before 1900 who were instrumental in the development of flash photography.

3. What are some of the peculiarities of flash powder?

4. Who invented the stroboflash?

5. Describe the difference between clear and blue flashbulbs.

6. How does a matte-finish reflector compare with a bright flash reflector?

7. Who was William Henry Fox-Talbot?

8. What was Dr. Harold E. Edgerton noted for?

9. What are the advantages and disadvantages of both flashbulbs and electronic flash units?

10. When should a press photographer use flashbulbs?

11. What is the proper way to photograph a large group with one or two flashbulbs?

12. What is the advantage of using more than one unit in flash photography?

13. How are shutters synchronized for flashbulbs and electronic flash units?

14. When using two flash units, how is the exposure determined? three flash units?

15. What is bounce flash?

16. What are the advantages of synchro-sunlight photographs?

17. How is the correct exposure determined for synchro-sunlight pictures?

18. What can be done to cut down glare from highly polished surfaces?

19. Explain the use of the guide number.

20. What is the Quint?

21. What should be done with used flashbulbs?

CHAPTER 7

Available Light and Night Photography

AVAILABLE LIGHT

FOR A NUMBER OF YEARS there has been widespread use among press photographers of the technique known as *available light photography*. Although some think this is a new development and impart to it an aura of mysticism, available light photography was actually used by the early pioneers in the field, in that pictures were taken without flash or other auxiliary light to help illuminate the scene.

Early portrait studios, including those of Mathew Brady and many others, all used a north light or as it is commonly called the *artist's light*. I know of one studio today that still uses no artificial light for portraits but follows the method developed by its founder in Hendersonville, N. C., 80 or 90 years ago. All portrait pictures in this studio, now owned by Don Barber whose father originated the studio, are taken with only the north light that comes through a skylight and is reflected. No artificial lighting of any kind is used.

However, the available light technique used by today's press photographers does not mean that no artificial light is used but that no additional light, such as a flash unit or flood lamps, is brought in to take the picture. One reason many press photographers use this available light technique is that shadows are softer, tones are less contrasty, and available light pictures taken properly give good reproduction in today's newspapers, providing the equipment is in good condition and the engravers are competent.

However, some press photographers will take no photographs except

Fig. 7-1. Ralph Weinlaub photographed this boatload of Cuban refugees with available light at 11 A.M. Backlighting blacked out the subjects' faces. Rollei, $f/22$, 1/500 sec., Tri-X film. Courtesy of the Ft. Lauderdale (Fla.) *News.*

available light pictures, and in so doing they limit themselves in certain areas. With today's high-speed emulsions that can be pushed to ASA 2000 and with lenses having a maximum stop of $f/0.95$, it is almost possible to take a picture where there is no light. Such equipment and film is really necessary only in rare cases, and there is the problem that one professional photographer, who owned a camera with an $f/0.95$ lens, mentioned to me. He said that he quit using it because it attracted too much attention from camera "bugs," who were always stopping him to talk about the camera and keeping him from working as fast as he wanted on the job.

It is easy to use an ordinary camera with an $f/4.5$ lens and ASA 125 film and take available light pictures at 1/30 sec. or 1/60 sec. in most modern offices. These offices are usually lighted by fluorescent light, the walls are light-colored, and visibility is normally good throughout the entire area. Even in many of today's homes it is quite possible to take pictures at perhaps somewhat slower shutter speeds or using an ASA 500 film and get satisfactory available light pictures. To determine the exact exposure for any lighting situation, an exposure meter that will read low

Fig. 7-2. Taken in the shade, this poignant, available light portrait is part of a photo study by Barry Edmonds of the great problems facing old people. Courtesy of the *Flint* (Mich.) *Journal.*

light levels is needed, such as a Sekonic L-28C or L-98, Gossen Lunasix, Miranda Cadius II, or Weston Ranger 9.

Why do photographers use high-speed films or push the speed of certain films to three or four times their normal speed by special developing? In some instances, they do this to stop the action of sports, such as basketball, bowling, or football. In others, it may be done partly as an experiment or in answer to a challenge to see what they can do.

One of the disadvantages of available light photography is that it sometimes tends to be unflattering, particularly to older people. Because the available light in the room is overhead, for instance, slight shadows develop under the eyes, giving the subject a haggard or tired appearance. Some of this effect can be eliminated with a white cardboard reflector or a sheet of newspaper held to one side to bounce some light onto the face. A more permanent reflector can be made by covering a piece of masonite with crumpled aluminum foil or with aluminum paint.

Most press photographers either do not have time or will not take the trouble to use such reflectors, however. I prefer either direct or bounce flash or a flash without the reflector behind it when photographing most people, because I think the resulting picture is more flattering to them. Each photographer must make his own decision after experimenting with the two methods. Many good press pictures are made without flash equipment, and the photographer should use any method that gives him the best results, rather than limiting himself to just one technique.

Available light photography has several advantages—the photographer does not have to carry bulky flash equipment, flashbulbs, or even photoflood stands to light his scene. He is also released from the worry of whether his equipment is working improperly, such as flashbulbs failing to fire, an electronic flash not giving the full amount of rated light even though it does fire, or a photoflood burning out in the middle of the shooting session or changing color due to line voltage fluctuation or age. He need not be anxious about any one of the other numerous things that could happen such as having the shutter set for the wrong type of flash equipment or a flash cord break in the middle. (The latter problem is solved by the Biloxi-Gulfport *Daily Herald*, which keeps a spare flash cord taped to every flash unit.) Not having to worry about flash equipment saves the photographer time and enables him to take his pictures faster, and a photographer is less conspicuous when not using a flash unit; in the courtroom or church, its use may even be prohibited.

If the photographer is working in a crowd, as I was one New Year's Eve, the less equipment he must carry, the easier it is for him to remain mobile. I had a flash unit on my camera in this particular instance, but I had to move very quickly to get out of the way of a fight that broke out almost where I was taking the picture.

There is always an element of risk in any civil disturbance, such as a strike or demonstration, or in any large gathering of people where emo-

Fig. 7-3. This dramatic, available light picture, with firemen climbing three aerial ladders and pressure hoses playing, is most unusual. Courtesy of American LaFrance, Elmira, N.Y.

tions run high. Not a few photographers have had cameras smashed or even received bodily injury when photographing criminal suspects leaving the courtroom or well-known personalities being welcomed as they stepped off the plane. At such times, the less equipment the photographer has to worry about, the better.

NIGHT PHOTOGRAPHY

Night photography is actually a form of available light photography. Some night scenes can be taken with almost any camera, including the simple box camera. When the lighting is very weak, it requires a time exposure, a tripod, or some other sturdy base in order to avoid camera movement and blurred pictures.

Besides the standard tripods, there are numerous clamps of various kinds, some of which can be bought in a regular camera store. The more ingenious photographers often make their own tripod or clamp adaptation, such as using vice-grip pliers with a hole drilled into them to accept the bolt which in turn is threaded to a small tripod pan head. Some of

Fig. 7-4. This pioneer news photo of the earth rising above the moon's horizon was taken by an Apollo 8 astronaut using a telephoto lens. An artist's drawing of this photo appears on a six-cent postage stamp commemorating the mission. Courtesy of NASA, Houston, Tex.

the very small swivel heads made to fit on tripods are no larger than the first joint of a man's thumb.

Even bracing the camera against a wall, on a window ledge, or on some other stationary object will often serve as an adequate support. Although I always advocate that a photographer carry some sort of tripod at all times, I remember one night when I was photographing an industrial assignment in Scottsbluff, Neb., for General Electric, and I had neglected to bring a regulation tripod with me from my home in Denver. The com-

pany was going to install new mercury vapor street lighting to replace the town's outmoded incandescent street lights and wanted a "before" shot to compare with a subsequent one taken after the new lighting equipment had been installed.

It was fall, and I happened to be there on a Friday night while a football game was in progress. I parked my car at one end of the main street and proceeded to set up my 4″ × 5″ Speed Graphic on the fender of the car. I had determined, through calculation, that my exposure would need about 30 seconds to get the light on the main street. With a few snow flurries in the air and people driving up and down the street because of the game and just ordinary traffic, I could see that it would be impossible to take a time exposure of 30 seconds without waiting until 3 or 4 A.M. when there would be little traffic on the street. I was scheduled to take pictures in a coal mine some miles away early the next morning, and waiting until 3 A.M. in the cold weather, with a chance of snow, was unthinkable.

Solving the problem proved to be simple. I set the shutter on "Time," pulled out the dark slide from the film holder, tripped the shutter, using a cable release, and started counting: "One thousand one, one thousand two," allowing one second to each count. After about seven seconds a string of cars headed down the street toward me. If I had continued exposing the film, there would have been light streaks on the picture; instead, I held the dark slide over the lens and stopped counting. After the cars had passed, I removed the slide and started counting again until more cars appeared, at which time I repeated the process. Although interrupted several times by the lights of automobiles, I was successful in getting a good negative, which the company purchased from me. However, I was in doubt at the time as to whether I had a picture, since I was fairly inexperienced at night photography.

Night photography is difficult, in many ways, because of the conditions under which the photographer must work. Lighting will usually come from street lamps, neon lights of theater marquees, or signs or lights from buildings. Except at dusk, on bright moonlit nights, or during a storm in which there is ample lightning, the photographer will have to rely on some artificial source of light for night pictures, even at times using flash by setting the camera on the tripod, tripping the shutter while it is set on "Time," and either running around flashing flashbulbs at several points or having a series of flashbulbs tripped by photoelectric cells or synchronized by being wired together.

Some of the most interesting night pictures combine both daylight and artificial light. Many pictures published in magazines showing refineries, power plants, buildings, and cities at night employ both types of light. This is done by beginning at dusk, while a definite outline of the subject matter can be seen, and making an exposure on a piece of film.

Fig. 7-5. Photographer Bill Stephens silhouetted the two firemen against the flames in the background. The only way the foreground could have been lighted is with a flashbulb or powerful electronic strobe. Nikon F, 85mm lens, *f*/4, 1/250 sec., Tri-X film. Courtesy of the *Wichita* (Kan.) *Eagle & Beacon.*

Later at night, a second exposure is made on the same piece of film when all the artificial lights are turned on.

It is obvious that since the camera must remain in exactly the same position for both exposures, this type of picture calls for a rigid tripod and some type of shutter that permits double exposures. Color pictures, also, can be taken in the same manner.

The photographer will need to experiment in order to get the right exposure for both the night shot and the dusk shot. Usually, the latter can be calculated by taking an exposure meter reading and using normal exposure. The night picture is also normally exposed for whatever the calculated exposure should be for a normal night picture under the existing night lighting. Under some conditions, one exposure of the building with the lights turned on will suffice. In such cases, the exposure should be made when the light meter reading for the reflected light from the sky falling on the building shows two stops less than the light coming from the artificial lighting in the building. A good exposure meter that has a light amplifying unit or one of the extra-sensitive meters using CdS cells powered by batteries should be adequate for the job.

Outdoor lighting varies greatly in intensity, and the light radiates in

many different directions unless there is a reflective surface to turn the rays in one specific direction. Among the best reflectors of light rays in night photography are puddles of water standing in the street after a shower. The different reflections and tonal values from the light and especially the highlights from wet surfaces often transform a commonplace picture into a prize-winning photograph. Rivers and lakes can also be used to reflect the scene in night photography, but in the absence of these, a sidewalk or street can easily be hosed down to give the desired reflections. Subjects that have natural light-reflecting surfaces, such as light walls of other buildings, flowers, signboards, and even cars, often help improve the picture being taken.

One interesting aspect of reflective power that I ran into while attempting to photograph mercury vapor lights on West Colfax Ave. in Denver came about one night when there was a cloud cover over the city. One of the General Electric officials in the city had asked me to take a picture of the street lighting. Because of the large amount of normal traffic on the street, we had decided that it would be best to take the picture at about 3 A.M. from Lookout Mountain, just above Golden, Colo. The first time we tried, the camera was not working properly and we had to go back on another night. Although we could not see any buildings or

Fig. 7-6. Night photos of large plants, oil refineries, or even a city with lights reflected in a river, lake, or puddles on a rainy night make fine shots for publication. Courtesy of the Educational Affairs Dept., Ford Motor Co.

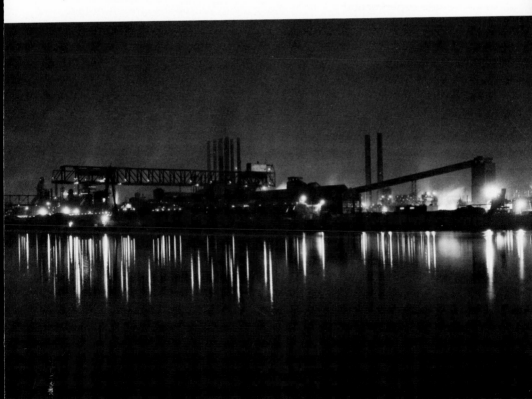

roads in the foreground unless a car happened to drive by or someone turned on a light in one of the farmhouses, when the film from the second shooting session was developed, we found that the light from the city reflecting off the clouds had given enough exposure to make every building, every road, and nearly every fence in the foreground of the valley visible in the photographs.

Students have come to me after making their first picture at night, saying, "Dr. Logan, this picture doesn't seem right. I couldn't see all this! What happened?"

I would explain to them that it is quite possible for the camera, through a time exposure, to record things that the human eye does not see under certain night-lighting conditions. It is also possible to take pictures with invisible infrared rays when the human eye sees nothing at all, as explained in the section on infrared photography in Chapter 15.

Night pictures tend to be contrasty and to extend beyond the range of the gray scale of film. The use of low-contrast, high-speed film, therefore, such as GAF Super Hypan or Kodak Tri-X will give less contrasty negatives. When contrasts are extreme, the film should be overexposed two or three stops and underdeveloped as much as 40 per cent, in order to flatten the contrasts of the negative.

Some photographers use a water bath method of developing their film to flatten contrasts. Since this type of manipulation is a more or less personal thing with most photographers and requires considerable testing and experimentation, no recommended procedures are given here.

Because uncoated lenses tend to produce lens flare on the negative, only coated lenses should be used for night photography.

If possible, it is advisable to keep some object, such as a tree or a human figure, between the camera and the light source, such as a street lamp, to decrease contrast. Exposure conditions under which night photographs are taken vary so greatly that it is best to use the standard bracketing method for making exposures—make at least three negatives, one which you think is the normal exposure, one with two stops more light, and one with two stops less light (see Chapter 5 on bracketing).

Remember that light falls off the square of the distance. In other words, an object 10 feet from a light source will receive four times as much illumination as one that is 20 feet from the same source. Fog, smoke, or dirt in the air will change this ratio, making the light fall off even faster. One advantage of mist and fog, however, is that they tend to isolate the subject and often add a mysterious halo or glow to it in the photograph.

The following table suggests exposure settings that will be helpful in determining the correct exposure for typical night situations.

SUGGESTED EXPOSURE SETTING
FOR OUTDOOR NIGHT PHOTOGRAPHS
(ASA 125 Film with Normal Development, $f/3.5$ Lens)

Theater entrances	1/30–1/10 sec.
Brightly lighted streets	1/5–1 sec.
Normally lighted streets	20–45 sec.
Dimly lighted streets	2–5 min.
City skyline at a distance	10–15 sec.

Window Displays

One of the most difficult night subjects to photograph is the shop window display. The window tends to pick up reflections from the sign across the street, street lamps, automobile headlights, and so on. One of the best ways to combat this problem, as mentioned in the section on filters in Chapter 5, is to use a polarizing filter on the lens to subdue the unwanted reflections.

Another way of overcoming this difficulty is to have the camera on a tripod outside the store front and to use a long extension cord to trip flash units hidden from view of the camera lens to take the picture. The shortness of the exposure will tend to eliminate reflections that would otherwise appear on the negative if the scene were photographed by normal available light in the window setting.

SUMMARY

Available Light

Available light photography was used by the early pioneer photographers. Such photographs have soft shadows, are less contrasty, and are often more evenly lighted than other types of photographs.

Today's fast- and medium-speed films are well suited to available light photography in most homes or offices as well as in many types of sports photography. Available light photographs tend to be unflattering in some instances, especially to older people. One great advantage of available light photography is that it permits the photographer to carry a minimum of equipment.

Night Photography

Most night photographs are taken with the camera on a tripod. Some night photos require exposures of long duration. Some of the most interesting pictures combine both daylight and night photography, with a first exposure being made at dusk and a second later at night.

An exposure meter often simplifies exposure computation in night photography. Reflections on wet, rainy streets or from rivers or lakes may

enhance a night scene greatly. The film often records things on night exposures that are not visible to the human eye. Mist or fog tends to isolate the subject and may add an air of mystery to the photograph.

Window displays are difficult to photograph.

QUESTIONS

1. What is north light commonly called?

2. What is meant by the available light technique?

3. At what exposure should an office normally lighted by fluorescent light be photographed for an ASA 125 film?

4. Why is available light photography sometimes a disadvantage in photographing people? How can this problem be eliminated?

5. What is one of the main advantages in equipment of available light photography?

6. How is night photography closely allied with available light photography?

7. What are some factors that make night photography difficult?

8. What type of light meter is best for night photography?

9. What do reflections do for night pictures?

10. Explain how it is possible for the film to see more at night than the naked eye does.

11. What is the best type of film for night photography?

12. What are some of the problems of taking night photos of window displays in retail shops?

13. Give the approximately correct exposure for a city skyline at night, using ASA 125 film, normal development, and an $f/3.5$ lens.

CHAPTER 8

Color Photography

THERE IS AN OLD JOKE about a man who walked into a clothing store and asked for a blue suit when the store had none. The proprietor realized the situation, and not wanting to lose a sale pulled the clerk aside and asked, "Why don't you turn on the blue light?" knowing this would make a gray suit appear blue.

Although this might work with some people, others would take the suit outside to see what color it really was in daylight before purchasing it. However, some, viewing it under the blue light, would still see gray, because they are what is called color blind.[1]

There are two different types of vision—day vision, known as *phototopic vision,* and night vision, or *scotopic vision.* In day vision, the rods and cones at the back of the eye function together, and the objects we see appear sharp. At night, however, only the rods function, and as a result nothing appears sharp; everything seems to be blurred and indistinct.

Color vision comes from the cones. Scientists believe that the sensation of color is produced because these cones are sensitive to the three primary colors. A deficiency in the operation of the cones is what produces color blindness. The rod cells enable us to detect movement.

Color is a product of light, and the color we see comes from the light waves reflected from the object we are viewing. In darkness, even the most colorful object appears to have no color, because the eye cannot see the color.

[1]There are several types of color blindness. Some persons can identify only certain colors; others can distinguish no color. To the latter, everything appears to be gray.

Fig. 8-1. The Yashica Electro-35 is a 35mm rangefinder camera with a solid state electronic shutter, which gives an infinite range of in-between speeds from a full 30 sec. to 1/500 sec. Because of this shutter and the CdS sensor, which analyzes the light, this camera is ideal for color photography as well as black and white. Courtesy of Yashica, Inc., Woodside, N.Y.

In dealing with color, we are dealing not only with its physical but also its psychological aspects. An interior decorator will paint a room on the sunny side of a house with a cool blue, to give a feeling of coolness and will use a warm color, such as a red or yellow, to make a north room appear warmer. A color may appear green when next to a neutral gray object, yet when the same green is next to a darker green, it may appear blue. A similar effect results when two identically colored objects are placed one on a white background and one on a black background. In the former case, the color will appear not only more saturated but also brighter than in the latter.

COLOR THEORY

Man has been intrigued by color since he first appeared on earth. The Greek philosophers, as well as the artists and scientists of the Renaissance, were all color-conscious. But the first understanding of the properties of color came from Sir Isaac Newton's experiments with the refraction of light through a prism in 1666. Newton concluded that light was a stream of *corpuscles*, or tiny particles, shooting out in all directions from the light source.

Later, other scientists found the corpuscle theory inadequate to explain the properties of light. A Scottish physicist, James C. Maxwell, theo-

rized that light was an electromagnetic field and travelled in waves. The wave theory worked perfectly in certain situations but not in others.

Using Max Planck's quantum theory of energy, Albert Einstein theorized that light, being a form of radiant energy, did not travel in waves but in tiny spurts, or *packets;* the belief of many scientists today is that light has a dual nature, travelling in both waves and spurts.

Photographers usually speak of light as travelling in waves and measure the various colors of light in *wavelengths,* those of the shortest and longest wavelengths being invisible to the human eye. At the lower end of the color spectrum are the X and ultraviolet rays. At the upper end are infrared and other heat rays. The wavelength of the various colors is measured by the distance between the crest of two adjacent waves. The visible color spectrum runs from 400 millimicrons, for blue light to 700 millimicrons, for red light.[2]

Light travels through air at a speed of approximately 186,000 miles per second. In glass, it travels roughly one-third this speed, and for this reason, sunlight (white light) can be separated into its components with the aid of a glass prism. White light is a mixture of all the colors in the spectrum.

Newton's spectrum distinguished seven different colors—red, orange, yellow, green, blue, indigo, and violet. In reality, there are innumerable colors, because a small change in the light wavelength produces a new and different color.

Because of the refractive difference, lenses used for color photography should be corrected for the differences in color wavelengths.

Objects appear to be a certain color because they absorb some wavelengths and reflect others. Paper, for example, may reflect green and red wavelengths but absorb only blue wavelengths. When this happens, the paper will look yellow, assuming that there is complete absorption of one color and that the colors being reflected are pure colors. This is not usu-. ally true, however, as most colors being reflected or absorbed are not pure.

A red apple appears red because it not only reflects red light but reflects that light better than it does blue or green light. In color photography, there are six main colors—the *additive* colors, which are red, green, and blue, and the *subtractive* colors, which are yellow, magenta, and cyan. A mixture of colored lights of the additive colors will give white light. A mixture of filters of the subtractive colors will give no light at all where all three filters overlap.

How a color appears to the human eye depends upon the light acting upon the scene as well as the actual colors of objects within the scene. Colors will appear more yellow under tungsten lamps, because these lamps are yellow, than they would under direct sunlight, because sunlight is whiter and has more blue in it. Fluorescent lights fall somewhere be-

[2]A millimicron is a millionth part of a millimeter.

Fig. 8-2. To get this photo of the Gemini 7 spacecraft over the west coast of India, an astronaut in Gemini 6 used Ektachrome color film in a modified 70mm Hasselblad camera. The two vehicles were approximately 50 feet apart at the time. Courtesy of NASA, Houston, Tex.

tween the two, and for this reason, it is sometimes difficult to determine whether to use tungsten color film or daylight color film when shooting scenes illuminated by fluorescent lights. Fluorescent lights labeled "daylight" are more nearly the color of white light, or sunlight, than other fluorescent types. It is usually necessary to employ some kind of color-correcting filter when using fluorescent lights.

The intensity of light also affects the colors we see, and the direction as well will modify the color of light reflected from an object. When lighting is soft and diffused, colors tend to appear unsaturated and dull. This is particularly noticeable on an overcast day. The favorite light of artists, the reflected light coming from the north in the northern hemisphere and from the south in the southern hemisphere, is bluer than direct sunlight.

HISTORY

The first color photographs using an additive system were made by James Clerk Maxwell in 1861. Maxwell used black-and-white positive transparencies, making separation negatives with the aid of color separa-

tion filters similar to today's color separation methods. He projected the three transparencies through three magic lanterns, using the same filters he had used to make the separation negatives. The result was a color picture, but to Maxwell it was just an experiment and nothing came of it as part of the color photographic process. Maxwell's trichromatic theory, however, is the basis for today's color photography methods.

In 1862, Louis Ducos du Hauron designed a forerunner of today's expensive one-shot color camera, which contains filters and exposes three separation negatives at one time through the use of mirrors or some similar device. Du Hauron's camera made three separation negatives, using angled transparent mirrors. He held several patents on his color processes, which included both additive and subtractive color methods. He also developed a screen-plate process that led to later successful color plates by others. However, du Hauron was ahead of his time. He lacked panchromatic films for good color separation negatives, and his primary colors were not correct.

In 1873, Hermann W. Vogel, a professor of photography at a technical university in Berlin, discovered how to use dyes to make film sensitive to the green and yellow portion of the spectrum. His was the first orthochromatic emulsion, for previous emulsions were color-blind, sensitive only to blue. Vogel later developed a panchromatic emulsion, which was the breakthrough that led to today's color photography.

Frederick Ives, at the age of 18, became the official photographer of Cornell University in 1874. Having been trained as a printer, Ives moved to Philadelphia in 1880 to do research in both the photographic and photomechanical fields. This was a wise choice, since he received many awards and honors for his work in both fields. He improved on the halftone process with a cross-line screen. As early as 1885, he exhibited both color separation plates and color printing from such plates, although he was not satisfied with the process at the time. Among his inventions was a camera for making color separations and a method for viewing the separations in their natural colors. One model of his camera took stereo color negatives.

Three-color printing became a reality in 1893, when William Kurtz, a portrait photographer, paid $40,000 to Ernst Vogel, the son of Hermann Vogel, to come to New York and work with him. Vogel worked with Kurtz for six months and then returned to Germany. In March of 1893, Kurtz printed a color picture using single-line blocks. The angles of the blocks were 45° to the left of vertical for the blue printer, 45° to the right for the red printer, and 90° to the vertical for the yellow printer.

Today's color engraving plates follow almost the same pattern, with 90°, 45°, and 15°. A close examination with a magnifying glass of any halftone color engraving will reveal the directions of the various lines or dots of the different color plates. This is what makes the reproduction of printed color photographs in publications possible.

With the demand for color photographs for publications, many new developments in color photography took place in the years that followed. Color printing shops sprang up in every major city before 1900. In 1910, William C. Huebner, using offset lithography, was able to make and print four-color plates, making the separations direct. The first color picture was transmitted by wire in 1924.

Color cameras also progressed, with the most popular being the one-shot camera, which used either mirrors or a sliding back.

Kodachrome film, invented by Leopold Mannes and Leopold Godowsky, was introduced in 1935 by Eastman Kodak Company and revolutionized the industry. This new color film consisted of three separate emulsions bound together on one support. The top layer was sensitive to blue light only; the second was sensitive to green; and the last, to red. Between the first and second layers was a yellow dye that allowed the red and green rays to go through but absorbed any unrecorded blue light rays. Thus, the three primary colors were recorded on one piece of film.

Processing this film was complex and required intricate machinery. The film was first developed as a negative and then, by a reversal process, converted to a positive. Die couplers were introduced during the reversal process, leaving the three film layers in the three complementary colors—yellow, magenta, and cyan. The process used today is similar to the original Kodachrome process, except that there have been improvements made and a shift in colors.

Whereas photographers use three primary colors, artists and color engravers work with four—blue, red, yellow, and black—because the medium with which they work is pigment or ink rather than dyes in gelatin. The newspaper process that uses only three colors of ink, omitting the black, has gained great popularity in recent years.

COLOR TEMPERATURE

Besides contrast, there are two additional factors to consider in taking color photographs. Professional photographers use two different types of meters to determine proper exposure. One meter (see Chapter 5 on exposure meters) measures the amount of light on the subject, as in black-and-white photography. The other measures the color temperature of the light and is calibrated in degrees Kelvin ($^\circ$K). The name comes from W. T. Kelvin, 1824–1907, who devised a scale for measuring color temperatures for light sources. Because using a color temperature meter requires experience and judgment in interpreting the reading, it is not recommended for the inexperienced photographer.

All light sources can be measured in degrees Kelvin. A candle flame, which is quite yellow, registers about 1800–1900° K. Incandescent lights are 2900° K.; clear flashbulbs 3300–3800° K.; white fluorescent lamps 3500° K.; morning and afternoon sunlight 5500° K.; noon sunlight with

Fig. 8-3. The Gossen Sixticolor Light Meter is used for measuring the color temperature of light in degrees Kelvin. Courtesy of Berkey Marketing Companies, Inc.

blue sky 6000° K.; daylight flashbulbs (blue) 6000° K.; and speed lights from 5500–7000° K. Blue skylight with no direct sunlight is 10,000–12,000° K.

Daylight color films are made to be exposed in direct sunlight between about 9 A.M. and 3 P.M. in the summer and 10 A.M. and 2 P.M. in the winter. The color temperature of outdoor film is about the same as that of direct sunlight during these hours.

Tungsten color film will vary from 3200 to 3400° K. Because a fluctuation in the voltage of current will change the color temperature of a tungsten bulb, most professional color photographers use voltage control devices on their enlargers and on lines that supply power for photofloods, to keep the color temperature of the lamps constant. Lamps will also change color with age, and a voltage regulator can help compensate for this change by adjusting the voltage until the bulb is the correct color temperature.

The best light to use with tungsten film is a clear flashbulb, because the light from the flashbulb is consistent and is made to match most of the tungsten film. When using clear flashbulbs, check the data sheet accompanying the film to see if any color correction should be made.

It is impossible to manufacture a film that will meet all the different color temperatures of daylight or all the color temperatures of artificial illumination. The only way to compensate for a change in color temperature is through the use of filters that change the color temperature of light entering the camera. Filters can convert the light to the proper color for the film (see Chapter 5 for the various types of filters used in color photography).

Most electronic flash units give off a light suitable for daylight color

films. Some older models required a correction for excessive blue, which was accomplished by a shield on the flash unit or a filter on the camera to change the color more nearly to that of daylight.

Blue flashbulbs or a special blue shield over clear flashbulbs are used with daylight color film. If a tungsten reversal color film is used with a blue bulb, the resulting transparency will appear too blue. If a daylight color film is used with a clear bulb, the transparency will appear too yellow.

Tungsten color films have been manufactured for three distinct color temperatures: 3200° K., 3400° K., and 3800° K. Because manufacturers change their specifications from time to time, there may be other color temperatures available. Check data sheets on tungsten color film and be sure that the color temperatures of the photofloods and of the color film match. Otherwise a filter correction must be made to balance the two.

NEGATIVE VS. POSITIVE COLOR FILM

Many of today's newspapers using the three-color plates use negative film, because it has a wider exposure latitude and requires less work in the engraving room. The same film is used for both tungsten and daylight exposures, and color-corrections are made in the darkroom. Some papers use both a positive color (reversal) process, resulting in a transparency, and a negative color process, but the trend is toward using the latter. More newspapers are using color photographs daily, and it appears that this trend will continue in the future.

Some newspapers use 35mm color film almost exclusively, and others use a larger size, even 4″ × 5″, because the larger transparencies or negatives will reproduce much better or because the paper has used 4″ × 5″ color transparencies for a number of years and is reluctant to change to the color negative process.

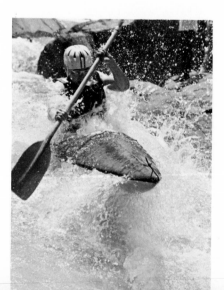

Fig. 8-4. This original color photo by Fred I. Kissell is one of a series shot for a large industrial firm's national advertising campaign. A black-and-white print was made from the color transparency. Nikon F, 135mm lens, f/4, 1/500 sec., Kodachrome II film. Courtesy of Koppers Co., Inc.

If a transparency is used, it is necessary to go through a process called separating, or breaking down, the transparency. This consists of making three black-and-white negatives: one made with a red filter over the transparency for the negative that will make the blue plate; one with a green filter for the one that will make the red plate; and one with a blue filter for the one that will make the yellow plate. If a four-color process is used, a K2 (black-and-white) filter is ordinarily used to make the black plate.

With varying the times of exposure and development, the resulting negatives made from this process will be equally matched on a gray scale. It is then necessary to get each in *registration* on the press, which is done by having cross-hair, or registration, marks on each plate. It requires considerably more skill for a platemaker to produce a set of color plates that will register perfectly on a press than to make an ordinary black-and-white plate.

In the breaking down process of a color transparency, masks are placed next to the transparency. These masks are actually very thin negatives or positives held in contact with the transparency in order to subdue the highlights so that the transparency will print within the range of tonal gradation that is possible on the printing plate. Others are placed on two other separation negatives to filter out the unwanted colors, the pigment dyes of the film not being true but picking up some extraneous and unwanted colors.

Through a machine such as a Curtis Color Analyst, the three separation positives are viewed together and a laboratory technician can tell what change is needed or whether the positive was properly masked.

Newspapers have turned to negative color because it eliminates making these separation negatives. Masking must be done to correct the colors, however, just as in the positive transparency process. Again, the masks take out unwanted color and reduce some of the contrast.

There are several advantages to the color negative process: it requires less special equipment; it takes much less time to make plates from color negatives; it requires operators with less skill; negative film has a much wider exposure latitude; and almost any camera becomes a color camera, provided it has a good color-corrected lens.

Perhaps another advantage of using negative color film with three-color plates is that the color quality need not be held to the tolerances of color printing necessary when using the transparency–separation negative process. Often the colors appearing in three-color newspaper photos depart considerably from the true colors of the subject photographed.

Because most color negative film is rather slow, some photographers have resorted to using high-speed film, such as High-Speed Ektachrome, and then developing it as a negative. In some cases, it is possible to double the film speed of a normal transparency in this way. This type of manipulation, of course, requires professional experience and the advice of people

familiar with the process. It is not recommended for the beginner, who should stay with a good negative film, such as Kodak's Kodacolor or Ektacolor, GAF Print Film, and Agfacolor. The latter has one film with no orange mask, which is easier to use when making black-and-white photographs from color negatives.

COLOR FILM VS. BLACK-AND-WHITE FILM

Color film is more critical than black-and-white film. It should be exposed with the use of a light meter, and in bracketing exposures, it is best to make one exposure at the normal f/stop for the subject and lighting, one a half stop over, and one a half stop under. If the photographer wishes to bracket this even further, he can include another exposure a full stop over and yet another a full stop under, making five exposures in all. Color negative film has greater tolerance and can be bracketed by using full stops rather than half stops.

There are many problems with color photography that are not present in black-and-white. For instance, when light is reflected off any surface, such as a red brick wall, there is a tendency for the wall to reflect red light. If a subject is standing too close to the wall, although the photographer may not detect this extra red light reflection, the color film will pick it up, and the resulting transparency will appear unnatural or too red on one side of the subject's face. For this reason, it is best to have reflectors made from aluminum foil or a neutral white or gray when bouncing any light onto the subject.

Sharp contrasts such as shadows are often more apparent in color transparencies than in black-and-white films, because of the short latitude of the color film. Color photographers try to avoid contrasty lighting, preferring light ratios of three to one or two to one, although some exposures may be made as high as ten to one. (A three-to-one light ratio would have three times as much light in the highlights as in the shadows.) Color often looks more pleasing in a diffused light such as a sunny but slightly overcast day. Many photographers choose this type of day for shooting color film outdoors.

The color temperature changes with the angle of the rays of the sun. For this reason, it is better to make exposures in winter, depending somewhat upon the latitude where the picture is taken, between 10 A.M. and 2 P.M. and in summer between 9 A.M. and 3 P.M., unless the photographer is trying to get an unusual effect, such as a warm glow of sunrise or an orange-red sunset scene.

Color exposures made in the north light of the shade of a building or in any deep shadows, including those on snow, will have a blue cast. In such instances, the camera is picking up the blue light from the sky rather than the direct white light of the sun. The color temperature of this light

will vary from 10,000° to 20,000° K. A warming filter will correct the light to that of white sunlight. This is where a color meter or a filter chart comes into use, with the strength of the filter depending upon how blue the subject is. The 81 series color filters are applicable to this situation (see Chapter 5 on filters). The 82 series are used to correct the warm red evening and morning sunlight.

The use of synchroflash is advisable with most pictures taken outdoors in bright sunlight, in order to cut down the harsh contrasts. Pictures taken outdoors in color at noon often have unattractive shadows, and professional photographers often try to avoid shooting color at this time of day.

To capture clouds in outdoor scenes, most photographers use a polarizing filter, which will darken the sky and make the clouds appear brighter. This filter does not change the color but merely darkens the sky. Almost all color filters require some increase in exposure, and the polarizing filter is no exception.

Negative color film can be used in all types of light without correction filters, but this makes it more difficult for the laboratory or the photographer to get good color-balanced prints. For this reason, most photographers use filters with negative film also.

Various lenses may transmit the same color light differently, due to a difference in the lens coating and composition of the lens elements. In most cases, these differences are barely noticeable, but in others they may be more apparent. Some lens manufacturers try to match, as nearly as possible, the color transmission qualities of all or a part of their lenses. In buying lenses, a photographer should try to obtain lenses that match in color transmission factors. Sometimes this may require a certain amount of testing on the photographer's part.

It is surprising that a photographer can sometimes produce a fine color picture on a gray, dull day. I remember one instance when I was making a motion picture film of earth-moving equipment building a dam. The only time I could shoot the picture was during a drizzly, dull, gray day. I compensated heavily for the blue-grayishness of the light, and the resulting footage was perhaps better than if it had been taken in bright daylight, because there were no harsh shadows of trees and other vegetation to hide the subject, and the colors were close to normal. As it is with all photography, of course, this is a matter of taste. One person may like the color of a particular scene whereas another may dislike it because he feels it is not natural.

The photographer should realize, however, that there is no such thing as color that is truly natural or normal. Light on all subjects, unless in a sealed room, will change from time to time during the day or year, during storms, or during a period when there is an unusual amount of dust in the air. There is no truly normal light on any given subject. The photographer must often decide what is normal to him and then try to come as close to that norm as he can.

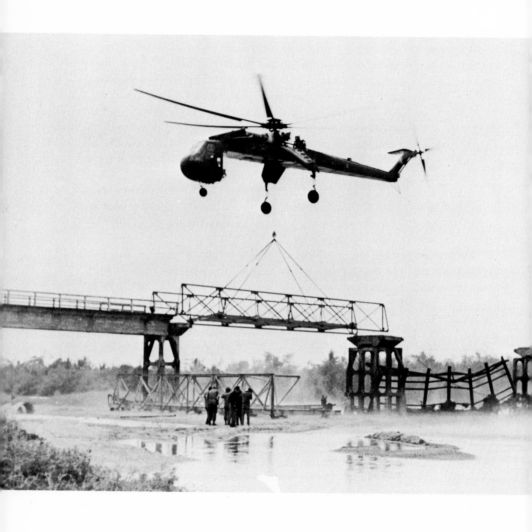

Figs. 8-5a, b, and c. The story of the Vietnamese war is, in part, the story of the helicopter, shown in these photos, two of which were copied from 2¼" × 2¼" color negatives taken on Kodak Ektacolor. (a) A Sikorsky flying crane helicopter was used to rebuild a 1000-foot steel and cement bridge. (b) Choppers such as this CH53A carry men, supplies, and the wounded and when equipped with special guns are used to fire upon guerilla troops on the ground. (c) Flying cranes pick up other downed choppers or haul heavy artillery pieces. Courtesy of Sikorsky Aircraft, Stratford, Conn.

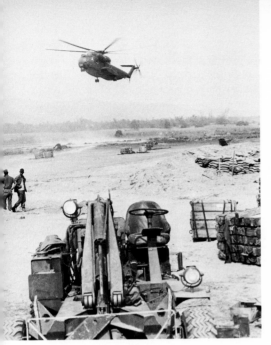
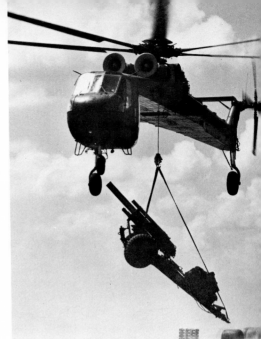

STORAGE

Color film is manufactured in such a way that elaborate controls are exercised throughout the whole process. Yet even with all these safeguards, many things can make one film differ from another. These variables include, of course, the manufacturing process itself. Professionals buy a quantity of film of one batch number, run tests on it, and store it under uniform conditions, usually in the frozen food compartment of a refrigerator unless it is to be used quickly, in which case the unused film may be stored in the regular part of the refrigerator.

Color film deteriorates with age, no matter what the the storage conditions are. Being kept in a cool, dry place will slow the deterioration, however, and prolong the life of the film. If color film remains on the counter of a warm drugstore for several months, a decided change will occur from the time it was first received from the manufacturer to the time the photographer uses it. Most manufacturers date their film so that the expiration date is somewhere near a year and a half from the manufacturing time, and it is recommended that the photographer check any color film to see how near it is to being outdated before purchasing it.

Heat and humidity are the worst enemies of color film; all color film should be stored at temperatures below 75° F. One day in an attic, near heating pipes in winter, or in the glove compartment of an automobile in summer can greatly deteriorate color film. Professional photographers who travel a lot keep their film under refrigeration even when travelling in a car, using some type of portable icebox or refrigerator.

The original packing of color film is usually sufficient to protect it against humidity, unless a person is in the tropics. In such cases, the use of a dessicating agent will be necessary. Some professional photographers store their color film in a moisture-proof container, such as a sealed glass jar or tin can, before storing it even in an icebox or refrigerator.

In places such as laboratories, doctors' offices, or hospitals where there is X-ray equipment or radioactive material, there is always the chance that the film may be exposed to harmful rays. Precaution should be exercised particularly when entering such places.

SUMMARY

Color is a product of light and results from light waves reflected by the object we are viewing. Color has both physical and psychological aspects, causing us to view the color of a particular object differently under different colored lighting or near a background having another strong color. The intensity of light also affects the colors we see.

Although there are several theories of light, many scientists believe it has a dual nature, travelling in both waves and spurts. (It is generally described as travelling in waves only.)

From Newton's experiment with a prism, it was learned that light is divided into seven basic colors. Most objects being viewed are not of one pure color. Objects perceived appear to be a certain color because they absorb some wavelengths and reflect others.

In color photography, there are six main colors—red, green, and blue (the additive colors), and yellow, magenta, and cyan (the subtractive colors).

Some of the pioneers in color photography were James C. Maxwell, who made the first color photographs in 1861; Louis Ducos du Hauron, who used both additive and subtractive methods in 1862; Hermann W. Vogel, who made film sensitive to the green and yellow portion of the spectrum in 1873; Frederick Ives, who made color separation plates in 1885; William Kurtz, who developed a system of three-color printing in 1893; and William C. Huebner, who made the first four-color offset plate in 1910.

In the film world, the most important invention was Kodachrome film, introduced in 1935 by Eastman Kodak Company and invented by Leopold Mannes and Leopold Godowsky. This was the first time that the three primary colors were recorded on one piece of film.

Making the correct exposure with color film is more complex than with black-and-white film. Color film allows less latitude, and the factor of color temperature (measured in degrees Kelvin) must be considered. The two basic types of color film are *daylight*, which is based on the color temperature of the light at noon on a normal, bright, sunny day (approximately 6000° K., and *tungsten* film, which is based on a color temperature

of 3200° K., 3400° K., and 3800° K. Most professional photographers use a color temperature meter in order to learn the exact color temperature of the light they are working with. When this color temperature deviates from that of the film, special color filters must be used in order to obtain the correct color balance in the exposure.

Both negative and positive color films are used in making color plates for today's newspapers and magazines. Making color plates from color positive (transparency) film requires more critical exposure and more complex engraving methods .

The most common color used in today's newspapers is a three-color process without the black plate that is normally used in the four-color process.

Even though color negative film has more exposure tolerance than color postive, neither has the exposure latitude of most black-and-white films.

There are many problems in color photography that are not present in black-and-white photography. Reflections from painted walls, contrasts that are too great, lighting that is dull and overcast can all compound the difficulty of making a suitable exposure with color film. Even various lenses may give different results because of the differences in lens coating and the composition of the lens elements. Heat, humidity, film manufactured at different times, and film that may be nearly outdated can complicate the problem of getting the desired color picture.

A color photograph that is "normal" for one photographer may not be normal for another. For this reason, you must establish some sort of standard for yourself.

QUESTIONS

1. What makes us see color differently in the daytime from at night? In answering, explain the function of the eye.

2. What are some of the psychological aspects in seeing color?

3. How does Newton's theory of light differ from that of Albert Einstein?

4. White light is a mixture of which colors in the spectrum?

5. Explain the scientific theory of how a spectrum works.

6. Why do objects appear to be a certain color?

7. What result will be given by: (a) a mixture of colored lights of the three additive colors? (b) an overlapping of the filters of the subtractive colors?

8. What were du Hauron's problems in making color separation negatives?

9. Before Vogel's first orthochromatic emulsion, to which color or colors were previous films sensitive?

10. Who was the first man to make the three-color printing process a reality?

11. How does a one-shot color camera work?

12. What was the first film to record the three primary colors on one emulsion? Who invented this film?

13. What is the most popular color process for newspapers today?

14. At what end of the Kelvin scale is a candle flame?

15. How does tungsten color film differ from daylight color film?

16. Why is it easier to use color negative film than color positive (transparency) film in making separation plates for printing a color photograph?

17. What are some of the problems inherent in color photography but not usually present in black-and-white photography?

18. What is the advantage of using synchroflash in taking outdoor color pictures?

19. What are some of the problems to consider in storing color film?

Portraits and Group Photographs

ALMOST ANYONE can take a good picture of a pretty girl, with little or no knowledge of portrait photography. When the subject is plump in the wrong places, however, and has circles under her eyes and hair that obviously has not been shampooed in one of the products highly advertised on TV commercials, it takes more than simple photographic skill to make a flattering portrait—the $15 photograph mentioned at the beginning of the book.

Unless the press photographer has had special training in portraiture, this may be the most difficult work he attempts. In photographing a building, which holds still and does not suddenly move, his only problems are those of lighting, knowing which lens to use, and correcting distortion by using the camera's swings.

Studying portraits made by other photographers and giving special attention to lighting, posing, and other such factors should help any beginning press photographer take better portraits. One of the easiest places to find examples of portraits is in studio show windows. To be sure of choosing a high-quality studio, one has only to pick one with only a few portraits in the window. Such a studio may display only one, two, or three portraits. On the other hand, cheaper-quality studios, especially those that sell coupon pictures at bargain prices, normally have display windows jam-packed with all types of photographs. Studios usually display their best pictures and most photogenic subjects, and if the quality of work in the display window is poor, the general run of the studio's work will probably be even poorer.

Fig. 9-1. The official portrait of President Richard M. Nixon, taken by Philippe Halsman. Halsman is a favorite portrait photographer of national celebrities and has photographed such notables as Winston Churchill and Marilyn Monroe. His photographs have made the cover of *Life* magazine 100 times. Photo by Philippe Halsman.

Portrait photography is a study in itself, with complex lighting, posing, and many psychological factors to consider. This is as true for the formal portrait taken in the studio as for the casual "posed candid" type of portrait so often taken by press photographers and many amateurs as well. The whole question, in fact, of just what is or is not a portrait can be confusing when one reads the photographic magazines that circulate to the large mass audiences. Appearing in such publications will be examples of fine work done by such photographers as Yousuf Karsh and Phillipe Halsman and poorly posed, often distorted, and sometimes fuzzy shots that any snapshot photographer could make without even trying. In either case, the photographs are called portraits.

For this reason, I like to distinguish between well-posed, technically correct, professional-looking portraits and casual shots by calling the former portraits and the latter, semi- or candid portraits. Candid portraits are most often taken with smaller-format cameras, such as 120-size roll

film and 35mm cameras. The best portraits, even of the candid type, are the result of careful planning, lighting, posing, and photographic skill.

Outside their own studios or an occasional photograph with a credit line in a publication, examples of the work of the nation's best portrait photographers are seldom found except in professional photographic magazines, such as *The Professional Photographer,* or in the exhibits of members of Professional Photographers of America, Inc. This organization has a number of travelling exhibits which can be borrowed by responsible groups for showings. I frequently display such exhibits in order that my students can see what top-quality photographic prints look like. It is unfortunate that so few people, including many professional photographers, have ever seen work done by Paul Gittings, Louis Garcia, Kurt Jafay, and the many other outstanding portrait photographers.

LENSES FOR PORTRAITURE

Much in the appearance of a portrait depends upon the lens it was taken with. Almost all portraits are taken with longer than normal focal length lenses, unless a full-length portrait is taken in limited space. The lens may be a telephoto lens, which means that it will have a shorter bellows extension than a regular lens of the same focal length. Telephoto lenses are usually lighter weight and shorter from front element to back element. Telephoto lenses are used almost universally on press and small-format cameras, and there is little difference in the quality or image size of a photograph taken with a telephoto lens and one taken with a normal lens of the same focal length.

The long focal length of such lenses gives larger head sizes on the negative with less distortion of the nose, head, and ears. Portraits taken with these lenses give the subject a roundness that is more pleasing to the eye because the camera and lens are farther away from the subject than they would be with a normal focal length lens. Psychologically, this added distance gives the photographer an advantage. He can move about more freely, adjusting his lights, shifting props, or making camera adjustments without being almost in the lap of his subject. This also tends to lessen tension on the subject's part.

Some lenses are called *portrait lenses* because they either have a focal length commonly used on studio portrait cameras, or they may be able to impart what is called a "soft-focus" effect to the subject's photograph. Soft-focus lenses were widely used by both portrait and landscape photographers at one time, and even today they have not completely lost their popularity with portrait photographers. Some of these lenses are as sharp as any others at smaller openings, such as $f/16$, but soft at larger apertures, such as $f/4.5$. One soft-focus lens, the Rodenstock-Imagon, changes its soft effect with an adjustable grid that is placed over the front

of the lens. There are also diffusion filters that can be purchased in several different sizes for most lenses, but these filters do not work as well as the specially designed lenses.

Soft-focus lenses are not totally unsharp but are designed so as to have a certain amount of sharpness in some parts of the negative and a diffused halo effect in the other parts. Often, it is the center or the highlights that are the sharpest. Although most portrait photographers diffuse their enlarging lenses for at least part of the exposure when making portraits, diffusion of the enlarger lens alone will not give the same effect as a soft-focus lens on the camera. Most soft-focus lenses are designed for large-format cameras and are not recommended as necessary pieces of equipment for press photographers.

Focal Lengths for Specific Cameras

For a 4″ × 5″ negative, the minimum focal length should be 12 inches. Most 4″ × 5″ press cameras are equipped with semi-wide-angle lenses, either 127mm (5-inch) or 135mm (5¼-inch). Some press photographers use a 120mm lens on a 4″ × 5″ press camera. Any of these three lenses has a depth-of-field advantage over the normal 163mm (six-inch) lens but is not a good portrait lens.

For the 2¼″ × 3¼″ press camera, many photographers use either a 180mm or 240mm lens for portraits. The normal focal length lens for a 2¼″ × 2¼″ reflex camera is 75mm or 80mm. A 180mm telephoto lens is an ideal focal length for portraits with the 2¼″ × 2¼″ reflexes. The normal focal length lens for a 35mm camera is approximately 50mm. Some photographers prefer a 105mm lens for miniature camera portraits, whereas others use either a 135mm or 200mm lens, depending upon taste.

If he is not careful, a photographer using normal or wide-angle lenses for portraits can make a person appear misshapen, with the nose large or elongated or the head small or oddly shaped. These distortions often remain unnoticed until the finished print is made.

LIGHTING

Whole books have been written on portrait lighting alone, and it is hard to set down an ideal lighting arrangement, because each portrait is an individual thing. It is even more difficult, because of space limitations, to give all of the possible lightings that can be used for portraiture. The beginning photographer should limit himself to two or three lights rather than a half-dozen.

Fig. 9-2. Red Grange as seen by Fred Comegys through a 105mm lens on his 35mm camera. Courtesy of the *Wilmington* (Del.) *News-Journal*.

Perhaps the easiest lights to use are floodlamps, which can be moved about to give the lighting desired. Floodlamps on folding stands are probably preferable to reflector floods in clamp-on sockets. Lamps on stands are not only much easier to adjust, but the size of the lightbulb can be changed to give more or less illumination as desired.

Most portraits require two lights or one lamp and one reflector, with the reflector taking the place of the second lamp. One secret of good portraiture is to avoid the flat lighting produced by movie bar lights with the camera in the center or one flashbulb in a reflector attached to the camera. Such pictures have neither depth nor three-dimensional effect.

Mastering portrait lighting requires considerable experience and practice. One reason for this is that each person must be lighted to bring out what photographers may call his "character." The subject with deep-set eyes or wearing glasses may require entirely different lighting than would be used on a beautiful fashion model. With most persons one side of the face or one angle is more photogenic than any other. The person who is bald will require less light on the top of his head than will one with a full head of hair. This situation calls for using a head screen, which is a wire frame covered with black or neutral-colored muslin and placed between the subject and the light in order to tone down the light. Head screens receive wide use in motion picture photography.

It is possible to make a portrait with only one light, but most portraits require at least two—a main light, sometimes called a *key light,* and a second light known as a *fill light.* A third light may be used as a background light or, in some cases, as a *hair light* (one that shines directly on the hair). The latter is used especially in glamour photography.

Perhaps the most important factor in learning to use lights is to read each light individually. The main light, which may be either a flood or electronic flash or even a flashbulb, should do the main lighting of the subject. The fill light merely softens the shadows created by the main light. Generally speaking, the main light is placed to the right or left of the camera, with the fill light on the opposite side at about a 45° angle from the subject.

It is important to remember that if both the main light and the fill light are equidistant from the subject and of the same intensity, the result will be a flat picture, lacking the desirable three-dimensional effect, which gives depth. Since light falls off the square of the distance, it is quite easy to get the one-to-four lighting preferred by many photographers simply by placing the fill light twice the distance from the subject of the key light, providing both are of the same intensity.

Another way to accomplish the same thing is to use a No. 2 photoflood in the main light and a No. 1 in the fill light, in this case keeping the lamps about equidistant from the subject. (Many professional portrait photographers tie a string the proper length onto their photoflood holders or strobe units and use this string to determine the correct dis-

158

Fig. 9-3. Young, beautiful women like this coed are easy to photograph with simple lighting and posing techniques. In this case four electronic flash units were used: a main light, a fill light, a background light (low), and a hair light. Only one highlight shows in the subject's eyes, because the author removed the second highlight with a No. 1 sable brush and Spotone dyes. Photo by author.

tance to place the lamp from the subject, in order to be sure of getting the same exposure each time.)

One reason I recommend the use of floodlamp holders is that a set of three or four can be purchased for from $20 to $35. Also, the small portable strobe units used by most news photographers have no modeling light for determining exactly where the shadows will fall on the subject. This is a disadvantage, since a slight movement of the edge of a shadow to one side or the other or up and down may give an entirely different effect from that desired.

Electronic flash units designed for studio use have a modeling light built into the flash reflector. The photographer turns on the modeling light to get his lens in position and to focus his camera. When he is ready,

he turns off the modeling lights and fires the electronic flash. Some units do this automatically, and others simply leave the modeling lights on when the flash is fired.

Another advantage of using a modeling light for focusing is that the light is dimmer and hence much easier on the subject's eyes than the full photoflood light. Some people's eyes are so light-sensitive, in fact, that they cannot stand the brightness of even ordinary photofloods for any length of time. With such a subject, it is best to have him keep his eyes closed until the instant you are ready to take the picture, open them, and then close them again quickly after the picture is taken, to avoid their becoming red or watery.

SUBJECTS WEARING GLASSES

Persons wearing glasses would often come into my studio for a portrait and remove the glasses for the picture. If one wears glasses most of the time, however, his portrait will look unnatural if he does not have them on. For this reason, I always take several poses of such subjects, some with the glasses and others without. A picture with the glasses would almost invariably be chosen as the best portrait.

Another approach to the problem, particularly with men, is to have the subject hold his glasses in his hands.

The reflection on some types of glasses can be quite troublesome to the photographer. Keeping the lights high and looking through the groundglass of the camera, if it is so equipped, usually allows the photographer to determine whether the camera is picking up a reflection from the glasses. Sometimes tilting the subject's head slightly down or to one side will eliminate the reflection. One can hardly make an inflexible rule here, since we are again dealing with individual persons rather than a group of inanimate objects.

If the lights are too far to the side or too high, the shadow from the rim of the glasses may be distracting. I have found that having the subject push his glasses up on his nose toward the face helps minimize the shadow and get light into deep-set eyes.

It is possible to borrow rims without glass in them in order to avoid reflection in especially troublesome cases. Another remedy is to have a competent retoucher etch out the shadow on the negative. This etching is best done on a large negative, preferably on cut film, since the emulsion is normally thicker on it than on roll or 35mm film. The fees charged by retouchers are nominal, and almost any professional photographer can recommend a good retoucher.

There has been much discussion about the best camera for portraiture, but I feel that the camera using the larger negatives is a decided advantage, if only for the retouching feature alone. There is, of course, the purist school of photographers who do not believe in retouching;

these are also the photographers who wonder why they cannot produce work similar to that done by professional portrait photographers. Fortunately, there are few professionals who do not use some type of control, whether it be through retouching, makeup, or manipulation in the darkroom.

In portraiture, the photographer is dealing with mental impressions people have of themselves or others. Each person usually has a different opinion of which photograph of several different poses is a perfect image of the subject. Many teen-age girls like to appear older and more sophisticated, whereas older people usually prefer to appear younger than they are, not revealing the wrinkles or circles under their eyes, which denote age.

BACKGROUNDS

Plain backgrounds are usually best for portraits. Inside a building, there are often pictures, maps, or other decorations on the walls, which provide undesirable backgrounds. Windows or curtains may or may not make good backgrounds, depending upon whether they create a distracting pattern. In taking pictures in a subject's home or office, I have often either removed pictures from the walls (with the subject's permission, of course) to provide a plain wall or shifted the locale to another room with no distracting features.

In an office, it is sometimes impossible to change the background, because there are filing cabinets, doors, or other unsuitable features. If the view through the window fits into the picture, I try to equalize the light exposure indoors with that outdoors. This is done by computing the exposure for the outdoors, over which there is no control, and placing the flashbulb a distance from the subject on the inside that will give the identical exposure that would be needed for the outside exposure.

In other cases, I may close a venetian blind on the window so that only a pattern of the slats is shown.

If the subject is an attorney, I may use his bookcases for a background, or I may use room dividers, a folding screen, or even a roll of cloth, such as monk's cloth.

In homes, I use a pastel sheet or blanket, because a white sheet has too much glare. A neutral gray, light green, medium tan, or some pastel color makes a good all-around background for most formal or semi-formal portraits. Many portrait photographers who take pictures house-to-house or at various locations carry a roll-up background screen similar to those used for home movie projectors. These screens can be purchased from photo supply houses and can be obtained with different colored sides—a dark side for blond-haired people and a light side for dark-haired people. Some screens come with hand-painted backgrounds.

Many advertising and studio photographers purchase no-seam paper,

Fig. 9-4. For variety in informal portraits, outdoor backgrounds can be used with suitable subjects. A flash-fill brings out detail in the shadow area of the faces and in the young man's clothing. Photo by author.

which comes on a roll and can be pulled down to any length needed. The no-seam paper comes in many colors for black-and-white photography and can be purchased from paper supply houses in large cities. One advantage of using this no-seam paper is that full-length portraits can be taken without showing the normal seam found in all rooms where the wall and floor meet. In case such paper is not available, the ends of a roll of newsprint will serve the same purpose. Newsprint, however, is more brittle and tends to wrinkle more easily.

Some photographers wanting an unusual background either purchase or obtain from a department store the paper that is used in displays. This paper comes in many patterns; some is corrugated, some looks like wood, and some has various other designs. Other props used in window displays, such as columns, may also be useful in providing background material.

Certain objects outdoors also make nice backgrounds. I had one student who did an assignment in fashion photography for my class and borrowed fully dressed mannequins, posing them outdoors alongside a wooden fence. For a newspaper assignment, I once used the wall of a savings bank, made of unusual two-foot-square concrete blocks, as a background for a shot of a fashion model for newspaper advertising.

It is good practice for the photographer to learn the location of various natural backgrounds, keeping them in mind when called upon to do an assignment. Keeping a card file or, better still, a contact print of the wall pattern or background pasted on a card, will give an instant idea of the texture and effect the background will provide.

Suitable backgrounds for both indoors and out can be made from cloth purchased by the yard, such as monk's cloth, decorator burlap, terry cloth toweling, and other textured materials, which come in a number of good background colors.

Portability

But how, it may be asked, can a news photographer carry all this material with him to take a portrait, especially when he goes from one assignment to another? It is obvious, of course, that his equipment should be portable, and the news photographer must use what is on hand or what he can easily transport in his car. This is why folding floodlamps or folding electronic flash units with modeling lights on stands that fit into cases are more suitable than the regular studio equipment. On the other hand, it is highly desirable where possible to have a room in the newspaper office that can be used for a studio. In this case, various props can

Fig. 9-5. A single flash unit held high was used to take this photo of the oldest college graduate, in her eighties, at an annual homecoming celebration. Courtesy of the *Houston* (Tex.) *Chronicle.*

be kept on hand. The more resourceful a photographer becomes, the less he has to carry.

Preparation

It is always advisable, time permitting, for the photographer to go out on location to see what is available and what would make the best picture possibilities. When something additional needs to be done, he can allow time for this. It is helpful to call up the day before or drop by to take a look at the surroundings. The more preparation a photographer makes for a portrait, the more likely he is to get a successful picture. Good portraits are almost never taken on a haphazard basis.

POSING

In posing a subject for a head-and-shoulders portrait—the most common type made—a backless bench, such as a piano bench or dressing table stool, makes a versatile posing bench. Chairs should be avoided unless they have special significance, as in the case of a large overstuffed chair for a man's portrait, or a chaise longue or period chair for a woman's portrait. Many professional portrait photographers buy special posing benches from studio supply houses.

Seating and Positioning

One mistake many photographers make is seating the subject facing straight into the camera. This makes the shoulders appear broader than normal, which, except for football players, is less flattering than the quarter-turn position. The ideal pose is to place the posing bench or stool at a quarter turn from the camera, and then have him turn his head toward the camera.

Another rule that photographers often violate is that the subject should never look into the camera for a picture. Such a pose gives him a staring expression and makes the person viewing the picture feel uneasy. As with all rules, of course, there are exceptions, but it is generally best not to have anyone look straight into the camera, except for large group pictures.

A photographer can take four poses quickly by having the subject sit on a diagonal to the right and turn his head slightly toward the camera for one picture, having him turn a little more toward the camera for the second. The subject should then rise and sit down on the diagonal to the left and repeat the two poses from this position, thus giving four poses and showing both sides of his face. It is important to have more than one exposure of a portrait. The beginning photographer with little experience in posing will have four different poses to choose from, one of which should be better than the others, since one side of the subject's face is usually more photogenic than the other.

Special Problems

There are many things to make provision for, such as "floating" eyes or other minor physical defects. Some people have weak muscles in one eye, so that when they turn their head suddenly, the eyes do not move together. The picture should not be taken at this instant, to avoid the subject's appearing cross-eyed. It must be remembered that the camera will record more than the human eye may see.

Other problems may be prominent scars, one eye smaller than the other, prominent or large ears, long neck or no neck, receding chin, or other over- or under-emphasized features.

When one eye is smaller than the other, I pose the subject with his small eye in direct light and closest to the camera. The other may or may not be shaded. If done properly, both eyes will appear to be the same size in the finished picture.

For protruding ears, it is best to light the subject so that one ear is completely shaded. Because of the great variety of difference in facial features in human beings, certain corrections can be made by turning the head one way or the other, so as to de-emphasize the unusual features.

People with round, full faces should be taken with the face slightly turned to the side, in order to de-emphasize the fullness. Turning it too far, however, will tend to make the face look broader. Persons with slim features may be taken with more of the side of the face showing, to make the face appear full. Heavy-set people with double chins should be taken with the camera at a high angle and the subject leaning slightly forward with his back perfectly straight, so as to stretch the chin muscles.

Hands

If hands show in the photograph, it is preferable to have the subject holding something, such as a book or a pipe. Women may hold gloves or a flower to give the portrait a light, feminine feel. Women with unattractive hands may look better wearing the gloves. Posing the hands in the lap with the palms up and one resting on the other pulls the elbows in to the sides and makes the whole arm appear more relaxed. Hands should never be photographed broadside, but should be turned at an angle. Women's hands are more attractive with the wrists straight but relaxed, rather than bent.

Feet

When women's feet show in the picture, it is important that they do not face the camera straight on. As any model well knows, the most flattering pose results from placing the left foot behind and toed slightly to the left, then sliding the right heel back to about the middle of the left arch and toed slightly to the right, thus avoiding any light showing between the legs or ankles.

Fig. 9-6. Hands are expressive, often hard to photograph, but when they belong to an artist spinning a bowl on a pottery wheel, not much more is needed to tell the story. Courtesy of Mississippi State College for Women.

Dress

A plain-colored dress with no pattern or a black dress with no frills usually photographs better than those having ornate designs. Depending upon the individual, a white collar will sometimes add to the picture, particularly if the woman has a long neck.

Hair

It is usually better to wait at least one day after a woman has had her hair done at the beauty shop, so that her hair style will not be too tight. Likewise, it is better to photograph a man the second day after he has had a haircut. A new haircut often gives him a close-cropped look.

The best time of day to photograph a man is in the morning, when he is freshly shaven. If this is impossible, try to arrange with him to shave just before you take the photograph. (If he normally wears a beard, of course, this would alter the situation.) Having a man powder after shaving also minimizes any remaining shadow.

Makeup

A woman's makeup for a portrait should normally be darker than her ordinary street makeup. If possible, she should use heavy pancake makeup similar to stage makeup. The public library should have a number of

excellent books to aid the photographer with information on photographic makeup.

Sun-tanned or dark-skinned people photograph lighter if a yellow or orange filter, such as K2 or G, is used on the camera with black-and-white film (see Chapter 5 for other uses of filters). Heavily sun-tanned or sunburned people tend to look unnatural in their pictures, even those taken with flash. I try to avoid taking such subjects until the tan fades, if possible, because of these problems. In photographing women, the difficulty can be solved with makeup.[1]

Groups

In posing two people for a portrait, their heads should be as close together as possible. The human eye tends to minimize the space between heads, but the camera emphasizes it. To the eye, people may appear close together, but when recorded on film, the subjects will appear much farther apart. If the subjects are man and wife, I try to get their heads touching or at least posed so that no space appears between the woman's hair and the man's head.

The easiest way to pose a man and wife is to have her sit on the bench faced on a diagonal as you would a single subject; then have the man straddle the bench much as he would a saddle on a horse, sitting as close as possible to the woman. Because of a difference in length of torso or legs, a woman who is actually shorter than the man will sometimes appear taller when seated. The best way to correct this difficulty is to place a pillow, telephone book, or other object under the man so as to bring his head higher than the woman's. The photographer can find many other poses for two people by studying portraits made by professional portrait studios or reading books on portrait photography.

For three people, especially if one is an infant or small child, the man and woman can use the same pose while she holds the child in her arms or seats it on both of their knees in the center of the picture. A second or third child, depending upon the height, can stand close to the parents on one side or the other. When there are several children, the photographer may make several attempts before finding a pleasing arrangement. Instead of having the children stand to the side, it may be necessary for them to stand behind the parents and to one side and lean over slightly, so that everyone will be at almost the same plane of focus on the negative. Such posing requires time and patience.

For aesthetic reasons, uneven numbers make better balanced pictures than even numbers. Therefore, the photographer should try to group an even number of subjects so that they appear as an uneven number. For practical reasons, an almost ironclad rule is to try not to have more than

[1]Special makeup kits are sold for both black-and-white and color photography.

Fig. 9-7. The wire-caged vacuum tube catches the reader's eye and gives an air of mystery to what otherwise might be a dull photograph of a scientist. Many portrait shots can be enhanced by including an object tied in with the subject's work. Photo by author.

three persons in any photograph to be used in a newspaper.[2] Most newspaper editors like this type of photograph and will often edit out more than three people in a group, if possible.

Whether of a group or a single subject, pictures for publication are usually more interesting if the persons are doing something rather than just staring at the camera. What the subjects are doing should be related to the story or caption that the picture illustrates; for instance, a musician could be playing an instrument, a trapshooter holding his shotgun, or the bank president holding a gold bar in his hands.

[2]If there are a number of officers of a club, for instance, break them up into groups of three and take separate pictures, giving the editor a choice. If there is space, he will probably use one or two additional pictures.

It is sometimes mandatory to take a large group, such as a football team, a marching band, or a convention. In the case of sports teams, a formal group is most often used. For a convention, the group will sometimes be taken seated at tables or in a meeting, and there is little else the photographer can do but go ahead and take the picture. For conventions or meetings, the photographer should also take pictures of individual happenings to illustrate the news story about the event.

Unusual pictures of small groups can be made on spiral staircases or, in the case of a football team, placing the camera on the ground and having all the players look down toward it in a huddle; or the photographer can climb up on a high ladder or balcony and have the group in some artistic arrangement, looking up. This type of photography takes time and planning. But with experience and ingenuity, most photographers can add a slightly different twist to a familiar setting.

I once had an assignment to take a group of more than 20 ministerial students. Instead of posing them in the usual formal way of three or four rows, I arranged them around a large fountain with some sitting on the rim, some standing, and two or three seated on the ground. Some who were standing rested one foot on the rim of the fountain and placed an elbow on the raised knee in a relaxed position. There is no definite formula for making this kind of picture, but it is best to remember that both the seated individuals and those who are standing should be as close together as possible. The photographer must also avoid leaving too much space between individual groups, so that the continuity of the photograph remains unbroken.

In taking large groups of two or three hundred, I try to arrange them in rows of similar height levels and have everyone stand as close together as possible. For this type of picture, steps or bleachers are normally used. Professional photographers who do this type of work often have special stands made for taking these pictures. The subjects in large group pictures should stand sidewise, facing toward the center from each end rather than straightforward, since this allows them to stand closer together and gives larger head sizes in the whole picture.

It is also important to have the subjects stand or sit so that their heads are staggered, and the individuals in the second row look between the two persons ahead of them in the front row.

For large group photographs, I have found placing the camera above the group an advantage for at least two reasons—it is easier to get the entire group into focus and to see every person in the group. This arrangement also makes it easier for the photographer to get the attention of the whole group.

I try to get a fairly high stepladder, truck, or some other object that will elevate me above the group being photographed. There are special tripods made with clamps for attaching them to the top of the stepladder

Fig. 9-8. This photo of 1,003 DuPont scientists and research engineers appeared in an article in *Fortune* magazine. With only three days notice, the site was chosen, a 30-foot scaffold erected, and a public address system installed. Because of thorough advance planning by DuPont, it took only 14 minutes to get this group together and photograph it. Courtesy of E. I. DuPont de Nemours & Co.

or other support. If there is no room for a regular tripod, a clamp tripod should be used.

It is important to use a sturdy tripod in photographing large groups, in order to avoid camera movement and to allow the photographer greater ease in focusing critically. I prefer at least a 4″ × 5″ press or view camera for taking large groups, but I have made satisfactory prints of such shots taken with twin-lens reflex cameras.

Being above the group gives the photographer a psychological advantage, in that most of the individuals can see him readily. I usually make some unexpected remark or do something else out of the ordinary, such as pretending to fall off the ladder, to get attention. In group pictures, it is important to take a number of exposures to minimize the chances of getting subjects in unattractive poses or with their eyes closed. I usually take six exposures of such groups and from these decide which is the best single negative. This is the only print that I ever show, since otherwise one person wants one shot and someone else prefers another. Showing the one shot makes it easier for the photographer and avoids possible argument.

Children

From photographing youngsters in a studio, I have found that the photographer should never present an appearance that the child could associate with a physician, dentist, or barber, since children have an instinctive fear of such persons and the uniforms they wear. For this reason, I prefer not to wear a white shirt when photographing small children with floodlamps or electronic flash units on a stand in a studio atmosphere.

I caution the parents or grandparents ahead of time not to tell the child that he is having a picture made but that we are going to play a game, such as ball with boys or dolls with girls. Or I use a toy telephone, a bunny rabbit, or some other toy to get the child's attention and make him forget that he is being photographed. Sometimes using these toys as part of the picture makes the child more relaxed. For Valentine's Day one year, I photographed two small children on their tricycles with one giving the other a valentine, and the shot was featured on the front page of the newspaper.

Fig. 9-9. Some of the most interesting and charming photographs of children are candid shots. "The Magic of a Book" was taken for the National Library Week feature and as a result won first place in the New England Press Association Competition. Richard P. Lewis used a Graphic to take this photo. Courtesy of the *Journal-Transcript,* Franklin, N. H.

It is important to talk to the child on his level, both psychologically and physically. Sometimes the photographer may have more success by kneeling down and talking to him more nearly at his height. All these factors tend to put the child at ease. It is also important to remember that a child's attention can seldom be maintained for long, so the photographer must be prepared ahead of time and make his pictures as quickly as possible.

Animals

Psychology also plays an important part in photographing animals. In the case of a dog or cat, making a sudden strange noise, such as a hissing sound, with the mouth will get the animal's attention for just the right instant to make a good picture. In the case of a horse, I have had someone wave a sack in the air just as I was going to take the picture, so that the horse would prick up its ears. There are no set rules on which attention-getter to use, and most such practices photographers learn through trial and error, profiting by their experiences.

Fig. 9-10. "Honeymoon," by W. Forres Stewart of the Bradford (Pa.) *Era,* won second place in the newspaper feature category in the 1967 Annual Pictures of the Year Competition, sponsored jointly by the National Press Photographers Association, the University of Missouri School of Journalism, and the World Book Encyclopedia Science Service, Inc.

Props

Portrait photographers usually keep on hand all sorts of props, such as special backgrounds, fancy chairs, boxes, draping material, and toys. Supply houses for store window decorations offer many useful items for photography. Some photographic supply houses sell drapes, special costumes, and other aids for glamour portraits. Many times the right prop will make an ordinary portrait into an extraordinary one.

SUMMARY

Portraiture may be the most difficult work a press photographer attempts. Each subject requires special posing and lighting to bring out his best pictorial qualities.

It is desirable to take almost all portraits with longer than normal focal length lenses. Longer focal length lenses enable the photographer to work farther away from the subject and give less distortion of the facial features.

Candid-type portraits are most often taken with smaller-format cameras. Most formal portraiture is taken with large-format cameras.

Floodlamps on stands are usually preferable to small electronic flash units, because the floodlamps can be read before the exposure is made. Studio electronic flash lamps have a pilot light used for placing the flash unit so that the shadows fall where the photographer wants them.

Studio-type portraiture normally requires from two to four lamps.

People with glasses, bald heads, or other features that present difficulties for the photographer require special treatment.

Professional portrait photographers normally use a film that can be retouched with pencil or dye and, in some cases, etched with a knife, in order to produce a more pleasing portrait. Portraiture deals with the mental impressions that people have of themselves or others.

A plain background is preferable for portraiture whenever possible. Outdoor backgrounds can give an unusual appearance to portraits and advertising pictures.

The press photographer should not try to take portraits on the spur of the moment but should prepare himself beforehand with the proper equipment, surroundings, and background.

Backless benches are the best posing benches. Subjects for portraiture, unless under unusual circumstances, should not have the torso facing directly toward the camera. The head should be at an angle from the body. Hair style, makeup, and dress should be appropriate for the picture, unless an unusual effect is desired.

In group photography, a man and wife require different treatment from two women or two men. A picture of two adults and one child may be made with the child held in the arms or standing, depending upon the size of the child. Uneven numbers in a group make better composition;

therefore, groups should be posed to convey the feeling of uneven numbers whenever possible.

How a large group, such as a sports team or band, is handled, will depend largely upon the situation—whether stairs are available and so on. The camera should be elevated above the head of the group in order to get the best view of everyone in the picture.

Children should be treated as children in their world rather than as adults. Psychology also plays an important part in animal photography.

QUESTIONS

1. Why is portraiture difficult?
2. How does the focal length of the lens affect the finished portrait?
3. What is meant by soft focus?
4. How does candid-type portraiture differ from studio-type?
5. Describe how you would use two floodlamps in lighting a subject for a portrait.
6. What are some of the problems involved in photographing people who wear glasses?
7. Why is the photographer said to be dealing with mental impressions people have of themselves or others?
8. Explain the difference between: (a) the main light and the fill light; (b) the background light and the hair light.
9. What type of background should be used in portraiture?
10. Where can special backgrounds be found?
11. What is the best type of posing bench?
12. Explain how you would pose a single subject and how many exposures you would make in order to get an acceptable negative for a portrait.
13. If a subject has one eye smaller than the other or protruding ears, how should he be lighted for a portrait?
14. What are some of the problems involved in photographing women's hands and feet?
15. What is the problem encountered in photographing heavily tanned people?
16. How would you pose a man and wife for a group portrait, (a) using a posing bench? (b) with a second and third child?
17. What are some of the problems involved in photographing large groups?
18. How would you set the scene psychologically for photographing: (a) a young child? (b) a prize schnauzer?

The Picture Story
and Feature Photographs

No ONE KNOWS exactly when man first began making picture stories, but it was many centuries before Christ. Even the hieroglyphics that made up ancient languages were a form of picture story. Many examples of these early picture stories can be found in the caves of sourthern France, the tombs of Egypt, and the Mayan temples of Yucatan.

Some are only feature pictures depicting a single episode, such as the chief of police of Akhenaten handing over two robbers to the vizier of Amarna in Egypt.[1] Others, such as the torture of Mayan prisoners at Bonampak, Chiapas, illustrate a complete story.[2]

In todays' picture story, the photographer "writes" his story with a sequence of photographs. A well-made picture story may tell the story completely and clearly with only a few words of explanation or identification.

When most people think of picture stories, they probably think of some of the popular national magazines sold on newsstands and read by a great many subscribers. Upon investigation, however, they will find picture stories published in even the smallest weekly newspaper and in many business and highly technical publications as well. A weekly pub-

[1]Christiane Desroches-Noblecourt, *Tutankhamen*, New York Graphic Society, Ltd., New York, 1964, p. 157.

[2]Roman Piña Chan, *Maya Cities*, Instituto Nacional de Antropologia e Historia, Mexico City, 1959, p. 32.

lication such as *The National Observer* or a monthly such as *Fortune* magazine will occasionally present picture stories equal to any others that are published.

Picture stories are not the work of photographers in this country alone, although the picture story started in the United States in 1925, with experiments in the Des Moines *Register and Tribune* rotogravure section. *Life,* begun in November, 1936, and *Look,* started in January, 1937, were the first two magazines to use photographic narration in the form of picture story continuity. One of the outstanding magazines known for picture story reporting today is *Paris Match,* and a counterpart in Germany is *Bunte.*

On large magazines, most picture stories are the work of more than one person. From three to five people may be involved in the finished product, working together as a team that usually includes, besides the photographer, a writer and a layout artist. Magazines have more time and money to spend on careful planning and preparation for picture stories than do most newspapers. A writer often produces a script similar to that used in motion-picture photography, from which the photographs are taken. There are usually close-ups, some medium-distance, and some long-distance pictures that give the overall background of the story.

How a story is done depends upon the type of story and the publication in which it is to appear. The most important aspect, from the photo editor's viewpoint, is to have a variety of composition—different angles, some pictures that will print small and others that will print large, and so on—in order to make an attractive layout.

For a news event of international importance, such as Churchill's funeral or a visit to the United States by the Queen of England, much preparation is made for producing the elaborate picture layouts seen in some publications. For the visit of Pope Paul to New York, *Paris Match* used 18 photographers, some of whom were flown over from France and some of whom were hired here in the United States, to cover the event. The magazine carried 29 pages of pictures in its special issue on the visit.

During World War II, a photographer travelling with a ship convoy crossing the Atlantic took more than 300 exposures on special assignment for one magazine. From this group, 14 photographs were chosen and two additional ones purchased from a seaman who was an amateur photographer travelling with the convoy. He had snapped two pictures of a burning tanker after it had been torpedoed by a German submarine. As is often the case with a large magazine, only three or four per cent of the pictures made in preparation for the story were finally published.

Most photographers cannot afford to use this much film on picture stories, unless they are hired by a large publication or can command high prices for their work because of their professional reputation. Remember, however, that any photographer should shoot many exposures to be sure that he has more than enough shots for a good picture story layout.

TYPES OF PICTURES STORIES

The three main types of picture stories are the picture-text combination, the pure picture story, and the picture story within a text story. Text illustration is the most common use of photographs, but this is not considered a type of picture story, because the text actually tells the story and the photographs are incidental. In this case, the pictures merely dress up the article and give added pertinent information.

Picture-Text Combination

In the picture-text combination, the pictures and the text are closely interrelated and neither tells the complete story in itself, unlike the other two types. The photographs carry the full weight of the story, in most cases. This is the easiest picture story to do and is the most common type found in publications. *National Geographic* has superb examples of both this type and the picture story within text.

Fig. 10-1. Shooting through a rain-streaked windowpane, Stanley Wolfson gave this photo of a group of pickets that "just different look" that is part of the policy of *Newsday.* A good example of a picture-text combination, this photo was taken with a Nikon on Tri-X film. Courtesy of *Newsday,* Garden City, N.Y.

Pure Picture Story

This is the rarest type of picture story, because only a few words of text are needed to help the picture sequence perform the whole story-telling function. Sunday newspaper supplements occasionally carry good examples of this type. In the years before and during World War II, *Life* and *Look* had exceptionally fine stories of this type. Both still carry pure picture stories, but because of changes in editorial policy, their emphasis has been more on text and less on pictures in recent years. Mechanics and handicraft magazines also have many good examples of the pure picture story. Not all of the latter publications, however, use photographs for their picture stories; some use drawings instead.

Fig. 10-2. Winning third place in a news photography contest in Florida, this picture story, "A Plunge into Sisterhood," by Ricardo Ferro was obviously not planned or pre-arranged. Courtesy of the *St. Petersburg* (Fla.) *Times.*

Fig. 10-3. California's Governor Ronald Reagan at the GOP National Convention in Miami, 1968. This picture by Lou Touman needs little explanation. Nikon F, 135mm telephoto lens, f/8, 1/125 sec., Tri-X film. Courtesy of the Ft. Lauderdale (Fla.) *News*.

Picture Story Within Text Story

This type is not as common as the picture-text combination, and it is sometimes difficult to differentiate between the two. In the story-within-text story, the text is a complete story in itself, and the photographs also tell a complete story. The combination of the two catches the reader's eye and makes the story more appealing. Scientific, mechanics, and specialized publications, such as photography and trailer magazines, include examples of this type. Examples are also found in many other publications including Sunday newspaper supplements.

IDEAS FOR PICTURE STORIES

Some picture stories may develop spontaneously, such as the time when a spectators' stand collapsed at the Indianapolis 500-mile race, and the photographer who is able to take a rapid series of pictures can produce a picture story in a short time. On a holiday, such as New Year's

179

Eve, or even at a football game, picture story sequences may develop without the photographer's needing a script to follow. This type of picture sequence is closer to spot news than the feature story, however, for most picture stories are of the feature type and require some preparation.

The idea is the most important part of the story, in either case. In the first example, the idea comes from the event itself. In the second, it must be conceived in the photographer's mind and planned out ahead of time.

Perhaps the best source of ideas is to study what other photographers are doing, and one of the best ways to learn how picture stories are handled is to study those appearing in a wide variety of publications. Such study should include some of the many publications not sold on the newsstand, such as company and business publications circulating only to persons in one particular field or company. Examples of these are the *Oil and Gas Journal,* which goes to oil industry workers; *Ford Times,* which goes to car owners; and *Audubon* magazine, which is read by bird and wildlife enthusiasts.

Reading newspapers or publications of almost any kind that carry picture stories gives the photographer a background in what is being done elsewhere. He can follow a pattern similar to one of these borrowed ideas, localize the story in the case of a daily or weekly newspaper, or slant it to a particular publication and add a slightly different twist.

One college public relations department has a bulletin board on which are displayed the public relations stories, with pictures, developed by rival institutions, appearing in the regional newspapers. This serves two purposes: to give the public relations personnel an idea of what the editors are publishing and to enable them to compare these items with those printed from their own college's press releases.

I know of an owner of a department store in a small city (34,000 population) who is considered an outstanding advertising copywriter and layout man. Few people know that he looks at all the ads in several large metropolitan dailies, from which he gets most of his ideas.

The photographer working for a newspaper probably has an opportunity to read the exchange newspapers that come into the office daily. Libraries also take many publications, including daily newspapers, news magazines, technical journals, trade publications, and foreign publications. They sometimes receive special interest publications that are not on display, and it is wise to ask the librarian for them. Libraries also have bound volumes of back issues of many publications, and many have extensive microfilm files of them.

A photographer gets ideas for picture stories from being a good observer. When he sees something odd, unusual, or even just a little different he should ask himself if it might make a story. The only way he can tell is by learning more about it—in other words, having an inquisitive

mind, the mark of a good photojournalist. Often asking a question or two from only the barest fragment of an idea will lead to a good story.

In a jeweler's shop, I once noticed some unusual stones and mountings in the display cases. If the stones had been the usual diamonds or even star sapphires, I would have paid them little attention, but instead, they were polished stones of various colors in baroque shapes. When I inquired, the jeweler told me that he polished the stones and made his own mountings as a hobby. It is not unusual for people to polish semiprecious stones, as there are many rock hounds who collect and polish rocks either in an old Indian-style tumbler somewhat resembling a barrel or on a lapidary wheel. What was unusual about the story was that jewelers are almost never rock hounds.

As a result of my interest, I sold a picture-text combination feature to a large trade publication in the jewelry field. From this story came ideas for several stories and a new knowledge of rocks and semiprecious stones. (I had to research the article before I could do the story, since I did not know enough about it and finally became a rock hound myself because of it.)

Even so common an event as a rainstorm will provide a good picture story for an alert photographer. People do odd things in the rain. They lose some of their inhibitions and show emotional effects of the fear

Fig. 10-4. When a young girl walks in the mud after the rain, she is in a world all her own. Bill Tutokey took advantage of the pattern of puddles to set the mood. Courtesy of the *Billings* (Mont.) *Gazette.*

of getting wet or enjoyment of the downpour. It is not uncommon to find adults going barefoot, men carrying women's brightly colored umbrellas, and people wearing odd-looking garb or using newspapers, sacks, or boxes for emergency rain gear. Animals, too, look and act differently in the rain; and how about the little tots that love to play in the mud puddle, against their mothers' wishes? A panel of three to five such pictures across the top or bottom of a newspaper page will make an interesting pure picture story that people will enjoy because it reflects a little of themselves in what they see.

Research is a key part of any type of journalism, whether for a written story or a photographic essay. Only by acquiring a background through research can one ask intelligent questions that produce an authentic picture story. For trade and specialized publications in particular, the photographer must become a temporary specialist in the area. If the photographer does not know what he is doing, a volley of letters from well-informed readers will let both him and the editor know about the error.

Once when shooting a motion picture on apple harvesting and packing, I photographed one of the pickers dumping his sack into a container. From the photographer's viewpoint, the picture looked better with the apples being dumped from above the container. But when the film was viewed by an outstanding horticulturist, I was quickly informed that this was not the proper way to dump apples into a container. Doing it the way I had photographed it would bruise the apples. As a result, I had to do additional shooting and editing to correct the film.

A good source of ideas comes from acquaintances and people who learn that you are seeking material for picture stories. Policemen, postmen, barbers, beauty operators, government officials, and small businessmen come to know many people and hear of unusual happenings. Some of their tips will be worthless, of course, but many should develop into first-class leads.

If the photographer is specializing in a certain area, such as agriculture, visits to the county farm agent or home economist from time to time should turn up valuable leads. Machinery dealers, feed dealers, and real estate agents who specialize in farm property can also give the photographer some profitable ideas.

If he specializes in animals, his acquaintances should include veterinarians, pet shop owners, pet show judges, and other such persons.

PLANNING THE STORY

After the idea has been conceived, the photographer may need some kind of shooting script. Because many publications cannot afford to have a writer do this, the photographer must often write the script himself. Even the editor does not always know exactly what he wants and when talking to the photographer may give only a vague idea of what the story

Fig. 10-5. Even though your staff is small and the city may only have a population of 12,000, there is always ample opportunity for feature pictures. Dave Swan, the only photographer on his paper, used a Rolleiflex with Tri-X film to capture this migrant worker. Courtesy of the Bend (Ore.) *Bulletin*.

is to be. Unless he works on a large publication, the photographer will probably have to do much of his own script writing, because the publication either cannot spare the extra help or has no one else qualified to produce such a script.

The photographer should know approximately how many pictures are to be used in the story and what type of layout is planned. Picture stories need to be flexible, so that one picture can be omitted or another added, if necessary, since the layout of a publication varies with the amount and type of advertising it carries. Particularly on a daily newspaper, there will be ample room some days and a "tight" paper on other days, when everything possible is edited out or held until the next day.

Large newspapers put out several editions of each issue. Sometimes there is extra space in early editions, which go to outlying parts of the state and rural areas. Space that may be used for localized or late-breaking news in the city and final editions can be used for a picture story in early editions.

One picture editor showed me a full-page, three-photo layout used in an early edition of his paper, explaining that he would only have space

for one four-column picture in the later editions. Yet the three pictures used in the original layout were each seven columns wide.

Theme

The picture story should have a central theme that ties all the pictures together. There is usually a need for an introductory or lead photo as well as one that concludes the story. In his script or outline, the photographer should determine two or three ways to start his story, in case one does not work out when he arrives on location, and follow in sequence with a group of pictures that illustrate the theme.

Variety

The photographer should be sure to include a variety of medium shots, some close-ups, and enough long shots to set the scene. A variety of angles also adds interest to the story and expedites layout for the picture editor, or as happens on some newspapers, the photographer may have to make his own layout and write his own captions.

It is important to take some pictures that lead into the page from the right and some that lead in from the left. A picture with the movement from the right, such as a person walking, should be placed on the right-hand side of the page and is called a righthand picture. One having movement from the left should appear on the left side and is called a lefthand picture (see Chapter 16 on photo editing).

Identification

Even if the photographer does not write his own captions, it is important that he identify fully each person in a picture. It is easy to make an error of identification, which not only irritates the person whose name was misspelled or omitted or who was incorrectly identified, but in some cases, might furnish grounds for a libel suit.

In the story I did for a hardware magazine some years ago, the son of the owner of the hardware store was incorrectly identified as the owner himself. How this happened I do not know, as I had each photograph captioned and identified correctly, but somehow the error was made. The owner did not take issue with the mistake, fortunately, but the incident embarrassed me greatly.

One of the best ways for the photographer to prevent error in his identification is to have each negative numbered and to use a corresponding number when writing down the subjects' names and pertinent information. Some film holders have a small number that exposes when the film is exposed in the camera. Some photographers have their holders numbered and write the number of the film on the emulsion with a pencil in the darkroom before developing. Professional studios have a device that numbers cut film in the corner from a number printed on paper.

Roll film users can use the numbering devices on the edge of the film.

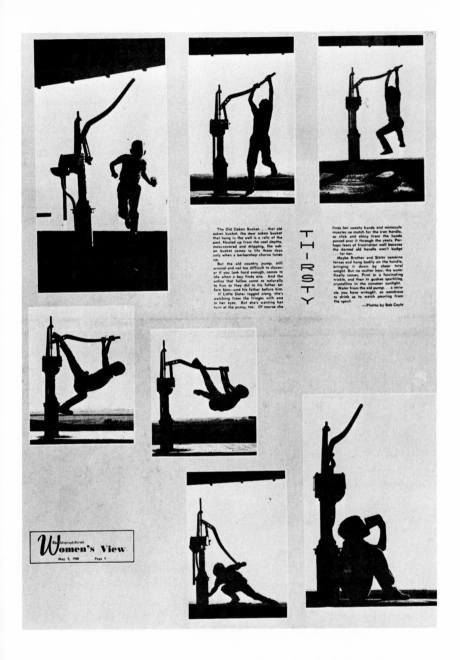

Fig. 10-6. When planning a picture story, the photographer should know approximately how many pictures are to be used and what type of layout is planned. The picture story should have a central theme that ties all the photos together. Photos by Bob Coyle, editorial layout by James A. Geladas, the *Telegraph Herald,* Dubuque, Iowa.

Fig. 10-7. This picture of an inmate in a school for wayward boys by Fred Comegys evokes a sympathetic response from the reader which the newspaper editor looks for in feature photos. It placed first as "Picture of the Month" and ran on the cover of the NPPA magazine in 1968. Courtesy of the *Wilmington* (Del.) *News-Journal*.

They should be careful, however, that one entire roll of film is not confused with another, or the numbering system will be valueless.

The best time to get a name for identification is as soon after taking the picture as possible. I carry a small notebook for this purpose, write down the number of the film, and make sure that I spell each person's name correctly. Identification is no major problem if there are only two or three people involved in an entire picture series, because one should know each by sight after getting their names the first time.

FEATURE PICTURES

A feature photograph may create a mood, present information, or have continuing interest. It differs from spot news photographs in that

the former can normally be used the next day as well, whereas the latter is of value only while the news is hot. Feature photographs are more striking, have better composition, and like the picture story, require more planning.

Many feature photographs are taken by public relations photographers, who try to shoot something unusual or striking that publications will print and at the same time give their client free publicity. Probably the most common subject for feature photographs is a pretty girl, usually in a bathing suit at a resort, water skiing or participating in some other outdoor activity. It is easier to get a picture of a pretty girl published than almost any other type of photograph. Children and animals are also favorites.

Beautiful scenery, such as the photographs put out by railroads, airlines, or famous resorts, often finds its way into newspapers and magazines, particularly in travel articles or on the travel page of a newspaper. Movie stars, television personalities, political figures, and well-known persons are also good material for feature photos. Sports personalities get more than their share of feature photo coverage because of the great interest in sports pages of newspapers and sports magazines.

It is difficult to say what makes a perfect feature picture; it should have impact, singleness of purpose, and universal appeal. The subject matter should stand out, and the best feature pictures have no distractions in the background.

Fig. 10-8. "Guts," so named the brave cat that is carting away this bear's dinner, was taken with a Leica M-2 fitted with a 135mm lens on Plus-X film. Photo by William Senft.

Humorous incidents lend themselves well to feature pictures. A cat nursing an adopted litter of baby squirrels, for instance, or a bird nesting in an old straw hat would be good examples of feature picture subjects. Freak happenings, such as a straw that had been driven through a telephone pole in a tornado, a plant growing in an unusual shape, or a hen's egg shaped like a seashell, also make good feature picture material.

Some feature pictures can be a combination of spot news and feature material as well. This is particularly true of a photograph of a mother crying because her son has drowned or the explosion of the German dirigible Hindenberg as it approached its moorings in Lakehurst, N. J., in 1937. A child's first day at school, his first haircut, or little girls dressing up in their mothers' clothes are common feature photo subjects.

Many feature pictures are used to illustrate advertising. Photography has largely replaced the work commercial artists used to do in that field (see Chapter 11 on advertising photography). Magazines also use many feature pictures on their covers. Certain types of pictures showing action, such as an old steam-driven locomotive in operation, a sailboat under full

Fig. 10-9. This feature photo, "Handy Man for the Band," was a first place winner in the Wisconsin Press Photographers Contest, 1960. It was also used in *Life* magazine as a miscellany. Nikon F, 200mm lens, Tri-X film. Photo by Ed Stein.

sail, a ballet dancer executing a *pas de deux,* or an adventurer shooting dangerous rapids in a kayak, all have universal appeal and appear often.

Feature pictures and picture stories are everywhere, and all the photographer has to do is learn to recognize them.

SUMMARY

Picture stories are used everywhere—in large national magazines as well as in the smallest weekly newspaper. The photographic picture story began in the United States in 1925 and has developed from that time.

A picture story may be the work of one person or a team. Often this depends upon the size and policy of the publication. From the editor's viewpoint, probably the most important thing is to have not only enough pictures but a variety, in order to make an attractive layout. In the case of large magazines, only about three or four per cent of the pictures made for a story will finally appear in the published form.

The three main types of picture stories are picture-text combination, pure picture story, and picture story within text story. Although some picture stories develop spontaneously, most are produced after much study and preparation, often including a script for the photographer to follow. The idea or theme is the most important part of the story. Many develop from studying what other photographers are doing and perhaps adding a new twist.

In studying picture stories, one should not look only at those publications sold on newsstands but also at house publications and other specialized publications circulating to persons in a particular field. These publications can be found in large public libraries.

The mark of a good photojournalist is an inquisitive mind. He must also be a trained observer. To such a person the appearance of something unusual immediately sparks an idea for a picture story. Research is the key to photojournalism, as it is to any other type of journalism.

Everyday occurrences, such as a rainstorm, a policeman on his beat, the postman making his rounds, or a taxi driver picking up or discharging fares, will make a good picture story with the right treatment.

When the photojournalist specializes in one area, he may become widely known and be asked to do work in this particular field by many types of clients.

In planning the picture story, the photographer should know approximately how many pictures are to be used in the final layout and what type of layout is planned. If he cannot write a script, he should seek the services of someone who can. The script is used to tie the central theme of the story together.

In taking a variety of pictures for the picture story, there should be some medium shots, some close-ups, and some long shots, as well as a

variety of angles to add interest and expedite the work of the picture editor or layout man.

Even if the press photographer does not write his own captions, he should clearly identify every person that he possibly can in a photo. It is most important that he stop and get accurate identification of the main persons in a picture.

Feature pictures require more planning than spot news, which arises instantaneously. Many feature photographs are taken by public relations photographers, and the most common subjects are pretty girls, children, and animals.

It is difficult to state what makes a perfect feature picture; it should have impact, singleness of purpose, and universal appeal.

Photography has largely replaced the work of the commercial artist in the advertising field.

QUESTIONS

1. When was the first picture story made?
2. Give your definition of a picture story.
3. Where are picture stories most commonly found in today's publications?
4. What type of personnel is involved in producing a picture story for a large magazine?
5. What should the photographer consider in taking pictures for a picture story?
6. Approximately what percentage of the pictures shot in preparation for a picture story in a large magazine are finally published?
7. What is a picture-text combination story?
8. What is a pure picture story?
9. What is a picture story within text story?
10. Where can the photojournalist get ideas for picture stories?
11. Discuss how many pictures you would shoot and what kind of subject you would choose in producing a picture story on a rainstorm for a metropolitan daily.
12. What is the advantage of a photojournalist's becoming a specialist in one particular field of photography?
13. What is meant by the *theme* of a picture story? What does it do?
14. How can the photojournalist get variety in his picture stories?
15. Why is identification of subjects in picture stories so important for the photographer?
16. What is a feature picture? How does it differ from a spot news picture?

Advertising and Architectural Photography and Composition

ADVERTISING PHOTOGRAPHY

In Lincoln's political campaign of 1860, badges bearing a tintype of the candidate appeared for the first time. This was the first direct use of photographs in advertising, although a New York firm selling men's hats had advertised in the New York *Daily Tribune* in 1853 that the purchaser of a hat would be given a free Daguerreotype of himself.

Before the first halftone engraving was printed in 1880 in the New York *Graphic,* an illustration was handmade by an engraver. Sometimes engravings were copied from photographs, usually to illustrate news stories. Most of the advertising illustrations of the period were small linecuts, and most newspaper advertisements were small. Even brand names, except for patent medicines, were not common. Not until World War I did the advertising photographer begin to come into his own.

At the same time that methods of marketing were changing from unbranded bulk products sold through jobbers to branded products put into individual packages, the quality of film was improving and the speed of lenses increasing. Marriage of the trends in these two fields resulted in the advertising photography industry, which developed rapidly in the 1920's and has grown to the point where the frequency of the use of photographs in advertising is several times greater than that of any other type of illustration.

If it were not for advertising revenue from space sold, very few publications distributed on a subscription basis would be a financial success. Money received from regular subscriptions will seldom even pay for the

Fig. 11-1. This is an ad for a hat detective camera, which was being sold around 1889. Notice the appeal for its use as a candid or secret camera. This ad appeared in the *British Journal Almanac*. Courtesy of the George Eastman House Collection.

paper used in publication, let alone cover the overhead of plant equipment, printers' wages, and various wire or other services that publications subscribe to in order to have news and feature material for their readers.

The entire economy of the United States is geared to mass production and mass distribution. Advertising is the method by which "news" of new and old products reaches the consumer. Generally speaking, advertising is not an expense in itself but a part of the cost of distribution, for mass distribution makes it possible to buy a new mass-produced automobile for $3,000. The same car made in small quantities would have to be priced many times higher in order for the manufacturer and dealer to realize a profit.

Mass distribution requires mass advertising. Using high-speed rotary presses, daily newspapers are able to print the papers that distribute these ads at a rate of 50,000 to 60,000 copies per hour. Some of the huge web-fed presses will print more than 100 pages, including some pages in full color, at one time. It is possible for one advertisement placed by a national advertiser to reach a great percentage of the population of the United States in one day. Although the cost of the original ad, including the photograph, may run into thousands of dollars, the cost per printing

impression is infinitesimal. Such photographs are bought through advertising agencies, which usually employ some of the nation's top-name photographers.

The small local advertiser usually cannot afford the services of an advertising agency, and he must either do his own advertising or rely on the services of the display advertising salesman from the local newspaper. He needs good photographs to illustrate his product properly just as much or even more than the national advertiser, if he is to compete for sales.

To provide illustrations for the small advertisers, newspapers subscribe to one or more *mat* services. These mats are usually received on a monthly basis and come in large sheets that can be cut apart when a particular mat is desired. The mats are made of a special paper pulp that will withstand the heat of the hot metal poured upon them in a special casting machine. They will form either line or halftone engravings, which can, in turn, be used a number of times, since the metal from the engravings is melted down and re-used. Relatively cheap, the mats are mass-produced by mat services for distribution to many newspapers.

Larger department stores and chain stores usually subscribe to special mat services for their particular type of store; they also employ artists to prepare the ads for the store, so that the advertising salesman has little to worry about besides picking up the ad and making sure the store receives a proof of it before it appears in the newspaper.

Unfortunately, mat services seem to cater to certain types of businesses and to neglect others. For instance, illustrations for a department store ad are easy to find, whereas locating certain photos of food dishes to illustrate a restaurant ad may be nearly impossible. Also, many of the mats are of a somewhat general nature and not suitable for use by a store that has a "personality" of its own.

For these reasons, photography often plays an important part in the advertisements of smaller companies or service industries. A large photograph showing a drive-in restaurant or a close-up of one of the restaurant's attractive employees holding a tray of food may create more readability than just a cut made from a mat clipped from the mat service book.

Another problem is that most small merchants have not studied advertising and often lack creative ideas. Photographing a pest exterminator's fleet of vehicles may lend credibility to his ad by showing the reader the large size of the organization, whereas giving the reader such an impression through the use of good copy alone may be more difficult and in some cases, almost impossible.

The beginner doing advertising photography for a newspaper should be careful of the type of subject he attempts and limit his area to work that he can do properly. Even a subject as simple as a plate of food should not be chosen unless the photographer has sufficient experience to turn out a picture of professional quality. Most food photographs are taken with a large camera, such as an 8" × 10" or 11" × 14" view camera, in

Fig. 11-2. "The good old days—who wants them?" is the implication in this publicity photo by a major tire manufacturer. Contrasting old and new in this photo helped gain reader interest and the attention of newspaper editors throughout the nation. Courtesy of Goodyear Tire & Rubber Co., Inc., Akron, Ohio.

a studio furnished with an array of professional equipment. A picture of a boy eating a hamburger or a youngster drinking a glass of milk is more commonly the type of photography that a news photographer can perform well.

It is also important not to include too many items in an advertising photograph. The fewer persons and the less clutter in the picture, the easier it is for the reader of the newspaper to distinguish what the photograph is. The photographer must remember that pictures reproduced in newspapers are subject to some smudging and considerable loss of tone, because of the very nature of the process, although offset printing on the better grades of paper gives better photographic reproduction than does the letterpress process.

Because advertising photography covers all types of situations, no one camera is best for this type of work. The photographer should determine beforehand that he understands what he is going to photograph and either have or borrow the equipment necessary to do the job. It is not a sin to tell a customer that you do not have the proper equipment and to suggest that he hire another professional who can do it, or else you can

recommend a different type of picture. This is much better than having a dissatisfied account.

It is also possible to take a picture for the advertiser and then have the art department, if the newspaper has one, or a commercial artist make a drawing from the picture, when the object or equipment cannot be photographed so that it will appear to the best advantage. The artist may be able to make a drawing that will do this or save poor photographs by retouching. One of the most useful tools of retouching is the airbrush, which enables the artist to block out backgrounds, put highlights on machinery, add foliage, and do numerous other things to enhance the quality of the photograph for reproduction.

Of course, this work costs money, and the photographer or advertising salesman taking the photograph should explain the cost to the advertiser before going ahead with the work. If there are any additional charges to the advertiser for photographic or other services, he should clearly understand them beforehand, to avoid any misunderstanding later when he receives the bill.

The photographer should be sure to get model releases from all subjects who appear in any photograph to be used for advertising (see Chapter 17 on model releases). Written permission should also be obtained for the use of any copyrighted material, such as the words of a song or a poem, several paragraphs from a printed work, or a copyrighted picture. There are also certain legal restrictions pertaining to copying money, postage stamps, passports, money orders, draft cards, badges, and other official items.

Fig. 11-3. This type of advertising photograph is furnished to local newspapers to show the type of equipment, before it is delivered or while a bond campaign is being conducted, which taxpayers can expect to get for their money. American LaFrance employs a photographer on a free-lance basis to photograph their equipment. Courtesy of American LaFrance, Elmira, N.Y.

ARCHITECTURAL PHOTOGRAPHY

Although many press photographers do not expect it, they are occasionally called upon to do architectural photography. The most common such assignment they receive is to photograph the front of a new store or some other new building to illustrate a news story about its opening. Sometimes the editor of the Sunday magazine section may want a number of pictures from which to choose a comprehensive layout to illustrate a feature on one of the fine homes or historic buildings of the community.

Some of these photographs can be taken with an ordinary twin-lens reflex or 35mm camera. However, when the building is tall, the street is narrow, or telephone poles, trees, or other objects obstruct the view, a wide-angle or extreme wide-angle lens is the only one that will include all of the desired features in the negative.

If the camera must be tilted back to include the upper portion of the building or swung to one side to include the end, the resulting picture will have converging vertical lines and distortion. This is the type of picture Aunt Minnie takes with her box camera when she shoots up at Uncle Harry standing on the front steps of the state capitol building.

One must remember that even though the building is actually distorted when the human eye views the top from the base, the brain refuses to accept this impression, and the viewer does not see the lines as converging toward a point but as parallel to each other. This is what the viewer's brain tells him is correct when he looks at the finished photograph. Although he may not be able to explain it to the photographer, he knows something is not right in a photograph in which the building appears to topple over or the lines are not parallel.

Correction Methods

Except for the Nikon, which has one special lens (the 35mm focal length perspective control), and the Rolleiflex SL66 single-lens reflex, which has a bellows, no cameras other than the press and view cameras have any means of making corrections for architectural photographs, and the former two allow only limited corrections.

It is possible to correct a certain amount of distortion by either tilting the negative in the enlarger or tilting the paper board or both. The paper should be tilted in the opposite direction from the negative, and the lens must be stopped down considerably to keep the projected image in sharp focus. Depending upon the lens and the magnification involved, the image will appear either elongated or compressed in relation to a straight print from the negative. In the long run, it is preferable to correct the converging lines on the negative itself.

It is desirable that the focal length of the enlarger lens be greater than that of the lens used on the camera. In making large prints, some photographers produce a copy negative with the corrections under the enlarger and use the copy negative for making exceptionally large prints

Fig. 11-4. The Schneider PA-Curtagon 35mm Perspective Adjustment, $f/4$, moves 7mm out of elliptical axis in order to correct the perspective when taking photos of tall buildings; when shifted to the side, it can be used to correct perspective on wide buildings. This lens and a similar one for the Nikon camera give some of the advantages of bellows-equipped view cameras to 35mm SLR's. The Curtagon can be adapted to most 35mm SLR's; however, the one for the Nikon can only be used on that make camera. Courtesy of Burleigh Brooks, Inc.

that would have been impossible using the tilted-negative effect described above.

The view camera, the most versatile of all cameras, has three principal movements in front: the rising front, which raises the lens higher; the lateral swing, which tilts the lens at an angle; and the vertical swing, which swings the lens at an angle to one side or the other. The back of the view camera usually has two movements—a vertical swing and a lateral swing.

Through the proper use of these camera movements, it is possible to correct the perspective in almost any situation the photographer will encounter. It requires considerable practice and experimentation to know immediately how to make a certain correction, but the photographer can

Fig. 11-5. This $4'' \times 5''$ Linhof has triple extension bellows, rising front, sliding front, movable back, and is a precision instrument that will give all the movements needed for architectural work. Courtesy of Berkey Marketing Co., Inc.

always look at the groundglass to view the image before he photographs it and see that it is in proper pespective. For this reason, it is desirable to use a 4″ × 5″, 5″ × 7″, or 8″ × 10″ view camera when attempting to make complex corrections.

Another factor involved in the use of the view camera is that some wide-angle lenses allow more control than others. Some photographers use a lens that would be an extreme wide-angle lens on a 5″ × 7″ camera as a lens on a 4″ × 5″ camera, in order to make greater corrections of the perspective of vertical lines.

Press cameras allow only limited corrections, because they usually have only a rising and tilting front, as does the Speed Graphic, or they also have a swing back, as do some models of the Linhof and the Mamiya. The Linhof and the Speed Graphic allow certain slight horizontal corrections also, but these are relatively insignificant.

One of the easiest movements to use on a view or press camera is the rising front, which allows the camera to remain level yet capture an image of a tall building or other subject. However, if the subject is so tall that even the rising front will not enable the camera to capture the top, another solution must be found. This calls for tilting the camera high enough so that the object being photographed is all visible on the groundglass. The camera back is then put in a true vertical position by loosening the control knob and tightening it again when the back is vertical. The image may be out of focus at either the top or bottom with the lens wide open, but stopping down will make it sharp. A similar sideways correction of converging lines can be made by placing the camera back parallel to the subject being photographed.

If the front lensboard of the camera is swung parallel to the back after the back is placed in a corrective position, less stopping down is needed to get the entire area on the groundglass in focus. Through using the different movements, it is possible to get everything in focus from very near the front of the camera to a great distance away, even though the lens being used is of normal or longer than normal focal length.

Once when I was photographing a large structure with a 4″ × 5″ view camera and an eight-inch focal length lens, I was able to get everything in focus from about 3 or 4 feet in front of me to 150 feet away at the top of the eight-story structure, later making a 30″ × 40″ print from the negative, which showed no degree of unsharpness at any point on the print. Using a view or press camera for photographing architectural subjects both indoors and out requires considerable time and patience. Much

Figs. 11-6a and b. These two photographs were taken at approximately the same time, but from different viewpoints. Psychologically there is a great difference in the mood of these two construction photos. It is important for the photographer to study architectural subjects for lighting, texture, and viewpoint before making exposures. Photos by author.

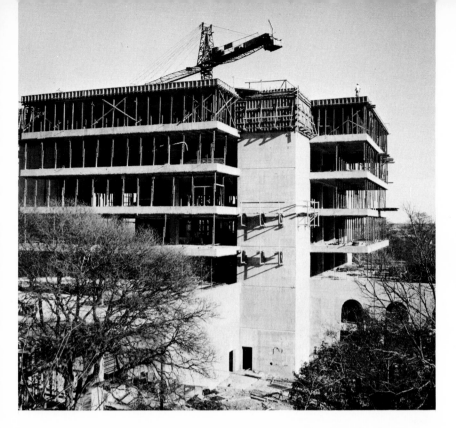

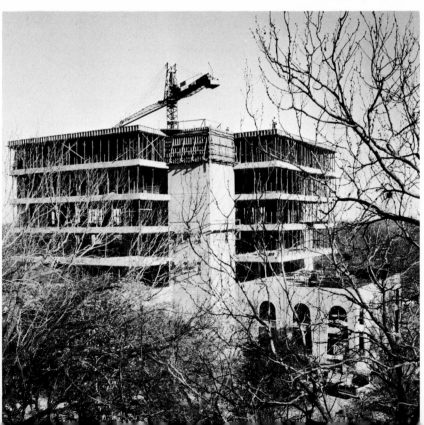

can be learned from studying the camera and the various things that can be done with it while on location.

Another application of front and back camera movements that a photographer may find valuable is being able to photograph a building or another subject from off-center, yet make it appear as if the photograph had been taken directly in front of it. This is accomplished by putting both the front lensboard and the camera back parallel to the subject yet with the lensboard shifted to one side, closest to the center of the object being taken. In the case of a press camera that has only a small sideways shift, it is possible to mount the lens on the lensboard on one side, thus giving the same effect as achieved with a view camera that has a lateral shift.

It is sometimes possible to make an acceptable picture with a camera that has no corrective movements by purposely tilting the camera cornerwise so that the main part of the picture runs on the diagonal. Numerous examples of this technique can be found in publications if one keeps his eyes open, usually in pictures of a tall building, smokestacks on a factory, or some such object. Although the lines converge in such a picture, the unusual effect seems to prevent them from bothering the viewer in the way that a straight picture in which the building appears to be toppling might.

Architectural photographers often try to photograph a building in such a way as to make it appear larger or more beautiful than it actually

Fig. 11-7. This house, where President Lyndon B. Johnson lived while he was a student at Southwest Texas State College, was photographed late on a cloudy afternoon to cut down on the glare from the freshly painted white siding. The author removed a large canvas from the front porch and "policed" the yard and sidewalk for debris left by workmen before taking this picture. Photo by author.

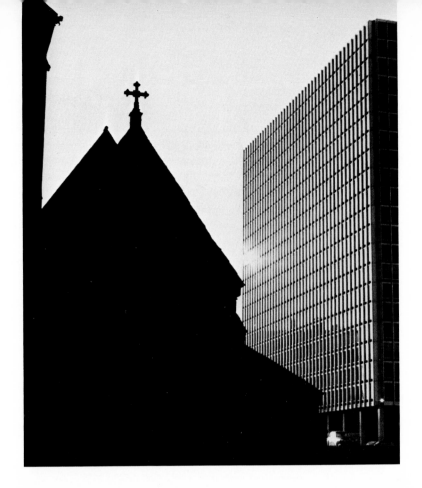

Fig. 11-8. "Old and New" won the first prize in a Newark, N.J., photo contest during the annual regional Photo Seminar of the National Press Photographers Association, 1967. Taken with a 35mm Canon, 50mm lens, f/16, 1/1000 sec., Tri-X film. Photo by John G. Kenney.

is. They will first study the building from all angles, taking into consideration the lighting at different times of the day. A building photographed early in the morning will not look the same as when taken from the same spot at 2 P.M. Some buildings will photograph best at one time of the day, and some at another.

Even if the ground is bare and lacks shrubs and landscaping, photographers have been known to use artificial foliage, place potted flowers on the ground, or even hold a tree branch over the top of the camera so that a little of the foliage shows and frames the photograph to give it a scenic effect.

With certain buildings, the photographer may want to show the ruggedness of rock or the texture of brick, and to do so he must first make a study of the angles and lighting of the building.

Shooting interiors of buildings may entail placing photofloods in lampshades or moving furniture in order to make the room appear cozier, larger, or in some way different. Such photography requires a certain amount of planning and good powers of observation. Looking through the groundglass of a view or press camera, more than any other type of camera, enables the photographer to see which angle will photograph best. The person who is creative, has some ingenuity, and takes time to study the subject will make better architectural photographs than will the one who just goes in and shoots away haphazardly.

COMPOSITION

There are many rules of composition, and many good photographs break the standard rules. It is difficult to say that any subject should be photographed in one certain way, because of the difference in the uses to which the photograph may be put and the different ways in which various photographers interpret the subjects they see.

One of the most common guidelines for composition suggests divid-

Fig. 11-9. In order to obtain balance in this picture and to compensate for the subject's looking to the right, it should be placed closer to the left in the final layout. Converging lines in the field and the water spray on top also help to keep the viewer's eyes directed at the main subject. Courtesy of Campbell Soup Co., Camden, N.J.

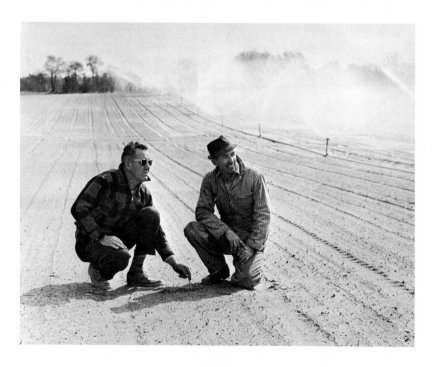

ing the scene into thirds both horizontally and vertically, giving nine parts to the picture, and then placing the subject at one of the four points where the horizontal and vertical lines intersect. This places the subject at neither the exact center nor the extreme edge of the picture and adds interest by having near but not perfect symmetry.

The subject should, of course, be moving into the picture rather than out of it; to get this psychological effect, a boy walking, showing his profile, should be walking toward the center of the picture rather than toward the edge. In the latter instance, the eye tends to follow out of the picture toward some other subject; what the photographer should do is to keep the viewer's eye on his picture.

Many of the rules of composition are based on the psychological and aesthetic involvements of the viewer and the photographer. For this reason, it is desirable to keep the subject away from the very edge and from the exact center of the picture and to allow more space in front of the subject than behind him.

The subject's eyes should never be staring directly at the photographer except in rare cases. In pictures of people, it is usually more desirable to have them looking at one another doing something, rather than just staring at the photographer as is so common in many newspapers and magazines, particularly in the smaller publications.

It is desirable to keep the picture as simple as possible, with three persons or fewer, and to eliminate all clutter such as gum wrappers, tin cans, half-drawn venetian blinds, papers, telephone wires, trees, or any foreign objects that play no part in the picture. A good professional photographer will police the area, picking up all paper and other debris, if the picture is outdoors. He will either avoid distracting backgrounds or throw them out of focus by using a combination of fast shutter speeds and wide apertures. Indoors he will either synchronize his light so that he captures the view through the window or close the venetian blinds to eliminate all light from outside and form a pleasant background. Sometimes it is necessary to move furniture (with permission, of course), remove pictures or calendars from a wall, tidy up a desk, or even borrow another desk in taking a picture for publication. (See Chapter 9 on backgrounds.)

Many pictures appear in publications in which the subject has a telephone pole or tree growing out of the top of his head. Such pictures can be avoided if the photographer is aware of the background where he is shooting and changes to a different angle.

It is not desirable to split a picture in the middle either by having perfect balance on each side or by arranging a group in a symmetrical form. Uneven numbers of objects are psychologically more pleasing to the viewer than are even numbers.

Extreme high-angle or low-angle pictures sometimes give an unusual composition to a photograph. An example would be setting the camera

on the ground with the lens pointing upward and photographing a group of football players in a huddle looking down into the camera. A flash picture taken in this way makes an effective shot. An example of a high-angle shot might be one of a crowd scene in Times Square on New Year's Eve, taken from a tall building, showing the myriads of celebrants from above.

Most landscape photographers try to keep the sky either in the top third or top two-thirds of the picture, depending upon the effect they desire and the subject being photographed. Photographers also look for certain artistic forms, such as an "S" or "Z" curve or crescent or triangular shapes, in attempting to make pleasing compositions. A difference in contrast of white against black as well as in size will also help to create a pleasing effect.

Perhaps the best rule for the beginner is to attempt some of the standard compositions and then work out new ones of his own. Some ideas can be obtained for scenic views from looking at picture postcard scenes sold by places that cater to tourists. A favorite technique of this photographer is framing buildings or other scenes with overhanging branches. Some photographers achieve this effect even when no trees are available by cutting off branches and having someone hold them so that they will appear on the groundglass of the camera. Commercial photographers who use this technique also rent plants and other props to improve a bleak-looking landscape or building.

However, the photographer should not try to copy the work of others exactly but should develop his own compositions, disregarding the rules when the occasion warrants. How well I remember seeing the work of an art student who had studied under a very famous Missouri artist. It was quite evident that the student was the artist's pupil, because his work was an exact copy of that painter's unusual style. Probably the reason that this student did not become a successful artist is that he had not developed a style of his own. This illustration applies to photography as well, for it is equally as important for the photographer to develop his own distinct style.

The artist can view a scene and take the component parts and rearrange them so that they make an attractive painting. The photographer, however, must either shift his viewpoint to make the composition attractive or rearrange some of the objects within the picture. Thus, a photographer will usually take several different angles when shooting any one

Figs. 11-10a and b. Pattern shots can be found in many places, indoors as well as out. They are often used in advertising, but are not uncommon in Sunday photo feature sections. These photos of motorcycles being assembled in the Harley-Davidson plant are typical examples of pattern shots. Both photos were taken with a 35mm SLR on Tri-X film using available light. Courtesy of Harley-Davidson Motor Co., Milwaukee, Wis.

Fig. 11-11. The circles of wire in this pattern shot by Fred Comegys subtly focus attention on the man working with them. Pattern shots can be found in piles of lumber, stacks of brick, concrete culverts, pipes, and many other objects, and the enterprising photographer will train himself to see the endless possibilities. Courtesy of the *Wilmington* (Del.) *News-Journal.*

scene; there is also the factor that one type of composition may fit better in the page layout than another. A good photographer will take this into consideration and study the layout, if he has been furnished one, or take pictures that can be used in various layouts.

The strong point in the picture should be emphasized by arranging supporting details so that they direct the viewer's eye toward that point. The photographer or photo editor may also emphasize the strong point by cropping the picture to de-emphasize or eliminate unwanted parts that were included in the negative.

It is desirable to balance one object in a picture with another. A large, light object may be counterbalanced with a smaller, darker object.

According to the Gestalt theory of psychology, the human brain tends to conceive of objects as rougher than they are if irregular in shape and smoother than they are if the object is smooth. The texture of an object as it appears in a photograph can often be controlled by either the angle of the shot or the lighting. Although some highly successful prize-winning pictures have been happy accidents, most consistent prize winners shoot pictures that are pre-planned, at least in the photographer's mind, before the shutter is actually snapped.

SUMMARY

Advertising Photography

The first use of an advertising photograph was during Lincoln's campaign of 1860. Not until the advent of halftone engravings in 1880 did advertising photographs start to come into popular use. Extensive use of

photographs in advertising came about during World War I, with the introduction of brand names and modern marketing methods.

Photography in advertising increased rapidly during the 1920's, until today the use of photographs in advertising is several times that of other art.

The entire economy of the United States is geared to mass production, calling for mass distribution; mass advertising is the method of assuring that distribution. It is possible for one ad placed in a number of publications by a national advertiser to reach a large percentage of the population of the United States in one day. Photographs for such use are bought through advertising agencies.

Because it has a personality of its own, photography is often used in ads by smaller companies or service industries, in preference to a standard ad illustration clipped from a mat service book.

The fewer persons and the less clutter in the picture, the better the advertising photo generally is. Some types of ad require large-format cameras, and others may be taken with a small-format camera.

Getting a signed model release from all subjects appearing in any advertising photo is of utmost importance.

Architectural Photography

Most architectural photography is done best with a press or view-type camera, which has certain camera movements that correct for distortion. When other types of camera are used, some distortion can be corrected in the darkroom.

View-type cameras also offer the advantage of interchangeable lenses, enabling the photographer to have the proper focal length lens for the subject he is photographing.

Movements of view cameras include rising, tilting, and side movements in both front and back.

It is important for the photographer to study the lighting and surroundings of a building before photographing it in order to discover the best angle and lighting conditions.

Composition

Subjects of pictures should be placed neither at the exact center nor the extreme edge, except for some unusual reason. A moving subject should be moving toward the center of the picture, rather than toward the edge. Generally, a subject's eyes should not be staring directly out of the picture.

The area should be policed for debris before the picture is taken. Telephone poles, trees, and other undesirable objects should be eliminated from pictures by changing the angle of view whenever possible.

An extremely high or low angle may give unusual impact to some photographs. Following some artistic form, such as an "S" or "Z" curve

or a circular, crescent, or triangular shape, may make the composition more pleasing. The strong point in a picture should be emphasized by directing the viewer's eye toward it.

QUESTIONS

1. What is the basis for the revenue of most publications?
2. Explain how mass advertising helps in the mass distribution of products.
3. How has the printing industry made it possible for wide distribution of national ads?
4. What are some problems of the small newspaper advertiser regarding advertising photography?
5. What is a mat service?
6. Why should a beginner be cautious with the type of advertising photography he attempts?
7. What is the best type of camera for advertising photography? Explain.
8. When should the newspaper advertising photographer suggest that the advertiser hire a professional photographer?
9. How is an airbrush useful in retouching photographs in advertising?
10. Why should a photographer get a signed model release from all subjects who appear in an advertising photograph?
11. What is the most common assignment that a press photographer receives in architectural photography?
12. What are the advantages and disadvantages of the small-format camera as contrasted with the large-format camera in architectural photography?
13. How can converging lines or other distortions be corrected in the darkroom?
14. What are the three principal movements of the view camera and what do they do?
15. How does a press camera differ in use from a view camera in architectural photography?
16. If the ground is bare and lacking in shrubs and landscaping, how can the photographer correct the situation in his architectural photographs?
17. What is one of the most common guidelines for composition? What does this do?
18. Give several rules of composition, including the use of contrast to create pleasing effects.

CHAPTER 12

Sports and Spot News Photography

SPORTS

SPORTS PHOTOGRAPHY can be fun, especially if the photographer is a sports enthusiast. For certain sports, however, being a good photographer takes much physical effort, an excellent sense of timing, and some luck in being fortunate enough to be in the right spot at the right time. The photographer who goes out to cover a sports event and knows nothing about the rules of the game, the names of the players, or the correct place to stand in anticipation of the results of a certain play will find that he offers little competition to the veteran sports photographer.

No matter what type of camera or lens the photographer uses, he will find that each has certain limitations and certain advantages. The most successful sports photographer is the one who knows what his equipment will and will not do and shows some originality in covering sports events.

Football is probably the most photographed sport, because of its great popularity and the large number of games that are played. Its season comes at the beginning of the school year, when many school photographers also cover this one sport. Basketball and baseball are also heavy favorites of sports photographers.

Cameras and Lenses

At one time many of the best-known sports photographers carried a 4″ × 5″ or 5″ × 7″ single-lens reflex Graflex camera with a long telephoto lens, sometimes having a focal length as long as 36 or 40 inches.

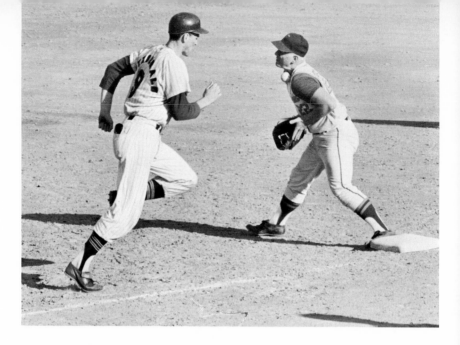

Fig. 12-1. Eddie Davis, who took this humorous photograph, was alert and ready to capture the action at this baseball game. As a result, it won him first prize in a sports photography competition. Courtesy of the *Gainesville* (Fla.) *Sun*.

These cameras were known as "Big Berthas" because of their great weight and bulk.[1] It took one or more tripods or some other sturdy support to handle these big cameras.

However, most of today's sports photographers have gotten rid of the big cameras and are using small single-lens reflex cameras, mostly 35mm and 120 film size, with either fixed focal length telephoto lenses or one of the zoom lenses. The latter lens changes focal length and enables the photographer to change his image size, depending upon whether he is down on the sidelines, up in the stands, or at the top of the stadium in the press box.

There is no one universal camera or focal length lens used in sports photography. A small newspaper covering mostly high school games, such as the Biloxi-Gulfport (Mississippi) *Daily Herald*, may cover football and basketball games with a Mamiyaflex and a 180mm lens. A photographer working for the Kansas City *Star* may be using any one of three cameras: a 4″ × 5″ if he is shooting color; a 2¼″ × 2¼″ twin-lens reflex or a 35mm if he is shooting black-and-white. The camera used will also depend, of course, upon the photographer who has the assignment.

If he is working on a newspaper like the *Daily Oklahoman* (Oklahoma City), he will probably be using a 35mm Nikon or Pentax single-

[1]They were named after the huge German cannon of World War I fame.

210

lens reflex for football, whether the picture is to be taken in color or black-and-white. For basketball, he would most likely be using a 2¼″ × 2¼″ Rolleiflex, because most of the pictures will be taken with strobe rather than available light.

Sports photographers for the New Orleans *Times-Picayune* will probably use a 35mm Pentax with 200mm and 400mm lenses for the Tulane and Louisiana State University stadiums because the lighting is bright. For the dim lighting of local high school games, 2¼″ × 2¼″ Mamiyaflexes are used with electronic flash in order to stop the action.

The camera-film combinations used by any sports photographer may depend upon several factors: whether the camera is his or the newspaper's; the type of sporting event; the lighting; the use of the pictures (feature vs. regular sports-page use); what equipment and supplies are available.

There are also special rapid-sequence cameras that have been converted from 35mm motion picture cameras and shoot at a very high speed, somewhere between 1/750 sec. and 1/1000 sec. A number of 35mm cameras either have built-in spring motors or electric drives for making

Fig. 12-2. A 400mm and 560mm Leitz Telyt, *f*/5.6 lens, in a rapid-focusing mount, with a prism viewfinder for Leica rangefinder cameras. These lenses are handy for taking pictures of sports, wild life, or similar shots requiring long focal-length lenses. The follow-focus allows the photographer to follow rapidly moving sports action, such as football or racing. Courtesy of E. Leitz, Inc., New York.

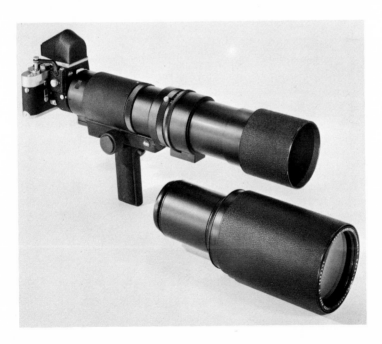

rapid-sequence pictures. By shooting enough bursts throughout a game, the photographer is almost sure to have a good sequence.

Flash Equipment

For sports photography, even the beginning photographer working the sidelines of a football field should have a camera with a very fast shutter, 1/1000 sec. being preferred. One of the problems of using a focal-plane shutter in shooting games, such as basketball, is that most focal-plane shutters do not work satisfactorily with electronic flash at speeds greater than 1/60 sec., and some will work only at 1/30 sec. Because of the slow shutter speed and the amount of existing light, there is a tendency for the photographer to get ghost images when using electronic flash units at such slow speeds. With electronic flash units, most photographers prefer to use a leaf shutter of some kind, such as is found on twin-lens reflex cameras and some of the 2¼″ × 2¼″ and 35mm single-lens reflex cameras. However, focal-plane flashbulbs will synchronize up to 1/1000 sec. on most cameras with focal-plane shutters.

Fig. 12-3. "Mirror, Mirror on the Floor" won first place for sports action photos in the Hudson County, N.J., annual Memorial Awards Photo Contest. At a high school track meet, where it had rained all the previous day, the photographer took advantage of a large puddle to catch the runner's reflection and to illustrate the water-covered track. Photo by John G. Kenney.

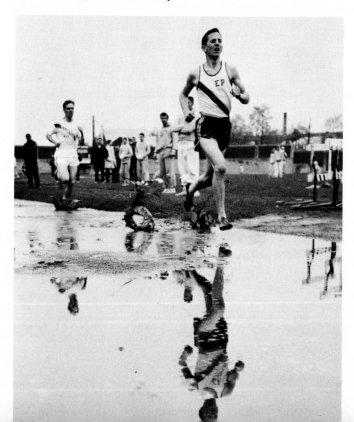

The Super Graphic, which has a leaf shutter with accurate speeds up to 1/1000 sec., is a favorite with some sports photographers. But nearly any camera that has a shutter speed of 1/500 sec. will do quite well in stopping the action in most sports events lit by artificial light when used with an electronic flash unit. In this case, the actual shutter speed is governed by the electronic flash itself, and the picture will actually be taken by the speed of the flash, which may be 1/1000 sec. or 1/2000 sec. Early electronic flash units usually had shutter speeds of 1/10,000 sec., and it is possible to get special units with even shorter durations of time.

It is also possible to obtain electronic flash units that put out much more light than the normal portable unit gives, but these units are usually bulky and require that the lights be permanently fixed and in place before the sporting event begins. This requires permission and a great deal of preparation and is generally used only in the case of rodeos or some outstanding sports event.

Some photographers use slave units, tripped by a photoelectric cell, either fixed in one position or held by the photographer's assistant in such a way that the photoelectric cell is pointing at the photographer's flash unit. The problem here is that other photographers may trip the unit with their own flash, and the photoelectric cell may require shielding. It is also possible to trip these units by radio signal, with a transmitter on the photographer's camera and a receiver on each slave unit. The surest way is to have them connected directly with extension cords, but this is not always possible (see Chapter 6 on electronic flash).

Fig. 12-4. "His Stock is on the Rise" by Roy Miller of UPI won first place in the sports category in the 1967 Annual Pictures of the Year Competition, sponsored jointly by the National Press Photographers Association, the University of Missouri School of Journalism, and the World Book Encyclopedia Science Service, Inc. This spectacular shot shows the disintegration of driver Johnny Roberts' car (his head is sticking out the window) as it flipped over five times during a race at Daytona Beach, Fla. Roberts was not seriously injured.

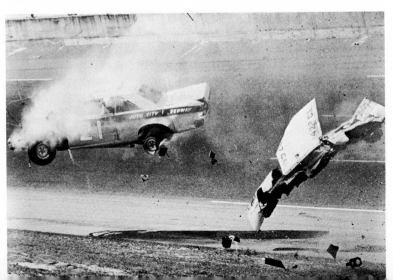

Even with the short duration of electronic flash units and high shutter speeds, it is quite possible to stop action in many different kinds of sports by knowing exactly when the action will reach a peak. If two basketball centers, for instance, jump into the air to hit the ball, as at the start of the game, there is one particular moment when both are in the air at the peak of their jump and will be almost motionless for an instant before they start down. The photographer anticipating this action can take a good picture at a relatively slow shutter speed, even 1/50 sec. or 1/100 sec.

Stopping and Blurring Action

As is true of any motion or moving object, the shutter speed needed to stop action depends upon the direction of movement of the subject in relation to the position of the camera. A racing car photographed straight on as it is moving toward the photographer will require a slower shutter speed to stop the action than the same car being photographed at right angles, from the side. If the same subject is photographed half way between straight on and a 90° angle, the shutter speed needed to stop the action will be slower than that for the right angle but faster than if the photographer were shooting straight down the track at the oncoming car.

There is also the factor of proximity to the camera to consider. The closer the subject is to the camera, the larger will be the image size on the negative. As the image size increases, movement becomes more apparent to the eye. Therefore, it is necessary to use faster shutter speeds when photographing moving objects at close range than when photographing them at some distance.

Most sports photographers normally use 1/500 or 1/1000 sec., if light permits, in order to stop movement under any condition. A good rule of thumb is that moving objects being photographed at right angles require four times as fast a shutter speed as subjects being photographed straight on.

Sometimes the photographer wants to get a blurred image and uses slower shutter speeds in order not to stop all movement in the picture. Another technique that photographers use on such events as auto races or track meets is to pan with the moving subject. This results in a blurred background but more or less distinct image of the subject being photographed. The decision as to whether or not to use a blurred effect depends upon what the photographer is trying to accomplish. Generally, it is better to stop as much action as possible, rather than to have a blur in the picture. Even here, most of the movement is stopped, but an arm, a leg, or a hand will sometimes be blurred because of a quick motion of the subject.

Many sports photographers push the speed of films by development and thus give a film a rating two to four times as fast as it was originally intended to have. The novice, however, should stay with the given rating

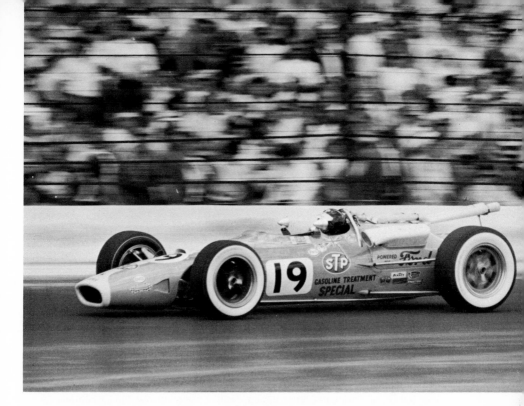

Fig. 12-5. This is a perfect example of panning. Notice how the photographer shows motion in the wheels of the Lotus Ford racer, while the spectators in the background form an interesting blurred pattern. Courtesy of Ford Motor Co.

of a film until he gains enough knowledge and experience to be able to compensate and rate the film at a different speed from the one the manufacturer specifies.

Focusing

Because fast-moving action will seldom permit a photographer to focus fast enough to snap a picture, most sports photographers learn the distances on the playing field from the location of their camera and predetermine the correct camera setting for important playing areas of the football field, track, or basketball court.

The old Big Berthas had a lever that enabled a photographer to change his focus as the action moved from different parts of the field, using either notches or marks. This enabled the photographer to keep the action in focus without concentrating on focusing the camera but, rather, on the play taking place. With the popular single-lens reflex, some sports photographers use a lens such as the Novoflex, which changes focus by squeezing or releasing a pistol grip. Photographers usually work out some kind of a system to solve the problems encountered, and some of the ideas and devices that they employ are quite ingenious. The follow-focus

device is advantageous only to long focal length lenses, since the shorter focal length lenses have a much greater depth of field and need not be focused as critically. The longer the focal length of the lens, the smaller the depth of field.

During the heyday of the Speed Graphic, most press photographers used a wire finder rather than the small viewfinder on top of the cameras for two reasons: first, it was easier for them to frame their subject and know how much would be recorded on the negative. More important, by using the wire finder, the photographer could see to the side and overhead, allowing him to see more than he photographed. Several times this saved photographers' lives, in the case of racing car photography, by enabling them to jump out of the way of crashing cars or wheels flying through the air. There is always a disadvantage in using an enclosed finder or a reflex prism in photographing hazardous events.

Some photographers keep both eyes open while photographing such events, thus gaining some view of what is happening besides what the camera lens sees. Safety pays. One must be especially careful when photographing hazardous events.

Fig. 12-6. This action photo, taken by Don Gould, of quarterback Steve Spurrier of the University of Florida in a game against the University of Miami was blown to 8 columns by 20 inches for a sports section cover of the Ft. Lauderdale *News.* Nikon F, 200mm lens, *f*/11, 1/1000 sec., Tri-X film. Courtesy of the Ft. Lauderdale (Fla.) *News* and *Sun-Sentinel.*

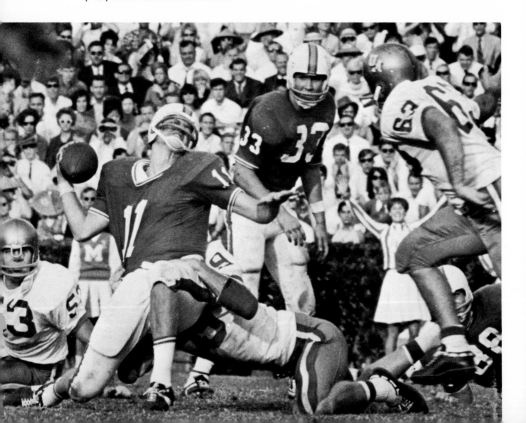

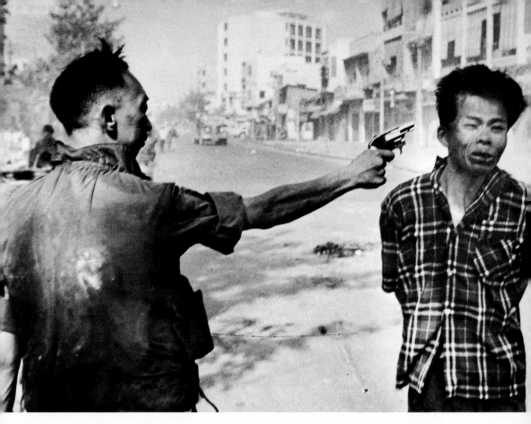

Fig. 12-7. "Viet Cong Officer Executed," taken Feb. 1, 1968, by Edward T. Adams of the Associated Press, won first place in the newspaper spot news category in the 1967 Annual Pictures of the Year Competition, sponsored jointly by the National Press Photographers Association, the University of Missouri School of Journalism, and the World Book Encyclopedia Science Service, Inc. It was taken the instant that South Vietnamese national police chief Brig. Gen. Nguyen Ngoc Loan pulled the trigger of his pistol, executing a Viet Cong officer after his capture.

SPOT NEWS

When the news photographer goes out on an assignment to cover spot news anything can happen, particularly if the story is breaking fast and there are unexpected developments. The photographer's life itself could be in danger, if it is an assignment where the police have a gunman holed up in a building or there is a fire where a dangerous explosion might occur or a wall might crumble.

Equipment

The photographer should always keep his equipment ready and in good working order, for it is maddening to have to come back from an assignment and say, "I would have gotten the picture but my camera wasn't working right," or, "I left my synchronizer cord at home," or give some other excuse. Cords do have a way of breaking down just when picture opportunities are best, and one head photographer on a daily

newspaper tapes an extra cord to each flash unit for just such emergencies. It is even wise to carry an extra flash unit or an extra camera in the car, if possible, in case the regular camera jams or the flash unit fails to work. When carrying any type of electronic flash, I always carry a small folding flashgun and a few bulbs with me as well, because I have had electronic flash units fail to work properly at very crucial moments.

When a story is breaking fast and there is a good deal of movement, the photographer should not have to think about the camera or what his exposure should be or be out checking a light meter. He should have enough practice so that he is almost part of the camera and can make a reasonable estimate of the correct exposure under any type of lighting conditions, in case he forgets his exposure meter, it does not work properly, or he drops and breaks it.

The simpler a photographer can keep his equipment and the less he must pack, the faster he can operate and the more likely he is to cover the news. Magazine photographers I know sometimes have as many as four or five cameras around their necks and carry as much as a thousand pounds of equipment out on an assignment even halfway around the world. But a photographer on a daily newspaper must have the pictures today. If he misses, he does not have time to go back and get more for tomorrow's paper. By tomorrow, the news of yesterday is stale.

The news photographer should standardize his film and be so used to operating his equipment that he need not think about what he is doing but can concentrate on the subject, waiting for just the right moment to get a prize-winning picture or at least a good news picture.

Coverage

Many spot news assignments are somewhat dull, and the thrilling news story is a rare happening. This should not prevent the photographer from doing an outstanding job, however. Sometimes a good picture can be taken after all the other photographers from competitive media have taken theirs and left the scene. On several occasions, this has happened to me, and I have been able to get a better picture by staying just a little longer and working with a rather trite subject to come up with something worthy of a news photograph.

Of course, if there are deadlines to meet and the picture must be on the press, the photographer may not have time to stay longer. But many times he will not be rushed, and by exercising his ingenuity and creativity when he is free to do so, he can greatly improve his photographic skill.

There is no set formula for covering spot news stories, and different photographers will approach the same subject in different ways. Luck in being in the right place at the right time plays a part, but most good photographers enhance their odds by knowing the members of the police department, the various districts of the town or city, the names of leading personalities, and as much as possible about the beat they cover.

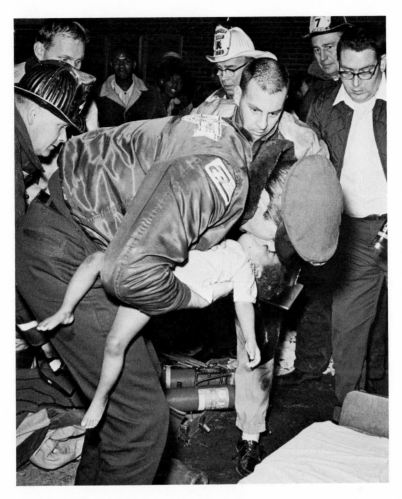

Fig. 12-8. Some of the best spot news photos taken report local news. This dramatic shot by Ted Walls of a fireman trying to save the life of a youngster in a local fire won first place for spot news in the Ohio Press Photographers Contest. Courtesy of the *Beacon Journal,* Akron, Ohio.

Sometimes there are added obstacles to getting a newsworthy picture. Where a murder has taken place, police may bar photographers from a certain area, or there may not really be much to photograph. In the case of a fire or some other disaster in a restricted area or military base, the photographer may be prevented from getting close enough to take the pictures he desires. In such instances, he must use his originality and come up with something for the city editor. Using a telephoto lens often helps; even pictures of the crowd that gathers around any disaster often make an effective spread.

Perhaps no one was in a more advantageous spot than the news photographer who took the picture of Jack Ruby shooting Lee Harvey Oswald after the assassination of President Kennedy. This type of news event is rare but such things do happen, and the photographer should be on the alert for unusual events that can occur.

I remember one picture I missed while photographing a Fourth of July rodeo in Denver, Colo. It was just a rodeo, with all the usual cowboys, fans, horses, and so on. I was standing up on a truck right next to the corral when a bulldogger came out trying to throw a steer. The steer got up and headed straight for the fence. Since the fence was exceptionally strong, I felt sure that he would not go through—but I was wrong. The steer broke through the fence and knocked over six people in the crowd, which would have made an excellent news picture had I been ready for it.

Getting to the scene of the news event can be more of a problem for the photographer in a large city than in a smaller community. But with the radio-equipped automobiles, helicopters, airplanes, and speedboats in use today, the photographer can usually get to the scene of a fast-breaking news event if he has the right connections. He must be able to keep calm when confronted with the pressure of deadlines and the difficulty of getting through police lines, crowds, and other obstacles. After the assignment is completed, the photographer will usually bring or send his film back to the office but not before calling the city editor to learn if there is anything else in the area.

The photographer must sometimes be very diplomatic in order to get the picture he wants, especially when directing a large group for a picture or dealing with irate individuals who have no use for anyone connected with the press. One of the most important things that a photographer must learn is to take the picture some official may want, then go ahead and take the shot he wants for his publication. This is not difficult to do, for after the photographer takes the shot the subject wants, he can say, "Now let me take one from a slightly different angle," or make some similar suggestion, trying to get the elements in the picture composed in such a way as to provide the greatest storytelling value. It is also easier to snap a picture of people staring into the camera, if that is what they insist upon, and then to get a more desirable news photo of them looking away or at each other.

Fig. 12-9. "Rough Job" developed from an assignment for the *Bergen County Record* in June, 1967, to shoot a meadowland fire. John G. Kenney says that such fires were common, and he decided to make an artistic photo rather than the usual spot news shot. It won honorable mention in the news feature class of the New Jersey Press Association annual contest and won an award in the World Press Photo Contest in the Netherlands, 1967, where the photo was hung in The Hague. Photo by John Kenney.

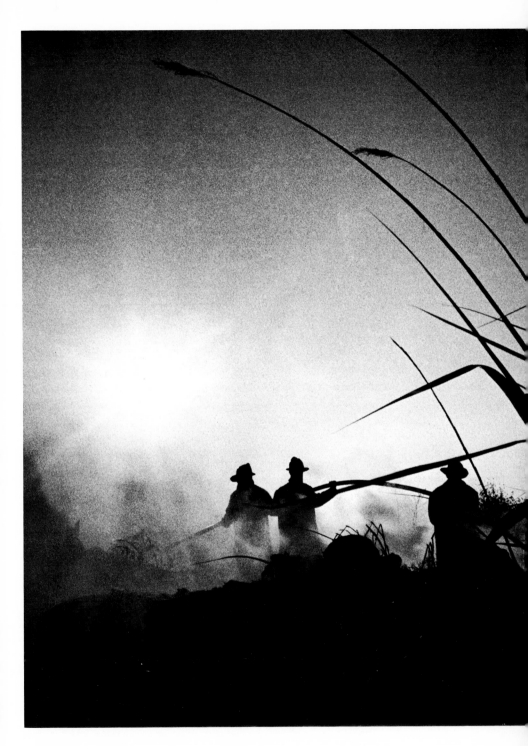

The spot news photographer needs a great amount of energy; he must be a good craftsman and have a creative imagination. He needs to know how to conduct himself properly anywhere he goes to cover an assignment, in some instances dressing for the occasion if it is a formal party or some other formal affair.

Fig. 12-10. Even though a spot news photo is usually taken very quickly, a good photographer will compose his shot carefully. The action in this horrible accident scene, photographed by Jim Shearin, all points to the center of interest, the victim, in the right center. Courtesy of the *Memphis* (Tenn.) *Commercial Appeal.*

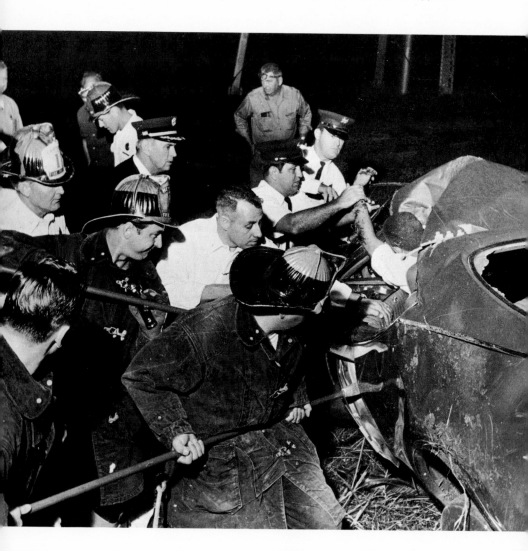

SUMMARY

Sports

Being a good sports photographer requires an excellent sense of timing, much physical effort, and some luck. Extensive pre-planning is often necessary in order for the camera to be at the right spot at the right time. Successful sports photographers know the game, its rules, and the background of the players thoroughly.

Certain types of sports, such as football or baseball, require cameras with telephoto lenses a good portion of the time in order to give the game adequate coverage.

The most popular cameras for sports photography are the 120 and 35mm film sizes, with the latter having the advantage of a wide selection of lenses. Some photographers still use the 4″ × 5″ press camera, particularly when shooting color or trying to cover a wide area. Most sports photographers use fast film either for stopping action or because of the dim lighting at night games.

When the light is very dim, as in most high school football games, sports photographers often use a 2¼″ × 2¼″ twin-lens reflex, with either electronic flash or flashbulbs. In some cases, photographers may use sequence cameras, specially mounted cameras tripped by radio signal. They may even use electronic flash units tripped by a signal quite a distance away, because they would not be allowed to take pictures from a particular spot, such as overhead in a basketball game. To stop action, 1/500 sec. and 1/1000 sec. are the common shutter speeds used in sports photography when light permits.

Many sports photographers use various tricks to obtain the pictures they want, such as pushing the film rating in the developer, panning, or in some cases, even using a slow shutter speed to blur the action purposely. The type of equipment used often depends upon the conditions, the equipment available, and the desires of the editor of the publication the photographer works for.

Spot News

Spot news is anything that happens unexpectedly, such as a wreck, fire, shooting, and so on. The photographer who always keeps his camera ready and in good working order is the type of person who is successful at spot news photography.

The simpler a photographer can keep his equipment when moving through crowds, as in covering a riot or some other such occurrence, and the more familiar he is with his equipment, the easier it is for him to operate and to get the type of news picture that wins awards.

There are often obstacles to getting a newsworthy picture, because police or military authorities may bar photographers from a certain area. All types of vehicles are used to get to the scene of fast-breaking news

events; after the picture is taken, the photographer must have some provision for getting his film back to the newspaper or wire service. The spot news photographer needs great energy, good craftsmanship, and a creative imagination.

QUESTIONS

1. Give an example in which luck might play an important part in a sports photographer's getting a good picture.

2. What type of information should a sports photographer have about the game he is covering?

3. What are three of the games most heavily covered by sports photographers?

4. What kind of camera is a "Big Bertha"?

5. What are the best camera and focal-length lenses for use in sports photography?

6. How does the difference in lighting conditions affect the type of camera used?

7. What are rapid sequence cameras used for?

8. What advantage has a slave unit in sports photography? What are some of the problems involved in using such a unit?

9. Why do most sports photographers use fast shutter speeds? How does a photographer obtain a blurred image?

10. What is meant by "pushing" the film?

11. Why is it important to pre-determine certain focusing distances on the main playing areas of a football field or basketball court?

12. What is the most important factor in being ready to cover spot news assignments?

13. What is meant by spot news?

14. Why should a spot news photographer keep his equipment as simple as he can?

15. Why is it important that the photographer know the members of his local police department in the various districts of his town or city?

16. What are some of the problems of getting to a news event in a large city?

17. Why does the spot news photographer need a creative imagination?

CHAPTER 13

Women in Photography

EVEN THOUGH national laws forbid discrimination between sexes in employment except in certain areas, such as religious orders and specialized fields, the question is often asked, "Will newspapers hire women photographers?"

Upon asking a number of photo editors and photographers on both large and small publications, I always get the same answer: "Yes, we would employ a woman photographer if she were the right person." This seems to hold true for other positions in the field of journalism as well.

Underneath remains the feeling, however, as a number of men who hire journalism personnel have told me, that there are certain jobs that you just cannot send a woman to do. It is difficult for a woman to cover a police beat, they say, or to work in other areas where she may be subject to criminal assault or other acts of violence; yet there are women who do cover these areas.

Newspapers generally prefer to hire men as sports photographers, but recently one of the Oklahoma press associations modified its rules to allow women photographers to work on the sidelines of football games, because a number of papers were using women as sports photographers.

There have even been women war correspondents, particularly combat photographers or combination photographer-writers. One famous woman photojournalist, killed by a land mine during the Vietnam conflict, was Dickey Chapelle. Well-known to the GI's and South Vietnamese troops, she has been compared to Ernie Pyle, the famous World War II writer-correspondent killed in the air in South Pacific action.

Fig. 13-1. Dickey Chapelle in Saigon, 1965, wearing attire and carrying equipment she needed to cover the war in Vietnam. Although past 40 and a veteran war correspondent when she went to Southeast Asia, she always carried her own equipment and asked no special favors from anyone. Courtesy of *The National Observer*, Silver Springs, Md.

Although not a newspaper woman but an outstanding portrait photographer in Tallahassee, Fla., Evon Streetman admitted that a woman is never on an equal basis with a man in photography. When she first started in photography on a professional basis after receiving her bachelor's degree in fine arts at Florida State University, she found being a woman somewhat of a handicap. However, after she became well known for her work, the situation changed and the fact that she was a woman was to her advantage at times. In other words, as she said, a woman is never on the same basis as a man in photography but has either an advantage or disadvantage.

Perhaps one reason why newspapers are reluctant to hire women photographers, at least on a full-time basis, is that some women expect other people to carry their equipment and make special allowances because of their sex. One newspaper executive told me that this type of individual would not last long on his paper, because everyone must be able to transport his own equipment to the job, wherever it was.

One group of West Coast studios for which I worked during the 1950's hired almost all women portrait photographers. Few male photographers were employed in the entire chain of 33 studios, one reason being that male photographers were difficult to hire at the salaries being offered by the organization. But the main reason was that the corporation found women just as good, if not better, with a portrait camera than men, especially with children and family groups.

Figs. 13-2a and b. These two Vietnam shots were taken by famous war correspondent Dickey Chapelle and appeared in *The National Observer* in 1965: (a) Sergeant Benz; (b) a group of American GI's crossing one of the many streams in the area. Courtesy of *The National Observer,* Silver Springs, Md.

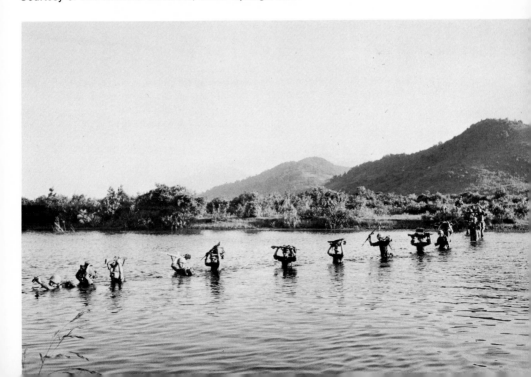

CAMERAS

Because of their lighter weight, smaller cameras appeal to women photographers more than to their male counterparts. It is better to have a small camera that can be carried in the purse at all times than to have a large bulky camera that is only carried occasionally on an interview or in the role of reporter. Even though a large-size camera will give better negatives, the important factor here is not the negative size but always having a camera, small light meter, small flash unit, and a few flashbulbs in one's purse. Always having the equipment handy enables the photographer to cover a fast-breaking story as well as the pre-arranged interview.

Because there is a continuous change in camera models, it is difficult to recommend any particular camera. A camera suited to one individual may not meet the needs of another. However, a few cameras that might be considered because of their compactness include the Canon Demi, whose several models include the Canon Demi Custom with interchangeable lenses, and the Canon Dial 35 with a spring motor film advance and an automatic film rewind. Both have built-in exposure meters, as do a number of small single-frame cameras, including Minolta, Fujica, Olympus, Petri, Ricoh, and Agfa.

Two particularly popular single-frame cameras and the only single-lens reflex cameras in the single-frame size are the Olympus Pen FT and Pen FV. These cameras have interchangeable lenses and will take a number of lenses made for single-lens reflex cameras, including several zoom lenses. They will also synchronize with Class M (20-millisecond delay) flashbulbs at all shutter speeds up to 1/500 sec. These models, however, are not as compact as some others mentioned.

Some models of regular 35mm (double-frame) cameras are much smaller than others. One learns about cameras only by comparing and

Fig. 13-3. The Yashica Atoron is excellent for candid photography or for one-column newspaper pictures. It has matched-needle built-in exposure meter and built-in filters. The Atoron has an f/2.8, 18mm fixed focus lens, with shutter speeds from 1/45 sec. to 1/250 sec. Courtesy of Yashica, Inc., Woodside, N.Y.

Fig. 13-4. Small enough to fit in a woman's purse, this Yashica EZ-Matic, with its cartridge load and unique electronic shutter, is just the thing for the woman reporter who wants to be able to take pictures wherever she goes. It has a 37mm, f/2.8 lens, with shutter speeds from 2 sec. to 1/300 sec., and has a built-in flash socket for rapid fire of flash cubes. Courtesy of Yashica, Inc., Woodside, N.Y.

trying various models to see if they meet one's specific needs. In large cities, it is often possible to rent or try out various cameras before buying one.

It is easier to carry a small flash unit and a few miniaturized flashbulbs in a purse or pocket than to carry even a small electronic flash. Not only are the flashbulbs usually more certain to fire, but they also put out much more light than the small electronic units. With the camera, flash, and bulbs, it is also wise to carry some kind of small meter if the camera does not have a built-in light meter.

In addition to the equipment always carried, the photographer should also have a regular camera, perhaps a twin-lens reflex, such as the automatic Rolleiflex, Minolta Autocord, or one of the Yashica models, all taking either 120 or 220 film. The purpose of the compact camera is to get the unexpected picture, whereas the regular camera using the larger negative size will, of course, make more critical enlargements.

THE WOMEN'S PAGE

Few newspapers have a society page any more, for the name has been changed, in most instances, to the women's page, family and home, the woman's world, or some other such expanded title. This does not mean that there is no society news published; it does mean that besides the

society news, women's pages have expanded to embrace many fields, including careers, homemaking, fashions, health, advice columns of various kinds, and other special features.

The women's page editor is almost always her own boss, often choosing even the type faces and layout. With the expansion of the women's section has come increased use of pictures. These are larger and often in color as well as black-and-white. The women's pages in some Sunday newspapers include several pages of color photos. On many large papers, the assignments for photography are turned over to the photography department, but in some cases, a photographer may be employed for the women's section alone.

Fig. 13-5. This feature shot of a child with a jack-o'-lantern won second place in the 1968 Mississippi Presswomen's contest for Mrs. Betty Brumfield. Courtesy of the McComb (Miss.) *Enterprise-Journal.*

A number of the pictures used come from outside sources, such as those received in the mail from news services and from public relations departments of various firms. Although a number of ordinary bread-and-butter pictures are used, some layouts call for well-posed and somewhat elaborate pictures. Perhaps one of the greatest advantages to a photographer working for the women's page is that much of the material is undated and can be prepared with the extra care that added time allows. Although it is not always evident, many newspapers have enough time to make layouts similar to those used in magazines.

However, one problem that does arise is that a reporter for the women's page may be able to take simple pictures of a person at an informal party or a simple close-up of a subject doing something, to illustrate the news story about him, and yet not be able to make a fashion layout for the front page of the Sunday women's section.

Some women's page editors prefer not to have their own reporters take certain pictures but, instead, use the regular news photographers or obtain pictures from other sources, such as from the professional photographer who shot a particular wedding or group. This rule may avoid embarrassment for the reporter who tries to take pictures beyond her skill, and it is an easy way out for the editor.

THE MARKET FOR WOMEN

Many company magazines and newspapers are edited by women, and it is usually an advantage to have a woman staff writer who is also a photographer and can take pictures of the winner of the bowling tournament, the person who receives an award, or the employee who has a special birthday. Often the company photographer is not available for this type of picture or is out on an assignment when it needs to be taken. The budget may not permit hiring an outside professional photographer, and anyone with a camera is usually welcome in such cases. This is one reason, of course, why so many company publications carry photographs that are out of focus, improperly composed, and generally of amateur snapshot quality. A woman who is both a journalist and photographer will often find that she will be employed more quickly by smaller newspapers, company public relations departments, or trade publications if she can handle a camera well enough to take simple pictures that reproduce well for publication.

Although few women sell display advertising, more are being hired to do so all the time. A display advertising salesman who is also a photographer is able to do a better job of selling advertising than one who is not. One reason is that the ad salesman does not have to arrange for a photographer to come and take pictures but is able to service his accounts better by taking the pictures and the suggested layout while talking to the advertiser at his place of business. There never seem to be enough

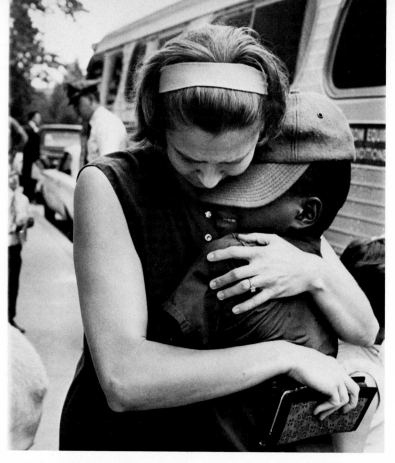

Fig. 13-6. This shot was taken to illustrate a story about a Fresh Air Child Program in which New York youngsters spent three weeks with local families in Dover, Delaware. As this eight-year-old boy was leaving to return home, both he and his "temporary mother" burst into tears, giving Ginger Wall a human interest photo. Courtesy of the *Delaware State News,* Dover, Del.

photographers to take the many pictures required in most phases of journalism. The woman who becomes proficient with a camera, knows something about journalistic practices, and approaches prospective employers in a business-like manner appearing neat and well-groomed (never in a dress only appropriate for a party) will have little trouble obtaining suitable employment if she knocks on enough office doors.

It is particularly important that a woman photographer carry a professional-looking portfolio containing samples of her work, either 11″ × 14″ or 16″ × 20″ dry-mounted pictures on pebble-grain mount board, which can be obtained from a professional photographic supply house or

an art store. Clippings of published work should be neatly displayed or otherwise mounted in a professional manner in order to give prospective employers the impression that the woman photographer can do professional-quality work. It is a mistake to rely on good looks or femininity alone, although these are seldom detrimental.

Even though many employers say they are looking for a man to fill a position, should a qualified woman come along, she will be hired. The person who questions this needs only to look around him to find women working at almost every type of occupation. What the employer implies when he says he prefers a man is that he feels a single woman may work only a year or two, get married, and quit to have children; or if she is married, her husband may move to another city and she will go with him. Of course, little is said about the fact that men quit jobs for various reasons or may move to another city because a close relative is ill or the climate is better there.

Even though most head photographers and picture editors on newspapers say they prefer to hire men as photographers, I have found a number of such persons who, when asked if they had ever employed a woman photographer, replied, "Yes, we had one during World War II," or "We have had two women photographers." And almost invariably the remark continues, "and you know—they were excellent photographers, better than some of the photographers we hire today."

To my surprise, I found that very few women even apply for photographic positions on newspapers. Some photo editors said they had

Fig. 13-7. "Space Playground" was taken by Liane Kruse while working for *Newsday* on an internship program. She is presently employed by the Los Angeles *Times*. Courtesy of *Newsday*, Garden City, N.Y.

never had a woman do so. The head photographer of the Biloxi-Gulfport *Daily Herald* told me he thought there should be more women in press photography, particularly doing some of the darkroom work and printing, which men sometimes dislike because of the detail involved. He felt that women would perhaps be better at opaquing negatives (to eliminate backgrounds) and making engravings because they ordinarily have more patience.

When I worked on the *Daily News* in Independence, Mo., we had a woman platemaker for our offset daily newspaper who did an excellent job in both the lithographic and the press darkrooms. This was quite a number of years ago; the paper is no longer in existence today.

Probably one reason why more women are not employed in photography is that women do not apply for the positions that are open. Many are employed in professional portrait studios, particularly as retouchers or oil coloring artists, receptionists, and assistants to help women with their costumes or special types of posing, including arranging a drape or straightening clothes. For ethical reasons, a male photographer would often prefer to have a female assistant adjust the clothing of a female subject than do it himself.

Some women become expert at posing other women, particularly in keeping up with hair styles and trends in dress and fashion. They may become specialists in this particular field, and the person who is a specialist often commands higher wages than does the photographer who shoots everything but has no particular specialty. In large cities, it is not unusual to find a studio that specializes in babies' photographs or in models' photos for advertising or in a similar photographic service.

Photographers in smaller cities usually do more general work. Many women have become photographers because their husbands were professional photographers and needed help in the studio. Upon working with photography, they found they had a natural liking for the field, and this husband-wife combination is often found in the portrait studio.

One head of a college public relations department for a woman's college told me that he would prefer a woman photographer on his staff, because she could enter dormitories without getting special permission that a man would require and could obtain many photographs that a man would be unable to get. The last time a position was open for a school photographer, he had to hire a man because he could not find a professionally qualified woman to fill the vacancy.

QUALIFICATIONS FOR PRESS PHOTOGRAPHY

How does a woman become a press photographer? Perhaps the most important thing is a degree in journalism, with the ability to take simple pictures for women's page assignments or for use throughout the paper.

Although some newspapers, such as the *Daily Oklahoman,* try to get male high school and college students to work in the photographic department in the summer to learn the operations, many newspapers are now asking for graduates of good journalism schools.

In the past, many graduates with degrees in English or liberal arts were given the opportunity to work on newspapers, because there were not enough journalism school graduates and because some of these schools were not as high in caliber as they should have been. However, the trend today is toward starting people with degrees from journalism schools, and a number of photo editors have told me that they prefer the individual with a journalism background, because he will most likely understand some of the workings of the paper as a whole.

Many photographers have been hired on newspapers, however, who have neither a journalism degree nor a degree of any kind, because there were no such applicants available; many photographers are either self-taught or have served some sort of apprenticeship by working on a high school yearbook or other photographic project.

For a woman, the degree is perhaps much more important, because she will often be expected to write as well as take photographs. She will be expected to have even more editing skill than her male counterpart, because the woman's section is often a separate entity run more or less freely by the woman's editor, with little interference from other editors or the general staff of the publication.

The woman who is a competent typist and also knows shorthand may sometimes work into an advanced position on a newspaper because she has these skills, plus the ability to write articles and take pictures for the company publication. In the case of a newspaper, she can be sent out on an assignment and do both the story and the pictures, writing the cutlines and laying out the page for publication. To get a job in some phase of press photography, a woman needs more ability and a greater variety of skills than a man applying for the same position. But if a woman is good enough, I know of no editor who will not hire her if he has an opening where she can fit in.

Women often ease themselves into doing company publications as the organization grows, because the firm cannot afford to hire a full-time writer, editor, and photographer to do the work. For this reason, the woman who has the skill and is available is the one given the job. Unfortunately, many company publications are poorly done, either because the boss does not think they are important or there is no one available with the necessary journalism background. This is usually true only in the case of smaller companies, for as a company grows larger, it becomes more conscious of its public image and tends to replace those who lack journalistic ability with persons who have a journalism background.

A number of my students have gone to work on company magazines and plant publications immediately after receiving their bachelor's degree

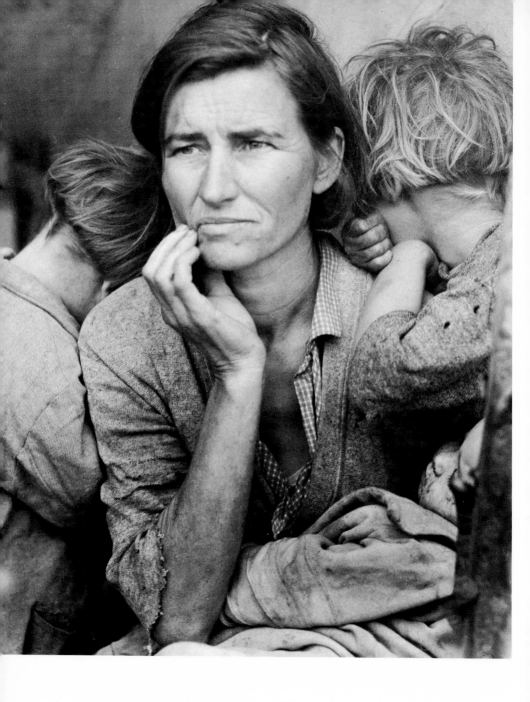

Fig. 13-8. "Migrant Mother" was taken in February, 1936, by Dorothea Lange, famous photographer of American country women, for the Farm Security Administration. Courtesy of Library of Congress, Farm Security Administration Collection.

in journalism. These young men and women were hired because of their professional approach to the job that needed to be done. Once a graduate gets a position on a newspaper or with a company and does outstanding work, it is usually not long before other publications are trying to hire him away at a much better salary. I have seen this happen any number of times.

For this reason, it is important for anyone trying to enter press photography to accept a first position that will give him a good background and opportunity for advancement, rather than the position that pays more money but offers little advancement opportunity or is in another field where advancement is not as rapid.

Experience in journalism is highly important, whether acquired during summers while one is a student or on a small publication although a person might wish to work on a larger one. The job and work experience are of utmost importance for the beginning press photographer; the money will come later, even if the first job accepted is low-paying.

SUMMARY

Within certain limits, opportunities for women press photographers are as great as for men. However, women do not often apply for press photography positions. When women are hired as press photographers, they are expected to carry their own equipment; for this reason, they usually prefer a smaller camera than those used by their male counterparts.

Being ready to take a picture at any time is easy for the woman who carries a miniature camera and flash unit in her purse at all times. However, a regular camera yielding a larger negative will make more critical enlargements and should be used for the bulk of the work a woman press photographer does, unless she is a specialist with a 35mm camera.

Most women's pages use a number of photographs, and much of the material is undated, which allows careful preparation ahead of time. Many company magazines and newspapers are edited by women, most of whom have learned to take photographs in order to illustrate their publications.

A woman who is both a writer and photographer can obtain employment more quickly with smaller newspapers and public relations departments than a woman who knows only one of these skills. A number of women are employed in the display advertising departments of newspapers and other publications where photography is needed.

Women sometimes become expert in photography because they are married to a photographer. This is most common in the studio portrait field. For most women, the journalism degree is almost a prerequisite for obtaining a position in press photography; in most instances, they will be expected to write, too.

QUESTIONS

1. What is one objection newspapers may have to hiring women photographers?

2. Name at least one famous woman magazine photographer.

3. Why is it advantageous for a woman to carry a miniature camera and flash unit in her purse at all times?

4. What has been the trend in women's sections of newspapers over the last decade?

5. Why do some women's page editors prefer not to have members of their immediate staff take pictures for their section?

6. Why is it advantageous for a woman to be both a writer and photographer?

7. How should a woman photographer prepare a professional-looking portfolio in order to present her work to a prospective employer?

8. What sort of photography can women specialize in if they wish?

9. Explain why it is important for a woman to have a college degree in journalism if she expects to advance in press photography.

Freelancing and Marketing Photographs

DESPITE THE GLAMOROUS life depicted by the Hollywood movies and an occasional magazine feature article, the average free-lance photographer is a hard-working person with considerable photographic experience.

Many free-lance photographers started by taking simple photographs for friends or for their high school annuals or perhaps were writers, artists, or advertising men who became interested in photography as a hobby. Many outstanding magazine and free-lance industrial photographers learned their trade through being newspaper photographers, occasionally winning press awards until they became expert at a certain type of photography. Having one's photographs in photography magazines, business papers, and other publications will often attract the notice of photograph buyers of corporations and advertising agencies. Each published assignment and award brings added recognition and eventually more assignments.

Some photographers begin in small towns; others get their start in large cities. Some have learned photography in school, but there are few schools devoted exclusively to photography and a shortage of competent teachers of photography exists throughout the country. For this reason, many photographers are self-taught or have served a working apprenticeship under an outstanding professional photographer.

Because competition for the top jobs is keen, it is often difficult to break into the field, even though one is fully qualified, without knowing someone or having the backing of a well-known person. Most well-known magazine photographers work out of large cities, such as New York, Chicago, London, or Paris, and quite a few from the United States have

begun their photographic career in a foreign country. Some of these photographers work on a salary-plus-expense basis, especially when on the regular staff of a large magazine or news service. Others may work on some sort of retainer. They are paid a substantial fee for each working day or for the completed job.

Freelancing in itself is highly competitive, and many free-lance photographers who sell to magazines have other photographic businesses, such as portrait or commercial studios, or even dissimilar business interests. Some photographers may do not only still photos but also motion picture films for industrial firms and footage for TV programs. Some of the most successful photographers of this type are not located in large metropolitan centers but in areas where it is not easy to get good coverage by the regular staff personnel of publications and television news services.

MARKETS

There are many small free-lance markets that almost any photographer with reasonable skill can sell to. These markets are mainly business publications known as trade journals, company magazines or house organs, and Sunday newspaper supplements.

Unfortunately, most of these markets pay rather low rates, and it is not unusual to find a publication offering only two or three dollars a photo for an 8″ × 10″ glossy and expecting to pay the photographer on publication. House organs often have their own photographers or obtain pictures from employees or others who occasionally take photographs for them. As a rule, newspapers pay little for free-lance work, and it is difficult to sell them pictures without some type of prior arrangement.

Some photographers specializing in industrial or agricultural photographs have become so well-known in their field that they have a considerable following among the large industrial and agricultural firms in the area. It is quite possible for a photographer to build up a good free-lance business if he becomes a specialist in one area and is also able to gather accurate facts so that the company writers can prepare an intelligent story to accompany the photographs for publication either as an advertisement or an article in the trade publication. This type of work requires ingenuity on the photographer's part in recognizing salable photos and stories, plus the ability to do some travelling in order to cover an area several hundred miles from the home base.

The free-lance photographer must usually wait from one to six months to receive payment for his pictures. This requires that he maintain a substantial bank balance in order to remain solvent while waiting for the checks to come in. A photographer who is also a writer will find that he has a much better market with most publications, since many editors prefer to buy a package of a feature story complete with photographs.

Fig. 14-1. Good foul weather shots, such as this one made in a snow storm, are hard to get but have a ready market in industrial firms for advertising, as well as editorial use in newspapers and magazines. Courtesy of North American Rockwell.

Market Lists

Some publications also buy scenics and various other types of photos for front covers or stories. There are several sources to consult in locating these markets. Perhaps one of the best, if one is both a writer and photographer, is the *Writer's Market*, put out each year by *Writer's Digest*, Cincinnati, Ohio. A book listing 4,000 to 5,000 house organs is *Gebbie's House Organ Directory*, P.O. Box 111, Sioux City, Iowa 51102. A publication revised from time to time is *Where and How to Sell Your Pictures* by Arvel W. Ahlers, published by Amphoto, 915 Broadway, New York, N. Y. 10010. Any large public library should have these and other similar publications.

Some photography magazines, such as *Popular Photography, Modern Photography,* and *U. S. Travel & Camera,* publish information on photo markets at various times, but most of their lists that I have seen are not comprehensive and not of great value to the free-lance photographer. The *Writer's Digest, Author and Journalist,* and *The Writer* frequently publish information on photos and articles or photos alone desired by various publications. On one occasion, I sold a small item to *Popular Photography* after seeing a notice that appeared in *Writer's*

Fig. 14-2. *Life* magazine chose this picture by Eddie Davis for its humor photo (inside back page) for a March, 1968, issue. It also won first place in an Associated Press contest. Courtesy of the *Gainesville* (Fla.) *Sun.*

Digest, and I have sold a number of photographs with stories to various business publications through information found in these writers' magazines.

Developing a Market

Perhaps the best approach for the free-lance photographer is to develop his own market by talking to editors of newspapers and magazines published in his area to learn if they buy photographs, how much they pay, and whether they pay upon acceptance or publication. A word of caution is necessary here: The photographer should be wary of editors who say, "Well, I think we can use it," and then stall him repeatedly, sometimes for months, before finally rejecting the photograph, which then is probably of no value to anyone else. It is best to have a definite understanding with any editor as to the method of payment, time, and other necessary details.

In dealing with out-of-town firms, I usually write some kind of inquiry, commonly known as a *query letter* in the writing trade, to learn if the editor or company is interested in seeing the photographs on a speculative basis. This is the best approach for the beginner, since it will

save him from making many photographs that he may not be able to sell. After the photographer knows his market, he can then determine which photographs to shoot and send in to a certain editor or company for consideration.

Many of the most successful free-lance photographers work on some sort of speculative basis with their pictures and in turn receive assignments for which they are paid whether the magazine uses the pictures or not. The assignment usually comes at a stage after the photographer has become well-known and has established himself professionally.

The beginner should not expect to write a letter to a publication and receive an assignment by return mail, without ever having done work for the publication before. Although this may occur after one becomes an established professional, it seldom happens to the beginner.

Most photographers working on publications, particularly on newspapers, have opportunities to sell photographs to companies, individuals, or other publications as well. To maintain ethical standards, the photographer who goes to work for a publication either as a full-time salaried employee or on an assignment basis should have a definite understanding as to which pictures he can take for other clients and the amount of money he receives from such work.

Some newspapers maintain a photo service in conjunction with the paper and compete with regular professional photographic studios. In such cases, the photographer may receive a salary or commission in addition to his regular salary on work sold to outside clients. Other newspapers allow their photographers to sell pictures outside and expect no return except, perhaps, payment for any company materials used. In such cases, the photographer may receive a lower salary than would be paid otherwise if he were not making this extra money by selling photos to outside clients.

Another possible source of markets for photographs is printing plants that publish brochures and do printing for many different types of customers. Often the customer will want some type of picture for a brochure or letterhead and will ask the printer if he can furnish such a photo or can recommend a photographer to do the work.

Other business may come from industrial firms, companies, and various business enterprises that need photographs, color slides, and other photographic work from time to time. Even though the firm may have a company photographer, it will sometimes buy special types of photographs either because its photographer is too busy or because he is not qualified to do the specialized job. Developing such accounts takes time, leg work, and many return calls following the first visit. If the photographer gets one such account, however, it is often easier to add another. Sometimes the photographer may shy away from taking competitive accounts for ethical reasons; in other cases, it is quite proper to take photographs for highly competitive firms without either party's objecting.

Companies will often buy pictures of their attractive window displays or of their equipment in use, such as heavy earth-moving machinery or large electrical equipment. The company usually wants some sort of testimonial or at least a limited amount of information to accompany this sort of photograph. In the case of a window display, the trade magazine will want to know how the display was conceived, how the public reacted, and whether it brought customers into the store. It will also need a signed interview with the store manager or owner about the display and his operation.

The photograph of the earth-moving machinery would normally be sold to the manufacturer, who would want to know in somewhat technical terms, what the equipment was doing; in other words, how many cubic yards of dirt was being moved, where the dirt was obtained for the fill, how long the job was expected to take, how much the job cost, and what the name of the contracting firm was. The manufacturer would also want a signed statement from the supervisor on the job. In the case of large electrical equipment, the information would be of a similar nature but would pertain to the type of equipment being used. Any unusual use of equipment, animals, or anything new in the way of advertising signs, promotion, and so forth, is always good for a free-lance sale if the photographer can locate the proper market.

Fig. 14-3. City progress is often measured in new sewer projects, park expansion, and miles of paved streets. This photo was taken to illustrate a news story on a new sewer line. Many such pictures can be sold to trade magazines and companies that manufacture these machines, for their own advertising purposes. Photo by author.

Fig. 14-4. Pretty as a picture, this shot has all the necessary qualities for calendar or stock photo sales. The lighting and exposure are perfect, and the boat's wake and reflection in the water all add impact and reader interest. Courtesy of Kiekhaefer-Mercury, Fond du Lac, Wis.

Stock Photos

There is also a market for stock photographs, but this usually requires a minimum file of 10,000 negatives in a specialized area, such as agriculture, children, scenics, school students, and so on. These photographs are sold on a one-use basis, and one photograph may be sold as many as 100 times over a period of several years. A number of large stock photograph houses in metropolitan areas compete with free-lancers in this field.

Agencies

I have often been asked if a photographer should send his pictures to a photo agency that specializes in selling photographs for free-lance photographers. These agencies usually charge commissions of 50 per cent of the sale price for black-and-white prints and 40 per cent for color. I do not recommend picture agencies unless the photographer becomes well-known, since these agencies tend to receive a lot of pictures from photographers and hold them for a number of years with very few sales. In my opinion, only well-known photographers would do well in using a picture agency.

Fig. 14-5. Because this dog might be a member of the hippie generation, posing him in front of a barber shop with the appropriate sign adds the touch of humor that so many editors are looking for and so few photographers realize is saleable. Courtesy of Bill Perry, *Rocky Mountain News*, Denver, Colo.

Pricing

Even if the photographer is a rank amateur, he should charge enough when someone wants to buy a photograph to pay not only for the materials used but also for the use of photo equipment. He should receive something for his time and some profit as an entrepreneur. The best way for the beginning photographer to judge prices on pictures is to learn what professional photographers in the area are charging and set his prices accordingly.

The beginning photographer should not try to undercut the professional, but he should, in most cases, expect to receive less money than the professional would for the same type of work, because the beginning photographer's quality is not as good.

It is better to give people the pictures, I feel, rather than to charge too little for a job. Even if the customer takes his own snapshot photo to the corner drugstore, the druggist will charge him $1.50 or $2 for an ordinary snapshot-quality 8″ × 10″ enlargement. The beginning photographer should price his work above this, perhaps $3, $5, or even $10, depending upon the type of photograph and the ability of the photographer.

The person who pays a respectable amount for a photograph will value it more highly than if he got it for practically nothing, since the customer judges the value of a photograph largely by what he pays for it.

Just as the artist's painting is not merely the paint, canvas, and frame, the photograph's value lies not merely in the separate component parts but in the intrinsic quality of the finished product. The photographer should keep this in mind when selling his photographs and not look upon his finished photos as merchandise to be sold over a store counter.

THE BUSINESS OF PHOTOGRAPHY

To be a successful photographer, one needs to know something about business, accounting methods, taxes, and approaching people in a positive yet business-like manner. Beginning photographers make a number of mistakes, one of which, as mentioned above, is pricing their goods and services too low; but perhaps their worst error is in trying to undertake every photographic job that comes along. The professional photographer who is not turning down some business is certainly not a good businessman. I usually learn what the customer wants, and if I cannot do the job for the price he wants to pay, I refer him to one of my competitors. If the competitor can make money on the job at that price, I am glad for him to do so, but I do not want to lose money on any photographic work that I undertake for profit.

Even though the photographer considers all angles, computes the cost carefully, including his time, depreciation on his car and equipment, and daily overhead, he will lose money on certain jobs at times for some unforeseen reason. I always hope to have few such jobs, but I feel that if the photographer does not lose money on an occasional job, he is not pricing his work closely enough. It is easier to compete on quality than on price, for there is always some photographer who will undercut the price, no matter how much money he loses. It is much easier to do high-quality work and take fewer jobs than to do a large volume of work and make very little money on any individual job. I prefer to build a reputation on fairness and high-quality work. If I charge enough money, I can afford to correct an error on a good-quality order. But if I price my work for volume alone, I cannot afford to correct any errors I might make. Much of the photographer's work will come from repeat business, and it is important that he build a good image with the public.

PHOTOGRAPHING WEDDINGS

Where to Start

Perhaps the easiest outside work for the press photographer to do is candid weddings, which are also good practice for any photographer. Weddings provide a variety of situations, such as large formal groups, candid shots of people moving, and posed-candid, storytelling photographs of the reception, including such memorable events as cutting the cake.

Preparation

There are several factors for the photographer to consider before he undertakes to shoot a wedding, and perhaps the most important is to study a series of photographs of candid weddings made by professionals. These can easily be obtained from friends or newly married couples.

The beginning photographer should not undertake a whole wedding on his first attempt but should shoot just a few pictures in order to get the feel of the wedding and to learn a little about wedding photography. This is important because a wedding cannot easily be retaken, and many a sad bride has been talked into letting an amateur friend take her wedding pictures, rather than hiring a well-qualified professional. The net result was that the bride ended up with either no pictures or pictures of such poor quality that the couple had nothing to show of this once-in-a-lifetime occasion.

Know the Equipment

The second most important thing is for the photographer to be sure that he is familiar with his equipment and can operate it under the conditions in which a wedding is performed. Various professionals use different types of cameras for candid wedding photographs, from 35mm and 2¼″ × 2¼″ twin-lens reflexes to 4″ × 5″ press cameras. The smaller cameras are not as satisfactory for large groups as the 4″ × 5″, because of the difference in negative size. The most popular cameras used by professional photographers on candid weddings are the 120 or 220 film-size cameras, including 2¼″ × 3¼″ press cameras, twin-lens reflexes, and single-lens reflexes.

Flash or Available Light?

Although in some situations no flash is needed, most weddings are photographed with either flashbulbs or electronic flash. Professional pho-

Fig. 14-6. Winning a blue ribbon (first place) in the South Dakota Professional Photographers contest, this photograph of an industrial crane is a good example of how highlights and shadows can make almost any object a photographic subject under the lens of a creative photographer such as Richard Ingalls. Courtesy of Raven Industries, Inc., Sioux Falls, S. Dak.

tographers usually use the latter because of the expense involved in buying flashbulbs. Sometimes the situation may call for available light photography because the pastor prohibits the use of flash during the wedding ceremony or because the picture is to be taken from the balcony, for instance, too far away for a flash to be of any great help.[1]

Color or Black-and-White?

Many of today's weddings are taken with color negative film, but the novice should start practicing on weddings with black-and-white film, because there is more latitude in black-and-white than in color negatives. Also, black-and-white materials cost less than those for color.

Attend the Rehearsal

A good plan for the beginning wedding photographer is to meet with the wedding party at the rehearsal and become acquainted with various members of the bridal party, the layout of the premises, and the minister, rabbi, or judge to learn if there are any regulations on taking wedding pictures. Some ministers and rabbis allow even professionals to take pictures only at certain times during the ceremony, if at all. Others allow pictures at any time, even at the altar. Permission of the officiant should be obtained before the photographer attempts to do the wedding.

Another reason for attending the rehearsal is to learn where various members of the bridal party will be as well as the order of the procession.

The importance of advance preparation is illustrated by an experience I had one Friday night when I went to take pictures for a friend who was being married in a local church that I had never been in. I had taken a number of weddings and decided where I would stand as the bride came down the aisle on her father's arm, planning to take the bride and groom as they came back the same aisle after they were married. It did not happen that way, however, for after the ceremony the couple went up another aisle, and I was unable to get there in time to take that particular shot. As luck would have it, a photographer friend of mine sitting on the other aisle was able to get the picture. This picture could have been posed later, of course, which is expedient when rules of the church or synagogue forbid taking pictures during or immediately after the ceremony.

As the professional photographer soon learns, anything can happen at a wedding, but I hope none will be like the one I photographed in Los Angeles while I was managing a portrait studio in Huntington Park.

[1]Mr. Fonville Winans of Baton Rouge, La., has won recognition as a professional wedding photographer using only existing light and 35mm cameras for his wedding pictures. A Master Photographer, he has a minimum charge of several hundred dollars for a single wedding, which is well above the average charge. He uses a larger camera for group photographs and does almost all his work in black-and-white.

The reception was to be held in a house about a half-mile away, and after the ceremony I grabbed my gear and drove immediately to take pictures there. The bride and groom had both been slightly inebriated at the wedding, and it was two-and-one-half hours later before they showed up in an even greater state of inebriation.

So many people attended the reception in this small house that they could not all get in and were tramping about outside over the shrubbery, some holding beer cans and others opening the gifts before the bride and groom arrived. The general turmoil looked more like a New Year's Eve celebration than a wedding reception, and I was unable to take any pictures at all. Had I known this would be the situation, I would never have agreed to take the photographs.

SUMMARY

Most free-lance photographers are hard-working and started out in some other photographic endeavor. One of the best backgrounds for an aspiring free-lance or magazine photographer is working for a newspaper. Many photographers are self-taught, whereas others learn through going to school or through an apprenticeship under a top-notch professional photographer. The magazine photographer usually lives in a large city, although some with small town addresses are quite successful.

Some photographers work on a retainer fee; others work on a salary; some work strictly by the job. Freelancing is a highly competitive business, with the greatest competition being in the large metropolitan centers.

Some markets require the utmost in skill, whereas others buy photographs that any amateur could take with just a little direction. The pay usually varies with the amount of talent required, being low from many smaller publications and often high from the larger ones, especially to established, well-known photographers.

Some travelling is usually required of any free-lance photographer, and he must be somewhat expert at marketing his photographs. He may also need a fair amount of capital to carry himself for several months, since some publications and companies may wait for quite a long time before paying for pictures they select.

Perhaps the best way to establish oneself as a free-lance photographer is to become a specialist in one particular area. There are a number of market lists, and the photographer who plans on freelancing should be well acquainted with the various lists available.

Some free-lance photographers work in a manner similar to free-lance writers, writing query letters to large companies to ascertain whether they are interested in buying photographs from a certain area. There is a certain element of speculation in freelancing, and a photographer with experience will often shoot the assignment even before making an inquiry to the publisher, since he knows fairly well what can be sold in this area.

Most photographers working on newspapers have opportunities to sell to other publications. Some type of understanding with the newspaper should be reached before any attempt is made to sell on the outside.

Unusual types of equipment, animals, or anything new in the way of advertising signs and displays will usually have a ready market, if the photographer can only locate it. One area that offers opportunity for free-lancing is stock photographs; although most stock photo agencies are in large cities, some very successful photographers, particularly those specializing in agriculture, have lived in remote rural areas.

Unless a photographer is well-known, a picture agency is of little value to him.

In pricing photos, the photographer should expect to be amply paid for his time, his materials, and his skill. The more skillful a photographer becomes, the higher the price he should charge for his photographs. No photographer should undertake every photographic job that comes his way. He should learn which assignments he can do successfully to make a profit and which he cannot. There are many factors, such as overhead, rent, taxes, and wear and tear on equipment, that should be considered in the price of any one assignment.

One of the easiest ways for a press photographer to enter free-lance work is through wedding photography. However, he should not attempt a large wedding until he has not only studied the type of photographs expected but has shot a few such photographs on his own.

A knowledge of the difference in cameras is a valuable asset in doing wedding photography, which provides a variety of situations and in some ways is quite similar to doing news photography. A photographer attempting to take weddings should attend the rehearsal and, before the actual ceremony, talk with the officiant to find out what restrictions there are on taking pictures in the building.

QUESTIONS

1. How do most photographers start freelancing?
2. Is it more advantageous to live in a small town or a large city if a photographer is attempting to freelance? Explain.
3. Most well-known magazine photographers: (a) work out of large cities; (b) work out of small towns; (c) work out of both; (d) none of the above.
4. Freelancing is (a) highly competitive; (b) not very competitive; (c) no more competitive than any other type of photography.
5. What are the best types of free-lance markets for a beginning press photographer with an average amount of skill?
6. What is one disadvantage of these markets?
7. What is the advantage of becoming a specialist in a certain photographic field where freelancing is concerned?

8. Why should the photographer have ample capital before he attempts any extensive free-lance photography?

9. Where are some of the places a free-lance photographer can find markets listed?

10. How can a free-lance photographer develop his own market?

11. What is meant by *speculation* in free-lance photography?

12. Why does the newspaper photographer have opportunities to sell free-lance photographs?

13. Name some types of photographs that can be readily sold on a free-lance basis.

14. What is meant by stock photos?

15. Why should the unknown photographer not attempt to use a picture agency?

16. What are some factors determining the price of photographs sold to clients?

17. What are some good business practices that every photographer should use in selling photographs?

18. Why is it fairly easy for a press photographer to shoot candid weddings?

19. Why is it important for him to attend the rehearsal?

20. What is the one best camera for taking wedding photographs? Explain.

CHAPTER 15

Copying Photographs
and Art Work

No MATTER what type of photographic work one is doing, copies of photographs must always be made. For an advertising agency, there are copies of paintings, drawings, and photographs for layouts. In a portrait studio, perhaps the most frequent copy work is of an old photograph of a deceased person. The individual wanting the copy is a relative who will usually say, "This is the only photograph we had of him (or her)." On a newspaper, there are copies of engagement photographs for the women's page, of old, yellowed photographs for the 100-year anniversary edition, and many more copies to be made of charts, photographs, and art work in general.

LIGHTING FOR COPY WORK

Photographers who do a considerable amount of copying normally use two lamps, usually photofloods, one on each side of the camera and equidistant from the work being copied. The light from the photofloods strikes the subject being copied at a 45° angle, which gives less glare than there would be at any other angle. Glossy prints and other shiny surfaces are more subject to glare than those with matte surfaces. One way to solve the problem of glare is to use a polarizing screen on each light, throwing the illumination in one definite direction. Using a third screen, which acts as a polarizing filter, on the camera lens will eliminate all reflections and *hot spots*, points where the light reflection is brightest. Four lamps placed one at each corner and three or four feet out from the subject being copied will give even more illumination.

Fig. 15-1. The designer is making a mock-up model to be photographed or copied on a 4″ × 5″ press camera with studio lighting. Many industrial plants and newspapers have such studio facilities for their photographers to use in doing this type of work. Courtesy of Ford Motor Co.

The photographer should see that the photograph or painting he is copying is lighted evenly over its entire area. One way to do this is to tie strings of equal length on each lamp near the point where it fits onto the stand and then stretch these strings from the center of the object being copied, to keep the lamps on the same level as the lens.

When there are no photofloods or other even illumination available, good copies can be made outdoors in either shade or bright sunlight. I prefer shade for monochrome materials and sun or reflected sunlight for copying subjects on color film. Here again, the use of a tripod and a wall can often make copying easier. Care should be taken that neither the photographer nor his camera cast a shadow on the copy material and in the case of color material that there is no unusual color hue being reflected onto the material being copied.

Electronic flash or flashbulbs can also be used for copy work. It is possible to use only one flash and get a fairly good copy, although I prefer two lights. If the camera is on a stand, from one-half to two-thirds the regular exposure can be given with the light on one side and a second

exposure can be made with the flash on the other side, both on the same piece of film.

Some photographers may prefer to use fluorescent tubes or carbon arc lamps of the type used on lithographic presses. Even, shadowless lighting can be obtained with a circle of incandescent lamps with the camera lens in the center, a fluorescent circle lamp such as is used in kitchens, or a special type of electronic flashlamp in ring form, with space for the camera lens in the center.

SETTING UP THE COPY

The material being copied should lie perfectly flat, and the camera should be parallel to it, or the perspective will be distorted on the negative. Many photographers buy or make a copy stand, which allows the material to be held behind glass in a frame that moves on horizontal tracks for sizing. There is a mount for the camera at the end of the tracks and facing the material.

When no copy stand is available, placing the camera on a tripod (preferably an elevating tripod) will allow the photographer to focus easily and will hold the camera steady while the exposure is being made. With the camera on a tripod, the copy material can be mounted on a flat wall in an upside down position, giving a right-side-up image on the groundglass of press and view cameras. For other cameras, the material is mounted right-side-up. Thumbtacks, transparent tape, or masking tape can be used to affix the material to the wall. The photographer must be careful, of course, not to mar or deface anyone's valuable photograph and should avoid damaging the wall as well.

Material may also be placed on the floor with the floodlamps pointing down from each side. In order to keep a photograph or newspaper clipping flat, a pane of glass may be placed over it. If the lights are placed properly, there should be no reflection from the glass.

CAMERAS AND ENLARGERS FOR COPYING

I find it easier to make copies with a press-type camera than with any other, because of the groundglass focusing and because the photographer can shoot only one or two pieces of film at a time if he wishes. Single-lens reflex cameras, which view through the lens, are also ideal for copy work. Some 35mm rangefinder cameras have special stands with calibrated charts that enable the photographer to make copies with ease.

Certain types of enlarger have an accessory camera back that will hold cut or roll film, converting the enlarger into a view-type camera. Special lamp holders are also available for doing copy work with cameras and enlargers.

If the photographer has none of these materials but still has a camera on which he can open the back and see the film plane, he can place

Fig. 15-2. The Speed Magny attachment, which replaces the regular back of a Nikon F, comes in two models: Model 100 for using Polaroid 3¼″ × 4¼″ film packs and Model 45 for using standard 4″ × 5″ holders for Polaroid or for conventional film. The camera retains all the advantages of the automatic mirror, automatic diaphragm, and through-the-lens metering. It is possible to make copies of documents; news, sports, commercial, industrial, or scientific pictures; and in the case of using the special Polaroid negative and positive film in the 4″ × 5″ camera, the negative can be used for enlargements or for quick reproduction of any number of photos when used under a standard enlarger. Courtesy of Ehrenreich Photo-Industries, Inc.

a sheet of waxed paper or groundglass material across the film plane in order to focus on the object to be photographed. After the camera is focused and while fastened to a tripod, it can be loaded with film and an exposure made. This is more of an emergency measure, however, than a satisfactory method of getting good, sharp copies. Most roll film cameras, therefore, are unsuitable for good copy work.

FILM, EXPOSURE, AND DEVELOPING

Black-and-white copies of photographs can be made with any good panchromatic film. There are, however, special films made for copy work. Usually slower in film speed, these films tend to keep the whites of black-and-white photographs from reproducing gray. These materials, known as *process films*, come in sheet film sizes only, thus limiting their usefulness to press cameras or roll film cameras that have a cut film adapter.

Because different materials photograph differently although copied on the same type of film, it is best to bracket important copy pictures by making one exposure at the calculated f/stop, one exposure a stop over, and a third a stop under. Usually, I use a medium-speed panchromatic film (ASA 125–200) for copy work. With two No. 2 photofloods set at a 45° angle and placed 3¼ to 4 feet from the copy material, I shoot one exposure at f/16, 1/25 sec., another at f/22, and a third at f/32. One of these exposures should be much better than the others. By experimenting, the photographer can work out his own calibration for any film and lamp combination.

For copy work, I develop my film normally, unless I am trying to increase the contrast, in which case I overdevelop the film 15 to 20 per cent.

VARIED SUBJECT MATTER

Textured Materials

Materials with a textured surface or photographic papers with a silk or tapestry finish will show valleys and hills of the texture when lighted on each side by photofloods or flash. Forty-five-degree lighting will emphasize the texture of these materials, but using a polarizing filter will help counteract this if it is not desired. Other solutions include using shadowless lighting or daylight but not direct sunlight. It is also possible to put the photograph in a pan of clear water and make the copy while the photograph is immersed. Permission should be obtained from the owner of the photograph, of course. If the photograph has been retouched with dyes or similar materials, the retouching may come off under water. Old photographs, of course, cannot be handled in this manner.

Oil Paintings

I prefer to photograph oil paintings with polarizing filters, shadowless lighting, or north light. If the copy must be made in color, however, I use direct or reflected sunlight between the hours of 10 A.M. and 2 P.M., placing the painting so as to eliminate glare or using a polarizing filter on my camera.

Maps or Drawings

For maps or drawings, I prefer process film or regular lithographic film, which will give suitable contrast for reproduction.

Old Photographs

Old, faded, or yellowed photographs will often make very good reproduced photocopies. Because panchromatic film is blue-sensitive, this is an ideal material to use on yellow or brown, faded photographs. Filters for black-and-white material also increase the contrast and will often

Figs. 15-3a and b. (a) This copy photo of the 630-foot Gateway Arch in St. Louis, Mo., is the kind of photo sent out by the chamber of commerce and other similar organizations. Because of the many requests for photos like this one, organizations normally pay a professional photographer for the original photo and then have copies made in large quantities to fill the many requests received. Of course, copies made by these copy houses lack the quality of an original picture, or even a precision copy made by a careful professional photographer who knows his copy material. (b) An artist's drawing, painting, or scale model is often used for news releases to announce planned construction. In some cases, even after the structure is completed, it is almost impossible to portray the scene as accurately by photograph as an artist's drawing or model can do. Courtesy of the Convention and Tourist Board, St. Louis, Mo.

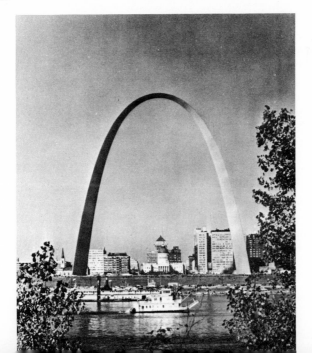

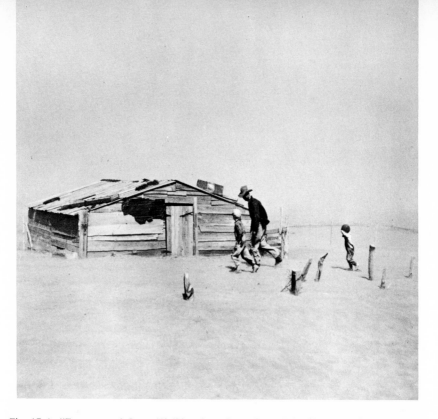

Fig. 15-4. "Farmer and Sons Walking in a Dust Storm" in Cimarron County, Oklahoma, April, 1936. This is a copy of Arthur Rothstein's famous photograph for the Farm Security Administration. Courtesy of the Library of Congress, Farm Security Administration Collection.

eliminate spots, if they are of a different color from other parts of the photograph. A blue filter on the camera will make a yellow or brown faded photograph appear more contrasty on the copy negative. A yellow filter, such as a K1 or K2, or an orange filter, such as a G, will eliminate brown or orange spots on black-and-white photographs. If there is a blue spot, use a blue filter to eliminate it; if the spot is red, use a red filter. The rule is to use the filter most nearly like the color of the spot you wish to eliminate.

INFRARED AND ULTRAVIOLET COPY WORK

Outside the limits of color visible to the human eye are two colors that are valuable in copying. These are the ultraviolet and infrared light rays, which are on opposite ends of the spectrum. Using infrared light, original photographs or documents that have been damaged, altered, or have deteriorated because of age may be reproduced satisfactorily when other copying methods fail. Infrared photography is also used in the

study of alterations made in a document or in the fakery of paintings. Although not apparent to the human eye, these differences appear when photographed using infrared materials. Infrared photography is also used by the military to detect camouflage.

Erasures and differences in chemical composition of old and new inks show up when photographed with infrared film and by using the proper red filter on the camera. Infrared film usually must be specially ordered, for few camera stores carry this film in stock. It comes in both roll and cut film sizes and is developed in standard black-and-white developers.

Because of the difference in the focal length of infrared rays, cameras with a long focal length, such as the 4″ × 5″ press camera, require some compensation with infrared film. Some lenses have a special dot to indicate the proper focusing distance for infrared film. Lens manufacturers usually supply this information in their instruction booklets, or it can be obtained by writing directly to them.

By rule of thumb for infrared film, the focal length of the lens increases 1/200 over the correct focal length for ordinary film. If this compensation is not made, the image will be out of focus. Exposure can be made by infrared bulbs, either flash or flood, or by tungsten lights.

Ultraviolet photography is also useful for photographing documents, engravings, and paintings. Invisible inks and fingerprints can easily be detected with ultraviolet materials. To detect fingerprints, particularly on a confusing background, a fluorescent powder is used. Sealing waxes differ in fluorescent properties, and tampering with seals may be detected because of this fact. The removal of cancellation marks or the authenticity of watermarks on stamps are more easily verified under ultraviolet light.

Sources of ultraviolet light include the sun, which provides about 5 per cent ultraviolet light, compared with 55 per cent infrared light and 40 per cent visible light. (High altitude sunlight has more ultraviolet light than does sunlight at lower altitudes.) Carbon arc and mercury vapor lamps are common artificial sources of ultraviolet emission.

Fluorescence is another property that is part of the phenomenon of ultraviolet light rays. Fluorescence is particularly noticeable in certain rocks and minerals when viewed under black light, a special type of ultraviolet light. The ultraviolet light rays make these objects glow in colors that are invisible under ordinary light.

The fluorescent wave is actually of longer length than the ultraviolet light itself. Through the use of the fluorescent light method, if ink has been erased or chemically removed from paper, the tampered part will show a difference in fluorescence from the rest of the material. When the light source is not primarily ultraviolet, special filters are required. These filters can be obtained from the Optical Sales Department of Corning Glass Works, Corning, N. Y. Wratten 2A and 2B filters can be employed when using the fluorescent light method. Medium-speed panchromatic

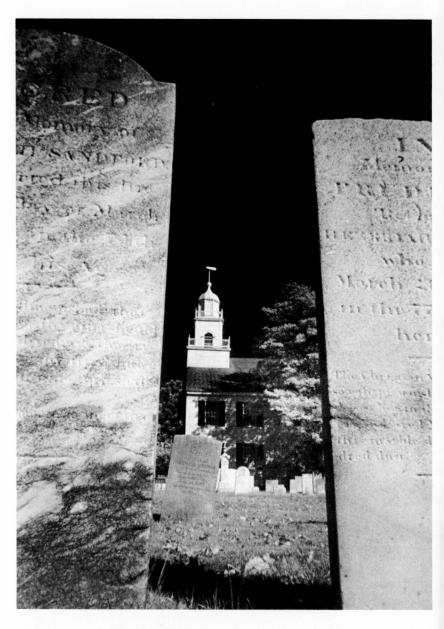

Figs. 15-5a and b. Infrared photos have been taken for a number of years, but are used very little by most newspapers. The way to recognize an infrared photo is that green foliage of trees (a) will be white, the sky black, and almost all such pictures will have a moonlit effect. These two photos were taken by *Newsday,* which uses a lot of "exotic" type emulsions—infrared, reversal, and anything else that is interesting: (a) taken with a Leica M-2, and (b) with a Leica M-4. Courtesy of *Newsday,* Garden City, N.Y.

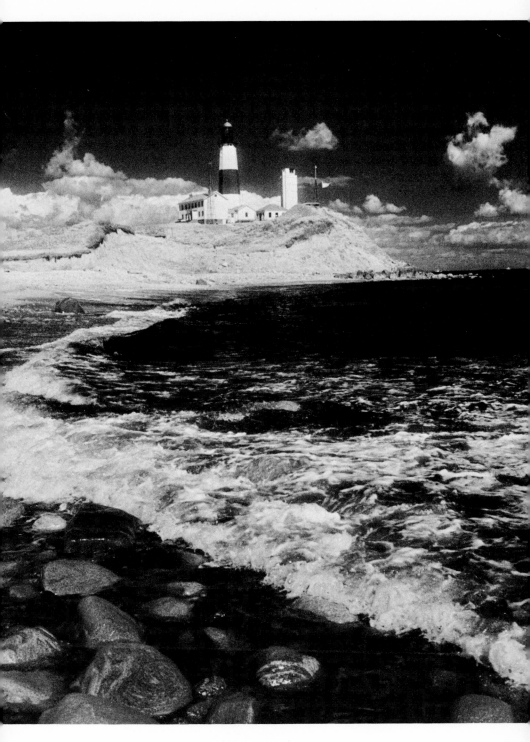

emulsions, particularly those more blue-sensitive, developed in either Kodak's DK-50 or GAF's Isodol, will give satisfactory results for ultraviolet light photography.

Ultraviolet light does not focus the same as visible light but comes to a sharp plane slightly in front of what would be the normal focus. Usually, this difference can be compensated for by stopping down the lens to a small aperture. The camera is first focused by the mercury vapor light, and then an ultraviolet-absorbing filter is placed on the lens to cut out the visible light before making the exposure. Theoretically, if there is no fluorescing of the subject being photographed, there will be no photographic image.

Color film may be used to photograph fluorescing objects, even when exposures are longer than is normally considered acceptable. The reciprocity factor should be taken into consideration, however.[1]

SLIDE DUPLICATION

Students in my classes often ask if it is possible to make a black-and-white print from color film. If the film in question is a color negative film, this is merely a matter of putting the color negative in the enlarger, making the test strip for the proper exposure, and using regular black-and-white projection paper to make a print. A special paper for color negatives should be used if the negative is the variety with an orange mask, such as Kodak Ektacolor or Kodacolor film. A suitable print can be made on ordinary black-and-white projection paper, preferably through a K2 filter. But even without the filter, the finished print will resemble an ordinary black-and-white print. For unmasked color negatives, such as Agfacolor, regular black-and-white projection paper can be used to make good black-and-white photographs.

If the color film is a positive (also called a *transparency* or *color slide*), a black-and-white negative must first be made. The easiest way to make the black-and-white negative is to put the transparency in the enlarger with the dull (emulsion) side toward the light. To focus the enlarging lens, use a piece of double-weight photographic paper the same size as a sheet of cut film. Place this paper in either an easel or a cut film holder with the dark slide removed. After the projected image is in focus, remove the paper and discard it. Then turn out all the room lights and insert the film in the film holder. With the enlarging lens set at $f/22$, flick the enlarger light on and off as quickly as possible.

[1] According to the law of reciprocity, as long as the exposure (light intensity multiplied by time) remains constant, the action on the emulsion is the same. Very short or very long exposures of electronic flash may need longer exposure times than normal because of the failure of the law of reciprocity. Sometimes long exposure also causes a color shift in color materials.

With ASA 125–200 panchromatic film, the f/stop of the enlarging lens should be set at $f/22$. Some adjustment will be needed for other films. When the film is placed on an easel, a piece of black paper should be inserted underneath the film to keep the light from bouncing through and causing halation.[2]

The emulsion, or dull, side of the unexposed film should also face the light. It is possible to make paper negatives from positive color films, either through enlarging or contact printing (see the section on paper negatives at the close of this chapter).

After the film is exposed, it should be developed and printed in the regular manner.

Color transparencies can be duplicated by several methods, and some professionals or firms with highly sophisticated duplicating equipment can produce slides that are almost the same as the original. In some cases, the duplicate may even be more pleasing than the original, but there is usually an increase in contrast, a loss of sharpness, and a shift of color values, so that it is almost impossible to make exact duplicates of color transparencies.

Good slide duplication machines are expensive, and most photographers who duplicate slides or transparencies only occasionally buy one of the duplicating attachments for a miniature camera, such as the focal slide and bellows attachment for the Leica rangefinder camera or one of the devices made especially for single-lens reflex cameras.

Electronic flash is usually considered the best type of light for slide or transparency duplication, because the speed of light prevents any loss of sharpness due to vibration or movement in the copying equipment. Some photographers make special viewing boxes that enable them to have a viewing light for focusing and a device for placing a filter between the electronic flash and the transparency being viewed through the camera. Eastman Kodak and GAF make special films for transparency duplication, but the speed of these films is so slow that they are generally used only by professionals having large strobe units or other specialized equipment that puts out a great amount of light. For this reason, regular daylight-type color films are used by most photographers using nonprofessional equipment. The film is developed in the normal manner for color.

Color sheet films can be duplicated using a contact printing frame. A printing frame is a device with glass on one side and a felt back that holds the negative in contact with the paper. This device is normally used for making sun proofs. The back of the frame opens and the negative is placed on glass with paper behind it. When the frame is closed, the pres-

[2]Light scattered in the emulsion is reflected from the bottom of the negative and forms a halo around bright image points. This causes the image to be diffused, or less sharp.

sure from one or more of the springs keeps the materials pressed against each other.

Tungsten light and tungsten color film can be used for duplicating when tungsten light is the only source available.

Photographers who wish a large number of duplicates usually make what is called an *internegative*, producing a color negative and making a quantity of slides from that negative. However, this procedure is not recommended for photographers who have only a casual acquaintance with color printing and developing processes.

THE PAPER NEGATIVE

Although not widely used, the paper negative has an appeal for those who want to do something a little out of the ordinary in making a photograph. An ideal size paper negative is 5″ × 7″ or larger, made on regular single-weight enlarging paper. Some photographers prefer a matte paper and others, a glossy paper for making paper negatives. There are also some very thin enlarging papers that are ideal for making paper negatives.

The paper negative is ordinarily used for two purposes—when the original negative is so small that it cannot be retouched and the photographer wishes to make certain corrections in shading, tone, or removing spots; and to add such things as clouds in a pictorial scene, by working on the back of the paper negative with a lead pencil.

Most of the work on paper negatives is done on the back, but some corrections can be made on the front. The front surface of glossy paper is so hard and slick, however, that doing much retouching on it is difficult. Because of the advantage of being able to work on both sides of the paper, some photographers prefer to use only matte paper.

The simplest way to make a paper negative is to place the finished photograph emulsion (shiny) side to emulsion side with a sheet of unexposed enlarging paper. With the finished photograph on top, place the two papers under an enlarger, using a sheet of clear glass to hold them perfectly flat. Expose them under the enlarger lamp with no negative in the carrier. Tests need to be made to determine the proper exposure (see the use of the test strip, in the section on printing the picture, Chapter 4).

Then develop the paper in regular paper developer just as you would develop a photographic print. When the paper negative is washed and dried, a positive can be made by repeating the original process.

If the original print cannot be replaced, then all retouching work must be done on the paper negative. In the case of an enlargement made from a film negative specifically for making a paper negative, retouching may be done on the positive as well as the negative.

Fig. 15-6. A reversal or negative print of the Brooklyn Bridge taken by Harvey Weber on Panatomic-X film. A negative print like this is easy to obtain by making a paper negative. Courtesy of *Newsday*, Garden City, N.Y.

RETOUCHING

When you are retouching either the negative or the positive, you can use frosted or clear glass over a light box so that the image shows through the back of the paper. A simple device can be made by using two thick books, one under each side of the glass with a small light burning underneath. Some workers would prefer to have the whole device tilted on an angle of about 45°. A fairly soft pencil, such as an HB drawing pencil sharpened to a fine point, will remove any small blemishes from the negative or positive, such as air bubbles, small marks, and scratches. The secret is to put only enough graphite into the corrected area to blend perfectly with the surrounding area. As is true with any photographic process, practice and skill will be required before the photographer can become expert with the paper negative process.

Any work done on the paper positive will appear dark on the finished print. Any work done on the paper negative will appear light on the print. Such things as clouds or larger areas that do not have a sharp line of demarcation should be blended with an artist's stump. (The cost of this tool is nominal. One can be purchased at any store where art supplies are sold.)

It is best for the beginner to restrain himself and not try to do too much hand work, since over-correction or work improperly done will detract from the quality of the final print. A skilled retoucher will be able to eliminate light traps in the hair, take out or add highlights, make eyebrows and eyelashes more definite, and even straighten a fold or wrinkle in a garment or eliminate a torn edge.

Care should be exercised not to smudge the print on the face or in some other place that will show. If a print or negative has too much graphite on the back, an art gum eraser can be used to remove the excess. Care should be taken not to leave any particles of the art gum embedded in the back of the print, for they will show up on the finished picture. The better the original print, the better the quality of the finished picture.

PHOTOGRAMS

Photograms are pictures made without using a camera. Toothpicks, sugar lumps, pins, plastic buttons, string, netting, and many other materials are useful in creating interesting photograms.

To make a photogram, take a sheet of enlarging paper, place it under the enlarger with no negative in the carrier, and then arrange various objects in some sort of pattern on the paper. Turn on the enlarger light for a few seconds with the enlarging lens stopped down to $f/8$ or $f/16$, thus exposing the paper, which is then developed in the usual manner for a photographic print.

Experiments and tests will produce an endless number of pattern pictures using the photogram method, which can be used to achieve artistic effects for illustrations, advertisements, and other purposes.

SUMMARY

Almost all photographers must make copies of photographs or art work at some time. Using one photoflood lamp on each side at about a 45° angle is one of the easiest ways to make copies. The material to be copied should be evenly lighted and parallel to the film in the camera, which should be on a tripod.

Many enlargers can be used for copying. Most camera films are suitable for this purpose, but films manufactured especially for copying will produce better whites in the copy photo.

Textured materials, oil paintings, old photos that have yellowed, or maps may require different copying methods and processing. Some copying is done in infrared and ultraviolet light because of the particular result desired, as in investigative work when invisible fingerprints must be revealed.

It is possible to make black-and-white prints or negatives from color film by using an ordinary enlarger and, in some cases, a filter, plus the proper film or projection paper. It is usually best to make a black-and-white negative from a color positive before atempting to make a black-and-white print.

Color transparencies can be duplicated by several methods, including an enlarger or a special device on the single-lens 35mm camera. Electronic flash is usually considered the best type of light for slide or transparency duplication. Duplicates can also be made by using a contact printing frame in a light-proof room.

A paper negative can be made either by projecting a color or a black-and-white positive through the enlarger onto an easel containing regular enlarging paper or by contact printing a regular photograph with a piece of enlarging or contact paper.

Retouching on the paper negative can be done by using pencil or ink to cover or take out blemishes, air bubbles, scratches, and so on. Either the positive or the paper negative can be retouched.

Photograms are pictures made without using a camera. Usually objects are placed on a sheet of photographic paper and the enlarging light is turned on for a few seconds, thereby exposing the paper in the normal manner.

QUESTIONS

1. Why does the news photographer often have copy work to do?

2. Describe the way you would light a glossy 8″ × 10″ photo that you planned to copy with a press camera.

3. Where would you place the press camera in relation to the picture you were copying, and what precautions would you take?

4. Can electronic flash be used for copying? Explain.

5. What type of films can be used for black-and-white copy work? What type is ideal?

6. What are the special problems in photographing textured materials and oil paintings?

7. How would you build up contrast when photographing an old, yellowed photograph?

8. How can filters be used in copy work?

9. What are some of the problems involved in using: (a) ultraviolet light in reproducing documents? (b) infrared light?

10. What are the problems in focusing photographs taken in infrared and ultraviolet rays?

11. How does the fluorescent light wave compare with the ultraviolet light wave?

12. Describe how you would make a copy negative from a color slide, using an enlarger.

13. What is an internegative?

14. Describe two methods of duplicating color transparencies.

15. What is the best type of light for duplicating color transparencies?

16. Describe one method of making a paper negative.

17. How can the paper negative be retouched?

18. What is a photogram?

Photo Editing

With lenses, cameras, and photographic materials superior to anything used in the past, the photographs of today should be the best ever produced. Sometimes this is true; some outstanding photographs are published in the nation's periodicals. Unfortunately, it is still too easy to find numerous examples of poor-quality photographs in most newspapers and magazines.

One reason why there are so many bad photographs is simply that there are so many photographers. Photography is one of the most popular hobbies in the country, and it is difficult to find anyone who does not think he knows what good photographs are. Many times a customer would come into my studio and pull from his wallet or purse a series of out-of-focus, gray prints of his child and tell me what outstanding pictures they were. The reason the customer thought the pictures were good is that he had taken them himself. He was picturing his child in his mind —and what child is not perfect in his parents' eyes?

Another reason for bad photographs is that many photos for publication are either poorly edited or not edited at all. Sometimes a printer who knows nothing about photo editing merely trims the picture to make it fit the space he has open, caring little whether he cuts off the top of the subject's head and leaves too much foreground at the bottom. Good photo editing can make an average photographer look better than he is. However, poor photo editing can make even a top-quality professional look like an amateur. Poor reproduction, dirty presses, or low-quality engraving plates can also ruin a photographer's reputation over a period of time.

Grainy and out-of-focus photographs are sometimes created intentionally for special artistic effects and for use in advertising, fashion, or for other specific purposes; however, some of the grainy and unsharp photos published result from the editor making blowups too large for small format work. Unfortunately, uninformed amateurs and some of the general public leap to the conclusion that such effects are desirable in all photographs. Photography magazines put out for popular consumption encourage this belief by publishing numerous poor-quality photographs as well as good ones. Perhaps the worst culprit in encouraging poor photography is the magazine or newspaper editor who cannot tell a good photograph from a bad one because he has had little, if any, training in professional photography or picture editing.

One picture editor told me that before he assumed his position on a large newspaper, the previous picture editor had always been someone who had had some editing experience but knew very little about photography. Fortunately, this attitude is not as prevalent as it once was, since more and more publications are now hiring competent photo editors.

Another person who helps to perpetuate poor photography is the occasional offbeat photographer who becomes famous because of his personality and the publicity he receives. No matter how poor his photographs are, he is widely imitated by gullible amateurs and some professionals. This type of photographer can make no errors, and one successful bad artist nurtures a rash of others. Fortunately, few if any of the imitators are financially successful and the fad dies, only to be supplanted by a new one from some new perpetrator.

On a large magazine, a picture editor will usually not only give assignments to photographers but also work with picture agencies and other sources of photographs. Usually both an executive and an administrator, he will not only supervise the photographic staff but will oversee print filing, the storage of negatives, and any background research that is done.

The magazine picture editor will normally make the final selection of pictures to be printed on any one story. As with most executive jobs, his duties will vary according to the type of publication and the staff. On some magazines, it may not be the picture editor but the managing editor who selects the photographs for publication. On other publications, there may be no picture editor as such, but some other person may perform these functions, such as the photographer himself. When I worked on a small daily newspaper, I was not only a reporter but also took most of the pictures, wrote the cutlines, planned the assignments, edited my own pictures as well as those of others, and made the layout for picture pages.

The picture editor has an important position on a publication. Even though he may not be a photographer himself, he needs to be able to judge high standards of craftsmanship. He also must know something about writing, printing, engraving, layout, makeup, and design. Keeping

Figs. 16-1a, b, and c. To make up a Sunday page, an editor needs a wide selection of photos in order to create an attractive layout. He needs close-ups (a); vertical shots (b); and horizontal shots (c). All photos were taken by farm reporter Con Marshall with a 35mm Pentax. Courtesy of the Scottsbluff (Neb.) *Daily Star Herald.*

abreast of new developments in photographic equipment and knowing what can be done with certain equipment will prevent the picture editor from sending out the wrong photographer or a photographer without equipment adequate for the job assigned him.

A good picture editor will work with his photographers to get them to produce their best work and to develop new approaches rather than falling back on the old familiar clichés. He will need to give more direction to some photographers than others and must be a good judge of people in order to determine how much supervision a particular photographer should have.

Many photographers are poor editors of their own work, because they are too closely involved to be objective about it. Some cannot work well on their own without specific assignments. Any editor who tells that type of photographer to go out and get a picture without giving him a clear idea of what he wants should not complain when the photographer comes back with something the editor dislikes. Giving directions may include the number of pictures wanted, the type of subject, the angle of view, the background, the lighting, and the specification of lefthand or righthand shots, close-ups, or long shots.

When there is a fast-breaking news story and the only photographs available are technically poor, the picture editor must take their news value into consideration. One famous picture of an unidentified woman leaping from the burning Winecoff Hotel in Atlanta won a Pulitzer prize

in 1947. It was a fuzzy, poor photograph, technically, yet the picture was selected for the prize because of its news value. Such exceptions occur, but in most other cases, technical perfection should be almost as important as news value.

AVAILABLE SPACE

One of the problems a picture editor encounters is fitting the pictures to the available space. On the inside pages of newspapers, the advertising is laid out before the text and pictures are. This sometimes leaves very little or oddly shaped space for the editor to fill with pictures and news stories. When the editor first made the assignment to the photographer, he may have had in mind a three-column by eight-inch picture. However, because of space limitations, the photograph may end up two columns by four inches, all the space available. Because the size of a newspaper is governed by the amount of advertising sold for any single day, the space available for pictures and news material will vary greatly from day to day. This can be frustrating to a photo editor who has a number of large-size pictures to fit into a newspaper on a day when space is limited.

Even the way the news breaks has great influence on the space available for pictures and news. If a great statesman dies and several other stories of similar importance break at the same time, some stories previously scheduled for page one must be crowded into inside pages, thus filling a great deal of space previously allotted for pictures. On a slow day, an editor may fill the pages with feature copy and public relations releases and use more space than normal for photographs in order to fill up the paper. On such a day, a photographer can get almost anything published.

When a group of photographers get together, they will occasionally be heard to discuss format—the rectangular vs. the square negative and so on. It makes little difference whether a photographer composes his pictures on a square negative, such as the twin-lens reflex camera provides, or on a long, rectangular shape, such as the standard 35mm negative, or on the 4″ × 5″ proportion format, which fits perfectly on an 8″ × 10″ sheet of enlarging paper. If the photographer composes his picture properly and does an adequate job of cropping under the enlarger, the picture editor will have few problems in preparing it for a certain layout. Most press photographers allow a little extra space for the picture editor to crop, because one is never sure exactly how much space is available or what shape the "hole" in the layout will be unless it has been planned ahead of time.

Although different publications require pictures of different sizes at various times, 8″ × 10″ photographs are the most common. Because of the introduction of the Photolathe, Scanagraver, and other engraving devices that can be purchased or rented by even the smallest weekly,

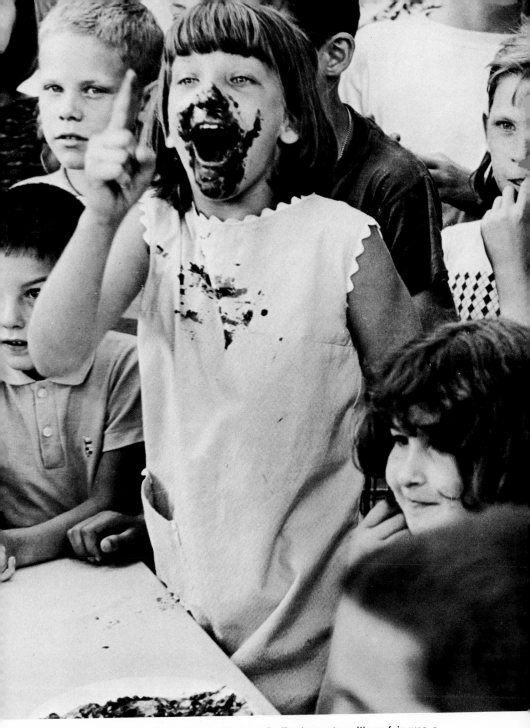

Fig. 16-2. This pie eating shot taken by Eugene D. Trudeau at a village fair was a second place prize winner in the 1967 New England Press Association contest. On a slow day, the editor might use such a feature photo larger than normal, because the space was available. Courtesy of the *New Milford* (Conn.) *Times.*

many newspapers prefer a size that fits their engraving machine. Special models of the Scanagraver will enlarge pictures, but none of the small engraving machines will reduce photographs. A photograph requiring reduction must be photographed again and made a size that will fit the engraving machine.

Most editors will tell the photographer the size they want the picture to be in columns. They might specify, for instance, either a one-column picture, a two-column picture, or a three-column picture. The photographer then enlarges or reduces the picture to the size that corresponds to the total width of that number of columns in the newspaper.

Magazines and large newspapers do not have this problem, for they use large engraving cameras that will either reduce or enlarge a photograph. Some magazines do use 11″ × 14″ photographs, but most publications prefer the 8″ × 10″ size because it fits easily into a filing cabinet and keeps the size uniform. Even a photograph taken with a twin-lens reflex, which fills the full negative, will be printed 8″ × 8″ size on a sheet of 8″ × 10″ paper. Other pictures that do not fit the 8″ × 10″ format will be printed on 8″ × 10″ paper with additional white space showing at the sides or top and bottom.

Many photographers believe that editors always want single-weight glossy photographs, but a photograph put on glossy paper that is not ferrotyped will reproduce the same as one that is ferrotyped. Some professional photographers prefer to put their prints on double-weight glossy paper, since the prints will stand more abuse and hold up better when passing through several hands.

Advertising photographers sometimes use a paper called Illustrator's Special, which has a tone similar to that of non-ferrotyped glossy paper. One reason advertising agencies prefer this paper is that it will take the artist's airbrushing, which is done on almost all advertising photographs of equipment and merchandise.

THE FUNCTIONS OF A PHOTO EDITOR

Picture editing, like photography itself, is full of innumerable variables that are difficult to predict or control. There is no way to determine an average or ideal way to perform the photo editing function, for even the organization of the newspapers themselves varies in many ways. One publishing company putting out both an evening and a morning paper will use one system on the morning paper and an entirely different system on the evening paper.

Much depends upon the type of personnel available, the original organization of the company, and the area being covered. Often the problems involved are peculiar only to a certain publication.

Because of these factors, it is difficult to give an exact outline of the photo editor's job or tell exactly what he does. One person will perform

certain tasks, whereas another will have the same title but do an entirely different job.

Do picture editors edit? Yes and no. Some picture editors write and edit the cutlines; others merely crop the pictures to size, eliminate unwanted background space, or crop the pictures closely to make the head size of the persons in the picture appear larger.

Fig. 16-3. This photo layout helped James A. Geladas win awards in the National Press Photographers Association picture editing contest. Geladas, managing editor of the *Telegraph-Herald* for the past 13 years, is responsible for the final presentation on the printed page and likes to think that "we are somewhat unique in photo-editing in that we are concerned, especially in our full-page layout, that the page be compatible with the subject matter." Courtesy of the *Telegraph-Herald,* Dubuque, Iowa.

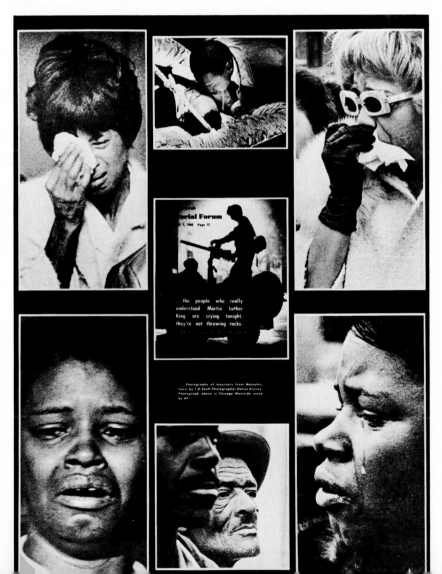

Many times it may be a reporter or someone on the city desk who writes the cutlines. Much depends upon the policy of the newspaper and the qualifications of the picture editor. Often the sports and women's page editors work directly with the photographers, editing and writing cutlines for their respective pages independently of the city desk or the picture editor.

Many newspapers do not have a picture editor as such but have a chief photographer who works with the city desk and is in charge of the processing, assigning the photographers to a particular news story the city editor wants covered. The chief photographer will also keep a log of the assignments, including the name of the photographer and the time and date the pictures were taken.

The chief photographer usually writes no cutlines and does very little, if any, picture editing. He ordinarily has nothing to do with the photos furnished by the press services, including those coming off the automatic processors. These machines will be located near the city desk or in some cases near the desk of the person performing the picture editing function.

Some newspapers, such as the New Orleans *Times-Picayune* (morning) and *States Item* (evening), have photo editors for each paper, who write the cutlines and edit the photographs used in the paper. There is also a chief photographer, who is in charge of the 14 staff photographers and the photographic laboratory.

Part of the photographic staff work for both newspapers. The Sunday *Times-Picayune* magazine, *Dixie Roto,* has its own photographer who works directly with the editor of that magazine. In case he is needed for a special assignment, however, he may also take pictures for the two daily newspapers.

WHAT IS A GOOD NEWS PHOTO?

What the picture editor wants in a photograph depends upon the photo, its purpose, and even such a consideration as the time of year. A good photograph for a special holiday such as Christmas or Easter, for instance, might have no news value at other times.

Many editors will tell you that they do not know exactly what they want, but they know it when they see it. Often, they know it from the experience of having been a picture editor over a long period of time.

What an editor wants first is impact or storytelling quality. In the case of a youngster's first haircut, the interest may lie in the amusement it brings the reader as he recalls an incident in his past. Almost everyone smiles at the things youngsters do and relives a little of his own life through the child who is discovering the world and its problems. Impact may be found in many situations. It may be the sorrow that is evoked for the mother who has just lost her son in a boating accident or by drowning, or the anger aroused by the actions of some politician.

Figs. 16-4a and b. How would you give impact to such subjects as a lifetime supply of tires (a) or the rubber soles on a sportsman's boots (b)? It takes imagination, initiative, and photographic know-how to give normally dull subjects reader impact. Goodyear Tire & Rubber Co. uses two men for each assignment—a writer and a photographer. Courtesy of Goodyear Tire & Rubber Co., Akron, Ohio.

Besides impact an editor looks for simplicity, preferring 1 to 3 heads in a photograph rather than a group of 15 people that no one can recognize unless he reads the caption underneath. Simplicity also means uncluttered backgrounds, with no distracting elements such as telephone poles or wires that are bound to creep into the amateur's snapshots. Anything that causes confusion in a photograph or any element that can be edited out without hurting the picture is removed by the good photo editor. In the case of a wreck or storm, such as a hurricane or tornado, however, it may be that very clutter that contributes much to the story-telling quality and makes an exception to the rule of simplicity.

Beauty is another quality that a photo editor looks for, which may be one reason why beautiful girls have a habit of staring out from the pages of newspapers. Dressed in a bathing suit, lounging near an inviting

pool, or wearing ski clothes and posing at a winter resort, they have universal appeal. Beauty comes in many other guises, of course, such as the rapid flutter of a bird's wing or a butterfly's graceful pause on a flower. Beauty can also mean spring flowers, summer clouds in the sky, or white sails filled with an ocean breeze. It can be a very simple thing, such as a close-up of a bride's hand holding a white Bible.

Beauty is usually associated with youth, but age and antiquity have an appeal all their own. A study of an old sea captain on a bench recalling early voyages or a grandmother steadily rocking by the fire as she knits will have great impact on the reader. Even the coarseness of a rough-hewn board photographed in a lighting to bring out its texture or a rugged mountain with its jagged crags etched against the sky will appeal to a great number of people.

This brings up another element that the photo editor seeks—wide appeal. The greater the number of people who can identify with the photograph, the greater will be its impact value. On a sultry summer day, it is easy for almost anyone to associate himself with a youngster playing under a sprinkler or diving into the old swimming hole. In the winter,

Fig. 16-5. This simple but beautiful photo was winner in the Iowa Associated Press Newsphoto Competition, pictorial winner in the Iowa Press Photographers Competition, first place winner in the Mid-America Travel Contest, and third place winner in the National Press Photographers Association contest. Photo by Bob Coyle.

snow piled up over the rooftops during a freak storm will have a universal attention-getting quality.

A picture of a local event will usually have greater appeal than that of a national event, for the circulation of almost every newspaper is built upon the amount of local news that it carries. The size of the city governs how much impact such a picture will have, for almost any newly elected club officer in a small town will attract local interest, whereas in a large city the person will have to be more important or influential to appeal to many readers.

The photo editor also looks for photographic quality. He wants a picture with a good range of tonal values, not one that is too contrasty or not contrasty enough to reproduce well in his publication. If a picture editor has an extra hole to fill in the publication, he will often choose a photograph because of its excellent print quality, providing, of course, that it has some storytelling appeal too. However, he may use a picture with poor print quality, if it has outstanding reader interest or particular news value.

The picture editor also seeks the odd, the unusual, or the bizarre happening. The birth of a two-headed calf or a plant growing in an unusual shape make newsworthy pictures. A photograph of the little girl who won a contest because she had more freckles than any other contestant could be the one to arrest the reader's attention. A picture editor would immediately include it in the paper, for its unusual quality, alone.

A picture of a chimpanzee driving a car down the highway would surely arouse interest, and although there was no picture of it published, such an incident did take place in Florida several years ago. When the highway patrolman arrested the chimp for driving the car, it was learned that Florida had no law against a chimp's doing so. Of course, the owner of the chimpanzee was sitting in the seat beside him, but the legislature immediately passed a law to prevent such incidents from recurring.

Although trite because they have been used so often, there are always pictures published of a straw driven through a telephone pole in a windstorm, cows marooned on rooftops or in trees during a flood, or a dog or cat that has wedged itself into a pipe or small opening and must be freed.

One spring morning I heard something hitting my window repeatedly. When I investigated, I saw a cardinal flying into the window as if to do battle with his reflection. He kept this up for a good part of the day, stopping only to catch his breath. I photographed the bird in action and sent the picture to *Life* magazine. Although they did not buy the photograph, they sent a personal rejection letter, making me feel I had come close to taking a picture with universal appeal.

Even photographs taken at an unusual time of day, with long shadows, such as early morning or late afternoon, or a photograph taken in fog at night may be unusual enough to catch a picture editor's eye. He

Fig. 16-6. The goblins will get you, either by night or day. Instead of trying to get a night effect, Bill Tutokey set up this shot in the daytime giving uncommon treatment to a common subject. Courtesy of the *Billings* (Mont.) *Gazette*.

is always looking for something different and again, he never knows exactly what it is until he sees it.

CUTLINES

It would seem that a photograph of the capitol building in Washington, D. C., would need no explanation, because everybody surely knows what the national capitol building looks like. To dispel this theory, however, one needs only to take such a picture and ask ten different people to tell him what it is. Invariably, there will be some wrong answers, including such unlikely replies as the Taj Mahal or the Houston Astrodome.

Because so few pictures are self-explanatory, some type of identification and explanation must usually be printed with each picture used in a publication. Ideally, the picture and its cutline should be considered together as a unit. Most newspapers distinguish the type of a cutline from the text type used on the page by setting the cutline in either a larger size, a different face, or a boldface type.

Cutlines should be written in order to give in as few words as possible any information not immediately apparent from the picture itself. The most vital information usually appears in the first few words, which are set in all capital letters to distinguish them from the rest of the cut-

line. Not every publication follows this style, however, for some use what is called an *overline* (type appearing above the picture) or a *catchline* (type appearing below the picture but not a part of the cutline itself).

Cutlines, as a rule, should be short, simple, and as physically close to the picture as possible. Not all appear below the picture but are sometimes set to one side, or as is the case when a picture is incorporated within a box in a story, the information may be included in the story itself with only a word or two of explanation appearing above or below the photograph, more like a title than a cutline.

One of the greatest problems in writing the cutline is that the reporter, photographer, or picture editor is always in a hurry to get something ready and to rush the picture to the engraver, since the newspaper must go to press. In this rush, there often appear such trite cutlines as "Winner Jane is shown sunning herself on the diving board by a beautiful swimming pool." Such wording shows a lack of imagination and gives little information that the reader cannot readily ascertain from looking at the picture, except for identifying the subject. People who are easily recognizable, such as government officials or celebrities, may not even need to have their full names appear in the cutline because they are so well-known.

However, when the celebrity is in a large group, he will need some kind of identification. This is often done by printing an arrow that points to him, encircling his face, or some other such obvious device. At times, as in the case of the President or some other well-known personality, the cutline may merely give the name of the child he is with, such as "Sally Jane Smith and friend at a White House gathering."

A good way of tying in pictures with copy is to run a headline over both the picture and the story that accompanies it, immediately showing the reader that the story and photo go together. If the paper uses rules to divide columns, the rule can be omitted between the picture and the story beside it to convey this relationship. Different papers use various devices to accomplish this, with some using an arrow pointing from the picture to the material that goes with it. Pictures sometimes appear with the entire story told in the cutline, and in this case, the cutline is usually longer than if there were a separate story.

One of the best ways to interest the reader in the cutline is to begin it with an action word, such as an infinitive or a participial phrase. This device draws the reader into the cutline before he realizes it, while he is still trying to learn what is going on. Avoid starting a cutline with an article or noun, unless the latter is a verbal form being used as a noun. For example: "Nineteen-year-old Jane Truehart won the Prairie Flower Queen Contest last night in Oak Bucket. She is the daughter of Mr. and Mrs. J. E. Truehart" This cutline would be more interesting if it began, "Winning the Prairie Flower Queen Contest last night in Oak Bucket was"

There are many examples of cutlines being three, four, or five columns wide. In the case of three columns, it is better to break the cutline into two sections each 1½ columns wide, to make it easier for the reader's eye to follow quickly. A four-column cutline should be broken into at least two sections, each two columns wide. A five-column headline could be broken into either three or four equal parts or perhaps two two-column sections with some space on either side of the type. It is always better to have enough white space to give a light, airy look to photographs and cutlines.

CREDIT LINES

Although it is the policy of some publications not to use them, credit lines showing who took the photograph—the local photographer or a press service—should appear with every picture published. Staff photographers are often exempted from this rule, but they are also given credit in many instances.

Such credit lines are handled in several ways, the most common being "Photo by . . ." or just the word "By . . ." with the name of the photographer or wire service just under the picture, usually at the right side. If the photo is unusual or exceptionally important or in any other way shows the skill of the photographer, the name may appear in larger type just above the cutline or even at the end. For legal reasons, all copyrighted pictures should carry the copyright notice to avoid invalidating the copyright on the picture (see Chapter 17 on copyrighting).

Many editors do not realize the importance of running a photographer's credit line; this is usually the only recognition the photographer gets, and doing so builds a good public image for the publication at no additional expense. From my own experience, I have worked for some newspapers that always gave me a credit line and others that not only omitted my credit line but put one of their own under my picture, causing me great irritation, although I was powerless to do anything about it.

Professional photographers will often furnish a newspaper or other publication newsworthy photographs merely in order to get the credit line. This is particularly true with bridal pictures on the women's pages. When I was running a professional portrait studio, I took pictures of at least one or two weddings each weekend. The first thing I would do after photographing each wedding was to develop the film immediately and have an $8'' \times 10''$ glossy print ready for the editor at 8 A.M. Monday. I knew he needed time to make the engravings for the Thursday edition of the paper, but another reason why I always furnished him with a picture from each wedding was that he always gave me a credit line for each of my photographs that he published. On the basis of these credit lines, I was able to establish a reputation in this small community much faster than I would have otherwise.

Fig. 16-7. A five-alarm fire at the Denver Athletic Club provided Bill Perry with these dramatic photos of firemen rescuing members from the holocaust. Because of the nature of the subject, the editor of the *Rocky Mountain News* used all vertical composition for the final picture story. The club members climbing from the window and sliding down the drainpipe and the one man almost obscured by smoke add drama and impact to a local news story. Courtesy of the *Rocky Mountain News*, Denver, Colo.

Credit lines also give recognition to photographers who make good pictures, as well as pointing out those who make only acceptable or even rather shoddy pictures. The credit line also tends to increase reader interest by giving some identification to the various photographers, both on the staff and otherwise. Readers can become familiar with the pictures of a certain photographer and follow his work, just as they follow a certain writer or cartoonist. This helps to give personality to the publication, rather than allowing it to be just a mechanical production.

SIZING

Beginning press photographers often wonder how large a picture should be. Small, half-column pictures not only take as much effort as one-column pictures but are difficult for the reader to see. It is better to make a picture too large than too small. Much depends, of course, upon the space available and the subject. If a person of little prominence is speaking at an ordinary occasion, perhaps a one-column picture would be sufficient. If the subject is a celebrity speaking at an important meeting, the picture would be more suitable run two, three, or even four columns wide. Such decisions are hard for the beginning photographer to make but easy for the editor who has had considerable experience. However, there is no sure way to know what exact size a picture should be to get the greatest reader interest.

In sizing, or scaling, photographs, there are two problems—the first is to fit the photograph to an allotted space, and the other is to determine how long a photograph will be when it occupies a one-column, two-column, or three-column space. The proportions can then be changed, if necessary, by cropping. There are small scaling devices that will size photographs to fit a given space; and engravers use a more elaborately scaled computer wheel. If you do not wish to use such a device, you can solve this problem easily by projecting or drawing a diagonal line from the lower lefthand corner to the upper righthand corner of the space to be filled and another from the same points in the portion of the picture that is to be used.

Superimpose whichever is smaller—the space or the photo—upon the other, with their lower lefthand corners congruent. The point to which the shorter diagonal extends should be noted. A perpendicular line dropped from that point will give you the length of the shorter rectangle. This will indicate if cropping is necessary to change the proportions of the photo and can also be used as a basis for indicating the desired enlargement or reduction to the engraver. This is actually a much simpler and faster method than attempting to measure with scales or other computing devices.

There are some commonsense rules that apply to almost any publication in determining what size to make a photograph. A picture of three

people will look better in a three- or four-column photograph than in a one-column one. An old engraver's rule is that no human face should be smaller than a dime, which is, of course, a bare minimum. In the case of large groups, an exception must be made because there are too many heads in the photograph. In cutlines for such groups, it is always advisable to avoid long lists of names. Identifying the whole group as the "fifty members of the United Sunburst Convention" is more desirable. No one except the individuals in the group photo will read a long list of names in a cutline.

Some picture editors cut off ears and crop the tops of heads to get large head sizes, but I prefer to see the entire head. I also prefer to have the picture cropped so that the person does not appear dismembered, as he would if the picture were cut across the joint of the wrist or at the ankles. In the latter case, the picture looks better if cropped just above the belt line.

As for the ideal shape of pictures, opinions differ on this. Some persons do not like a square picture, a round picture, or one that is too long. The rule here is to make the picture a pleasing shape, whether it is long, round, square, or some other shape.

It is usually easier to overlap pictures in a publication printed by the offset process than one printed by letterpress. A photo editor should acquaint himself with the problems of the engraver in making odd-shaped pictures and not ask the impossible nor expect to use a great amount of the engraver's time on a relatively unimportant picture. It is generally best to keep most pictures rectangular rather than odd-shaped to avoid problems in making up the page.

Some newspapers do no retouching; others do a considerable amount. If an artist is available, he usually employs an airbrush to retouch photographs and eliminate backgrounds, bring out dark hair or clothing against dark backgrounds where they would otherwise not be apparent, and take out telephone poles or other distracting objects. I have even had publications airbrush one entire figure out of a photograph of three persons because the editor wanted a picture of only two of the subjects. Some simple retouching can be done on the photograph merely by outlining a dark head with a white retouching pencil.

A series of pictures should be handled similarly to the picture story with a variety of angles and photographs (see Chapter 10 on the picture story).

SUMMARY

Because photography is one of the nation's most popular hobbies, almost everyone considers himself somewhat of an expert on the subject. Photographs of snapshot quality are unlikely to be suitable for publication, although such photos may appear because of poor editing, no editing, or lack of any other pictures of the subject.

Good photo editing can make an average press photographer appear better than he is; poor photo editing might make even a top professional look like an amateur. Other factors involved include the quality of reproduction, old or dirty presses, or bad engraving plates.

Some photos taken on small-format cameras and fast, grainy film are too greatly enlarged for good reproduction. This may sometimes be done intentionally to achieve a certain effect, especially in advertising or fashion photos.

Currently, there is a shortage of competent photo editors on publications, although not as great as it once was. Usually, on a large magazine a picture editor will be responsible for several tasks, including making assignments to photographers, working with picture agencies, and doing a considerable amount of administrative work. The picture editor's job is not clear-cut, but varies from publication to publication. In some cases, the picture editor may be a photographer; in others, he may have been an editor or he may have some unrelated background. Some photographers require more direction than others, and the picture editor's job is to get the best work possible from each photographer.

In spot news, the picture editor will take the news value as his primary consideration with quality as his secondary consideration. Picture editors on newspapers have many problems of layout due to the great amount of advertising on inside pages of the newspaper. Some days there are too few pictures to fill the paper, and other days, too many.

The differences in size of the camera format and of finished prints have little bearing on the finished layout if the photographer pre-plans his pictures. The most common size of photos for publication is 8″ × 10″. The most common surface for publication photos is high gloss, but matte-surface pictures are sometimes used.

A picture editor may edit all pictures for a newspaper, or he may edit only those sent by wire service or mail, leaving the photography department or someone on the city desk to edit local photographs. Often the reporter writes the captions, but the photographer himself or even the picture editor may do it in some cases. Much of the policy of the newspaper in this respect depends upon the organization of the publication and the qualifications of the picture editor and other personnel. Many newspapers do not have a picture editor as such but instead a chief photographer works with the city desk, assignments being made by the city editor.

Qualities in a picture that the editor looks for are impact, newsworthiness, or storytelling quality. He also seeks simplicity, beauty (or in some cases, ugliness), youth, or old age, with probably one of the most important elements being wide appeal.

A picture with good tonal quality is more desirable than one that is either too contrasty, too thin, or poorly processed.

A good press photographer should form the habit of identifying his subjects as he takes the picture, so that interesting and accurate cutlines can be written.

The use of credit lines gives both the photographer and the publication prestige.

A picture appearing in the paper should not be too small; it should be large enough to arouse some reader interest. Much depends upon available space in the publication. One of the easiest ways to size a photo is by the diagonal-line method.

QUESTIONS

1. Why do many poor photographs appear in publications?
2. What does a picture editor do on: (a) a large magazine? (b) a small newspaper?
3. What type of background should a picture editor have?
4. How should he work with his photographers to get the best results?
5. What is the most important quality in spot news pictures?
6. What are some of the problems an editor faces in laying out photos on the inside pages of a newspaper?
7. What is the best format of camera for taking pictures for publication? What is the usual size of pictures for publication?
8. What is the most common photo paper used for pictures in publications?
9. Who usually writes the cutlines for photographs?
10. How does one write a good cutline?
11. What are some of the values of a good news photo?
12. Why will a picture of a local event usually have greater appeal than one of a national event?
13. What is the advantage to the photographer of having news pictures of the highest quality?
14. Should news pictures be taken in early morning or late afternoon? Explain.
15. What is one of the best ways to interest the reader in the cutline?
16. What is the importance of using credit lines?
17. Explain how you would scale an 8″ × 10″ picture to fit a two-column by three-inch hole.
18. How should a series of pictures be handled?

Legal and Ethical Aspects of Press Photography

LEGAL ASPECTS

AFTER THE press photographer has been taking photographs for some time, he will probably take a picture that someone wishes to use in an advertisement. If it is a picture of a store front, building, or some other object with no recognizable human beings shown, there is ordinarily no legal problem. The photographer can sell or give the picture to the client who wants to use it in an ad and no one is likely to be involved in a legal suit. Even a recognizable photograph of a store proprietor or some member of his family appearing in the ad of the store carries with it the implication that the owner had consented to the publication of the photograph.

Model Releases

If the subject of the picture is another person, however, even a model or a good friend of the photographer, he should obtain a written model release before using any picture for other than ordinary news purposes. State laws vary, but it is always safer to get a signed model release than to rely on oral consent. Even the written consent of a minor to the use of his picture is not adequate, for the signature of his parent or guardian is necessary to make the model release valid.[1]

[1]In some states, a minor may be any person under 21 years of age; in others, an 18-year-old married woman may be legally considered an adult. Also involved are the terms "void" and "voidable" pertaining to minors. In some states, any contract signed by a person under 18 is void, whereas one signed by a person 18 or over is voidable until he becomes 21. When he reaches the age of 21, the previous contract may become valid and not voidable, especially if the former minor ratifies it in some manner.

MODEL RELEASE

For and in consideration of my engagement as a model by_____ , hereafter referred to as the photographer, on terms or fee hereinafter stated, I hereby give the photographer, his legal representatives and assigns, those for whom the photographer is acting, and those acting with his permission, or his employees, the right and permission to copyright and/or use, reuse and/or publish, and republish photographic pictures or portraits of me, or in which I may be distorted in character, or form, in conjunction with my own or a fictitious name, on reproductions thereof in color, or black and white made through any media by the photographer at his studio or elsewhere, for any purpose whatsoever; including the use of any printed matter in conjunction therewith.

I hereby waive any right to inspect or approve the finished photograph or advertising copy or printed matter that may be used in conjunction therewith or to the eventual use that it might be applied.

I hereby release, discharge and agree to save harmless the photographer, his representatives, assigns, employees or any person or persons, corporation or corporations, acting under his permission or authority, or any person, persons, corporation or corporations, for whom he might be acting, including any firm publishing and/or distributing the finished product, in whole or in part, from and against any liability as a result of any distortion, blurring, or alteration, optical illusion, or use in composite form, either intentionally or otherwise, that may occur or be produced in the taking, processing or reproduction of the finished product, its publication or distribution of the same, even should the same subject me to ridicule, scandal, reproach, scorn or indignity.

I hereby warrant that I am $\frac{under}{over}$ twenty one years of age, and competent to contract in my own name in so far as the above is concerned.

I am to be compensated as follows:

I have read the foregoing release, authorization and agreement, before affixing my signature below, and warrant that I fully understand the contents thereof.

_____L.S.
 NAME
DATED _____

_____L.S.
 WITNESS ADDRESS

 ADDRESS

I hereby certify that I am the parent and/or guardian of _____ an infant under the age of twenty one years, and in consideration of value received, the receipt of which is hereby acknowledged, I hereby consent that any photographs which has been, or are about to be taken by the photographer, may be used by him for the purposes set forth in original release hereinabove, signed by the infant model, with the same force and effect as if executed by me.

_____L.S.
 PARENT OR GUARDIAN

 ADDRESS

Photographer: 1 - Fill in terms of employment.
 2 - Strike out words that do not apply.

Fig. 17-1. A photographer should obtain a written model release before using any picture for other than ordinary news purposes.

The more exact the language and the broader the release, the greater the legal protection given to the photographer. But even a written model release does not prevent the photographer from being sued if the picture has been altered or used in some way embarrassing to the subject for which he has not given his legal consent. It is also important to remember that the release must be voluntary on the part of the signer and not obtained by coercion or fraud.

From experience, I have found it best to obtain a model release at the time the picture is taken. In my release, I usually mention a consideration, which may be a sum of money, the gift of a finished photograph, or

Fig. 17-2. This picture of Mrs. Martin Luther King, Jr., taken during funeral services for her husband in April, 1968, won first place in the magazine portrait and personality category in the 1968 Annual Pictures of the Year Competition, sponsored jointly by the National Press Photographers Association, the University of Missouri School of Journalism, and the World Book Encyclopedia Science Service, Inc. It was photographed by Flip Schulke for *Life* magazine.

something else of value. I also include the date and state that the person signing the release gives his consent for the various advertising and publication uses, including the electronic media. A photographer can usually buy model release blanks from firms advertising in photography journals, or he may have his own forms printed or typed.

Right of Privacy

The model release comes under the right of privacy. There have been legal cases involving the right of privacy in which the photograph in question was not published but was only seen by a third person. Public figures, generally speaking, have little or no right of privacy, and the person who takes a picture of an actor, famous scientist, or politician has the right to reproduce it in publications for informative purposes. However, it cannot be used for advertising under any circumstances without the subject's permission.

The majority of lawsuits brought against photographers involve the right of privacy. As with most legal rulings, what constitutes an offense in this area depends upon the laws of a particular state and the intent of the photographer. In New York, a photographer can display samples of his work in his studio but must remove any picture for which he does not have consent if the subject of the picture objects. Other states may or may not allow such display, and for this reason, it is best for the photographer to be familiar with the laws of his own state on this point.

If a picture is taken in pursuit of news and published in a newspaper or magazine, the courts have usually held that the same picture may be used without the subject's consent in an ad to increase circulation of the publication or in some similar way. The picture cannot be used in connection with a product, however, or any other item not related to the

Fig. 17-3. This unusual shot of Governor Rockefeller taken during the 1968 presidential primary campaign won honorable mention in the National Press Photographers Association monthly clip contest for Fred Comegys. This photo, as well as Fig. 17-2, are good examples of public figures having little or no right to privacy; the person who takes this picture has the right to use it in publications for informative purposes. Courtesy of *Wilmington* (Del.) *News-Journal*.

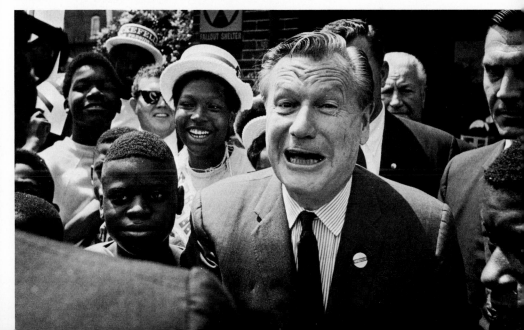

Fig. 17-4. This picture was made by the public relations department of DuPont for their *Better Living* magazine, an employee publication. This photo illustrates some of the legal implications photographers face. Although it may be used editorially, such as in a textbook or to illustrate a feature story in a magazine or newspaper, it cannot be used for advertising or promotional purposes. To be used for the latter, both the company's permission and a model release would be necessary. Courtesy of E. I. DuPont de Nemours & Co., Inc.

original legitimate news in the publication. The same rule usually applies to the use of a news picture in a book if the picture is of an informative nature or if it is of a public figure who, in a sense, has more or less surrendered the greater part of his right of privacy in becoming a public personage.

There are also questions of decency to consider in the taking of photographs. If the photographer is in doubt about a picture, it is best for him to ask his editor or some equally well-informed person, such as the newspaper's attorney.

Libel and Truth

In the Roaring Twenties, from 1924 to 1932, the New York *Evening Graphic* became famous as a perpetrator of sensational journalism and clever photomontage reproductions called *composographs*. In a circulation war with other New York newspapers, the *Graphic* used these photographs as a means of attracting a great number of readers. The composographs were made by superimposing models onto real photographs or by cutting out people's heads and placing them on the bodies of models posed in such a way as to illustrate news stories in the paper.

Even though there were no photographic wire services at the time of

Lindberg's safe arrival in Paris, the *Graphic* came out with a "scoop" in the form of a composograph showing Charles Lindberg in Paris after the first non-stop solo crossing of the Atlantic. Many people knew the picture was not true, but they bought the paper anyway. The captions stated that the pictures were composographs. Such pictures would not be published today because of a change in newspaper ethics and in the laws of libel and privacy.

Because truth is one of the defenses in libel cases and photographs are considered to be actual representations of scenes, it would appear that libel suits from "true" photographs would never develop. This is not necessarily so, although such suits are uncommon. Libel suits have been won where the photograph subjected a person to ridicule or was otherwise degrading to him. Photographs may not always tell the truth because of the perspective that certain lenses create. The distortion may make the subject appear grotesque or even obscene.

Libel cases may also derive from the captions on photographs, from improper use of photographs, or even from cases of mistaken identity. Many libel suits involving photographs come not from the caption but from the use of the photograph with an article that may imply that the subject is dishonest when he is not or in some other way debase the subject's character.

Generally speaking, news pictures reporting current happenings or illustrating other news items of public interest need not have the permission of the subject in order to be used. Persons who attend public events may have their picture taken as part of the audience, even though they may not desire that this be done. One person in such a situation cannot

Fig. 17-5. A bleached steer skull on the alkali flats of South Dakota's Badlands was photographed in May, 1936, by Arthur Rothstein. Later that year, a news syndicate circulated this picture with a different caption to symbolize drought conditions in the Great Plains. The photographer was at first accused of faking, and the photograph became an issue in the presidential campaign of that year. Courtesy of the Library of Congress, Farm Security Administration Collection.

be singled out, however, unless he is newsworthy. Here, the fine line drawn between what is newsworthy and what is not may be difficult to determine at times. The photographer is usually safe in taking such a picture if it is customary to do so at certain types of events, such as a New Year's Eve celebration, a fashion show, or a political rally.

Obscenity

Determining the difference between an obscene and an artistic picture in photographing nudes is somewhat difficult. In cases that have come to court, most of the decisions have been based either on the intent of the photograph or whether the picture excites or leads others to impure thoughts.

Nudity in itself is not necessarily a basis for obscenity. Many nude pictures are published in photography magazines or displayed in art galleries and other exhibits. Two considerations in making the decision on obscenity are whether the photograph shows a discernible pubic area or by posture, gesture, or in some other way implies immoral actions or thoughts. Laws on nudity vary from state to state, but there are also regulations on sending nude photographs through the United States mails; these regulations generally follow the two rules mentioned above. There are exceptions to the above guidelines for medical purposes, and if a photographer is in doubt, it is best for him to consult his local postmaster or some other postal authority.

Copyrighting Photographs

If a photographer wishes to prevent unauthorized use of a picture, he should apply for a copyright from the Registrar of Copyrights, Library of Congress, Washington, D. C. The cost of each copyright is $6, and two copies of each photograph must be sent with the application. Application forms (Form J) may be obtained from that office.

Because copyrighting each photograph is expensive, some photographers have placed a number of individual photographs on a piece of photographic paper and registered the whole group for one fee. In the case of photographs being published in a magazine, the publisher may copyright the magazine and thus protect the photograph, providing the photographer has retained the right to resell the picture. Every time the picture is published, the words "Copyright by . . ." and the owner's name should appear either on the published picture or just below it, unless the whole publication is copyrighted. The copyright symbol, ©, accompanied by the copyright owner's name, is frequently used. The date need not appear on photographs.

If publication of the picture is permitted without the copyright notice either on it or with it, the owner loses his copyright protection. The first copyright is good for 28 years and may be extended for another 28, upon application at the time the first copyright expires. The photographer need

not apply immediately for a copyright; it may be obtained within a reasonable time after first publication. The notice of copyright must appear with all photographs whether the copyright has been obtained or not, however, if the photographer wishes to protect himself.

One publishing firm I know published a children's book for an author with the copyright notice inadvertently omitted. The author later wanted to protect herself by copyright but could not do so because the book had been published first without the notice of copyright.

Insurance

Because camera equipment is quite expensive and subject to theft, breakage, falling off a pier into the water, and many other hazards, the cheapest insurance a photographer can get is insurance on his equipment. The policy with the greatest coverage is called a *floater policy*, which covers almost anything that can happen to the photographer's equipment outside of mechanical repairs or deterioration from normal use. I have found some insurance agents unfamiliar with this type policy, so it is advisable to be sure that the agent understands your insurance needs.

A second type of policy covers fire, theft, and storm damage but not breakage from accidental dropping and is included in the insurance of either a person's place of business or household effects. Different companies have different types of policies, and it is necessary to make comparisons among various coverage plans offered before making a decision. Premiums for floater policies usually run about $2 per $100 valuation, with the premium for household policies usually less. If the photographer has only a small amount of photo equipment, it would perhaps be better to insure it under the latter type of policy. However, if he has a considerable amount, carries it with him frequently, and uses it in earning either all or part of his income, the floater policy is perhaps more advantageous for him, because of the wide protection it affords. Generally speaking, there is a minimum of about a $250 valuation, or a $5 premium per year on a floater policy.

The photographer should also protect himself from financial loss due to suits or out-of-court settlements with subjects injured from a fall or similar accidents while working with the photographer or while the subject is on the photographer's property.

All sorts of freak accidents occur, injuring and sometimes killing persons. One such accident killed a high school cheerleader in the fall of 1966 while she was posing with six other cheerleaders on a crossbar of the goal post. It was the last picture of a shooting session, and the students were perched on the crossbar about ten feet above the ground, when the bar broke and one of the goal posts fell on the girl, fatally injuring her.

Normally, a photographer working for a company will be protected by the company's personal liability insurance, but a self-employed pho-

Fig. 17-6. News photographers can usually count on large industrial firms such as railroads, mines, and so on, to take special precautions to insure their safety. The Illinois Central Railroad built a special platform on a flatcar in order that newsmen and railroad officials could personally tour a new track route in comfort and safety. Courtesy of Illinois Central Railroad.

tographer will need protection for himself. Even though the photographer may not in any way be at fault in an accident, lawsuits are costly and no one knows how a jury will decide until the verdict is announced. Personal liability insurance coverage should be discussed with several agents and the cost and protection compared for the various policies.

The photographer who hires others and has employees who may handle money or financial transactions should consider bonding those employees through an insurance company. Most large companies follow this procedure, because it is impossible to determine who is honest or dishonest until the person embezzles or otherwise misappropriates the funds or property of the firm.

The most trusted person in the firm often turns to embezzling, because of the very trust in which he is held. It has been found in bank embezzlements that the guilty party is often the trusted "little old lady" who has been an employee for many years and is well thought of in the community. Her male counterpart may be the accountant or financial officer who is a church member and an apparently outstanding citizen of the community, until it is discovered that he has "borrowed" company funds to place bets on horse races or to invest in highly speculative securities. He always had every intention of paying back the funds, of course, but was unable to do so because of his losses. Remember that many small businesses have been bankrupted by an employee's dishonest actions.

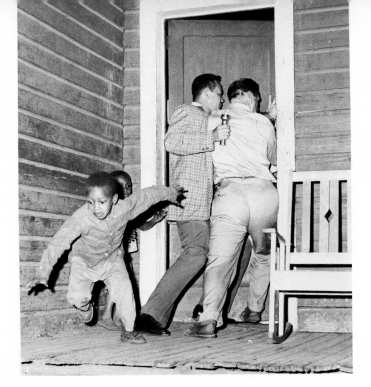

Fig. 17-7. When the sheriff's deputies staged a gambling raid, Eddie Davis was there with his camera to catch this prize-winning photo. Notice the action of the two men going into the house and the boy running off the porch. Cooperation with local authorities often pays off in prize-winning pictures for the news photographer. Courtesy of the *Gainesville* (Fla.) *Sun.*

Bonding insurance is reasonable in cost and is sold by a great number of insurance companies.

Military and Civilian Restrictions

Many newsworthy pictures are obtained through the cooperation of police, fire, and military authorities. The photographer covering such beats will soon learn what pictures he can take and how to get along with civilian and military authorities without becoming meddlesome. In large cities, press photographers carry special passes that allow them to go into places where there are fires, accidents, or other tragedies closed to the general public.

There have been occasions when even the police have destroyed a photographer's exposed film or his camera or roughed him up personally in some way. These cases are rare, and usually the photographer from a publication or press organization receives favorable treatment from civic and military authorities.

Military authorities have more restrictions on taking pictures, and sometimes it is difficult to get pictures of a crash of a military plane, an explosion on a military base, or some other restricted area. Often the

Fig. 17-8. This drawing is of the Clay Shaw trial in New Orleans, 1968, and is part of a series made by John Chase, TV editorial cartoonist, for WDSU-TV during courtroom proceedings. This sketch shows Dr. Pierre A. Finck marking the shirt of a defense lawyer to indicate where the bullets hit President Kennedy when he was assassinated in Dallas, Tex. Dr. Finck was one of the three persons who performed the autopsy at the U.S. Naval Hospital near Washington, D.C. In the chair observing the proceedings is New Orleans businessman Clay Shaw who was on trial. Ever since the Sheppard case on pre-trial publicity, it has become more difficult for press photographers to take pictures in or near the courtroom. Thus, artists are being employed to make photo-like drawings for both television and newspapers. Courtesy of WDSU-TV, New Orleans, La.

military will release only pictures that their own photographers have taken and will not allow newsmen to take pictures on their own.

Various agencies of the federal government have a "managed news" policy and will not allow certain types of pictures to be taken or statements quoted from government officials. This policy varies, sometimes being quite lenient and other times, quite strict.

When an accident involves two of the city's fire trucks or a policeman wrecks a car while under the influence of alcohol, a photographer will usually find it extremely difficult to get pictures of the event. The agency in question may pass it off as "taking all measures to protect the city and the public at large" or some similar ruse.

Whether pictures can be taken in a courtroom or not depends largely upon the judge and the custom of that particular court. The American Bar Association in 1937 adopted a rule known as "Canon 35," which stated that the association felt that taking pictures while the court was in

session or during recesses detracted from the dignity of the court and otherwise created misconceptions in the mind of the public and that any type of photography in the courtroom should be prohibited. The National Press Photographers' Association fought hard to have this rule changed, using as a basis for argument the fact that cameras with fast lenses and high-speed film could take pictures in the courtroom without distracting or interfering with court proceedings.

An amendment in 1952 provided that certain proceedings could be photographed. Actually, the *Canons of Judicial Ethics* are not laws but guidelines for the nation's judges and attorneys in non-federal jurisdictions. Some states strongly enforce this rule, and a violation can lead to a contempt citation with a possible fine or jail sentence for the photographer.

Federal courts come under Rule 53 of the Rules of Criminal Procedure, which was adopted by the United States Supreme Court in 1945. This rule prohibits taking photographs during judicial proceedings or radio broadcasting of judicial proceedings from the courtroom.

Pre-Trial Publicity

In June, 1966, the United States Supreme Court ruled that Dr. Samuel Sheppard, Cleveland, Ohio, had not had a fair trial when convicted of his wife's murder in 1954. The decision of the court was based on the widespread coverage by radio, television, and newspapers of Dr. Sheppard's arrest and trial, holding that because of the nature and the intensity of this coverage Dr. Sheppard was entitled to a new trial.

A number of other cases have developed in the same area, all having to do with pre-trial news coverage. Because of such cases, news media are finding it increasingly difficult to hold interviews, take photographs, and write news stories on important criminal cases.

Regulations and Licensing

A photographer working for a publication does not need an occupation license. When he goes into business for himself, he will be governed by the laws and ordinances of the community in which he lives and/or works. There are certain restrictions covering sanitation, commercial zoning, sales tax licenses, occupation licenses, and other areas, which a professional photographer must observe. It is wise to inquire what regulations affect photographers before establishing a part-time or full-time business. Some cities permit darkrooms in residential areas but not studios. Others may permit home studios but restrict advertising and displays or even have regulations on customer parking. These restrictions will vary from area to area. By joining one of the professional photographers' associations, the photographer can often learn more quickly about new legal and ethical problems than he could in any other way. Of course, he also has the opportunity to attend clinics and conferences and to meet other persons active in his field.

Figs. 17-9a, b, c, and d. Because photographers were barred from the courtroom in the trial of Sirhan-Sirhan, accused assassin of Senator Robert Kennedy, the ABC television network hired Bill Lignante to make drawings of the proceedings: (a) Sirhan-Sirhan; (b) Patrolman White, who took Sirhan from the Ambassador Hotel to the police station's interrogation room (notice the diagram of the room and the inset of White holding a microphone to record Sirhan's statement); (c) the mysterious girl in the case, known as "the girl in the polkadot dress," alleged to have been with Sirhan-Sirhan the night of the assassination. In the background are Judge Walker and David Fitz, a prosecuting attorney. Courtesy of ABC-TV, Hollywood, Calif.

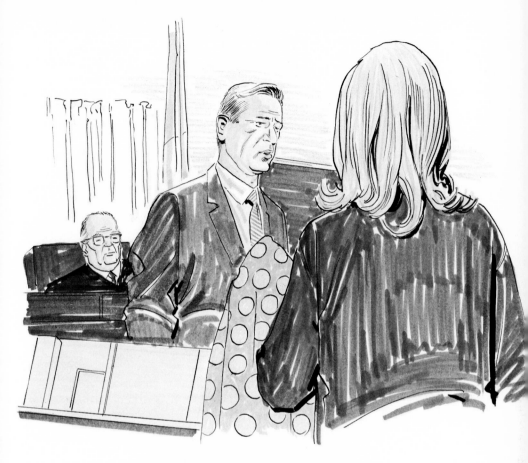

ETHICS IN PHOTOGRAPHY

Ethics is one important aspect of photography that the beginner might never consider. An ethical violation might not be brought before a court of law, although lawsuits can arise from such infringements, but both the photographer's business and personal reputation can be damaged by an inadvertent action on his part if he is unaware of ethical complications that may arise. Photography has its own special pitfalls, and they are not always easy to predict or judge with mere commonsense and good instincts.

The photographer seldom, if ever, needs to come into direct physical contact with a subject, and it is best to refrain from touching the person in any way, especially in taking studio pictures or portraits. Although a young child may be lifted or moved about slightly, young people and adults should be directed either by voice or by gesture or both, without actual physical contact being necessary.

The photographer wishing to avoid the wrong reputation should use

303

discretion when alone in the studio with a subject. For example, when I once owned a portrait studio in a small city, a young lady telephoned to ask if I took drape shots. I replied that I did but had no one else in the studio and that she should bring her mother, sister, or a girlfriend to help her with the drape. I prefer to have a woman assistant to smooth the wrinkles from a dress, straighten sleeves, put the hair in place, or otherwise arrange a subject's clothes and help with posing. Even though the photographer may innocently touch someone, the subject may receive the wrong impression due to the reputation that fiction has given photographers.

The photographer should never give the picture of a subject to anyone else without the subject's express permission, even though the picture may have been used for a news story and permission may have been obtained when the picture was taken. A boy may come in and ask for a photograph of a pretty girl, claiming to be her boyfriend. The girl may not want him to have her picture, and although giving him the picture without her consent might not bring about a lawsuit, it could very well damage the photographer's public image permanently.

Good Taste

Gruesome pictures of tragedies are taken from time to time. For example, a Buddhist nun is photographed after setting herself on fire, the

Fig. 17-10. James Earl Ray, accused assassin of the Rev. Martin Luther King, Jr., is being led into the Shelby County, Tenn., jail by Sheriff William Morris. Because of court rulings on pre-trial publicity, and the killing of Lee Harvey Oswald by Jack Ruby in Dallas, Tex., getting this type of photo has become increasingly difficult for news photographers. Courtesy of the *Memphis* (Tenn.) *Commercial Appeal.*

Figs. 17-11a and b. Spot news tragedies often produce some very gruesome pictures and the decision whether to print them rests upon the editor. A good news photographer should be able to judge what to photograph and what to omit. (a) This photo, by Charles Knight of the *Times-Gazette,* could be considered by some editors too distasteful to publish because it might provoke revulsion in readers and cause unnecessary suffering to the victims and their families. However, this photo of the aftermath of a bank robbery (b), taken by Lee Romero of the *Journal and Evening Bulletin,* might have been very bloody but the photographer avoided the grisly views and came up with a dramatic picture that still tells the story of sudden death. Courtesy of the *Times-Gazette,* Ashland, Ohio, and the *Journal and Evening Bulletin,* Providence, R.I.

burning funeral pyre of a great leader such as Mahatma Ghandi is shown, or grisly pictures of accident victims are made. Newspaper readers often criticize the publication of pictures that they think are in poor taste or are unpleasant to view.

Much of the decision as to whether to publish such a picture in the paper rests upon the shoulders of the editor. Photographers working with newspapers or wire services will know what to take and what to omit from experience and from guidelines set down by the organization's policy. Although there may be some legal questions involved in such pictures, usually the publication of gory or distasteful photos comes under the category of ethics rather than of legality. Such pictures do serve as warnings to others and definitely fall into the newsworthy class; however, some papers thrive on sensationalism and carry the publication of such pictures much too far. The paper should keep in mind the dignity of the victims of the tragedy, as well as the feelings of the audience the publication reaches. Whether to publish a picture of a tragedy is often a difficult decision for the photo editor to make.

Pricing

Two of the greatest problems I have found with beginning photographers is that they tend to price their work too cheaply and to attempt free-lance assignments for which they are not qualified.

The photographer should charge enough money to absorb the costs not only of his materials but also of his time, car expenses, depreciation on equipment, and other overhead expenses, such as insurance and taxes. Even the beginning photographer should charge two or three times as much for an 8″ × 10″ photograph as the customer would pay to have his own negative enlarged to an 8″ × 10″ size at the drugstore.

The beginning photographer should charge less, in most cases, for his work than a professional would because he lacks skill. He should not, however, try to take business away from a professional by pricing his work ridiculously low. Doing so not only reflects on the photographer's character but hurts the entire photographic profession as well.

I have had unethical and mostly inexperienced photographers solicit some of my better accounts by offering to make photographs for about one-fourth my regular prices. Many times the account would tell me about such photographers, remarking that the other photographer was not even considered because the account manager knew that good photographs could not be obtained at the price quoted.

Once, when I had my own industrial photography business in Denver, I was asked to quote a price for taking a number of 8″ × 10″ photographs of the interior of a very famous bar. I went to the establishment and talked to the owner, and we came to an agreement of $10 for each 8″ × 10″ glossy photograph, a price somewhat lower than I normally charged. When I went back to make a definite appointment to take the

pictures, the owner told me he had changed his mind because an airman from one of the nearby bases had offered to do the job for 35¢ per 8″ × 10″ photograph. As a result, neither of us got the job. The owner felt that I must be overcharging him at $10 a picture, and he did not hire the airman because he did not believe he could do the work properly.

Photographers need to build their reputation on sound ethical and business practices. False advertising, shoddy work, or other unethical tactics have no place in the professional photographer's life. The Professional Photographers of America, Inc., and other similar organizations have adopted codes of ethics, and it is a good idea for the beginning photographer to familiarize himself with these codes as a guide to his professional conduct.

SUMMARY

Legal

Whether a photograph is to be used for news or advertising often determines if written consent of any recognizable subject appearing in it is needed. Photographs used for advertising or similar purposes should carry with them the written consent of the subject being photographed. This written consent is called a *model release.*

The best time to obtain a model release is before or at the time the picture is taken. Such releases should be signed by parents or guardians if the subject involved is a minor. Public figures generally have little right of privacy and their photos may be reproduced in publications for informative purposes; they cannot be used for advertising, however, without the subject's permission. State laws on this subject differ, which makes it difficult to stipulate one set of rules that fit all conditions.

Another legal factor to be considered in taking photographs is libel. Truth is one defense for libel, but ridicule of a person or a poorly worded or erroneous caption may result in a libel suit. Generally speaking, news pictures used to report current happenings or to illustrate other items of public interest need not have the permission of the subject in order to be used. Sometimes the fine line between what is newsworthy and what is not may be difficult to draw.

Nudity and obscenity are two areas that have been the subject of many court cases. Laws vary from state to state, and even the very purpose for which the photograph is intended may decide whether such photographs are lawful or unlawful. Nude pictures in good taste are often published in magazines or displayed in art exhibits.

One way in which a photographer can prevent unauthorized use of his picture is to obtain a copyright from the Registrar of Copyrights, Library of Congress, Washington, D. C. Copyrights are good for 28 years and may be extended for another 28 upon application, at the time the first copyright expires. Any work that is copyrighted should include a notice of copyright in order to protect the photographer legally.

Because camera equipment is expensive, it should be adequately insured. The floater policy provides the greatest coverage. Other types of insurance a photographer should consider are household insurance, property damage, personal liability, and if the photographer is employing others, insurance against loss of funds by embezzlement.

Certain types of news events, especially those involving military accidents, police personnel, and government officials may be difficult for the photographer to cover because of restrictions made by the authorities in charge. He may also be prohibited from taking pictures in courtrooms or even outside the courtroom, because the factor of pre-trial publicity is involved.

A photographer working for a publication does not need an occupation license; if he is doing some type of commercial work, however, he may be required to meet certain licensing and zoning laws of the municipality in which he lives.

Ethical

Certain precautions should be taken by photographers in order to maintain a good reputation. Even touching a subject may sometimes lead him to draw the wrong conclusions. It is always advisable for the male photographer to have another woman present when doing any type of cheesecake, portraiture, or similar type of photography where it may be necessary to rearrange any part of the costume, put the hair in place, and so on.

Even giving a picture to someone other than its subject can give rise to ethical and even legal problems.

Whether to publish gruesome pictures of a tragedy often depends upon the decision of the editor rather than the photographer. Publication of such pictures is a matter of taste and is not bound by any specific rules. The question is most often decided by the newsworthiness of the picture.

The photographer doing outside work for others should charge enough to cover his materials and time and to net him a profit. He should not attempt to undercut prices of professional photographers, since this is unethical as well as unsound business policy.

QUESTIONS

1. Explain the factors involved in taking a picture for news and for advertising.
2. What is meant by a model release?
3. What type of individual has little or no right of privacy?
4. The majority of lawsuits brought against photographers involve what type of legal action?

5. What should a photographer do if he is in doubt about the legal implications involved in publishing a particular picture?

6. How may a photographer become involved in a libel suit even though the picture taken is not libelous?

7. What is the general rule governing news pictures in regard to libel?

8. On what basis has the decision of the court usually been made in suits involving obscenity?

9. How is a copyright obtained? How may a photographer extend it?

10. Discuss some of the different types of insurance that a photographer should have for his own protection.

11. What is meant by a "managed news" policy?

12. What are some problems involved in taking pictures of military disasters?

13. What is "Canon 35"?

14. What is pre-trial publicity, and how does it involve press photographers?

15. What type of license does a press photographer need when working only for a newspaper or similar publication?

GLOSSARY

ABERRATION: Optical defect in lenses; may be of several types.

ACUTANCE: Physical sharpness of a negative image.

ADDITIVE COLORS: The three colored lights, red, blue, and green, which, when combined in the proper proportions, make white light; also, a color photography film process, now obsolete, based on this principle.

AIR BELLS: Bubbles of air that prevent developer or other chemicals from acting on the surfaces of film or paper.

AIRBRUSH: A miniature pencil-shaped paint gun driven by compressed air and used by retouchers and artists.

APERTURE: The lens opening, controlled by a diaphragm, measured in f/stops.

ARTIST'S STUMP: Small cylindrical rolls of paper about the size of a pencil and tapered at one end; used by artists to smudge charcoal, pencil, or pastel drawings.

ASA: American Standards Association, a national association that sets up standards for comparing the products of one manufacturer with another for the purposes of measurement, not quality.

BACKLIGHTING: Light coming from behind the subject.

BIG BERTHA: A camera formerly popular with sports photographers, used with a large, long focal length lens.

BLOTTER ROLL: A long roll of blotter paper used for drying photographic prints.

BLOWUP: An enlargement printed from a negative.

BODY, CAMERA: The main part of a camera, without the lens.

BOUNCE FLASH: Light from a flash unit that is bounced off a wall or ceiling rather than aimed directly at the subject.

BRACKETING: A method of assuring the correct exposure by shooting several exposures, usually one two stops higher than normal, one normal, and one two stops lower than normal.

BURNING IN: Darkening part of a print by giving it more exposure under the enlarger than other parts receive.

CAMERA OBSCURA: A dark chamber through which an image from the outside is projected, usually through a very small opening.

CATCHLINE: Type, usually larger or heavier than cutline type, used between the cutline and the photograph printed in a publication.

CHANGING BAG: An opaque cloth device with light-proof openings and two sleeves, which allows the photographer to load or unload film in daylight.

CLAMP TRIPOD: A tripod with a clamping device that fits on a chair back, pole, window sill, or similar surface.

COLOR NEGATIVE: A negative in color, from which color or black-and-white prints can be made; distinguished from a color positive, such as a transparency.

CONDENSER: A single lens with one flat and one convex side; used in pairs in condenser enlargers.

COPAL (SQUARE) SHUTTER: A brand of shutter made in Japan; although resembling a focal-plane shutter, this type has slightly different characteristics.

COPY STAND: A special device made for holding work to be copied by a camera.

COPY WORK: Work copied photographically.

CREDIT LINE: The name of the photographer or organization that took the photograph appearing in a publication.

CUTLINE: Printed matter appearing under or above a photograph in a publication.

DIFFUSION FILTER: A filter that blurs or softens the image somewhat when placed over a lens.

DODGING: Shading a portion of the negative during enlarging.

DYE COUPLER: A colorless chemical either incorporated into the emulsion of color films, such as GAF Anscochrome film and Kodak Ektachrome film, or into the developer of Kodachrome film. When combined with other developing chemicals, it forms the three subtractive dyes—magenta, cyan, and yellow—in color film.

ELECTRONIC FLASH: A repeating flash unit using batteries or alternating current and containing various electrical parts.

EXCHANGE NEWSPAPERS: Newspapers received through the mail by a newspaper office at no subscription cost, in exchange for copies of its publication mailed to the publishers of those received.

FERROTYPE PLATE: A sheet of chrome-plated steel, brass, or japanned iron with a highly polished surface, upon which wet glossy paper prints are squeegeed for drying.

FILL LIGHT: A light used to fill in shadows in portraiture, as contrasted with the main, or key, light.

FILM SPEED: A standard of ASA measurement to compare one film with another for purposes of exposure and development.

FLARE: Reflections inside a lens that cause a bright spot on the negative.

FLASH FILL: The light from flash units used to put light in the shadows of outdoor photographs.

FLOATER POLICY: A special type of insurance policy that insures equipment against almost any type of hazard, including damage from accidents.

FOCAL-PLANE SHUTTER: A shutter adjacent to the film plane. It has a travelling slit, which makes the exposure. The moving speed of the slit

and the opening determine the shutter speed. It is used on some press cameras and on many 35mm cameras and permits higher shutter speeds than other common types of camera shutter.

F/STOP: The aperture opening, based on dividing the focal length of a lens set at infinity by the diameter of the opening; expressed as a number, which is the denominator of the ratio of diameter to focal length.

GRAY SCALE: A series of shaded areas progressing in density from black to white; also, a graduated scale of grays used in color photography for comparing densities of separation negatives.

GUIDE NUMBER: A number used in determining flash exposures.

HALATION: Scattered light reflected from the back of film.

HALF FRAME: One-half size (¾″ × 1″) of a regular 35mm negative; sometimes called *single frame*, as opposed to the double frame (1½″ × 1″) of a regular 35mm negative.

HEAD SCREEN: A screen usually made of gauze or some similar material, used in portraiture to keep some light off the subject's head.

HOT SPOTS: Areas that receive more light than their surrounding areas.

HYPERFOCAL DISTANCE: With the lens set on infinity, the distance from the camera to the nearest point in sharp focus.

HYPO: A fixing agent, usually sodium thiosulfate.

HYPO CHECK: A chemical mixture used for testing to see if hypo is too old or weak.

INCIDENT LIGHT: All the light falling on a subject as opposed to that reflected from it.

INCIDENT LIGHT METER: A meter that reads incident light.

INFINITY: A point beyond effective finite measurement on the camera lens; that is, "as far as the eye can see."

INFRARED: Invisible light rays lying just below the deepest visible red on the spectrum.

INTENSIFICATION: A chemical process for making weak negative or positive photographic images stronger.

INTERFERENCE: Light waves out of phase with other light waves, resulting in cancelling one another.

INTERNEGATIVE: A color negative made from a color film positive (transparency or slide) in order to make color prints.

KEY LIGHT: The main light in portrait lighting, as contrasted to a fill light.

LEAF SHUTTER: Sometimes called a *diaphragm shutter,* usually mounted between the lens elements but can be behind or in front of them; the leaves, or blades, are arranged around a circle and open outward, to leave a hole in the center that admits light into the film chamber.

MASTER PHOTOGRAPHER: The highest rating given by the Professional Photographers of America, Inc., to individual photographers. The rating is based on several factors, including demonstration of the highest standards in photographic skill. It usually takes several years for a pro-

fessional photographer to attain this standing.

MATTE-SURFACE PRINTS: Prints having a textured, non-glossy surface.

MODEL RELEASE: Written permission to use a person's photo in publications or for display.

MONOCULAR: Any telescopic lens arrangement of extremely long focal length.

MULTIPLE-CONTRAST PAPER: A single printing paper that gives various contrasts with filters as opposed to papers of different grades.

NOVOFLEX LENS: A follow-focus lens used mainly in sports photography.

ONE-SHOT CAMERA: A color camera that has built-in filters for making three separation negatives simultaneously with black-and-white film.

ONE-TO-FOUR LIGHTING: Lighting where highlights have four times as much light as the shadows.

ORTHOCHROMATIC: Sensitive to all but orange and red colors.

PANCHROMATIC: Sensitive to all colors.

PAPER NEGATIVE: A negative made on photographic paper.

PHOTOFLOODS: Lamps that burn much brighter than regular household bulbs but burn only for a few hours.

PICTURE STORY: A series or sequence of pictures that tell a complete story with little other explanatory material.

PISTOL GRIP: A device shaped like the butt of a pistol, for holding a camera steady.

POLARIZING SCREEN: A filter that allows light waves to come through in one direction; useful in cutting reflections, darkening skies, and so on.

PRIMARY COLORS: Colors covering one-third (each) of the visible spectrum—red, green, and blue.

PRINTING FRAME: A wood or metal frame with glass on one side and a felt or cloth pressure pad to hold the negative and paper together.

PROCESS FILM: A slow film used in copy work; gives purer whites in reproduction.

PURE COLOR: Light of one of the primary colors only.

RANGEFINDER: An optical device with two viewpoints, using geometric principles, that enables a viewer to determine the focusing distance of objects away from the photographer.

REDUCER: A photographic chemical used for decreasing the silver on a developed negative, thus reducing the density of the negative.

REFLECTED LIGHT: Light that does not come directly from a primary source but is reflected off one or more surfaces.

REFLECTED LIGHT METER: A device for measuring the amount of light reflected from a subject.

REVERSAL PROCESS: A method of developing film to produce a positive rather than a negative image.

SAFELIGHT: A colored glass-mounted filter or bulb used in a darkroom to prevent extraneous light from fogging light-sensitive materials.

SATURATED COLORS: Intense, chromatically pure colors; measured by their degree of difference from gray of the same lightness.

SHORT STOP: A mixture of acetic acid and water or similar chemicals; stops development of film and paper before they are placed in the hypo.

SHUTTER SPEED: The time required for a shutter to open and close.

SIZING, OR SCALING: Determining the amount of space a photograph will occupy in a publication or determining the proportions of a photograph to fit an exact space on a printed page; also figuring out the amount of enlargement or reduction necessary to make the photo fit.

SLANTING: Designing a photograph to fit the needs of the audience of a publication.

SLAVE UNIT: A device for tripping flash units by the sensitivity of a built-in photoelectric cell.

SOFT FOCUS: A diffused image made either under the enlarger or by a soft-focus lens on the camera, purposely undercorrected for spherical aberration.

STABILIZATION PROCESSOR: A mechanical developing machine that uses a special paper containing the developing agent.

STATIC BRUSH: A brush that eliminates dust clinging to a negative by desensitizing the film to static electrical charges.

SUBTRACTIVE COLORS: Colors formed by the absorption of the complementary colors from white light—cyan, magenta, and yellow.

SYNCHRO-SUNLIGHT: Combining flash and sunlight to make an exposure.

TENT: A box-like device covered with translucent material and lighted with flood lamps or other sources outside, used for photographing highly reflective metallic objects.

TRANSPARENCY: A color film with a positive image.

ULTRAVIOLET: Light beyond the visible violet (upper) end of the spectrum.

VARIABLE-CONTRAST PAPER: Paper that changes contrast when used with filters; multi-contrast paper.

VIEWFINDER: A wire frame or optical finder that gives the approximate area covered by the camera when sighted through.

VIGNETTER: An enlarging device that leaves an image in the center of the paper but fades the edges; used often in portraiture.

WATER BATH: A method of developing in which the film is put into the developer, then into water, and back again to cut contrasts.

WIRE FINDER: See viewfinder.

ZONE OF SHARPNESS: The distance in front and in back of a subject that is in focus at a given aperture; depth of field.

ZOOM LENS: A lens constructed so that the focal length can be changed, increasing or decreasing the image size. It remains in focus although the focal length is changed and is usually expensive, since it may have as many as 16 elements, contrasted to the 4 to 8 elements of single-focal-length lenses.

Suggested Readings
and Bibliography

ADVERTISING

Croy, O. R., *Design by Photography*, Amphoto–Focal, New York, 1963.

Gollschall, Edward M. (ed.), *Advertising Directions Three*, Art Direction Book Co., New York, 1962.

Pinney, Roy, *Advertising Photography*, Hastings House, New York, 1962.

ARCHITECTURE

Cleveland, Robert C., *Architectural Photography of Houses*, F. W. Dodge Corp., New York, 1953.

Shulman, Julius, *Photographing Architecture and Interiors*, Whitney Library of Design, New York, 1962.

BASIC TECHNIQUES

Feininger, Andreas, *The Complete Photographer*, Prentice-Hall, Englewood Cliffs, N. J., 1965.

Feininger, Andreas, *Total Picture Control*, Amphoto, New York, 1970.

Kodak Master Photoguide, Eastman Kodak Co., Rochester, N.Y., 1968.

Zim, Herbert S., R. Will Burnett, and Wyatt B. Brummitt, *Photography*, Golden Press, New York, 1964.

CAMERAS

Large-Format

Abbott, Berenice, *New Guide to Better Photography*, Crown Publishers, Inc., New York, 1953.

Foldes, Joseph, *Large-Format Camera Practice*, Amphoto, New York, 1969.

Giebelhausen, Joachim, and Herbert Althann, *Large Format Photography*, Verlag Grossbild–Technik, Munich, Germany, 1967.

Linssen, E. F. (English-language ed.), *Linhof Practice*, Verlag Grossbild–Technik, Munich, Germany, 1958.

Small-Format

Deschin, Jacob, *35mm Photography* (2nd ed.), Amphoto, New York, 1959.

Jonas, Paul, *Improved 35mm Techniques* (4th ed.), Amphoto, New York, 1967.

Woolley, A. E., *Creative 35mm Techniques* (2nd ed.), Amphoto, New York, 1970.

COLOR

Applied Color Photography Indoors (1st ed.), *Color Photography Outdoors, Here's How, More Here's How, Third Here's How, Indoor Color Slides, Outdoor Color Slides, Printing Color Negatives* (3rd ed.), Eastman Kodak Co., Rochester, N.Y., various dates.

Benser, Walther, *More Color Magic*, D. R. Diener K. G., Neumunster, Germany, 1959.

Engdahl, David A., *Color Printing* (3rd ed.), Amphoto, New York, 1970.

Feininger, Andreas, *The Color Photo Book*, Prentice-Hall, Englewood Cliffs, N. J., 1969.

Sipley, Louis Walton, *A Half Century of Color*, The Macmillan Co., New York, 1951.

ENLARGING AND PRINTING

Croy, O. R., *The Complete Art of Printing and Enlarging* (11th ed.), Amphoto, New York, 1965.

Jacobs, Lou, Jr., *How to Use Variable Contrast Papers* (3rd ed.), Amphoto, New York, 1970.

Jonas, Paul, *Manual of Darkroom Procedures and Techniques* (4th ed.), Amphoto, New York, 1971.

Litzel, Otto, *Darkroom Magic*, Amphoto, New York, 1967.

Lootens, J. Ghislain, *Lootens on Photographic Enlarging and Print Quality* (7th ed.), Amphoto, New York, 1967.

Satow, Y. Ernest, *35mm Negs & Prints* (3rd ed.), Amphoto, New York, 1969.

FILTERS

Clauss, Hans, and Heinz Meusel, *Filter Practice*, Amphoto–Focal, New York, 1964.

Filters for Black-and-White and Color Pictures, Eastman Kodak Co., Rochester, N.Y., 1969.

Rothschild, Norman, and Cora Wright Kennedy, *Filter Guide* (3rd ed.), Amphoto, New York, 1971.

HISTORY

Faber, John, *Great Moments in News Photography*, T. Nelson, New York, 1960.

Gersheim, Helmut and Alison, *The History of Photography*, Grosset & Dunlap, New York, 1965.

Horan, James David, *Mathew Brady, Historian with a Camera*, Crown Publishers, New York, 1955.

Meredith, Roy, *Mr. Lincoln's Camera Man, Mathew B. Brady*, C. Scribner's Sons, New York, 1946.

Newhall, Beaumont, *The History of Photography from 1839*, The Museum of Modern Art, New York, 1949.

Pollack, Peter, *The Picture History of Photography* (1st ed.), Harry N. Abrams, Inc., New York, 1958.

LAW AND COPYRIGHTS

Chernoff, George, and Hershel Sarbin, *Photography and the Law* (4th ed.), Amphoto, New York, 1971.

Wittenberg, Phillip, *The Law of Literary Property*, The World Publishing Co., New York, 1957.

LIGHTING

Applied Infrared Photography, Eastman Kodak Co., Rochester, N.Y., 1968.

Flash Pictures, Eastman Kodak Co., Rochester, N.Y., 1967.

Jacobs, Lou, Jr., *Electronic Flash* (2nd ed.), Amphoto, New York, 1971.

Karsten, Kenneth, *Science of Electronic Flash Photography*, Amphoto, New York, 1968.

Nurnberg, W., *Lighting for Photography*, Amphoto–Focal, New York, 1968.

Woolley, A. E., *Photographic Lighting* (2nd ed.), Amphoto, New York, 1971.

MARKETING

Ahlers, Arvel W., *Where and How to Sell Your Pictures* (6th rev. ed.), Amphoto, New York, 1966.

Hanson, Eugene M., *How to Make Money in Photography* (2nd ed.), Amphoto, New York, 1964.

Jacobs, Lou, Jr., *Free-Lance Magazine Photography* (2nd ed.), Amphoto, New York, 1970.

Schwarz, Theodore, *The Business Side of Photography*, Amphoto, New York, 1969.

Sweet, Ozzie, *My Camera Pays Off*, Amphoto, New York, 1958.

Winchell, Fred (comp.), *More Money Selling Portraits*, The Photographers' Association of America, Milwaukee, 1956.

PHOTOJOURNALISM AND THE PICTURE STORY

Bureau of Naval Personnel, *Journalist 1 & C*, Navy Training Course, Nav-Pers 10295, Washington, D.C., 1961.

Fox, Rodney, and Robert Kerns, *Creative News Photography*, Iowa State University Press, Ames, Iowa, 1961.

Halley, William C., *Employee Publications*, Chilton Co., Philadelphia, 1959.

Jacobs, Lou, Jr., *Free-Lance Magazine Photography* (2nd ed.), Amphoto, New York, 1970.

Kalish, Stanley E., and Clifton C. Edom, *Picture Editing*, Rinehart, New York, 1951.

Payne, Lee, *Getting Started in Photojournalism*, Amphoto, New York, 1967.

Rhode, Robert B., and Floyd H. McCall, *Press Photography*, The Macmillan Co., New York, 1961.

Rothstein, Arthur, *Photojournalism* (2nd ed.), Amphoto, New York, 1965.

Steichen, Edward, *The Family of Man*, Simon & Schuster, New York, 1955.

Vitray, Laura, John Mills, Jr., and Roscoe Ellard, *Pictorial Journalism*, McGraw-Hill Book Co., Inc., New York, 1939.

Woolley, A. E., *Camera Journalism*, Amphoto, New York, 1966.

PORTRAITURE

Nurnberg W., *Lighting for Portraiture* (7th ed.), Amphoto, New York, 1969.

Petzold, Paul, *Light on People*, Amphoto, New York, 1971.

Strelow, Lisolette, *Photogenic Portrait Management*, Amphoto–Focal, New York, 1966.

REFERENCE WORKS

Adams, Ansel, *Basic Photo Series*, Morgan & Morgan, New York, various dates. Book 1, Camera and Lenses; Book 2, The Negative; Book 3, The Print; Book 4, Natural-Light Photography; Book 5, Artificial-Light Photography.

British Journal of Photography Annual, Amphoto–Henry Greenwood & Co., Ltd., New York (revised annually).

Carroll, John S., *Amphoto Lab Handbook*, Amphoto, New York, 1970.

Morgan, Willard D. (ed.), *The Encyclopedia of Photography*, 20 Vol., Greystone Press, New York, 1967.

Pitarro, Ernest (ed.), *Photo Lab Index*, Morgan & Morgan, New York, 1970.

The Focal Encyclopedia of Photography, 2 Vol., (fully rev. ed.), Amphoto–Focal, New York, 1965.

RETOUCHING

Croy, O. R., *Retouching* (4th rev. ed.), Amphoto–Focal, New York, 1964.

Floyd, Wayne, *How to Retouch and Spot Negatives and Prints* (2nd ed.), Amphoto, New York, 1968.

West, Kitty, *Modern Retouching Manual*, Amphoto, New York, 1967.

Index